Understanding the Politics of

This book is part of a series published by Manchester University Press in association with The Open University. The three books in the *Understanding Global Heritage* series are:

> *Understanding the Politics of Heritage* (edited by Rodney Harrison)
>
> *Understanding Heritage in Practice* (edited by Susie West)
>
> *Understanding Heritage and Memory* (edited by Tim Benton)

This publication forms part of the Open University course AD281 *Understanding global heritage*. Details of this and other Open University courses can be obtained from the Student Registration and Enquiry Service, The Open University, PO Box 197, Milton Keynes MK7 6BJ, United Kingdom (tel. +44 (0)845 300 60 90, email general-enquiries@open.ac.uk).

www.open.ac.uk

Manchester University Press

Manchester and New York

Distributed exclusively in the USA by Palgrave Macmillan

in association with The Open University

UNDERSTANDING
the politics of heritage

Edited by Rodney Harrison

Published by

Manchester University Press
Oxford Road, Manchester, M13 9NR, UK
and Room 400, 175 Fifth Avenue, New York, NY 10010, USA
www.manchesteruniversitypress.co.uk

in association with

The Open University
Walton Hall, Milton Keynes
MK7 6AA
United Kingdom

First published 2010

Distributed in the United States exclusively by Palgrave Macmillan, 175 Fifth Avenue, New York, NY 10010, USA.

Distributed in Canada exclusively by UBC Press, University of British Columbia, 2029 West Mall, Vancouver, BC, Canada V6T 1Z2.

Edited and designed by The Open University.

Typeset in India by Alden Prepress Services, Chennai.

Printed in Malta by Gutenberg Press Limited.

British Library Cataloguing in Publication Data: applied for

Library of Congress Cataloging in Publication Data: applied for

ISBN 978 0 7190 8152 1

1.1

The paper used for this book is FSC-certified and totally chlorine-free. FSC (the Forest Stewardship Council) is an international network to promote responsible management of the world's forests.

Contents

Figures

Contributors

Professor Richard Allen is Professor of Literature at The Open University. He has contributed extensively to textbooks published for The Open University including the series *Literature and the Modern World*, *Approaching Literature*, and *Issues in Women's Studies*. His main interest is in literary relations between Britain and India. He has lectured in a number of Indian universities and been Visiting Professor at the University of Delhi. His publications in this area include 'British post-colonialism: 1956 and all that', in *Interrogating Post-Colonialism: Theory, Text and Context* (Indian Institute of Advanced Study, Shimla, 1996); with Harish Trivedi he is the editor of *Literature and Nation: Britain and India 1800–1990* (Routledge, 2001).

Professor Ian Donnachie is Professor of History at The Open University. He has a long-term interest in social history and heritage promotion, particularly industrial heritage. Currently Chair of the Friends of New Lanark World Heritage Site, he is the author of many books, including a biography, *Robert Owen: Social Visionary* (John Donald, 2005), and an earlier study (with George Hewitt) of *Historic New Lanark* (Edinburgh University Press, 1999). He has contributed to many Open University courses, including most recently *From Enlightenment to Romanticism, c.1780–1830* and a short course on Heritage. He chairs a Taught Masters dealing with local and regional history in Britain and Ireland.

Dr Rodney Harrison is a Lecturer in Heritage Studies at The Open University, who has a broad range of professional experience researching and working in the heritage industry in Australia, the USA and the UK. He has published widely on the topics of community archaeology, museums, heritage and colonialism and is the author of *Shared Landscapes* (University of New South Wales Press, 2004), a critical exploration of the heritage of cattle and sheep ranching in Australia, and co-editor of *The Heritage Reader* (Routledge, 2008).

Dr Lotte Hughes is a Lecturer in African Arts and Cultures in the Ferguson Centre for African and Asian Studies at The Open University, and Principal Investigator of an AHRC-funded research project on heritage, museums and memory in Kenya (2008–11), which runs in parallel with a British Academy UK–Africa Partnership project. Her key publications include *Environment and Empire*, co-authored with William Beinart (Oxford University Press, 2007); *Moving the Maasai: A Colonial Misadventure* (Palgrave Macmillan, 2006); and the chapter '"Beautiful beasts" and brave warriors: the longevity of a Maasai stereotype', in George de Vos, Lola Romanucci-Ross and Takeyuki Tsuda (eds), *Ethnic Identity: Problems and Prospects for the 21st Century* (AltaMira Press, 2006). Her previous work (for a D.Phil., University of Oxford, 2002) was largely on Maasai land alienation and resistance in British East Africa, and the repercussions of this to the present day.

Professor Anne Laurence is Professor of History at The Open University. Her research is primarily on gender and finance in the early eighteenth century, but she has also published on gender and material culture. She has written Open University teaching material on a range of subjects, but especially on the civil wars of the three kingdoms in the seventeenth century, on the Irish War of Independence and the preservation of the built heritage of Ireland. She has a particular interest in using built heritage to teach social history.

Audrey Linkman works in the Visual Resources Unit at The Open University. She has previously held positions with the Manchester Studies Unit seeking out records of popular culture. With the collaboration of other colleagues she established the Documentary Photography Archive in Manchester, UK, in the 1980s. Her work in building one of its special collections, the Archive of Family Photographs, inspired her research interest in photohistory and the role of photographs as historical record and heritage. Her publications include *The Victorians: Photographic Portraits* (Tauris Parke, 1993).

Dr Susie West worked in British field archaeology and regional museums before researching her PhD thesis in architectural history. She became a Senior Properties Historian at English Heritage, contributing to the public understanding of their historic properties. Much of her professional experience has been focused on the interaction between users and providers of heritage as a cultural resource, particularly in the museum and voluntary sectors. She joined The Open University in 2007 as Lecturer in Heritage Studies with a special interest in UK heritage practices and the English country house. Her publications include *The Familiar Past? Archaeologies of Britain from 1550* (co-editor with Sarah Tarlow, Routledge, 1999).

Preface

In recent years 'heritage' has become not only a topic of widespread public interest but also a central concern across a wide range of academic disciplines. This reflects the growth of official processes of heritage conservation into a multi-billion dollar industry throughout the second part of the twentieth century, alongside various developments relating to globalisation and the increased use of heritage in the manufacture of both national and community identity. *Understanding the Politics of Heritage* considers the political implications of the rise of the heritage industry. In particular, it examines the concept of 'World Heritage' and the ways in which this has mobilised a series of related concepts regarding the nature of heritage and the role of the past in contemporary global societies. The book does this by reflecting on the relationship between heritage as it is used at local and global levels, and heritage as it is used by the nation-state. The central theme is the relationship between heritage and power on the one hand and heritage as a form of social action on the other.

This is the first of three books in the series *Understanding Global Heritage*, published by Manchester University Press in association with The Open University (OU), which seeks to make a distinctive intellectual and pedagogical contribution to the emerging field of critical heritage studies. Each book is designed to be used either as a free-standing text or in combination with one or both of the other books in the series. The books were developed by a dedicated team of OU scholars together with other published academics representing the range of heritage-related disciplines as part of the development of the OU course that shares the series title. They form the first interdisciplinary series of books to address explicitly the teaching of critical heritage studies as a unified discipline. As such, they aim to provide a comprehensive and innovative introduction to key issues and debates in heritage studies as well as to demonstrate the ways in which the study of heritage can be used to inform our understanding of the global diversity of human societies. The authors form a varied team chosen to reflect the areas that inform heritage studies, including anthropology, archaeology, architectural history, art history, biodiversity and the natural sciences, geography, history, literature studies, religious studies and sociology.

The use of international case studies is an integral part of the structure of the series. These allow the authors not only to summarise key issues within each topic but also to demonstrate how issues are reflected in heritage practices in real-life situations. The international scope reflects the involvement of heritage in discourses of globalisation and the international nature of heritage practice: the issues discussed should transcend diverse national approaches to heritage, and the books should be equally valuable in the teaching of heritage studies in any English-speaking country throughout the world.

Each of the books aims to provide a sound introduction to, and detailed summary of, varied aspects of critical heritage studies as a global discipline. They do this through a consideration of official and unofficial heritage objects, places and practices. The books are concerned primarily with, on the one hand, the ways in which the state employs heritage at the national level and, on the other hand, the social role of heritage in community building at the local level. Using the concept of World Heritage they also explore the development of political notions associated with globalisation. This is accomplished by employing the idea that there exists an authorised heritage discourse (AHD) which works to naturalise certain aspects of heritage management while excluding others.

By leading with case studies that reflect on the ways in which wider issues are 'applied' to heritage and examining the theoretical and historical context of these issues, the books reinforce the relevance and value of critical heritage studies as a significant area of intellectual pursuit for understanding and analysing heritage and its contribution to matters of widespread public concern.

Rodney Harrison
Understanding Global Heritage Series Editor and Course Team Chair
The Open University

Abbreviations

AFRIDAD	African Initiative for Alternative Peace as Development
AHD	authorised heritage discourse
BJP	Bharatiya Janata Party (India)
CBO	community-based organisation
CDA	critical discourse analysis
CPMP	Community Peace Museums Programme (Kenya)
DPA	Documentary Photography Archive (UK)
FAIRA	Foundation for Aboriginal and Islander Research Action
FOI	Freedom of Information Act (UK)
GIS	geographic information systems
HABS	Historic American Buildings Survey
HAER	Historic American Engineering Record
HALS	Historic American Landscapes Survey
HHA	Historic Houses Association (UK)
HLF	Heritage Lottery Fund (UK)
ICAHM	International Committee on Archaeological Heritage Management (a committee of ICOMOS)
ICCROM	International Centre for the Study of the Preservation and Restoration of Cultural Property
ICH	intangible cultural heritage
ICOM	International Council of Museums
ICOMOS	International Council on Monuments and Sites
IFLA	International Federation of Library Associations and Institutions
IUCN	International Union for Conservation of Nature (also known as the World Conservation Union)
KANU	Kenya African National Union
NARA	National Archives and Records Administration (USA)
Narc	National Rainbow Coalition (Kenya)
NATO	North Atlantic Treaty Organisation
NGO	non-government organisation

NHM	Natural History Museum (UK)
NHPA	National Historic Preservation Act 1966 (USA)
NMK	National Museums of Kenya
NTS	National Trust for Scotland
ODM	Orange Democratic Movement (Kenya)
OWHC	Organization of World Heritage Cities
PNU	Party of National Unity (Kenya)
PRO	Public Record Office (UK)
RCAHMS	Royal Commission on the Ancient and Historical Monuments of Scotland
RSS	Rashtriya Swayamsevak Sangh (India)
TAC	Tasmanian Aboriginal Centre (Australia)
TNA	The National Archives of the United Kingdom
TRC	South African Truth and Reconciliation Commission
UN	United Nations
UNESCO	United Nations Educational, Scientific and Cultural Organization
WMF	World Monuments Fund

Introduction

Rodney Harrison

Understanding the Politics of Heritage seeks to illuminate debates about what should be preserved as heritage, about the form in which heritage should be conserved and how it should be presented to the public. These debates are not limited to the tangible traces of objects and places but extend to the intangible heritage of social practices and collective memory. The book seeks to question the unwritten suggestion within most contemporary western societies that heritage is necessarily 'good', and to uncover the ways in which heritage embodies relationships of power and subjugation, inclusion and exclusion, remembering and forgetting. It asks the reader to question who is represented by heritage, and who heritage has neglected to mention.

Many people would see 'authenticity' and 'quality' as the central questions for critical heritage studies. Why engage with the past and its material traces unless we are interested in the 'truthful' presentation of history and a desire to preserve 'very good' objects and places? Indeed, the greatest criticism to be levelled at heritage as a global phenomenon relates to the ways in which it might balance its commercial entertainment imperative with the accurate presentation of history. But what if we were to consider the possibility that heritage is *not* about truth or authenticity but about deliverable political objectives – about reinforcing social cohesion through the construction of myths of origin, identity and moral example? How might we play out this discussion?

Understanding the Politics of Heritage takes as its central theme the ways in which the past is used in the present, and the ways in which the politics of the past are expressed through both official and unofficial processes of heritage management in contemporary global societies. In this sense, the book is concerned both with the material residues of the past and with their interpretation in the present. The issue of who has the power to control this interpretation of the past in the present thus emerges as a key concern for critical heritage studies as an interdisciplinary academic field. When we talk of the politics of heritage we refer to the ways in which power is manifested through activities associated with the official processes of heritage at the global, national and local levels. These official processes relate to the definition, management and control of certain objects, places and practices that are attributed certain types of value, meaning that they are considered to be part of the heritage of certain human groups while, in the reverse process, certain other objects, places and practices are passed over as insignificant in heritage terms. We might think of these processes of ascription and neglect of heritage value as forms of collective remembering and forgetting. Understanding the ways in which societies choose to remember – or to

forget – certain aspects of their past is critical to understanding the ways in which certain groups within those societies are represented, and the relationships between individuals, groups and the contemporary nation-state. Significant to these processes of remembering and forgetting are the choices made by the professionals whose judgements and decisions are the basis for creating the 'canon' of heritage.

Understanding the Politics of Heritage makes regular reference to Laurajane Smith's *Uses of Heritage* (2006) and her concept of the authorised heritage discourse (AHD). Smith defines the AHD as a set of texts and practices that dictate the ways in which heritage is defined and employed within any contemporary western society. The 1972 UNESCO World Heritage Convention is one of the foundational texts of the AHD. For this reason, the book considers the influence of the World Heritage Convention and the World Heritage List on the management of heritage in various contemporary global societies, as well as the relationship between heritage as it is used at the local and global levels, and the uses of heritage by the nation-state. In doing so, it seeks to explore the relationship between heritage and power on the one hand, and heritage as a form of social action on the other. The book's principal focus is therefore on the relationships between heritage, globalisation, nationalism and grassroots heritage movements.

Chapter 1, 'What is heritage?' introduces the concept of heritage and examines its various uses in contemporary society. It then provides a background to the development of critical heritage studies as an area of academic interest, and in particular the way in which heritage studies has developed in response to various critiques of contemporary politics and culture in the context of globalisation and transnationalism. Drawing on a case study concerning the official documentation surrounding the Harry S. Truman National Historic Site in Missouri, USA, it describes the concept of AHDs in so far as they are seen to operate in official, state sanctioned heritage initiatives. The chapter suggests that critical heritage studies should be concerned with, on the one hand, these officially sanctioned heritage discourses and the relationships of power they facilitate and, on the other hand, with the ways in which heritage operates at the local level in community and identity building. It provides a number of ideas and reference points to which the authors of the other chapters return through the course of the book.

Chapter 2, 'Critical approaches to heritage' looks in more detail at what it means to be 'critical' when studying heritage as a phenomenon and examining source materials that relate to heritage. The chapter contains an extended case study on ways of reading photographs. This acts as a focus for visual discrimination skills that can be applied to photographs and other visual resources and for critical approaches to primary sources more generally. A second case study considers the ways in which photographs 'become'

heritage, using the example of the Donald Thomson photographs and Indigenous Australian Yolngu heritage. The chapter uses the photograph as an example of a heritage primary source and as a wider metaphor for heritage, to develop an approach which is subsequently employed throughout the rest of the chapters in the book.

Chapter 3, 'Heritage as a tool of government' explores how governments have used documentary heritage, drawing on case studies of the use of national archives as an arm of government, with particular emphasis on the UK and the Republic of Ireland, and the use of the Truth and Reconciliation Commission by the government of South Africa. The aim of the examples is to offer a critical view of the stated purposes and functioning of the institutions that guard documentary heritage on behalf of governments. They show that governments' use of heritage can be controversial, contradictory and inconsistent, and that governments may regard the destruction or neglect of the materials of the past as advantageous.

Chapter 4, 'World Heritage' provides an overview of the World Heritage concept, its political and cultural origins, and the role of UNESCO and other agencies in identifying and listing sites. It identifies and examines the major conventions and protocols affecting World Heritage. It shows how World Heritage expanded from cultural to natural sites to embrace landscapes, industrial and intangible heritages. It provides case studies of New Lanark as industrial heritage, Edinburgh and Bath as World Heritage Cities, and the Tarragona archaeological and historical ensemble as a driver of economic change and cultural tourism. Finally, it examines the ways in which ideas surrounding World Heritage, although essentially Eurocentric or pro-western, are increasingly being challenged by more inclusive views and strategies designed to promote forms of heritage that are more representative than the previous heritage 'canon'.

Chapter 5, 'The politics of heritage' considers the ways in which heritage can both stimulate and act as a symbol of political struggle, and how possession of heritage objects, places and practices might be considered to bestow political power. The case study of the destruction of the Bamiyan Buddhas in Afghanistan by the Taliban in 2001 shows what happens when heritage becomes embroiled in international political conflicts. It examines the ways in which the World Heritage List and the ideas it perpetuates about heritage come into conflict with alternative views of heritage, and the role of the World Heritage List in the production of national histories and local religious and cultural practices. The case study on repatriation of cultural objects by UK museums shows how 'ownership' of heritage conveys the right to control access to objects, places and practices, and the ways in which ideas about who should 'own' heritage are influencing museums in contemporary society.

Chapter 6, 'Heritage and nationalism' considers the role of heritage in relation to the nation-state, and in particular in developing ideas of nationhood. A case study on heritage and nationalism in India investigates the material meanings of the Taj Mahal in contemporary postcolonial India, and the various forms of heritage meaning that it embodies and suppresses. The second case study analyses the National Museum, Delhi, from the time of British colonial rule in the 1940s to the museum's contemporary displays, demonstrating the changing role of heritage in India over the twentieth century. The final case study considers the contested heritage of the Babri Masjid, Ayodhya.

Chapter 7, 'Heritage, colonialism and postcolonialism' suggests that many of the most important developments in critical heritage studies have occurred as a result of nuances of heritage in colonial environments, and postcolonial responses to them. The chapter briefly introduces colonialism and postcolonialism in a historical context and then looks at the ways in which heritage functions within these settings. A detailed case study on heritage in postcolonial Kenya compares the official discourses of the National Museums of Kenya with two examples of community-led heritage initiatives. The chapter considers the ways in which colonialism and postcolonialism should be seen not only as issues relating to 'new world' countries but also as issues that have influenced the nature of heritage and its politics globally.

Chapter 8, 'Heritage and class' notes that relationships between socio-economic factors, cultural capital and aspects of heritage have a long history, and that ideas about social class may be woven into the provision of official heritage. The first case study in this chapter considers the ways that class identities are dealt with in official practices of selecting or discarding potential objects of heritage through an examination of the official and unofficial recognition of working-class housing in Glasgow as heritage, from tenements to tower blocks. The reasons that people enjoy access to heritage, or appear to be absent from visitor statistics, can be explored through Pierre Bourdieu's concept of cultural capital and its application to the changing social conditions of recent decades. A contrasting case study of the representation of class and visitor identification with discourses of class is offered through an exploration of the visitor experience of English country houses.

The book's chapters ask questions that open a space for local and global communities to have new forms of engagement with heritage, and in particular with heritage as a tool of the nation-state. In doing so, *Understanding the Politics of Heritage* seeks to develop a new critical agenda for interdisciplinary global heritage studies in the twenty-first century.

Works cited

Smith, L. (2006) *Uses of Heritage*, Abingdon and New York, Routledge.

Chapter 1 What is heritage?

Rodney Harrison

This chapter introduces the concept of heritage and examines its various uses in contemporary society. It then provides a background to the development of critical heritage studies as an area of academic interest, and in particular the way in which heritage studies has developed in response to various critiques of contemporary politics and culture in the context of deindustrialisation, globalisation and transnationalism. Drawing on a case study in the official documentation surrounding the Harry S. Truman Historic Site in Missouri, USA, it describes the concept of authorised heritage discourses (AHD) in so far as they are seen to operate in official, state-sanctioned heritage initiatives. Where the other chapters in the book contain substantial case studies as part of the discussion of the different aspects of the politics of heritage, this chapter focuses instead on key concepts, definitions and ideas central to understanding what heritage is, and on heritage studies as a field of inquiry. The chapter suggests that critical heritage studies should be concerned with these officially sanctioned heritage discourses and the relationships of power they facilitate on the one hand, and the ways in which heritage operates at the local level in community and identity building on the other. It provides a number of explicit ideas and reference points to which the authors of the other chapters will return through the course of the book.

Introduction

This chapter begins with two photographs: a picture of the Great Barrier Reef in Australia (Figure 1.1) and a picture of the Mir Castle complex in Belarus (Figure 1.2)

The photographs appear to show very different types of place, in locations that are widely geographically spaced. One of these is a 'natural' place, the other is humanly made (a building, albeit a very grand one). In what ways might we characterise the similarities between the two places? What qualities can we find that link them?

Although they are very different, both of these places are considered to be 'heritage', indeed 'World' heritage, and both are listed on the United Nations Educational, Scientific and Cultural Organization (UNESCO) World Heritage List. Later in this book (Chapter 4) The **World Heritage List** and the organisation that runs it, the International Council on Monuments and Sites (ICOMOS), will be discussed in more detail. This first chapter concentrates on

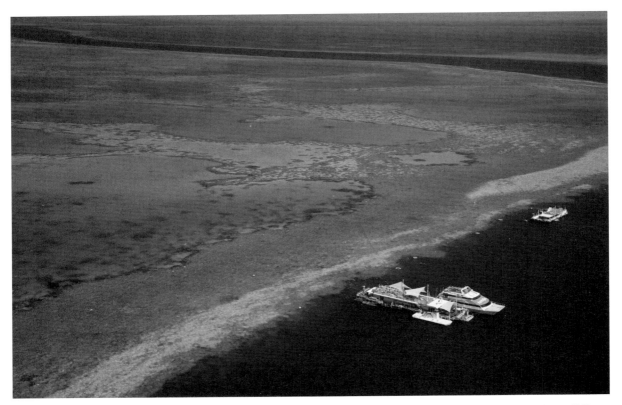

Figure 1.1 The Great Barrier Reef, Whitsunday Coast, Queensland, Australia. Photographed by Walter Bibikow. Photo: © Jon Arnold Images Ltd/Alamy.

the ways in which these two very different entities, in two very different places, can both be understood as 'heritage'.

The Great Barrier Reef is the world's most extensive stretch of coral reef. The reef system, extending from just south of the Tropic of Capricorn to the coastal waters of Papua New Guinea, comprises some 3400 individual reefs, including 760 fringing reefs, which range in size from under 1 ha to over 10,000 ha and extend for more than 2000 km off the east coast of Australia. The Great Barrier Reef includes a range of marine environments and formations, including approximately 300 coral cays and 618 continental islands which were once part of the mainland. The reef is home to a number of rare and endangered animal and plant species and contains over 1500 species of fish, 400 species of coral, 4000 species of mollusc and 242 species of birds plus a large number of different sponges, anemones, marine worms and crustaceans and other marine invertebrates. The reef includes feeding grounds for dugongs, several species of whales and dolphins, and nesting grounds of green and loggerhead turtles (United Nations Environment Programme World Conservation Monitoring Centre, 2008).

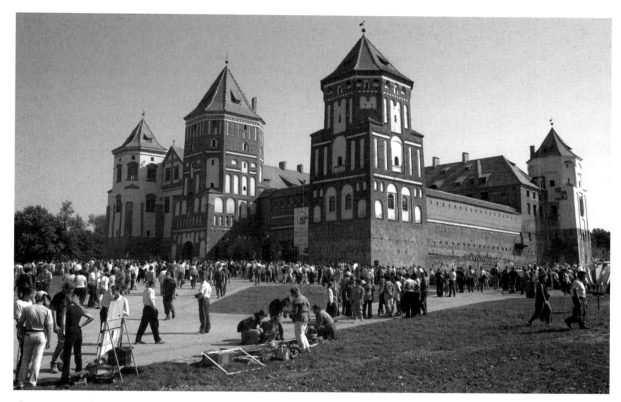

Figure 1.2 The Mir Castle complex, Republic of Belarus, 2003. Unknown photographer. Photo: Ullstein Bild – Russian Picture Service.

The Mir Castle complex is situated on the bank of a small lake at the confluence of the river Miryanka and a small tributary in the Grodno Region of what is now known as the Republic of Belarus. The castle was built in the late fifteenth or early sixteenth century in a style that architects familiar with the form it took in central Europe would recognise as 'Gothic'. It was subsequently extended and reconstructed, first in 'Renaissance' and then in 'Baroque' styles. The castle sustained severe damage during Napoleon's invasion of Russia in 1812 and was abandoned as a ruin. It was subsequently restored at the end of the nineteenth century, at which time the surrounding parkland received extensive landscaping. Mir Castle is considered to be an exceptional example of a central European castle, reflecting in its design and layout successive cultural influences (Gothic, Renaissance and Baroque) as well as the political and cultural conflicts that characterise the history of the region (UNESCO, 2008).

What makes these places 'heritage'? And what makes them part of the world's heritage? The process of nominating a place for inclusion on the World Heritage List involves an assessment of the ways in which a place meets a

particular set of criteria for inclusion. This argument is developed by a body representing the sovereign state of the territory in which the site exists and is submitted to a committee in charge of assessing the **nominations** (see further discussion in Chapter 4). Although it would be possible to look in detail at the criteria for inclusion, and at the **values** implicit in the **criteria**, it is clear that these sites are defined as heritage by the sheer fact that they have been classified as such through inclusion on a heritage register. This process by which an object, place or practice receives formal recognition as heritage and is placed on a **heritage register** can be termed an 'official' heritage process. Once places become statutory entities and are recognised as belonging to heritage by their inclusion on an official **heritage list**, they are 'created' as '**official heritage**' and subject to a series of assumptions about how they must be treated differently from other places. For example, official heritage places must be actively managed and conserved, and there is an expectation that funding must be allocated to them so that this can occur.

Although both of these places are recognised through their **listing** as belonging to the world's heritage, they have a range of different meanings for the local people who interact with them on an everyday basis. For example, the Barrier Reef, which is understood to be World Heritage on the basis of its **biodiversity** and recreational values, is a source of sustenance, livelihood and spiritual inspiration for the many different groups of Indigenous Australians who live along the Queensland coastline. They would traditionally understand their relationship with the reef as one of custodianship and the right to control access, hunt, fish and gather in its environs. Clearly the reef's promotion as a **World Heritage site** implies that it is 'owned' (at least culturally) not only by local people but also by the world community. So there is the potential for a range of different ways of relating to, understanding the **significance** of, and giving meaning to heritage objects, sites and practices. This range of values of heritage may not be well catered for within traditional western models of heritage and official definitions of heritage. In this case, such differences may give rise to conflict over who has the right to determine access and management of different parts of the reef. Indeed, in most cases the official and the local would be thought of as *competing* forms of heritage. Heritage itself is a dynamic process which involves competition over whose version of the past, and the associated moral and legal rights which flow from this version of the past, will find official representation in the present.

This brief example embodies the two inter-related understandings of heritage that form the central focus of this book: the largely 'top–down' approach to the classification and promotion of particular places by the state as an embodiment of regional, national or international values which creates 'official' heritage; and the 'bottom–up' relationship between people, objects, places and memories which forms the basis for the creation of **unofficial** forms of heritage (usually) at the local level. Critical heritage studies, in its

most basic sense, involves the investigation of these two processes and the relationship between them. Heritage studies is an exciting new interdisciplinary field of inquiry which draws on a range of academic disciplines and skills including history, archaeology, anthropology, sociology, art history, biology, geography, textual analysis and visual discrimination, to name but a few. The aim of this book is to form an introduction to heritage as a global concept, and critical heritage studies as a field of inquiry.

What is heritage?

The *Oxford English Dictionary* defines 'heritage' as 'property that is or may be inherited; an inheritance', 'valued things such as historic buildings that have been passed down from previous generations', and 'relating to things of historic or cultural value that are worthy of **preservation**'. The emphasis on inheritance and **conservation** is important here, as is the focus on 'property', 'things' or 'buildings'. So (according to the *Oxford English Dictionary*, anyway), heritage is something that can be passed from one generation to the next, something that can be conserved or inherited, and something that has historic or cultural value. Heritage might be understood to be a physical 'object': a piece of property, a building or a place that is able to be 'owned' and 'passed on' to someone else.

In addition to these physical *objects* and *places of heritage* there are also various *practices of heritage* that are conserved or handed down from one generation to the next. Language is an important aspect of who we understand ourselves to be, and it is learned and passed from adult to child, from generation to generation. These invisible or 'intangible' practices of heritage, such as language, culture, popular song, literature or dress, are as important in helping us to understand who we are as the physical objects and buildings that we are more used to thinking of as 'heritage'. Another aspect of these practices of heritage is the ways in which we go about conserving things – the choices we make about what to conserve from the past and what to discard: which memories to keep, and which to forget; which memorials to maintain, and which to allow to be demolished; which buildings to save, and which ones to allow to be built over. Practices of heritage are customs and habits which, although intangible, inform who we are as collectives, and help to create our collective social memory. We use objects of heritage (artefacts, buildings, sites, landscapes) alongside practices of heritage (languages, music, community commemorations, conservation and preservation of objects or memories from the past) to shape our ideas about our past, present and future.

Another way of thinking about this distinction between objects of heritage and practices of heritage is to consider the different perspectives through which heritage is perceived. For every object of heritage there are also heritage

practices. However one group of people (say, professional heritage managers) respond to heritage, other people may respond differently. Thus, around an object of heritage, there may be value judgements based on '**inherent**' qualities (which may indeed play a determining role in designating the object and conserving it), but there may well be other values which drive the use of the object (associations of personal or national identity, associations with history, leisure etc., as in the example of **designation** of Harry S. Truman's otherwise humble dwelling as a National Historic Site discussed later in this chapter). For every object of **tangible heritage** there is also an **intangible heritage** that 'wraps' around it – the language we use to describe it, for example, or its place in social practice or religion. Objects of heritage are embedded in an experience created by various kinds of users and the people who attempt to manage this experience. An analogous situation exists in the art world in understanding **aesthetics**. There is no art without the spectator, and what the spectator (and critic) makes of the art work sits alongside what the artist intended and what official culture designates in a discursive and often contested relationship. So in addition to the objects and practices of heritage themselves, we also need to be mindful of varying 'perspectives', or *subject positions on heritage*.

The historian and geographer David Lowenthal has written extensively on the important distinction between heritage and history. For many people, the word 'heritage' is probably synonymous with 'history'. However, historians have criticised the many instances of recreation of the past in the image of the present which occur in museums, historic houses and heritage sites throughout the world, and have sought to distance themselves from what they might characterise as 'bad' history. As Lowenthal points out in *The Heritage Crusade and the Spoils of History*, heritage is not history at all: 'it is not an inquiry into the past, but a celebration of it ... a profession of faith in a past tailored to present-day purposes' (Lowenthal, 1997, p. x). Heritage must be seen as separate from the pursuit of history, as it is concerned with the re-packaging of the past for some purpose in the present. These purposes may be nationalistic ones, as discussed in Chapters 3 and 4 of this book, or operate at the local level, for example in the case of the local Kenyan museum discussed in the case study in Chapter 7.

'Heritage' also has a series of specific and clearly defined technical and legal meanings. For example, the two places discussed earlier in this chapter are delineated as 'heritage' by their inclusion on the World Heritage List. As John Carman (2002, p. 22) notes, heritage is *created* in a process of *categorising*. These places have an official position that has a series of obligations, both legal and 'moral', arising from their inclusion on this register. As places on the World Heritage List they must be actively conserved, they should have formal documents and policies in place to determine their management, and there is an assumption that they will be able

to be visited so that their values to conservation and the world's heritage can be appreciated.

There are many other forms of official categorisation that can be applied to heritage sites at the national or state level throughout the world. Indeed, heritage as a field of practice seems to be full of lists. The impulse within heritage to categorise is an important aspect of its character. The moment a place receives official recognition as a heritage 'site', its relationship with the landscape in which it exists and with the people who use it immediately changes. It somehow becomes a place, object or practice 'outside' the everyday. It is special, and set apart from the realm of daily life. Even where places are not officially recognised as heritage, the way in which they are set apart and used in the production of **collective memory** serves to define them as heritage. For example, although it might not belong on any heritage register, a local sports arena might be the focus for collective understandings of a local community and its past, and a materialisation of local memories, hopes and dreams. At the same time, the process of listing a site as heritage involves a series of value judgements about what is important, and hence worth conserving, and what is not. There is a dialectical relationship between the effect of listing something as heritage, and its perceived significance and importance to society.

Some authors would define heritage (or at least 'official' heritage) as those objects, places and practices that can be formally protected using heritage laws and charters. The kinds of heritage we are most accustomed to thinking about in this category are particular kinds of objects, buildings, towns and landscapes. One common way of classifying heritage is to distinguish between 'cultural' heritage (those things manufactured by humans), and 'natural' heritage (those which have not been manufactured by humans). While this seems like a fairly clear-cut distinction, it immediately throws up a series of problems in distinguishing the 'social' values of the natural world. Returning to the example of the Great Barrier Reef discussed earlier in this chapter, for the Indigenous Australians whose traditional country encompasses the reef and islands, the natural world is created and maintained by 'cultural' activities and ceremonies involving some aspects of intangible action such as song and dance, and other more practical activities such as controlled burning of the landscape and sustainable hunting and fishing practices. It would obviously be extremely difficult to characterise these values of the natural landscapes to Indigenous Australians using a system that divides 'cultural' and 'natural' heritage and sees the values of natural landscapes as being primarily ecological.

Heritage is in fact a very difficult concept to define. Most people will have an idea of what heritage 'is', and what kinds of thing could be described using the term heritage. Most people, too, would recognise the existence of an official heritage that could be opposed to their own personal or collective one. For

example, many would have visited a national museum in the country in which they live but would recognise that the artefacts contained within it do not describe entirely what they would understand as their own history and heritage (see also Chapters 6 and 7). Clearly, any attempt to create an official heritage is necessarily both partial and selective. This gap between, on one hand, what an individual understands to be their heritage and, on the other hand, the official heritage promoted and managed by the state introduces the possibility of multiple 'heritages'. It has been suggested earlier that heritage could be understood to encompass objects, places and practices that have some significance in the present which relates to the past.

In 2002 during the United Nations year for **cultural heritage**, UNESCO produced a list of 'types' of cultural heritage (UNESCO, n.d.). This is one way of dividing and categorising the many types of object, place and practice to which people attribute heritage value. It should not be considered an exhaustive list, but it gives a sense of the diversity of 'things' that might be considered to be official heritage:

- cultural heritage sites (including archaeological sites, ruins, historic buildings)
- historic cities (urban landscapes and their constituent parts as well as ruined cities)
- **cultural landscapes** (including parks, gardens and other 'modified' landscapes such as pastoral lands and farms)
- natural **sacred sites** (places that people revere or hold important but that have no evidence of human modification, for example sacred mountains)
- underwater cultural heritage (for example shipwrecks)
- museums (including cultural museums, art galleries and house museums)
- movable cultural heritage (objects as diverse as paintings, tractors, stone tools and cameras – this category covers any form of object that is movable and that is outside of an archaeological context)
- handicrafts
- documentary and digital heritage (the **archives** and objects deposited in libraries, including digital archives)
- cinematographic heritage (movies and the ideas they convey)
- **oral traditions** (stories, histories and traditions that are not written but passed from generation to generation)
- languages
- festive events (festivals and carnivals and the traditions they embody)
- rites and beliefs (rituals, traditions and religious beliefs)
- music and song

- the performing arts (theatre, drama, dance and music)
- traditional medicine
- literature
- culinary traditions
- traditional sports and games.

Some of the types of heritage are objects and places ('physical' or 'material' heritage) while others are practices ('intangible' heritage). However, many of these categories cross both types of heritage. For example, ritual practices might involve incantations (intangible) as well as ritual objects (physical). So we should be careful of thinking of these categories as clear cut or distinct. In addition, this list only includes 'cultural' heritage. **Natural heritage** is most often thought about in terms of landscapes and ecological systems, but it is comprised of features such as plants, animals, natural landscapes and landforms, oceans and water bodies. Natural heritage is valued for its aesthetic qualities, its contribution to ecological, biological and geological processes and its provision of natural habitats for the conservation of biodiversity. In the same way that we perceive both tangible and intangible aspects of cultural heritage, we could also speak of the tangible aspects of natural heritage (the plants, animals and landforms) alongside the intangible (its aesthetic qualities and its contribution to biodiversity).

Another aspect of heritage is the idea that things tend to be classified as 'heritage' only in the light of some risk of losing them. The element of potential or real threat to heritage – of destruction, loss or decay – links heritage historically and politically with the conservation movement. Even where a building or object is under no immediate threat of destruction, its listing on a heritage register is an action which assumes a potential threat at some time in the future, from which it is being protected by legislation or listing. The connection between heritage and threat will become more important in the later part of this chapter.

Risk of loss if not conserved

Heritage is a term that is also quite often used to describe a set of values, or principles, which relate to the past. So, for example, it is possible for a firm of estate agents to use the term in its name not only to mean that it markets and sells 'heritage' properties, but also simultaneously to invoke a series of meanings about traditional values which are seen as desirable in buying and selling properties. We can also think here about the values which are implicit in making decisions about what to conserve and what not to conserve, in the choices we make about what we decide to label 'heritage' and what view as simply 'old' or 'outdated'. These values are implicit in cultural heritage management.

Governments, heritage registers and the 'canon'

One aspect of understanding heritage is appreciating the enormous influence of governments in managing and selectively promoting as heritage certain aspects of the physical environment and particular intangible practices associated with culture. One way in which governments are involved in heritage is through the maintenance, funding and promotion of certain places as tourist destinations. We are also reminded here, for example, of the many ways in which governments and nations are involved in the preservation of language as a way of preserving heritage and culture. Language is promoted and controlled by governments through official language policies which determine the state language and which often specify certain controls on the use of languages other than the state language. For example, in France, the 'Toubon' Law (Law 94-665, which came into force in 1994 and is named for the minister of culture, Jacques Toubon who suggested and passed the law through the French parliament) specifies the use of the French language in all government publications, print advertisements, billboards, workplaces, newspapers, state-funded schools and commercial contracts. We might also think of the suggestion by French president Nicolas Sarkozy (president 2007–) in 2008 that the correct methods for preparing classic items of French cuisine might be considered for protection as part of the UNESCO World Heritage List. At the time of writing, the nomination is still in preparation for presentation to the UNESCO World Heritage Committee.

In addition to such policies which ensure the preservation of intangible aspects of cultural heritage, governments play a major role in the maintenance and promotion of lists or databases of heritage. Most countries have a 'national' heritage list of physical places and objects which are thought to embody the values, spirit and history of the nation. In addition, governments may have multi-layered systems of heritage which recognise a hierarchy of heritage places and objects of national, regional and local significance. These lists (and indeed, the World Heritage List discussed earlier) might be thought of as offshoots of the concept of '**the canon**'. The word 'canon' derives from the Greek word for a rule or measure, and the term came to mean the standard by which something could be assessed. The idea of a canon of works of art developed in the eighteenth and nineteenth centuries to describe a body of artistic works that represent the height of aesthetic and artistic merit – works of art judged by those who are qualified in matters of taste and aesthetics to be 'great' works of art. Similarly, a literary canon describes those writers and their works that are deemed to be 'great literature'. The canon is a slippery concept, as it is not defined specifically, but through a process of positioning – the canon is represented by those works of art that are held in art galleries and museums and discussed in art books, and those works of literature that are cited in literary anthologies.

When we start to think of a list of heritage as a sort of canon it raises a number of questions. Who are the people who determine what is on the list and what is not? What values underlie the judgements that specify which places and objects should be represented? How do we assess which are the great heritage objects and places and which are not? How does creating such a list include and exclude different members of society? It is now widely recognised that the idea of a canon is linked closely with that of nation (Mitchell, 2005), and that canons might be understood to represent ideological tools that circulate the values on which particular visions of nationhood are established. Creation of a class of 'things' that are seen to be the greatest expressions of culture promotes, in turn, narratives about the set of values that are seen to be the most worthy in the preservation of a particular form of state society. The heritage list, like the literary or artistic canon, is controlled by putting the power to establish the canon into the hands of experts who are sanctioned by the state.

It is important to point out that heritage is a rather strange kind of canon. It is unlike the canon of modern art as it is usually understood, for example, since the criteria that constitute it are diverse rather than unified. Modern art is defined by current canons of taste and these create separate 'canons' for different ideologies, such as a feminist canon, or a social history of art canon. These can co-exist, but each maintains its own consistent identity. The heritage canon, if measured by the World Heritage List (or a national heritage list) finishes up as a *single* list, but one which is determined by a wide range of considerations.

It is also important to make the point that heritage is fundamentally an *economic* activity. This is easily overlooked in critical approaches that focus on the role of heritage in the production of state ideologies (Ashworth et al., 2007, p. 40). Much of what motivates the involvement of the state and other organisations in heritage is related to the economic potential of heritage and its connections with tourism. The relationship between heritage and tourism is examined later in this chapter, but it would be remiss to neglect a mention here of the economic imperative of heritage for governments.

'There is no such thing as heritage'

The first part of this chapter presented a range of definitions of heritage that derive from everyday and technical uses of the term. Here a series of approaches to heritage are introduced by way of a particular academic debate about heritage. Given the focus on preservation and conservation, heritage as a professional field has more often been about 'doing' than 'thinking'; it has focused more on technical practices of conservation and processes of heritage management than on critical discussion of the nature of heritage and why we think particular objects, places and practices might be considered more worthy than others of conservation and protection. But more recently scholars have

begun to question the value of heritage and its role in contemporary society. Archaeologist Laurajane Smith, who has written extensively in the field of critical heritage studies, writes 'there is, really, no such thing as heritage' (2006, p. 11). What could she mean by this statement? How can there be legislation to protect heritage if it does not, in some way, *exist*?

In making this bold statement, Smith is drawing on a much older debate about heritage that began in the UK during the 1980s. This debate has been very influential in forming the field of critical heritage studies as it exists today, not only in the UK, but throughout the parts of the world in which 'western' forms of heritage conservation operate, and in the increasingly large numbers of 'non-western' countries who are engaged in a global 'business' of heritage through the role of the World Heritage List in promoting places of national importance as tourist destinations. The next section outlines this debate and the ideas that have both fed into and developed from it, as an introduction to critical heritage studies as a field of academic research (this characterisation of the debate is strongly influenced by Boswell, 1999).

The heritage 'industry'

In the late 1980s English academic Robert Hewison coined the phrase 'heritage industry' to describe what he considered to be the sanitisation and commercialisation of the version of the past produced as heritage in the UK. He suggested that heritage was a structure largely imposed from above to capture a middle-class nostalgia for the past as a golden age in the context of a climate of decline.

Hewison believed that the rise of heritage as a form of popular entertainment distracted its patrons from developing an interest in contemporary art and critical culture, providing them instead with a view of culture that was finished and complete (and firmly in the past). He pointed to the widespread perception of cultural and economic decline that became a feature of Britain's perception of itself as a nation in the decades following the Second World War:

> In the face of apparent decline and disintegration, it is not surprising that the past seems a better place. Yet it is irrecoverable, for we are condemned to live perpetually in the present. What matters is not the past, but our relationship with it. As individuals, our security and identity depend largely on the knowledge we have of our personal and family history; the language and customs which govern our social lives rely for their meaning on a continuity between past and present. Yet at times the pace of change, and its consequences, are so radical that not only is change perceived as decline, but there is the threat of rupture with our past lives.
>
> (Hewison, 1987, pp. 43–5)

The context in which Hewison was writing was important in shaping his criticism of heritage as a phenomenon. His book *The Heritage Industry* is as much a reflection on the changes that occur within a society as a result of deindustrialisation, globalisation and transnationalism (in particular, the impact of rapid and widespread internal migration and immigration on the sense of 'rootedness' that people could experience in particular places in the UK in the 1980s, and the nostalgia that he saw as a response to this sense of uprootedness) as it is a criticism of heritage itself. He noted that the postwar period in the UK coincided with a period of growth in the establishment of museums and in a widespread sense of nostalgia, not for the past as it was experienced but for a sanitised version of the past that was re-imagined through the heritage industry as a utopia, in opposition to the perceived problems of the present:

> The impulse to preserve the past is part of the impulse to preserve the self. Without knowing where we have been, it is difficult to know where we are going. The past is the foundation of individual and collective identity, objects from the past are the source of significance as cultural symbols. Continuity between past and present creates a sense of sequence out of aleatory chaos and, since change is inevitable, a stable system of ordered meanings enables us to cope with both innovation and decay. The nostalgic impulse is an important agency in adjustment to crisis, it is a social emollient and reinforces national identity when confidence is weakened or threatened.
>
> (Hewison, 1987, p. 47)

The academic Patrick Wright had published a book some two years earlier than *The Heritage Industry* titled *On Living in an Old Country* (1985). Like Hewison, Wright was concerned with the increasing '**museumification**' of the UK, and the ways in which heritage might act as a distraction from engaging with the issues of the present. Wright argued that various pieces of heritage legislation that were put forward by the Conservative government could be read as the revival of the patriotism of the Second World War, and connected this Conservative patriotism to the events of the Falklands conflict. Like Hewison, he was also critical of the 'timelessness' of the presentation of the past formed as part of the **interpretation** of heritage sites:

> National heritage involves the extraction of history – of the idea of historical significance and potential – from a denigrated everyday life and its restaging or display in certain sanctioned sites, events, images and conceptions. In this process history is redefined as 'the historical', and it becomes the object of a similarly transformed and generalised public attention ... Abstracted and redeployed, history seems to be purged of political tension; it becomes a unifying spectacle,

> the settling of all disputes. Like the guided tour as it proceeds from site to sanctioned site, the national past occurs in a dimension of its own – a dimension in which we appear to remember only in order to forget.
>
> (Wright, 1985, p. 69)

These critiques of heritage in the UK centred on the ways in which heritage distracted people from engaging with their present and future. Both authors employed a 'bread and circuses' analogy in arguing that heritage, like the popular media, was a diversion which prevented people from engaging with the problems of the present:

> Heritage ... has enclosed the late twentieth century in a bell jar into which no ideas can enter, and, just as crucially, from which none can escape. The answer is not to empty the museums and sell up the National Trust, but to develop a critical culture which engages in a dialogue between past and present. We must rid ourselves of the idea that the present has nothing to contribute to the achievements of the past, rather, we must accept its best elements, and improve on them ... The definition of those values must not be left to a minority who are able through their access to the otherwise exclusive institutions of culture to articulate the only acceptable meanings of past and present. It must be a collaborative process shared by an open community which accepts both conflict and change.
>
> (Hewison, 1987, p. 144)

We need to pause to make a distinction between two criticisms of heritage which seem bound together here. There is a criticism of false consciousness of the past – the presentation of the past in an inaccurate manner – which can be corrected or remedied by 'better' use of history in heritage interpretation. There is also a criticism of nostalgia and anxiety that may be produced by an accurate understanding of past historical events (world wars, loss of empire and its influence etc.) but that direct attention away from the future. It needs to be kept in mind that nostalgia is separate from false consciousness. No matter how accurately history is represented by heritage, it can always be directed towards particular ends. The problem with official forms of heritage is not so much that it is 'bogus history' but that it is often directed towards establishing particular national narratives in reaction to the influence of globalisation on the one hand, and the local on the other. We can see the growth of heritage in the second part of the twentieth century as, at least in part, a reaction to the way in which globalisation, migration and transnationalism had begun to erode the power of the nation-state. In this guise, heritage is primarily about establishing a set of social, religious and political norms that the nation-state requires to control its citizens, through an emphasis on the connection between its contemporary imposition of various state controls and the nation's past.

Heritage as popular culture

Hewison's position was criticised by a series of commentators. The British Marxist historian Raphael Samuel noted in *Theatres of Memory* (1994) that the scale of popular interest in the past and the role of that interest in processes of social transformation argued against Hewison's connection of heritage with Conservative interests. He criticised Hewison's connection of heritage with Conservative political interests, arguing cogently that heritage and 'the past' had been successfully lobbied as a catch-cry for a range of political positions and interests; in particular, heritage had served to make the past more democratic, through an emphasis on the lives of 'ordinary' people. He also saw the roots of popular interest in the past as stretching back far earlier than the political era of 'decline' suggested by Hewison:

> The new version of the national past, notwithstanding the efforts of the National Trust to promote a country-house version of 'Englishness', is inconceivably more democratic than earlier ones, offering more points of access to 'ordinary people', and a wider form of belonging. Indeed, even in the case of the country house, a new attention is now lavished on life 'below the stairs' (the servants' kitchen) while the owners themselves (or the live-in trustees) are at pains to project themselves as leading private lives – 'ordinary' people in 'family' occupation. Family history societies, practising do-it-yourself scholarship and filling the record offices and the local history library with searchers, have democratized genealogy, treating apprenticeship indentures as a symbolic equivalent of the coat of arms, baptismal certificates as that of title deeds. They encourage people to look down rather than up in reconstituting their roots, 'not to establish links with the noble and great'...
>
> (Samuel, 1994, p. 160)

Samuel was quick to emphasise heritage not only as a potentially democratic phenomenon, but also to see in the social practices surrounding heritage the possibility for promoting social change. An advocate of the potentially transformative power of history, and of the role of heritage in producing diversity and scaffolding multiculturalism in society, Samuel described heritage as a social process:

> Conservation is not an event but a process, the start of a cycle of development rather than (or as well as) an attempt to arrest the march of time. The mere fact of preservation, even if it is intended to do no more than stabilize, necessarily involves a whole series of innovations, if only to arrest the 'pleasing decay'. What may begin as a rescue

operation, designed to preserve the relics of the past, passes by degree into a work of restoration in which a new environment has to be fabricated in order to turn fragments into a meaningful whole.

<div align="right">(Samuel, 1994, p. 303)</div>

It is difficult to argue with Samuel's point about the popular interest in heritage, as it is with the grass-roots involvement of people and communities in appeals to conserve particular forms of heritage. For example, SAVE Britain's Heritage, an influential campaigning body which works to conserve British architectural heritage, was formed as a direct result of the public reaction to the exhibition *The Destruction of the Country House* held at the Victoria and Albert Museum (V&A) of decorative arts and design in 1974. However, it is not really enough to say that it was formed in response to 'public' outcry – we need to think about who this public is. In this case, it is probably fair to say that the 'public' who attended the exhibition at the V&A were well educated, middle-class people with an interest in architecture. But this phenomenon of the movement of heritage into the public sphere as a form of popular entertainment outside of the museum and into public spaces cautions against seeing heritage as entirely something that is imposed 'from above'.

Heritage and tourism

John Urry's (1990) criticisms of Hewison's *The Heritage Industry* took another form, providing a useful corrective to the way in which both Wright and Hewison had criticised heritage as 'false' history. Focusing particularly on museums, he suggested that tourists are socially differentiated, so an argument that they are lulled into blind consumption by the 'heritage industry', as had been suggested by Hewison, could not hold true. Urry drew an analogy with French philosopher Michel Foucault's concept of 'the gaze' to develop the idea of a 'tourist gaze'. The tourist gaze is a way of perceiving or relating to places which cuts them off from the 'real world' and emphasises the exotic aspects of the tourist experience. It is directed by collections of symbols and signs to fall on places that have been previously imagined as pleasurable by the media surrounding the tourist industry. Photographs, films, books and magazines allow the images of tourism and leisure to be constantly produced and reproduced. The history of the development of the tourist gaze shows that it is not 'natural' or to be taken for granted, but developed under specific historical circumstances, in particular the exponential growth of personal travel in the second part of the twentieth century. Nonetheless, it owes its roots to earlier configurations of travel and tourism, such as the 'Grand Tour' (the standard itinerary of travel undertaken by upper-class Europeans in the period from the late seventeenth century until the mid-nineteenth century which

was intended to educate and act as a right of passage for those who took it), and in Britain, the love affair with the British sea-side resort which had its hey-day in the mid-twentieth century.

Tourism and heritage must be seen to be directly related as part of the fundamentally economic aspect of heritage. At various levels, whether state, regional or local, tourism is required to pay for the promotion and maintenance of heritage, while heritage is required to bring in the tourism that buys services and promotes a state's, region's or locality's 'brand'. Heritage therefore needs tourism, just as it needs political support, and it is this that creates many of the contradictions that have led to the critiques of the heritage industry relating to issues of **authenticity**, historical accuracy and access.

The connection between heritage and travel might be seen to have a much deeper history. The fifth-century BCE Greek historian Herodotus made a list of the 'Seven Wonders of the World', the great monuments of the Mediterranean Rim, which was reproduced in ancient Hellenic guidebooks. Herodotus' original list was rediscovered during the Middle Ages when similar lists of 'wonders' were being produced. What is different about the World Heritage List is that, as a phenomenon of the later part of the twentieth century reflecting the influence of globalisation, migration and transnationalism, it spread a particular, western 'ideal' of heritage. This image of heritage, and particularly World Heritage as a canon of heritage places, began to circulate freely and to become widely available for the consumption of people throughout the world. Another important difference is the acceleration in transforming places into heritage – what Hewison and Wright referred to as 'museumification' – which involves the almost fetishistic creation of dozens of different lists of types of heritage. Hewison connected this growth in heritage and its **commodification** with the experience of postmodernity and the constant rate of change in the later part of the twentieth century.

The growth in heritage as an industry can be documented at a broad level by graphing the number of cultural heritage policy documents developed by the major international organisations involved in the management of heritage in the western world. These organisations include the Council of Europe, the International Council of Museums (ICOM), the International Council on Monuments and Sites (ICOMOS), the International Committee on Archaeological Heritage Management (ICAHM, a committee of ICOMOS), the International Federation of Library Associations and Institutions (IFLA), the Organization of World Heritage Cities (OWHC), the United Nations Education, Scientific and Cultural Organization (UNESCO) and the World Monuments Fund (WMF). The graph of numbers of policy documents over the course of the twentieth century, as the organisations came into being, shows a major period of growth after the 1960s and 1970s (see Figure 1.3).

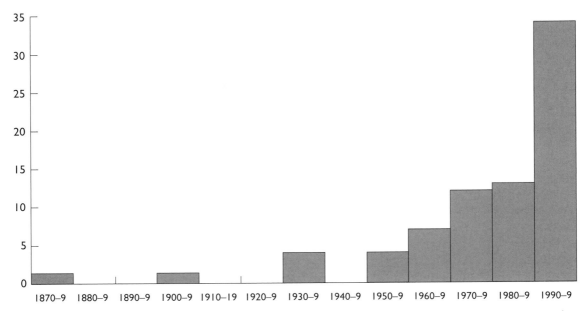

Figure 1.3 Cultural heritage policy documents by decade, 1870–2000, adapted from Getty Conservation Institute (2008) (see full list in the Appendix)

Urry was interested in explaining the power of the consumer to transform the social role of the museum. He suggested that the consumer has a major role in selecting what 'works' and what does not in heritage. It is not possible to set up a museum just anywhere – consumers are interested in authenticity and in other things that dictate their choices, and they are not blindly led by a top–down 'creation' of heritage by the state:

> Hewison ignores the enormously important popular bases of the conservation movement. For example, like Patrick Wright he sees the National Trust as one gigantic system of outdoor relief for the old upper classes to maintain their stately homes. But this is to ignore the widespread support for such conservation. Indeed Samuel points out that the National Trust with nearly 1.5 million members is the largest mass organisation in Britain ... moreover, much of the early conservation movement was plebeian in character – for example railway preservation, industrial archaeology, steam traction rallies and the like in the 1960s, well before the more obvious indicators of economic decline materialised in Britain.
>
> (Urry, 1990, p. 110)

The outcome of Urry's discussion of heritage was to shift the balance of the critique of heritage away from whether or not heritage was 'good' history to the realisation that heritage was to a large extent co-created by its consumers.

The popular appeal of heritage can be demonstrated by 'blockbuster' exhibitions of artefacts and archaeological finds, such as the *Treasures of Tutankhamun* tour, a worldwide travelling exhibition of artefacts recovered from the tomb of the eighteenth dynasty Egyptian pharaoh which ran from 1972 to 1979. This exhibition was first shown in London at the British Museum in 1972, when it was visited by more than 1.6 million visitors. Over 8 million visited the exhibition in the USA. A follow-up touring exhibition called *Tutankhamun and the Golden Age of the Pharaohs* ran during the period 2005–8. Interestingly, instead of being shown in London at the British Museum, this exhibition was displayed in a commercial entertainment space, the O_2 Dome in south-east London, which contains concert venues and cinemas (see Figures 1.4 and 1.5). Such an approach to the display of archaeological artefacts shows the way in which the formal presentation of heritage has moved outside the traditional arenas in which it would be presented, to be viewed almost exclusively as a 'popular' form of entertainment.

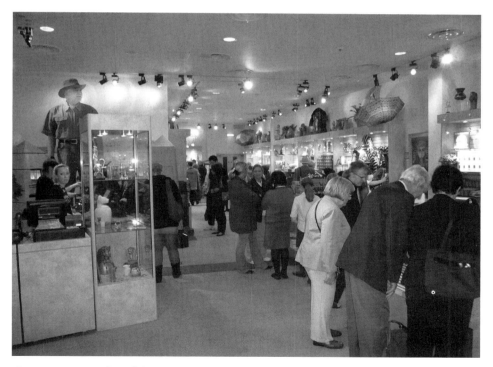

Figure 1.4 Interior of the *Tutankhamun and the Golden Age of the Pharaohs* gift shop at the O_2 Dome, London, 2008. Photographed by Rodney Harrison. Photo: © Rodney Harrison. Items for sale are lit and displayed in the same way as the artefacts from the exhibition. The gift shop is strategically placed at the exit so that people must walk through it to leave the exhibition. Such gift shops have become a ubiquitous part of the experience of heritage for the museum-going public.

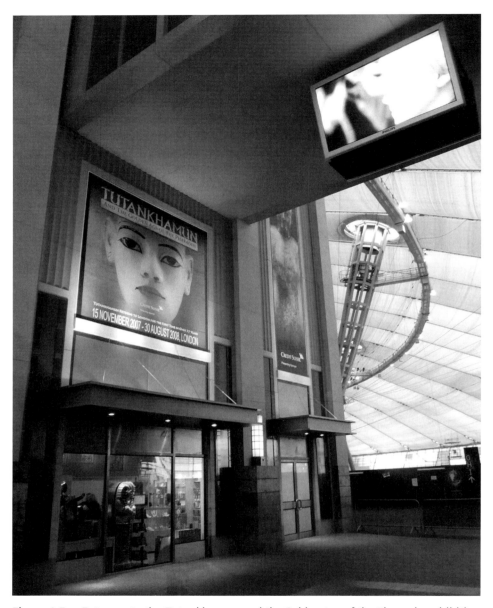

Figure 1.5 Entrance to the *Tutankhamun and the Golden Age of the Pharaohs* exhibition at the O_2 Dome, London, 2008. Photographed by Rodney Harrison. Photo: © Rodney Harrison. Note that the exhibition poster has been made to resemble a movie poster.

Ironically, it was to this same commercialisation of heritage and the past that archaeologist Kevin Walsh (1992) turned in support of the ideas put forward by Hewison in *The Heritage Industry*. Walsh argued in his book *The Representation of the Past* that the boom in heritage and museums has led to an increasing commercialisation of heritage which distances people from their

own heritage. He suggested that the distancing from economic processes – a symptom of global mass markets that has been occurring since the Enlightenment – has contributed to a loss of 'sense of place', and that the heritage industry (and its role in producing forms of desire relating to nostalgia) feeds off this. Loss of a sense of place creates a need to develop and consume heritage products that bridge what people perceive to be an ever increasing gap between past and present. Walsh used an argument similar to one employed by David Lowenthal in *The Past is a Foreign Country* (1985) and later in *The Heritage Crusade and the Spoils of History* (1997). Lowenthal suggested that paradoxically the more people attempt to know the past, the further they distance themselves from it as they replace the reality of the past with an idealised version that looks more like their own reality.

Heritage is not inherent

I want to return to Smith's contention that 'there is no such thing as heritage'. In arguing that there are only opinions and debates about heritage and that heritage is not something that is self-defining, Smith is challenging a model that sees heritage as an **intrinsic** value of an object, place or practice. An intrinsic value is one that is 'built-in' to an object, practice or place; it belongs to the basic and essential features that make something what it is. Under such a model of heritage, heritage objects, places and practices are attributed particular values by the professionals who are involved in assessing and managing heritage, such as architects, archaeologists, anthropologists, engineers and historians. With time, these values become reasonably fixed and unquestioned. This 'knowledge', as well as the weight of authority given to heritage professionals, gives the impression that the process of assessing heritage value is simply one of 'uncovering' the heritage values that already exist in an object, place or practice. We might think of such a model of heritage as **taxonomic**: it assumes that there is a pre-existing ordered hierarchy of heritage objects, places and practices in the world.

The idea that heritage is inherent and that its significance is intrinsic to it leads to a focus on the physical fabric of heritage. If value is inherent, it follows that 'heritage' must be contained within the physical fabric of a building or object, or in the material things associated with heritage practices.

The implication of this taxonomic viewpoint which holds that heritage is intrinsic to an object, place or practice is that a definitive list of heritage can be created. This idea is closely linked to the idea of an artistic or literary canon as previously discussed. Most practitioners would now recognise that heritage value is not intrinsic; value is something that is *attributed* to an object, place or practice by particular people at a particular time for particular reasons. Smith is challenging a process that attaches permanent legal conditions to certain places or things. She is arguing that all 'objects of heritage' need to be

constantly re-evaluated and tested by social practices, needs and desires. Her argument is essentially that heritage is culturally ascribed, rather than intrinsic to things. While this might at first glance appear to be a rather academic point, it is a linchpin of critical heritage studies.

Throughout the second part of the twentieth century the increased recognition of cultural diversity and the contribution of multiculturalism to western societies created a conundrum. How could the old ideas about a fixed canon of heritage, which was established to represent nations with closed borders, come to stand for increasing numbers of diasporic communities of different ethnic origin who were forced, or who elected, to relocate to areas away from their settled territories and who now made such a contribution to the character and make-up of nation-states in western societies? (See, for example, Anderson, 2006.) This challenge, coupled with a recognition that heritage values could not be seen as intrinsic, led to the development of the concept of **representativeness**, and a shift away from the idea of a single canon of heritage.

Representativeness in heritage recognises that those in positions of power cannot always anticipate the places that the diverse range of members of society will find important. However, through conserving a **representative** sample of the diverse range of places, objects and practices that could reasonably by called 'heritage', we safeguard the protection of a sample of places and things which may be recognised as heritage now or in the future. A representative heritage place or object derives its values from the extent to which it can act as an exemplar of a class of place or type of object. However, it needs to be understood that this was not a total shift in ideals, and that both of these ways of understanding heritage are still taxonomic in nature and still involve the production of lists of heritage.

A more fundamental challenge, which will be taken up in subsequent chapters of this book, is that of non-western cultures which emphasise the intangible aspects of heritage. This has led to a model of managing and assessing *values*, rather than *lists* of heritage items. The recognition that it is impossible to conserve an example of every 'thing' generates a shift towards a thresholds-based heritage system, where things must be assessed against a series of criteria to qualify for heritage status. The influences of these changing systems of heritage will become clear as you work your way through the chapters of this book.

Heritage and control: the authorised heritage discourse

Anything that an authority (such as the state) designates as worthy of conservation subsequently enters the political arena. Alongside any thought or feeling we might have as individuals about an object, place or practice there

will be a powerful and influential set of judgements from this authority which impacts on us. Smith's argument is that there is a dominant western **discourse**, or set of ideas about heritage, which she refers to as an authorised (or authorising) heritage discourse, or AHD. We will be returning to the concept of the AHD throughout this book. The AHD is integrally bound up in the creation of lists that represent the canon of heritage. It is a set of ideas that works to normalise a range of assumptions about the nature and meaning of heritage and to privilege particular practices, especially those of heritage professionals and the state. Conversely, the AHD can also be seen to exclude a whole range of popular ideas and practices relating to heritage. Smith draws on case studies from the UK, Australia and the USA to illustrate her arguments. This part of the chapter looks in detail at the concept of the AHD as developed by Smith to illustrate how this particular set of ideas about heritage is made manifest: the ways in which heritage conservation operates at a local or regional level through the documents, protocols, laws and charters that govern the way heritage is assessed, nominated and protected.

Smith suggests that the official representation of heritage has a variety of characteristics that serve to exclude the general public from having a role in heritage and emphasise a view of heritage that can only be engaged with passively. She sees the official discourse of heritage as focused on aesthetically pleasing or monumental things, and therefore focused largely on material objects and places, rather than on practices or the intangible attachments between people and things. She suggests that the documents and charters that govern heritage designate particular professionals as experts and hence as the legitimate spokespeople for the past; they tend to promote the experiences and values of elite social classes, and the idea that heritage is 'bounded' and contained within objects and sites that are able to be delineated so that they can be managed.

We can see how these discourses of heritage are made concrete in heritage practice by looking at the International Charter for the Conservation and Restoration of Monuments and Sites (1964) (known as the **Venice Charter**). The Venice Charter, adopted by the Second International Congress of Architects and Technicians of Historic Monuments, meeting in Venice in 1964, was a series of international principles to guide the preservation and restoration of ancient buildings. The philosophy behind the Venice Charter has had a major impact on all subsequent official definitions of heritage and the processes of cultural heritage management.

At the centre of the Venice Charter lie the concept of authenticity and an understanding of the importance of maintaining the historical and physical context of a site or building. The Charter states that monuments are to be conserved not only for their aesthetic values as works of art but also as historical evidence. It sets down the principles of preservation, which relate to

the **restoration** of buildings with work from different periods. In its emphasis on aesthetic values and works of art, it makes implicit reference to the idea of heritage as monumental and grand, as well as to the idea of a canon of heritage.

The Charter begins with these words:

> **Imbued with a message from the past**, the historic monuments of generations of people remain to the present day as living witnesses of their age-old traditions. People are becoming more and more conscious of the unity of human values and regard ancient monuments as a common heritage. The common responsibility to safeguard them for future generations is recognized. It is our duty to hand them on in the full richness of their authenticity.
>
> (ICOMOS, [1964] 1996)

It is possible to see the lineage of a whole series of concepts about heritage in the Venice Charter. This quote reveals a very important aspect of the AHD involving the abstraction of meaning of objects, places and practices of heritage that come to be seen as representative of something aesthetic or historic in a rather generalised way. The AHD removes heritage objects, places and practices from their historical context and encourages people to view them as symbols – of the national character, of a particular period in history, or of a particular building type. In doing so, they are stripped of their particular meanings and given a series of newly created associations.

The Charter establishes the inherent values of heritage, and the relationship between the value of heritage and its fabric through its emphasis on authenticity. In Article 7 it goes on to reinforce this notion:

> *ARTICLE 7.* A monument is inseparable from the history to which it bears witness and from the setting in which it occurs. The moving of all or part of a monument cannot be allowed except where the safeguarding of that monument demands it or where it is justified by national or international interest of paramount importance.
>
> (ICOMOS, [1964] 1996)

Ideas about the inherent value of heritage are repeated in Article 15 through the focus on the value of heritage which can be revealed so that its meaning can be 'read':

> every means must be taken to facilitate the understanding of the monument and to reveal it without ever distorting its meaning.
>
> (ICOMOS, [1964] 1996)

The Charter is focused almost exclusively on particular kinds of material heritage, namely buildings and monuments, and on the technical aspects of

architectural conservation. Once again, we see an emphasis on specialists as the experts in heritage conservation and management:

> *ARTICLE 2.* The conservation and restoration of monuments must have recourse to all the sciences and techniques which can contribute to the study and safeguarding of the architectural heritage.

> *ARTICLE 9.* The process of restoration is a highly specialized operation. Its aim is to preserve and reveal the aesthetic and historic value of the monument and is based on respect for original material and authentic documents. It must stop at the point where conjecture begins, and in this case moreover any extra work which is indispensable must be distinct from the architectural composition and must bear a contemporary stamp. The restoration in any case must be preceded and followed by an archaeological and historical study of the monument.

<div align="right">(ICOMOS, [1964] 1996)</div>

The ideas about heritage that Smith describes using the concept of the AHD circulate not only at the national or global level but filter down to impact on the way in which heritage is managed, presented and understood as a concept at the local level. The next part of the chapter shows how these abstract concepts are made operational in heritage management in North America through the case study of the Harry S. Truman National Historic Site in Missouri.

Case study: Harry S. Truman National Historic Site, Missouri, USA

Harry S. Truman National Historic Site was gazetted (listed on the register of historic properties) on 23 May 1983 and opened to the public as a house museum on 15 May 1984 after Mrs Bess Truman (née Wallace) donated the home to the US nation in her will. Bess Truman's grandfather, George Porterfield Gates, built the fourteen-room, two-and-a-half storey 'Queen Anne' style house over the period 1867–95. It was the house in which the thirty-third US president Harry S. Truman lived during the period from his marriage to Bess Wallace on 28 June 1919 until his death on 26 December 1972. The historic site originally included just the 'Truman Home', however a series of other properties known as the Truman Farm, the Noland Home and the two Wallace Homes associated with the life of Truman were added to the site in the years that followed (see Figures 1.6–1.8).

The heritage values of this site are expressed by the US Department of the Interior National Park Service, the owners and managers of the site, in this way:

The Harry S Truman Historic Site ... contains tangible evidence of his life at home before, during, and after his presidency – places where forces molded and nurtured him.

The significance of Harry S Truman National Historic Site is derived from the time Harry Truman served as the thirty-third president of the United States, from 1945–1953. Yet the park includes physical evidence of a period lasting from 1867 through 1982. This span of time represents nearly the entire context of Harry Truman's life, and encompasses all major park structures: Truman home, Noland home, Wallace homes and Truman farmhouse ... Most of his ideals concerning religion, social responsibility, financial stability and politics were derived from the people who lived here, as well as from his own experiences in these surroundings. Therefore, the park's story can be extended backwards to the 1867 date, so long as any interpretation of these times has direct bearing on, and gives the visitor insight into, Harry Truman as president of the United States.

(National Park Service, US Department of the Interior, 1999, p. 6)

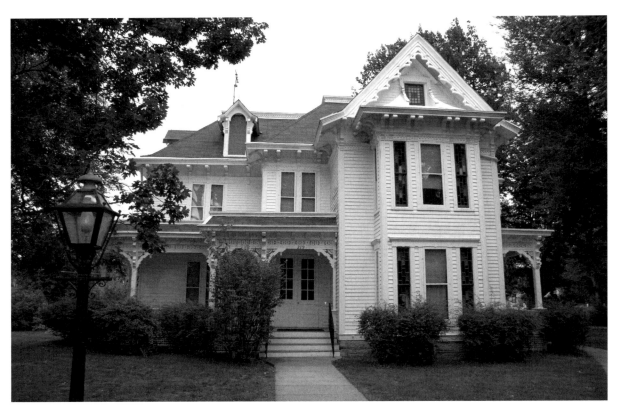

Figure 1.6 The Harry S. Truman Home, 219 N. Delaware Street, Independence, Missouri. Unknown photographer. Photo: © David R. Frazier Photolibrary, Inc./Alamy.

This place might be understood as a class of heritage place known as a 'house museum' – a site maintained 'as it was' to give the public an insight into the life of a person or persons perceived to have been historically important. And, indeed, the statement of significance reproduced in part above certainly makes it clear that the significance of the property lies entirely in its ability to 'give the visitor insight into Harry Truman as president of the United States'. The statement of significance gives the impression that the significance of the site is embodied within the physical material of the place and its contents: it contains 'tangible evidence' of the president and his life, and this material evidence has the ability to provide an insight into his ideas and the events of his presidency. This focus on the tangible and material, along with the rather pleasing setting of the home and its contents, seems consistent with Smith's contention that the dominant western discourse of heritage is focused on material things rather than intangible practices.

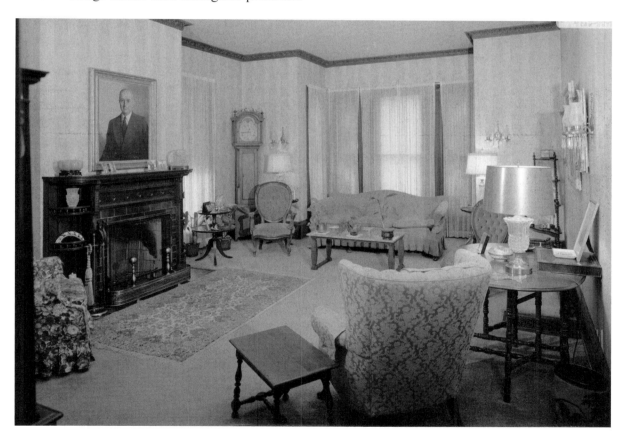

Figure 1.7 The sitting room of the Truman Home, as interpreted to the site visitor. Photographed by Jack E. Boucher, Historic American Buildings Survey. Library of Congress, Prints and Photographs Division, HABS MO, 48 INDEP, 3.

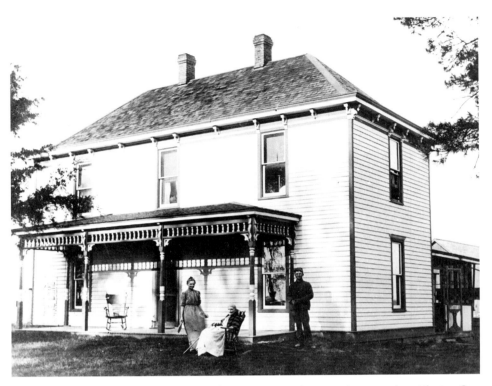

Figure 1.8 Grandview Farm, Missouri, *c.*1906–9. Unknown photographer. Photo: ©
Corbis. Left to right: Martha Ellen Truman, her mother Harriet Louisa Young, and Harry
Truman.

While Truman himself did not belong to the upper classes, he can be seen as
belonging to the 'elite' classes through his very powerful role as the president
of the USA. As you will see from the photographs in Figures 1.6 and 1.7, the
Truman Home is a rather humble dwelling for a president. Nonetheless, the
Truman Home does demonstrate the features that Smith outlines, as even
though the structure itself is reasonably humble, it gains its significance
through its association with power and celebrity. It derives its status as a
heritage site through its association with the 'biggest and best' – important
historical figures and great events. The home and its contents are presented in
a manner that is both aesthetically pleasing and familiar to visitors as a
'house museum'.

Another way in which the Truman Home conforms to Smith's model is
through the notion that there is some inherent virtue to this place that shaped
Truman's character and that can now be 'read' by the visitor. The association
of the home with a 'great historical figure' is consistent with the concept of the
AHD. But another key point which emerges from a close reading of the text is
that the word 'associated' signifies 'intangible' heritage. It would be
impossible to read this building as Truman's home without the interpretive

texts that tell us about the connection between Truman and the house. So there is a rather subtle interplay between the tangible and intangible aspects of heritage that are displayed in the text. The AHD balances the idea of the inherent significance of the fabric of the building against association, in this case, with Truman as president and what his relatively modest origins mean for current notions of US democracy.

The US Department of the Interior National Park Service General Management Plan (1999) specifies a series of further studies to be carried out to assist with the understanding and management of the Harry S. Truman Historic Site. These include an archaeological overview and assessment, cultural landscape reports, historic resources studies, long-term interpretive plan, and wildlife and vegetation surveys. These reports would be prepared, in this order, by an archaeologist, a cultural geographer or landscape architect, a historian, an interpretation specialist, and a zoologist and botanist. In specifying the form of planning documents required, the management plan establishes the expertise of particular professionals in assessing and documenting the heritage significance of the site. In this way, the general management plan excludes the views of the general public. It gives preference to the work of particular academic disciplines over members of the public or other (non-heritage) specialists who might form an opinion of the significance of the site; and this is despite the fact that the site is being conserved for the general public who 'need to know as much about their leaders as possible; the type of people we elect to the presidency tells us a great deal about ourselves' (1999, p. 7). Again, it is possible to see here the exclusion of the general public and the emphasis on heritage as the realm of professionals that Smith suggests are features of the AHD.

These ideas about heritage at the Truman Home do not exist in isolation, but flow down from various other documents which circulate particular ideas about heritage that make up what Smith refers to as the AHD. The National Historic Preservation Act 1966, as amended (NHPA), is the key piece of Federal legislation influencing the way in which heritage is managed and listed in the USA. Although the property was actually listed under the Historic Sites Act 1935, the NHPA is the legislative tool that governs the National Register of Historic Places on which the building sits alongside over 76,000 other heritage places or objects.

The NHPA defines the register as 'composed of districts, sites, buildings, structures, and objects significant in US history, architecture, archaeology, engineering, and culture' (Section 101 (a) (1) (A)). This definition immediately defines heritage as material, and the value of heritage as inherent in a 'district, site, building, structure' or 'object'. In this sense, the Act can be seen as fulfilling the first of Smith's characteristics of the AHD, that heritage is seen as contained within material things. The first section of the NHPA, which

sets out its purpose, does more to realise many of the official ideas about heritage that Smith describes as comprising the AHD:

(b) The Congress finds and declares that –

(1) the spirit and direction of the Nation are founded upon and reflected in its historic heritage;

(2) the historical and cultural foundations of the Nation should be preserved as a living part of our community life and development in order to give a sense of orientation to the American people;

(3) historic properties significant to the Nation's heritage are being lost or substantially altered, often inadvertently, with increasing frequency;

(4) the preservation of this irreplaceable heritage is in the public interest so that its vital legacy of cultural, educational, aesthetic, inspirational, economic, and energy benefits will be maintained and enriched for future generations of Americans ...

(NHPA, Section 1(b))

The NHPA declares the integral relationship between heritage and the nation, and the inherent 'correctness' of conserving heritage, which is seen to have a series of benefits to the well-being of the American people. It also introduces the idea that heritage is being lost 'with increasing frequency', which not only gives the act of conservation a sense of urgency in the light of this threat, but suggests a complete list of heritage (or a canon of heritage) that is being eroded by this loss. The Act specifies a range of heritage professionals as the experts on determining the values of heritage and the past through its explicit reference to 'history, architecture, archaeology, (and) engineering'. It also places the ultimate responsibility for the categorisation and management of heritage in the hands of the Federal government, which further excludes the general public from decisions about determining the significance of heritage. The term 'historic property' itself seems to presuppose not only that heritage is physical but that it will be a bounded entity such as a building or place, rather than a practice or a series of characteristics contained within a broader landscape.

The criteria for entry on to the National Register are standards against which places nominated for inclusion on the register are assessed. These criteria are laid out in Part 60 of the National Register Federal Program Regulations.

National Register criteria for evaluation

The quality of significance in American history, architecture, archaeology, engineering, and culture is present in districts, sites, buildings, structures, and objects that possess integrity of location, design, setting, materials, workmanship, feeling, and association and

(a) that are associated with events that have made a significant contribution to the broad patterns of our history; or

(b) that are associated with the lives of persons significant in our past; or

(c) that embody the distinctive characteristics of a type, period, or method of construction, or that represent the work of a master, or that possess high artistic values, or that represent a significant and distinguishable entity whose components may lack individual distinction; or

(d) that have yielded, or may be likely to yield, information important in prehistory or history.

(Advisory Council on Historic Preservation, 2008)

The emphasis in these criteria is on the archaeological, architectural or design values of a historic property. Clearly, a determination of what constitutes high archaeological value can only be carried out by an archaeologist. Similarly, architects and engineers would be involved in determining the values of the design and technical accomplishment in so far as these issues relate to historic properties. The use of complex threshold criteria also establishes the need for professionals to act as experts in undertaking a heritage assessment to determine whether or not a historic property meets the threshold.

The National Historic Preservation Act 1966 was passed two years after the Venice Charter. Although the USA had significant historic heritage legislation as early as 1906 with the Antiquities Act 1906, which protected historic or prehistoric remains on sites of scientific value on federal lands and made unauthorised destruction or removal of these remains illegal, the 1964 Venice Charter had a major influence on the way in which heritage was conceived and presented in the 1966 Act.

Reflecting on the case study

It is possible to represent this flow of ideas about heritage at the Truman Home schematically, as in Figure 1.9. This whole system represents Smith's AHD. Ideas about what heritage is, and who should be involved in determining which aspects of heritage to conserve and in what way, are implicit at all levels of documentation guiding the management of the Truman Home. It is in this way that Smith's AHD can be understood as a 'total' system that constantly reinforces its own philosophies and ideals. Authors in the chapters which follow will continue to consider the ways in which the AHD might be seen to be manifested in the examples they discuss. We hope that you will look closely at these and other examples of which you are aware and begin to notice instances in which the AHD applies, and other instances in which it may not.

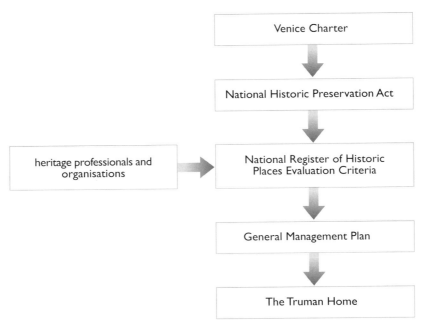

Figure 1.9 Schematic diagram showing the statutory and documentary influence of charters, laws and documents on the interpretation and management of the Truman Home as heritage

Heritage and the production of culture

Another way of thinking about heritage is to view it not simply in terms of physical things but as a form of social and cultural action. Most anthropologists now agree that cultures are not simply an accumulation of things and people but are better understood in terms of a series of processes by which new and old practices are adapted and adopted within a cultural system. These processes can be thought of as forms of 'work' which help to produce a culture. In these terms, culture (and by extension, heritage) can never be thought of as being lost, because culture is always produced in the present to deal with the circumstances of everyday life. Drawing on the work of anthropologist Arjun Appadurai (1996, [2001] 2008), archaeologist Denis Byrne (2008) discusses the ways in which communities use heritage as a part of the 'work' which maintains their connection to particular places and to each other. Appadurai calls this work the 'production of **locality**'.

A formal example of the use of heritage in the production of locality and community is discussed further in Chapter 7 in the case study of the local heritage museums in Kenya. Such approaches to heritage share a focus on the local and on establishing a sense of connection between people and places. An example of a heritage practice that is concerned with the production of locality and community from a contemporary developed nation is the 'traditional' tug

of war that is held between the Bull Hotel and the Feathers Hotel each year in Ludlow town centre (England) on Boxing Day (Figure 1.10). Here, hundreds of locals gather to eat and drink in the streets while cheering on the teams

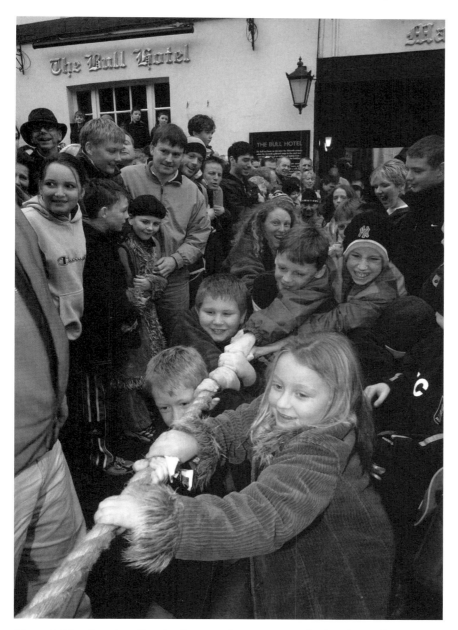

Figure 1.10 Locals gather to cheer on the two teams during the Boxing Day tug of war in Ludlow town centre. Unknown photographer. Photo: courtesy of the *Shropshire Star.*

representing these two pubs located on opposite sides of the main street. The focus on this particular place and on communal eating and drinking demonstrates clearly the ways in which such discrete heritage practices can help individuals express a sense of connection between people and place. The fabric of the buildings and the street are irrelevant to this heritage practice, which demonstrates the active role that heritage can take in a community by bringing people together to emphasise shared values.

Being able to connect one's self to the past, and to the collective past of others via the recollection or recreation of specific memories and histories, is a form of cultural capital that relates to heritage. For example, if an individual can make a connection between their past and the heritage that is promoted as an aspect of their community's past, it gives them a connection they can use to 'purchase' privilege in social interactions. In Pierre Bourdieu's concept of 'cultural capital' (see, for example, Bourdieu and Passeron, 1990) the skills and knowledge that people accumulate in the course of their lives can be employed culturally in a way that is similar to economic capital. Cultural capital might be understood to be similar to prestige or 'know-how': the ability to 'get along' and acquire more influence and status. Education is the key means of acquiring distinction through cultural capital. In this model, heritage is not something imposed from above, but something that people create and use actively to maintain the connections between themselves and other places and things. This model of heritage as social action is far better at accommodating the intangible aspects of heritage such as song, language and tradition – those forms of heritage described earlier in this chapter as heritage *practices*.

If heritage can be a form of cultural capital and a way of connecting people with each other and with the environment that surrounds them, the promotion of heritage or involvement in heritage can be considered to be a form of social action. By drawing on the past and creating a new significance for its traces and memories, people can transform and refigure the ways in which their societies operate. Such a model of heritage does not necessarily criticise heritage for creating alternative versions of history, but sees the role of this creation of collective memories as both the production and the transformation of society and culture.

Conclusion

This chapter has explored ideas about what constitutes heritage – from a canonical list of places and objects to community practices and social action. In the introduction to this chapter it was suggested that heritage studies as an academic discipline was concerned with the study of two processes and the relationship between them. The first of these processes concerns the ways in which ideas about official heritage, or AHD, are involved in the production

of a 'heritage industry' which grants the power to control heritage and, by extension, its messages, to 'experts' and the state. Critics have disapproved of aspects of the heritage industry for producing sanitised and unrealistic reconstructions of the past, as well as for distracting people from the contemporary and creative aspects of culture that could transform it. The AHD model presents heritage as complete, untouchable and 'in the past', and embodied within tangible things such as buildings and artefacts. Such a model of heritage is based on the idea that the values of heritage are inherent and unchanging.

On the other hand, scholars have pointed to alternative aspects of heritage that involve the production of identity and community, that relate to official and unofficial practices of heritage, and that have the potential to transform society. The relationship between local action and global networks has been highlighted as important to this process. This model of heritage as social action could also be characterised as a 'bottom–up' approach, in opposition to the way in which heritage as an 'industry' operates from a 'top–down' position. Heritage as social action is more concerned with practices or with the intangible aspects of heritage than with objects of heritage or tangible heritage. It is involved in the production of both collective and individual memory and performs 'social work' which helps to build community and identity. The chapters that follow include more thorough examinations of aspects of these two processes and the relationship between them through detailed case studies and discussion.

Works cited

Advisory Council on Historic Preservation (2008) National Register Evaluation Criteria [online], www.achp.gov/nrcriteria.html (accessed 10 October 2008).

Anderson, B. (2006) *Imagined Communities: Reflections on the Origin and Spread of Nationalism* (revised edn), London and New York, Verso.

Appadurai, A. (1996) *Modernity at Large*, Minneapolis and New York, University of Minneapolis Press.

Appadurai, A. ([2001] 2008) 'The globalisation of archaeology and heritage: a discussion with Arjun Appadurai' in Fairclough, G., Harrison, R., Jameson, J.H. Jr and Schofield, J. (eds) *The Heritage Reader*, Abingdon and New York, Routledge, pp. 209–18.

Ashworth, G.J., Graham, B. and Tunbridge, J.E. (2007) *Pluralising Pasts: Heritage, Identity and Place in Multicultural Societies*, London, Pluto Press.

Boswell, D. (1999) 'Introduction to Part 2' in Boswell, D. and Evans, J. (eds) *Representing the Nation – A Reader: Histories, Heritage and Museums*, London and New York, Routledge, pp. 111–15.

Bourdieu, P. and Passeron, J.C. (1990) *Reproduction in Education, Society and Culture*, London, Sage Publications.

Byrne, D. (2008) 'Heritage as social action' in Fairclough, G., Harrison, R., Jameson, J.H. Jr and Schofield, J. (eds) *The Heritage Reader*, Abingdon and New York, Routledge, pp. 149–73.

Carman, J. (2002) *Archaeology and Heritage: An Introduction*, London and New York, Continuum.

Getty Conservation Institute (2008) Cultural Heritage Policy Documents [online], www.getty.edu/conservation/research_resources/charters.html (accessed 8 September 2008).

Hewison, R. (1987) *The Heritage Industry: Britain in a Climate of Decline*, London, Methuen.

ICOMOS ([1964] 1996) The Venice Charter: International Charter for the Conservation and Restoration of Monuments and Sites [online], www.icomos.org/docs/venice_charter.html (accessed 8 September 2008).

Lowenthal, D. (1985) *The Past is a Foreign Country*, Cambridge, Cambridge University Press.

Lowenthal, D. (1997) *The Heritage Crusade and the Spoils of History*, Cambridge, Cambridge University Press.

Mitchell, W.J.T. (2005) 'Canon' in Bennett, T., Grossberg, L. and Morris, M. (eds) *New Keywords: A Revised Vocabulary of Culture and Society*, Malden, MA and Oxford, Blackwell Publishing, pp. 20–2.

National Park Service, US Department of the Interior (1999) *Harry S. Truman National Historic Site General Management Plan Revision*, Washington DC, National Park Service, US Department of the Interior.

Samuel, R. (1994) *Theatres of Memory: Volume 1, Past and Present in Contemporary Culture*, London and New York, Verso.

Smith, L. (2006) *Uses of Heritage*, Abingdon and New York, Routledge.

UNESCO (n.d.) The different types of cultural heritage [online], http://portal.unesco.org/culture/en/ev.php-URL_ID=1907&URL_DO=DO_TOPIC&URL_SECTION=201.html (accessed 31 January 2008).

UNESCO (2008) Mir Castle Complex [online], http://whc.unesco.org/en/list/625 (accessed 8 September 2008).

United Nations Environment Programme World Conservation Monitoring Centre (2008) Great Barrier Reef World Heritage Area Datasheet [online], www.unep-wcmc.org/sites/wh/gbrmp.html (accessed 8 September 2008).

Urry, J. (1990) *The Tourist Gaze: Leisure and Travel in Contemporary Societies*, London, Sage.

Walsh, K. (1992) *The Representation of the Past: Museums and Heritage in the Post Modern World*, London and New York, Routledge.

Wright, P. (1985) *On Living in an Old Country: The National Past in Contemporary Britain*, London and New York, Verso.

Further reading

Aplin, G. (2002) *Heritage Identification, Conservation and Management*, Melbourne, Oxford University Press.

Carman, J. (2002) *Archaeology and Heritage: An Introduction*, London and New York, Continuum.

Corsane, G. (ed.) (2004) *Heritage, Museums and Galleries: An Introductory Reader*, London and New York, Routledge.

Fairclough, G., Harrison, R., Jameson, J.H. Jr and Schofield, J. (eds) (2008) *The Heritage Reader*, Abingdon and New York, Routledge.

Fowler, P. (1992) *The Past in Contemporary Society: Then, Now*, London and New York, Routledge.

Graham, B., Ashworth, G.J. and Tunbridge, J.E. (2000) *A Geography of Heritage: Power, Culture and the Community*, London, Arnold.

Graham, P. and Howard, P. (eds) (2008) *The Ashgate Research Companion to Heritage and Identity*, Aldershot, Ashgate.

Harvey, D. (2001) 'Heritage pasts and heritage presents: temporality, meaning and the scope of heritage studies', *International Journal of Heritage Studies*, vol. 7, no. 4, pp. 319–38.

Hewison, R. (1987) *The Heritage Industry: Britain in a Climate of Decline*, London, Methuen.

Howard, P. (2003) *Heritage: Management, Interpretation, Identity*, London, Methuen.

Kirshenblatt-Gimblett, B. (1998) *Destination Culture: Tourism, Museums and Heritage*, Berkeley, University of California Press.

Lowenthal, D. (1997) *The Heritage Crusade and the Spoils of History*, Cambridge, Cambridge University Press.

Merriman, N. (1991) *Beyond the Glass Case: The Past, the Heritage and the Public in Britain*, London, Leicester University Press.

Merriman, N. (ed.) (2004) *Public Archaeology*, London and New York, Routledge.

Pearce, S.M. (1998) 'The construction and analysis of the cultural heritage: some thoughts', *International Journal of Heritage Studies*, vol. 4, no. 1, pp. 1–9.

Samuel, R. (1994) *Theatres of Memory: Volume 1, Past and Present in Contemporary Culture*, London and New York, Verso.

Smith, L. (2006) *Uses of Heritage*, Abingdon and New York, Routledge.

Walsh, K. (1992) *The Representation of the Past: Museums and Heritage in the Post Modern World*, London and New York, Routledge.

Wright, P. (1985) *On Living in an Old Country: The National Past in Contemporary Britain*, London and New York, Verso.

Chapter 2 Critical approaches to heritage

Rodney Harrison and Audrey Linkman

The aim of this chapter is to look in more detail at what it means to be 'critical' when studying heritage as a phenomenon and examining source materials which relate to heritage. An extended case study on ways of reading photographs, written by Audrey Linkman, provides a focus for developing skills of visual discrimination that can be applied when studying photographs and other visual resources in heritage. It also presents and develops critical approaches to heritage and primary sources more generally. A second case study, written by Rodney Harrison, considers the ways in which photographs 'become' heritage, using the examples of the Donald Thomson photographs and Indigenous Australian Yolngu heritage. Following the case studies, the chapter looks at the ways in which concepts from critical discourse analysis have been employed in critical heritage studies. The photograph is considered as an example of a heritage primary source, as well as a metaphor for heritage more generally, in order to develop a critical approach that will be followed throughout the rest of the chapters in the book.

Introduction

Because photographs are connected with heritage in many different ways, their study provides extremely valuable models of how to approach heritage in a critical manner. One of the ways in which photographs connect with heritage is their use as evidence to determine the authenticity of an object or building from the past in the present. Another connection is that the photograph is the most common object people use when describing and discussing their own personal heritage. So, photographs may be thought of as both the *subject* of heritage and a *means of recording* heritage. For example, many museums contain historic photographs of buildings, places and subjects, and in this context a photograph can be understood as the subject of heritage, as it has been curated as an artefact that relates in some direct manner to an object, place or practice of heritage. The Harry S. Truman Home discussed in Chapter 1, for instance, contains many photographs of the house and its occupants which relate to the period when it was in use. These photographs are now seen as part of the heritage of the home, as *artefacts*, like the pieces of furniture, books, letters and other personal belongings donated to the National Park Service which relate to its use as a home of the former US president. Photographs can also be thought of as *images* that document particular events, people or places

and that are helpful in interpreting and understanding heritage objects, places and practices. The photograph of the Grandview Farm in Chapter 1 (Figure 1.8), taken some time between 1906 and 1909, is a personal artefact of Truman's family but it can also provide information about how the house looked at that time, and how it was being used. Such photographs can help people in the present to interpret the physical remains of the Truman Home in an effort to understand how it functioned in the past.

Photographs are bound up with heritage in other, deeper ways (see Harrison et al., 2008). Throughout the course of the late nineteenth and early twentieth centuries, as photographs became more common and personal cameras were more widely available, photographs became linked to personal memories. Today, it is common for manufacturers of photographic film to ask us not to 'trust our memories to anyone else'. Indeed, the founder of Kodak summed up this connection in the remark, 'Kodak doesn't sell film, it sells memories'. Since the late nineteenth century, too, the increasing focus on photography as a form of forensic evidence and its role within the criminal judicial system have been important in developing a relationship with photographs in which they stand in directly for personal memories. As Susan Sontag notes:

> Photographs furnish evidence. Something we hear about, but doubt, seems proven when we're shown a photograph of it ... a photograph passes for incontrovertible proof that a given thing happened. The picture may distort; but there is always a presumption that something exists, or did exist, which is like what's in the picture.
>
> (Sontag, [1977] 2002, p. 5)

The apparent objectivity of photography is discussed further in the case study that follows. It is important to note this connection between the belief in the objective nature of representation provided by photographs, and the way in which photographs came to stand directly for personal memories in the twentieth century.

Some authors have suggested that this expectation of the forensic qualities of personal memory had an influence on the growth of the heritage industry as people developed new expectations of remembrance at a collective level. If personal memories were to be mediated by the materiality of photographs, then collective memories would also need to be represented by some corresponding physical evidence. So we can see that photography connects with heritage not only through acting as evidence in the interpretation of heritage, or as memory of a particular time, place, object or practice. The development of photography as a popular pursuit also had a role to play in the development of the western world's obsession with heritage in the twentieth century, and with the concepts of authenticity that underpin it.

So how do we approach photographs (and indeed, other sorts of heritage objects and places) critically? We need to think of photographs simultaneously as artefacts and images. In other words, we need to look at them as primary source documents. This approach requires us to not only understand the physical constraints and technologies that gave rise to photographs, which are able to be 'read' by looking at the photographs as artefacts themselves, but also to look at the ways in which photographs are arranged and produced as images, and the relationship between the photographer and their subject. Before we can do this, we need to know more about how photographs are made. The methods pursued in the following case study can be seen to apply not only to photographs but also to other types of visual source such as drawings, paintings, films and maps.

Case study: A critical approach to reading photographs as heritage

In the 1960s the Marxist historian Raphael Samuel led a movement to extend the legitimate sphere of historical research to include the history of working people (see also Chapter 1). At the same time he urged historians and others actively to engage in preserving and creating the records that would enable that history to be written. This, in turn, encouraged historians to move away from a narrow concentration on text-based documents and to embrace a wider range of primary sources. Towards the end of the nineteenth century history had emerged as an academic discipline based on the critical and analytical reading of text-based sources. At the time this critical approach to written records distinguished the professional historian from amateur antiquarians who engaged in the acquisition, descriptive cataloguing and display of a range of sources including drawings, engravings and photographs. In the first half of the twentieth century, then, academic historians remained distanced from any serious engagement with photographs, generally using them uncritically as illustrations of arguments proven by reference to written records, as decoration to 'prettify' publications or as breathing spaces in pages of densely argued text.

I was part of that process of change, working in the 1970s in the Manchester Studies Unit (MSU) whose founder, Bill Williams, was profoundly influenced by Raphael Samuel. Williams established an **oral history** unit, nurtured the early North West Film Archive and went on to found the Manchester Jewish Museum. My role in the MSU was to seek out the records of popular culture 'at risk' in the community and arrange for their preservation in publicly accessible libraries and record offices (Linkman and Williams, 1979). This work took me into the homes of local people where I discovered that the family photograph collection was the one record most likely to survive when other family records had been discarded. We therefore began to build an

archive of photographs copied from family 'albums' and accompanied by detailed contextual information about the family, individual sitters, dates, memories of being photographed etc. This archive was intended to serve as a research tool to investigate how photographs could be critically analysed as historical records.

What is a photograph?

Photographs are created by the action of light falling on the actual scene or object in front of the lens. The camera's presence at the event has created the illusion that the resulting photographs must therefore represent 'true' or 'accurate' records. Cameras, however, are operated by photographers who can materially influence both the content of the image and the way in which it is perceived by the viewer. Photographers can, for example, actively intervene in creating or changing a scene or object to obtain particular effects. They can introduce items into a setting that were not present before the photographer's arrival, or remove something that was. Photographers can also make significant interventions at the processing stage by retouching negatives or manipulating the digital image. However, it is important to recognise that the photographer's influence over image content occurs at a much more fundamental level in the picture-making process. The act of photography is an act of selection. It involves a series of choices relating to subject, framing, timing and lighting. In framing a subject, photographers choose what elements to include within the confines of the picture and what to leave out, as well as what will be given prominence and what is to be relegated to the background. Still images necessarily freeze time and movement, so photographers have to decide what part of the ongoing action is to be captured. The influential French photographer Henri Cartier-Bresson termed this the 'decisive moment'. Lighting is particularly important because it defines the mood of the picture and how the viewer responds to it. Whatever the choices, they are made consciously or unconsciously by every photographer every time they take a picture.

A photograph does not therefore present the subject 'as it was', but as the photographer perceived it and wished to represent it to the viewer. The people captured on photographs may collude with the photographer or may be victims of the photographer's interpretation with no opportunity to put their side of the story. So when we look at a photograph we shouldn't ask ourselves 'what does this say about the subject?'. Instead, we should question what it is the photographer wants to tell us and why. As a consequence we may legitimately query whether any photograph can be regarded as objective or true. My own response is to argue that all photographs are subjective interpretations and are, therefore, just like any other heritage source, partial and biased. As such they require careful scrutiny and critical analysis.

The question then arises of how best to undertake the critical 'reading' of photographs in order to identify and evaluate the evidence they contain. This process of deconstruction can start by developing an understanding of the way photographs were put together in the first place. Since the invention of practical photography in 1839, various distinctive applications have been developed. The nineteenth century, for example, saw the emergence of, among others, traditions in portraiture, architecture and landscape, two fine art traditions in combination printing and Pictorialism, and the tradition of record and survey work. The twentieth century added reportage, advertising and the documentary tradition. The photographers who worked in these different traditions shared a set of beliefs about the nature and purpose of their work and adopted a range of working practices that gave expression to their ideas. These ideas and methods work together to shape the generic or typical image. Ideology and methodology operate like scaffolding on a building: they are required to support the image under construction but are invisible in the finished work. It is possible to learn about the underlying ideologies and practical working methods from the books and articles that provided advice and guidance to contemporary practitioners. Obviously the various traditions were not watertight, and ideas naturally migrated between the different applications and changed over time. This is a historically specific process. Understanding the history of these conventions, when and how they changed, can therefore help us to read a photograph critically. In the next two parts of this case study I look at two of these traditions in detail – portraiture, and record and survey.

Portrait tradition

Portraiture was the first major commercial application of photography in the nineteenth century. By 1839, the year of photography's invention, a thriving trade in the sale of hand-crafted likenesses flourished throughout western Europe and the USA, offering a market ripe for mechanisation by the camera. The first commercial portrait studio in Britain opened in Regent Street in London in 1841. Although the pattern of development varied in different countries, by the 1860s photography had achieved a form of mass production with the invention of the *carte de visite* format which retailed by the dozen. *Cartes*, and a larger variation known as the cabinet which appeared in 1866, formed the basis of the Victorian family 'album'. As a consequence of their prolific output, they survive today in considerable numbers in the home, and in libraries, archives and museums.

Cartes de visite and cabinets comprised small paper prints of a standard size pasted on to cardboard mounts of a standard size (see the *carte de visite* shown in Figure 2.1). They established a trend in card-mounted formats. Although I concentrate in this case study on analysing the photographic image, it is

important to remember that photographs are artefacts. They can come pasted on to mounts, inserted into cases, albums, slips and frames, or set into jewellery. This packaging and the various processes used in their production, including silver, carbon, platinum and bromoil, are an integral part of the photograph and can assist analysis or dating or can further our understanding of the intended purpose and meaning. The technologies associated with the production of photographs and packaging leave physical traces that help us to understand the production process. Critical analysis therefore requires that physical appearance is considered in conjunction with the traditions that influenced the composition of the image. In this case study, however, I concentrate on analysing the image, and will begin by looking briefly at the ideas that informed portrait photography in the nineteenth century.

Ideology of portraiture

Early photographers not only mechanised the portrait industry but they also appropriated the rhetoric of the portrait painter in oils. By 1839 painters had evolved a sophisticated, professional rhetoric about the role of the painted portrait and the nature of the artist's interaction with the sitter. Clients, too, had expectations and attitudes based on existing practice. So, in mechanising the likeness trade, the first photographers were confronted with a readymade set of ideas about the portrait and its purpose. Portrait painters of the eighteenth and nineteenth centuries believed it to be fundamental to their purpose to idealise their sitters – to emphasise their beauty and to conceal or shadow any perceived physical defects or blemishes. Photographers of the nineteenth century accepted without question a similar necessity to produce idealised portraits – in spite of the fact that the camera's chief claim to fame was its accuracy of translation. According to one authority, 'the photographer who understands his art has to hide all the defects and show more pre-eminently what is beautiful and perfect' (Claudet, 1861, p. 47).

The painted portrait, however, was perceived to be something greater than the mere delineation of external features. The true purpose of the portrait was to reveal the character and soul of the sitter. This added a spiritual and moral dimension to the portrait. It also conferred prestige and status on a profession that could claim the ability to fathom the inner recesses of the mind and reproduce character on canvas. For the photographer Julia Margaret Cameron, the very act of portraiture was itself a reverent communion of souls. She wrote of her sitters, 'my whole soul has endeavoured to do its duty towards them in recording faithfully the greatness of the inner as well as the features of the outer man' (Gernsheim, 1948, p. 71). The inner qualities revealed in the portrait had to reflect credit on the sitter, and inspire the viewer to moral improvement. In the early nineteenth century few people questioned the belief that the true purpose of art was to inspire and ennoble. Since the portrayal of vice or imperfection was thought to degrade the sitter and corrupt the viewer,

it had no place in art. Thus the portrayal of the inner being was to be idealised in much the same way as the outer body – defects concealed, virtues revealed. I shall subsequently refer to this practice as limited, positive characterisation.

Expression in portraiture

If idealisation represented the underlying ideology of portrait photography, how did photographers put such ideas into effect when dealing with real people? Portraits comprise four elements – facial expression, pose, background/accessories and lighting. I will explore how notions of idealisation and limited positive characterisation informed the treatment of expression and pose. Expression was considered the most important element, as the vehicle through which the intangible qualities of character and soul were made manifest in the picture, thereby conveying the important moral message.

Figures 2.1 and 2.2 date to the late nineteenth and the early twenty-first centuries. The facial expressions are typical of their period. In the recent photograph the subject is smiling. We associate smiles with happiness, contentment, confidence and success. The Victorian sitter's expression is sombre and unsmiling. He looks serious, pensive perhaps. The absence of a smile suggests to us today that he may be sad, miserable or depressed. The convention of the unsmiling expressions in early photography is usually attributed to the length of exposures required by the early wet collodion negatives or to the fact that the sitter was concerned to hide bad teeth. Long exposures of 30 seconds or more were necessary before the introduction of faster negatives by 1880, but we need to question whether this limitation of technology was responsible for the convention of the formal expression. All authorities urged against any expression of strong emotion in portraiture because this was liable to distort the features and mar their beauty. Charles Bell, in *Essays on the Anatomy of Expression in Painting*, published in 1806, was able to define three categories of expression relating to laughter, dismissing broad laughter as 'too ludicrous and too violent a straining of the features' for anything other than the lowest class of Dutch painters and caricature draughtsmen. A smile was allowed to convey greater variety of meaning, but a more charming expression was conveyed by 'a certain mobility of the features which indicates the susceptible mind of a lovely woman ... an evanescent illumination of the countenance' (Bell, 1806, pp. 5–6). One leading authority insisted that in portraiture 'calmness must be preferable to any expression so called' (Rejlander, 1867, pp. 50–1). Another advised in 1891, 'a look of animation, far short of a smile, which suits nearly all faces' (Robinson, [1891] 1973, pp. 94–5). Other words of approval applied to expression in Victorian photographic portraiture included quiet and sober, steadfast, grave, deep and earnest. The Victorians read into a calm expression evidence of inner peace and self-control. Self-control implied refinement, since well-bred people

Figure 2.1 G. Washington Moon, *c.*1870, albumen print, *carte de visite*. Photographed by Elliott & Fry, London. Photo: Arts Faculty, The Open University.

Figure 2.2 Ceri, January 2006, digital photograph. Photographed by Martyn Field. Photo: © Martyn Field.

were not expected to display emotion in public. A serious expression suggested that you took yourself seriously and invited the viewer to reciprocate. Conscious that portraits survived the generations, the Victorians believed that a serious and calm expression conferred dignity on the sitter. A dignified stance would assist the portrait to weather the passage of time.

Sexual stereotyping was practised in relation to expression, since the same look on male and female faces could be interpreted in different ways and certain expressions were not considered suitable for both sexes. So, for example, the sculptor John Gibson approved a serious look because it represented men as thinking but women as 'tranquil' – a more passive, less dynamic state. The leading photographic authority of the nineteenth century, Henry Peach Robinson, conceded that ladies could be portrayed with a cheerful expression, and that some of the most delightful portraits of children showed them in a very happy frame of mind. The exclusion of all reference to males in this context clearly implies that smiles were equated with the absence both of intellect and consequence. Smiles appeared in humorous portraits taken for the commercial market and occasionally in portraits of actresses. Since the social status of the Victorian actress was equivocal, the respectable matron would seek to distance herself from such associations in her portrait. The absence of smiles in nineteenth-century portrait photography was not due to technical considerations regarding length of exposure, or even to poor dentistry. Indeed, when faster negatives appeared in the 1870s and exposure times were reduced to fractions of a second, we do not witness any immediate or widespread outburst of smiles and laughter in the family album. The unsmiling expression was evidently a matter of conscious choice affected by sitters who aspired to project a positive self-image to their contemporaries.

I have looked in some detail in this section at the interpretation of facial expression because it nicely illustrates an important concept in the evaluation of any source material from the past. This exercise clearly exposes the danger of bringing assumptions and perceptions of the twenty-first century to the interpretation of nineteenth century records. Values and attitudes change over time and we need to interpret sources in the context of their times. Careful reading of contemporary sources will expose differences in attitudes and expectations.

Pose

Pose was the most important consideration after expression. It was intended to assist idealisation by presenting the best view of the sitter. Consequently physical defects were concealed by judicious posing and careful lighting. Photographers were encouraged to strive for an elegant, graceful and fluid pose as these were the qualities that distinguished the educated and genteel in Victorian society. Their emulation by the less privileged was intended to

Figure 2.3 (top left) Full-length portrait of anonymous young man, *c.*1870, albumen print, *carte de visite*. Photographed by Outon, Landport. Photo: courtesy of Audrey Linkman.

Figure 2.4 (bottom left) Full-length seated portrait of anonymous young woman, 1860s, albumen print, *carte de visite*. Photographed by the London Stereoscopic and Photographic Company, London. Photo: courtesy of Audrey Linkman.

Figure 2.5 (bottom right) Miss Edith Charteris, *c.*1880, woodburytype, *carte de visite*. Photographed by the London Stereoscopic & Photographic Co. Ltd, London. Photo: courtesy of Audrey Linkman.

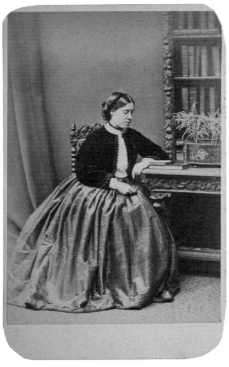

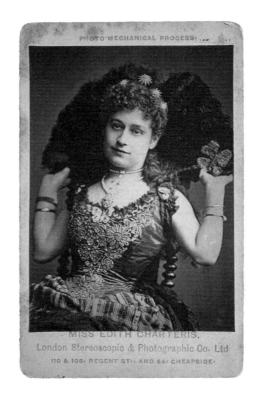

suggest refinement and so assist the idealisation of the sitter. This helps to explain why many appear so stiff and awkward in their portraits as they attempted to hold unaccustomed poses. Pose also continued the characterisation suggested by the expression, as 'there should be expression in the pose generally; in the carriage of the head; in the action of the hands; in the direction of the eye' (Anon., 1876, pp. 510–11). Sexual stereotyping is evident in the poses that were considered appropriate for males and females. The pose of the young man in Figure 2.3 kneeling with one leg on the chair invests the sitter with a nervous energy and vitality, too active to sit at the desk but poised for action should the need arise. Males were permitted to cross their legs and to sit or stand with their legs apart. They were often photographed with walking sticks, umbrellas and top hats, which projected into the space around them. These poses could convey authority, assertiveness and an engagement with the wider world through which men moved with a sense of ease and confidence.

By contrast, the poses of the women are characterised by a relative lack of exertion or activity, as in Figure 2.4. Photographers were specifically instructed that 'The pose of a lady should not have that boldness of action which you would give a man, but be modest and retiring, the arms describing gentle curves, and the feet never far apart' (Wall, 1861, p. 110). The absence of movement can convey a sense of repose, or even passivity. In women the slight variation in the angle of head and body, when allied to their inactive poses, is used to add gracefulness to the pose. Whether standing or seated, women normally keep their arms close to the body. This suggests the idea of self-containment and little interaction with the outside world. In portraits of women it is less common (though certainly not unknown) to find them gazing out directly facing the viewer. The frontal gaze can project notions of strength, courage and engagement. It can also be perceived as confrontational. Women usually have their heads turned to one side, gazing out of the picture. If they are looking downwards the pose can suggest meekness, modesty and docility. In general, however, gaze has to be interpreted in relation to other elements of the image. Commercial portraits of actresses, as in Figure 2.5, reveal how far their poses and dress differed from those of respectable females whose day dress exposed only hands and face.

Record and survey tradition

This same approach can be applied to the interrogation of photographs within the record and survey tradition, which emerged in the nineteenth century to generate images specifically intended to serve as historical records for posterity. In 1888 the Boston Camera Club in the USA announced its intention of making 'negatives and lantern slides of from 75 to 100 leading objects of interest in and about their city' (Edwards, James and Barnes, 2006, p. 10).

The first British survey was undertaken by the Birkenhead Amateur Photographic Society in 1888. Survey work was undertaken in Europe, and exhibitions of survey photographs were displayed at the St Louis World Fair in 1904 and the Dresden International Exhibition in 1909. Photographs produced within this tradition form the basis of all local history collections in Britain, and continue to inform thinking on the style of photograph considered appropriate as historical records today – as, for example, in the HABS/HAER project in the USA (see Figure 1.7) and English Heritage's National Monuments Record collections in the UK.

Origins of the record and survey tradition

Record and survey work was largely undertaken by amateur photographers, and the most popular subject was architecture. We therefore need to look briefly at the history of amateur photography and the treatment of architectural subjects prior to the 1880s. Early amateurs in the 1840s and 1850s comprised affluent gentlemen (and some ladies) with sufficient income, education and leisure to be able to afford the equipment and master the chemistry. They distanced themselves from the trade element in portrait photography by various means: by establishing photographic societies on the model of learned societies; by organising photographic exchange clubs to build their collections; and by largely avoiding portraiture and concentrating on those subjects, like architecture, which in Britain at that time offered few opportunities for commercial exploitation. Many early amateurs were also members of the recently established archaeological and antiquarian societies that emerged in growing numbers from the mid-1840s. Their approach was descriptive rather than analytical. The invention of photography dovetailed neatly with this growing interest in antiquarian pursuits and resulted in photographs of old buildings and ancient monuments, particularly ruined abbeys, castles, churches and buildings associated with famous people in the past. The treatment of these subjects by early amateur photographers is confident and assured, since they drew heavily on established conventions of picture making in drawing and painting, especially those associated with the Picturesque movement in art. Ideas relating to Picturesque beauty were first advanced by William Gilpin in a series of publications from the late 1760s until his death in 1804. The Picturesque permitted the depiction of those subjects which possessed neither classical beauty nor sublime grandeur. Whereas beauty was concerned with proportion, regularity and balance, the Picturesque incorporated ruggedness, variation and irregularity. Roughness, alternation of sun and shade and luxuriance of texture were defined as pleasing to the eye by those working within the Picturesque aesthetic. Since the Picturesque embraced notions of age and decay, ruins were by definition Picturesque. Early amateur photographers therefore avoided modern architecture, preferring to photograph old buildings and ruins.

Roger Fenton's photograph of Rievaulx Abbey in Yorkshire, Figure 2.6, is typical of the style. Such photographs were intended to appeal to the aesthetic senses, stimulate the imagination, promote historical awareness, and induce calm meditation and quiet reflection. Fenton's camera was directed down the nave at a slightly oblique angle to avoid regimented lines. The ruins are open to the elements, allowing the photographer to integrate the man-made

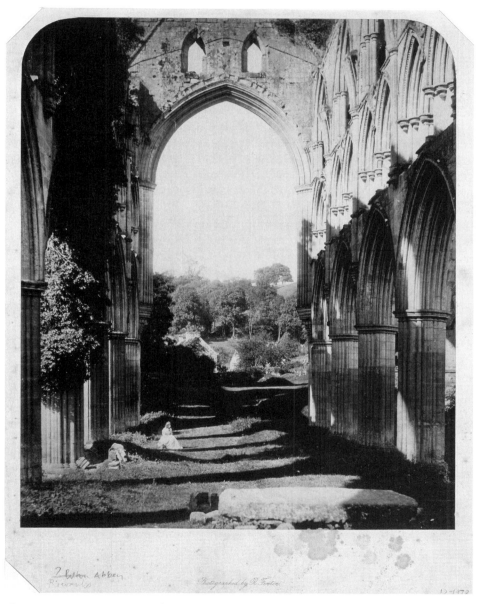

Figure 2.6 Roger Fenton, Rievaulx Abbey, Yorkshire, 1854, albumen print, 34.4 × 28.6 cm. Victoria and Albert Museum, London, 1978. Photo: V&A Images.

structure into the natural landscape by including the distant trees and encroaching greenery. The rough textures of nature – the grass, the distant trees and the clinging ivy – contrast with the smooth, elegantly proportioned stonework to suggest that humans, working in harmony with nature, can produce objects of great beauty and virtue. An important element of the composition is the rhythmic play of light and shade (known as chiaroscuro, the Italian for 'light-dark'). The sombre shadows anchor the pillars to the ground, confirming their solidity and earthly origins. However, the presence of the tiny, seated, solitary, white-clad female figure beneath the towering arches at once contrasts the ingenuity and prowess of human beings with our vulnerability in the face of such inexorable forces as time and decay. The dominant vertical lines of the composition, however, lead our eyes ever upwards suggesting the source of our salvation.

The 1880s marked a turning point in the character of amateur photography in Britain. By 1880 photography had become easier and cheaper due to the introduction of readymade, faster negatives that could be exposed on location and developed when convenient, and the manufacture of lightweight and handheld cameras for use outside the studio. Consequently more people from a wider range of social backgrounds could afford to take it up as a leisure pursuit. The new amateurs came from the middling classes. Many of these joined societies, taught themselves to develop and print, established record and survey work as a recognised branch of their many activities, and gradually articulated a distinctive methodology. Members of a record section would define their geographical area of coverage, allocate photographers to a given locality or subject, organise excursions and exhibitions, and channel the resulting photographs into a local library or museum to ensure future preservation and free public access.

Ideology of record photography

In 1839 William Henry Fox Talbot published details of the first photographic process to print positives from negatives. In a letter to the editor of the *Literary Gazette* on 2 February 1839, he explained that 'by means of this contrivance, it is not the artist who makes the picture, but the picture which makes ITSELF. All that the artist does is to dispose the apparatus before the object whose image he requires' (Harris, 1989, p. 96). According to this account, in which the role of the photographer was significantly underplayed, the photograph was capable of providing an unmediated record of the subject. This perception, in turn, led to what we may regard now as a naïve belief in the objectivity of the photograph, an attitude that largely went unchallenged until the 1880s. In addition to objectivity, the photograph was considered to be inherently accurate and truthful in the reproduction of detail because it was made directly by a machine without the intervention of an artist or engraver. In an address to an audience of architectural and archaeological societies in 1855,

the Revd F.A.S. Marshall described the camera as 'an eye which cannot fail to observe correctly ..., to give an unerring record of all that is brought within its scope of vision' (p. 14). Record photographers of the 1880s shared these ideas about the objectivity and accuracy of the photographic record.

However, at the same time as record photography was gathering pace a new tradition in art photography was also making spectacular advances. Known as Pictorialism, it posed a direct challenge to existing beliefs about the objective nature of the photograph. Pictorialism was the first tradition to recognise the pivotal role of the photographer and attach importance to subjective interpretation through the camera. The aim of the Pictorialists was to convey in their images the feelings, sensations and emotions aroused in photographers by their subjects. To articulate their emotions Pictorial photographers paid particular attention to light and shade, and exploited the moody effects of climate and atmosphere, especially smoke, haze, mist and fog. They abandoned sharp details in favour of soft focus. Pictorialists went even further to achieve effect by condoning all manner of interference at the printing stage. Dodges, such as shading or stopping back, made parts appear lighter or darker as required. Pictorial photographers had no inhibitions about making alterations to the original negative or working on the positive print with pigments and brushes. Cropping and even the total blocking out of unwanted elements were justified in the pursuit of artistic interpretation.

Methodology of record photography

Clearly the ideas advanced by the Pictorialists, and the practices to which they gave rise, were profoundly at odds with the concepts of objectivity and truthfulness espoused by record workers. This did not lead record photographers to question the validity of their own perceptions regarding objectivity. Instead they formalised a methodology that represented the antithesis of Pictorial practice. Record photographers believed that 'with the camera we ought to obtain a true and unbiased representation, and one that our successors may rely on' (Scammell, 1900, pp. 454–5). A record photograph was intended to be an accurate, factual, visual description of the subject, not an emotional response to it, or a critical reading of it. Since 'the greatest value of photography is in recording facts' (Anon, 1900, p. 185), record workers focused on the concrete and physical, and avoided the intangible and abstract. Detail was of paramount importance, and detail required sharp focus. Lighting was used in record work to illuminate detail rather than convey mood. The record worker courted a moral purity that disdained retouching or cropping, or any treatment at the printing stage that compromised the accuracy and objective truthfulness (as they perceived it) of the photographic negative. Record photographers were encouraged to work in permanent processes such as carbon and particularly platinum, which was also good for rendering tone and detail. In practice, however, silver prints, although they were liable to

fade, were generally accepted as they were cheaper and easier to produce. They placed an importance on identifying and labelling their images, recognising that photographs can be exploited more effectively as historical records when supported by information such as the subject content, date and photographer's details.

Records of buildings

The wide range of subjects photographed by record photographers clearly reflected the influence of the antiquarians and included notable buildings, landscape and scenery, passing events, antiquities, archaeological remains, geology, flora, fauna and meteorology. Architectural subjects continued to be the most popular but their treatment reflected developments outside the artistic sphere. The opening of the firm of Bedford Lemere & Company in London in the early 1860s saw the emergence of the first commercial firm in Britain to specialise in architectural photography serving a market composed largely of specialist practitioners. Architects began to commission photographs of their own works in progress and to use them in reconstruction work. Since the search for precedents underlay architectural creativity in the Victorian period, they also studied photographs of buildings at home and abroad in their search for new ideas to incorporate into future designs. Architects consequently required photographs that presented reliable and correct views of buildings with all the details in sharp focus. To satisfy these requirements architectural photographers employed large negatives, small stops and long exposures to produce sharp definition overall. This made it difficult to include people in the pictures. People are usually absent from the photograph altogether or marked by a ghostly blur as they moved through the long exposure. Camera angles were chosen to include as much of the building as possible in the frame, without reference to its context or surroundings. Architectural photographers avoided dramatic contrasts of light and shade, as a quiet uniform illumination permitted greater detail in the shadows. Commercial photographers also focused their cameras on new buildings. A comparison of Figures 2.6 and 2.7 illustrates the difference between the Picturesque and record traditions. By the 1880s specialist commercial photographers had established a tradition of photography for architectural subjects that was continued by record and survey amateurs, though with some modifications.

Among record photographers church architecture was a particular favourite, as in Figure 2.8. Domestic housing was another popular theme and included farms, cottages, almshouses and public houses built in the vernacular style. These photographs were intended to provide a record of the materials and methods used in their construction, and buildings were often photographed prior to alteration, renovation or demolition. Through images such as Figure 2.9 record workers could hope to 'illustrate in a measure a condition of rural life which is fast disappearing from our midst'. Rapid urbanisation and

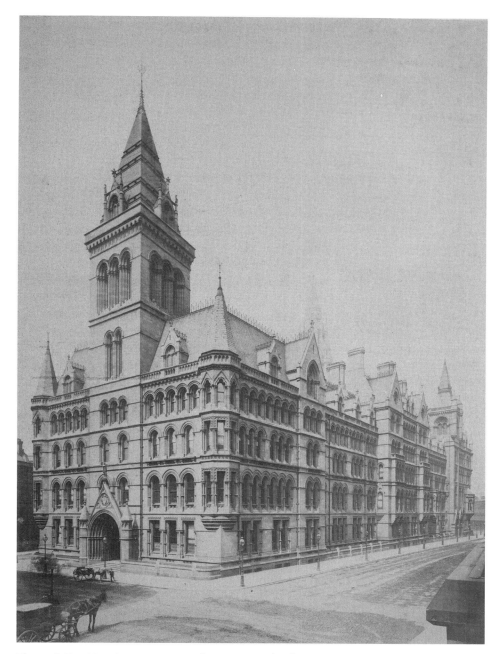

Figure 2.7 Manchester Town Hall, Cooper and Princess Street frontages, 1877, albumen print, 20 × 19 cm. Photographed by Bedford Lemere & Co. Royal Institute of British Architects, London. Photo: RIBA Library Photographs Collection.

Figure 2.8 Cardboard mount featuring interior of Old Shoreham Church, 1904, platinum print, 10.8 × 15.2 cm, photographed by E.F. Salmon; *Interior of Old Shoreham Church Sussex*, engraving; and Photographic Survey of Sussex information label. Sussex Archaeological Society, Photographic Survey of Sussex No. 349. Photo: Sussex Archaeological Society. This mount illustrates the way record and survey societies typically filed and stored their photographic collections.

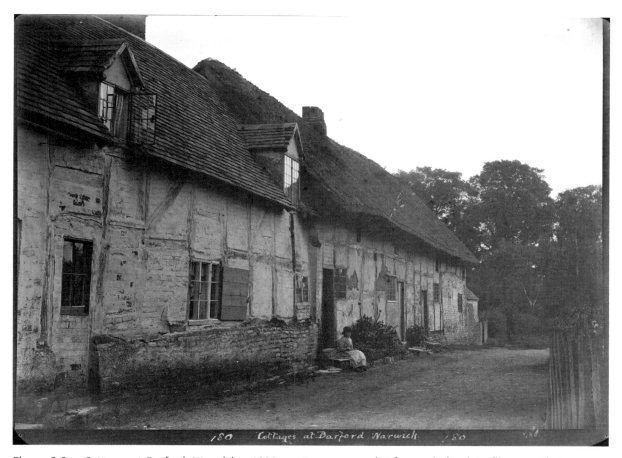

Figure 2.9 *Cottages at Barford, Warwick, c.*1890, contemporary print from whole plate film negative. Photographed by William Jerome Harrison. Birmingham Central Library, Archives & Heritage, WK/H4/14. Photo: reproduced with the permission of Birmingham Libraries & Archives.

the mechanisation of farming practices were seen to affect changes in 'agricultural architecture' as the present 'picturesque buildings' came to be replaced with 'the ugly factory type ... where everything is so trim, neat and sanatory [sic] that the artist flies away in disgust' (Anon., 1894, pp. 584–5). Record workers clearly experienced a tension in reconciling the requirements of straight record photography with the desire to create pleasing pictures. They drew on the basic rules of picture making inherited from painting such as balance, unity, harmony and contrast to produce simple images that pleased the eye. The disrepair and peeling plaster, evidence of rural poverty and deprivation, is presented here as charming and picturesque, authenticating the age and vulnerability of the buildings and justifying their inclusion in the record. Record workers demonstrated little interest in photographing the interiors of 'humble' homes or the experience of those who inhabited them, unless those activities reflected pre-industrial 'poetic' (or backbreaking?)

methods using scythe, sickle or horse-drawn plough. They were encouraged to introduce people (usually women and children) into their pictures to serve as guides to scale. In such cases the photographer appears to have suggested the poses and positions. Can such photographs therefore be regarded as objective? Indeed the compliant, and usually insignificant, presence of rural householders can be interpreted as a celebration of the status quo where the less privileged meekly accepted their place in society. We should not presume any natural bond of sympathy or understanding between these photographers and the rural poor. One contemporary speaker certainly felt the need to combat potential reservations about social contact by asserting that rustics gave satisfaction

> [on] account of the peculiarities and oddities of their dress, and their careless and simple habits ... many of the villagers are ... rather uncouth. But still they are welcoming, clean and healthy ... There is, therefore, nothing objectionable in mixing with them.
>
> (Thornton, 1891, pp. 451–2)

Street scenes

Dry-plate amateurs and record photographers, however, did pioneer one important innovation. They were among the first photographers in Britain to take their cameras into the street to capture scenes of everyday life. Street scenes were regarded as legitimate subjects for the record worker because 'the commonplace of to-day is frequently only the memory of to-morrow' (Gower, Jast and Topley, 1916, pp. 186–7). Photographs of everyday life had been exceptional in Britain before the 1890s. Photographers working in the art tradition known as combination printing which prevailed prior to the introduction of Pictorialism had produced photographs of 'low life' or rustic studies as exhibition pieces and for sale to the public. Since art at that date was concerned with beauty, the uncompromising realities of poverty and deprivation that the camera was capable of translating in grim detail had no place on the gallery wall. Photographers, such as Henry Peach Robinson and Oscar Gustav Rejlander, accordingly confined themselves to the studio, emerging occasionally to photograph some choice bit of natural landscape to serve as a background. They worked with models chosen mainly for their looks and the ability to hold a graceful pose, though some models did live the role they were asked to perform. Early art photographers claimed to influence the expression on the model's face. They also arranged the pose and kept a selection of clothes and accessories specially chosen for their authenticity and dilapidation. Combination pictures were often created using a number of negatives printed seriatim (one after the other) so that the landscape backgrounds from nature and figure studies from the studio could blend into a seamless entity in the finished picture. Because of these practices photographs produced in this art tradition have only limited value as evidence about the lives of the subjects.

Figure 2.10 depicts a shoeblack photographed by Rejlander within the traditions of combination printing. The photograph was taken in the studio where the boys were posed, and probably dressed and equipped, by the photographer. Rejlander is known to have used models from a local boys' home and may have been influenced by cartoons in magazines such as *Punch*. The treatment is humorous, with the crossing sweeper cheekily presenting his bare foot to the shoeblack. The boys are presented as lively, playful and endearing. The experience of most street urchins in the 1860s could hardly have been more different. Condemned to fend for themselves at a very early age, they were frequently homeless and usually destitute, wearing cast-off clothing until it fell off in rags. They earned a pittance by selling cheap goods, working as crossing sweepers, shoeblacks and street entertainers, or, when all else failed, by begging.

This image can be usefully compared with those in Figures 2.11 and 2.12 which also feature shoeblacks and are clearly taken on location in the street. Figure 2.11 is clearly posed because the bystanders on the left of the photograph are either watching the proceedings or looking at the photographer. John Thomson would have used a stand camera on a tripod, which could hardly have failed to draw attention. Everybody in this photograph was aware that it was being taken, and could therefore potentially 'act up' for the camera. In this situation, too, photographers had the opportunity to make whatever adjustments they considered necessary to get the effect they wanted. 'The Independent Shoe-Black' (Figure 2.11) is one of a series of photographs from an exceptional publication, *Street Life in London*, produced by Thomson and Adolphe Smith, a journalist. *Street Life* was originally issued in twelve monthly instalments (price 1/6 per copy) between February 1877 and January 1878. Each issue comprised a photograph of a street character and a detailed description of that person's past career and current circumstances. The authors aimed to draw attention to the hardship and poverty that existed on the streets of London despite the increase in national wealth, and were among the first to use photographs to inform and influence public opinion. The photographs, they felt, would provide 'unquestionable accuracy'. But does this photograph do so? Did the photographer select the location because of the lighting? Did the photographer decide the pose of the shoeblack (neat, upright and attentive) and his customer? Was the well-dressed customer associated with the photographer, or typical of the shoeblack's regular clientele? Did the shoeblack smarten himself up as best he could for the photograph? We cannot know the answers to these questions but we need to ask them if we are using this picture as evidence of the shoeblack's life. We do know that Smith and Thomson wished to present a positive image that would encourage viewers to look on their subjects with sympathy and compassion. This sympathy is evident in the conception behind the project and in the informative and detailed descriptions. Smith and

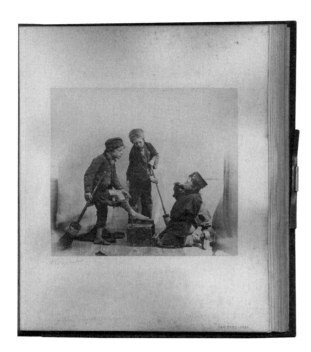

Figure 2.10 Oscar Gustav Rejlander, *Adding Insult to Injury*, *c.*1867, albumen print, 17.4 × 18.6 cm. The University of Texas at Austin, Harry Ransom Humanities Research Center, 964:0582:0031. Photo: Harry Ransom Center.

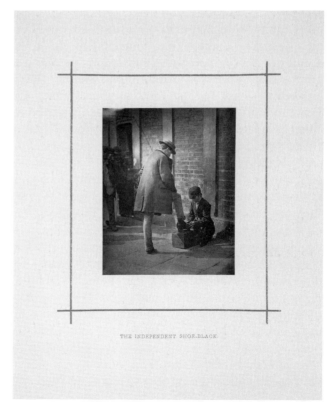

Figure 2.11 John Thomson, 'The Independent Shoe-Black', woodburytype, 11.2 × 8.6 cm, in Thomson, J. and Smith, A. (1877) *Street Life in London. With Permanent Photographic Illustrations Taken from Life Expressly for the Publication*, London, Sampson Low, Marston, Searle & Rivington. National Media Museum, Bradford, Royal Photographic Society Collection. Photo: Science & Society Picture Library.

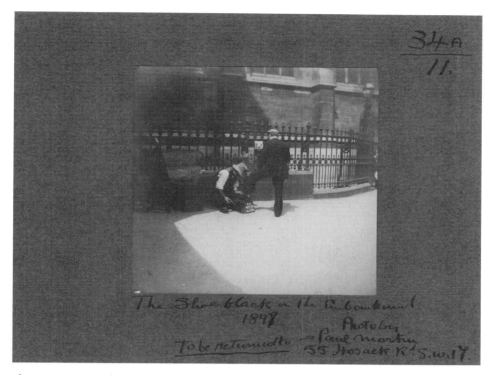

Figure 2.12 Paul Martin, *The Shoe-Black on the Embankment,* 1897/8, gelatin silver print, 8.4 × 8.6 cm. The University of Texas at Austin, Harry Ransom Humanities Research Center, 964:0480:0662. Photo: Harry Ransom Center.

Thomson's objectives were unusual for the time, as was, certainly in Britain, their practice of photographing subjects in the street. Their treatment of those subjects represents a mid-point between combination printing and the style of candid street photography that followed in the 1890s.

In Paul Martin's photograph of a shoeblack on the Embankment (Figure 2.12) neither of the participants appears to be aware of the camera and could not therefore react to it. In the 1890s Martin was an amateur and founder member of the West Surrey Photographic Society. If photographers wished to avoid detection they forfeited the opportunity to make any direct interventions during the taking of the picture, other than the important choices about framing, lighting and timing discussed at the beginning of this case study. The availability of hand cameras, faster negatives and improved lenses made it possible to take candid shots. Early manuals on street photography stressed the importance of obtaining 'views of life as we see it, rather than views in which attention was being given to the photographer and his work' (Yellot, 1900, p. 76). To achieve this result photographers were instructed to

> keep it [the camera] at your side, to raise it when the occasion requires, and make the exposure. Then drop it again, and turn in some other direction while you prepare for a new exposure.
>
> (Yellot, 1900, p. 77)

Writers stressed the need for speed, deftness and proficiency in handling the camera, a confident but unobtrusive manner, and never catching the eye of the subject. These remain the basic rules for candid photography to this day. Advice on composition in street pictures was based on existing rules in painting and drawing. Photographers were told to identify the main object of interest, select a viewpoint where the lines in the street would run in the most 'pleasing' manner and note the direction of the light to ensure 'pleasing' contrasts. These photographs were intended to rescue quaint and colourful types from oblivion before the onward march of 'progress'. They were not intended to disturb the conscience of the affluent. Record photographers had no desire to record the social conditions of the poor and dispossessed. Indeed it is questionable if their sympathies lay with their subjects.

In 1933, with the establishment of the Historic American Buildings Survey (HABS) in the USA, the record tradition consolidated its position as the style of photography considered best suited to historical record. HABS received state funding through the National Park Service which collaborated with the American Institute of Architects and the Library of Congress to ensure authoritative guidance and a prestigious national repository to preserve and make publicly available the collections of measured drawings, photographs, technical descriptions and written histories. The Historic American Engineering Record (HAER) came later in 1969 to parallel the work of HABS by documenting engineering works and industrial sites, with the American Society of Civil Engineers providing advice and financial support. The Historic American Landscapes Survey (HALS) was added in 2000. The HABS and HAER programmes established standards both for the technical quality of the photography and the archival quality of the materials used in the production, storage and cataloguing of the photographic records. The project employs professional photographers whose work conforms to approved procedures disseminated through official publications such as *Recording Historic Structures* (Burns (ed.), 2004). Systematic regulation of the type defined and implemented by the HABS and HAER programmes was designed to set high standards to ensure consistency, accuracy and reliability in documenting and recording the built environment. These standards have been widely adopted in both the private and public sector in the USA and in numerous other countries. Such standards served to formalise heritage practices. The downside, of course, is that the rules governing procedures become too rigid, unresponsive to challenge or change, and alternative approaches are not considered.

Taking critical analysis forward

The greater our knowledge and critical interrogation of heritage source
materials, the more effectively we can mine them as sources of information in
activities linked to interpretation such as research, publication and display.
This same critical awareness is a necessary prerequisite to the intelligent
curatorship of existing collections. It is also the vital springboard for extending
diversity in relation to the range of records that we preserve today as sources
for the future – following the example of Raphael Samuel. So I will end this
section on that note by looking briefly at one project which attempted to create
a body of photographs as historical records for future use but firmly rejected
the dominant record and survey model. In the 1980s and 1990s the
Documentary Photography Archive (DPA), whose collections are housed at
the Greater Manchester County Record Office, commissioned photographers
who worked within the documentary tradition. Documentary photographers
seek their subject matter in the world about them and assert their right to
explore, question and comment. They effectively combine the candid
photography of the street photographer with the subjective approach of the
Pictorialist, as in Figure 2.13. Photographers on the project provided subjective

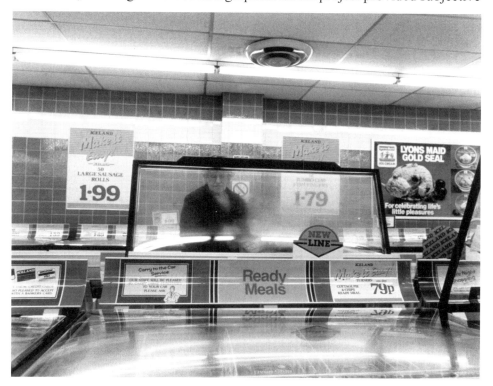

Figure 2.13 Martin Parr, *Iceland Freezer Centre, Lower Broughton, Salford*, 1984,
Kodacolor. Commissioned by the Documentary Photography Archive, Manchester.
Photo: © Martin Parr/Magnum Photos.

interpretations on themes concerned with the routines of everyday life that had largely gone unrecorded. In addition to their images, photographers were asked to produce a written account of the project, recording their attitude and approach to the subject, and reflecting on their successes and failures. The DPA preserved the total body of work produced in the course of the commission which included negatives, contact prints, work prints and exhibition prints, if any. This complete archive provides a record of the photographer's journey of exploration around the subject. The production of a written account and the preservation of the entire output were unusual features. They were intended to assist subsequent users to a greater understanding of the ways in which photographers attempt to influence and control our perceptions of the subject.

Reflecting on the case study

This account of the history of various western traditions of photography and their relationship with contemporary heritage recording illustrates a number of points about how critical approaches to heritage materials, particularly visual sources, are necessary to contextualise and make use of such sources in heritage. Images and objects cannot be read on 'face value' – we need to understand the technologies that have enabled (and constrained) their production, and the traditions that have influenced their composition, before we can begin to understand them. In the same way that photographs must be contextualised before we can comprehend them, so must other visual sources, objects, places and practices. For example, in Chapter 1 we saw the example of a 'traditional' Boxing Day tug of war in Ludlow, England. To understand this practice at anything other than face value, we would need to research not only the history of this particular event but also the histories of the two pubs, the town itself and traditions in the region associated with the tug of war. Similarly, the processes and practices of *heritage management* need to come under critical scrutiny. Sometimes this is difficult, as in most cases heritage conservation and management is presented as inherently positive, even 'natural'. But we must look beyond the rhetoric of heritage and the ways in which it is used in contemporary society to understand its function and meaning. This is what we mean by taking a 'critical approach' to heritage.

You can probably see similarities between the value judgements that were discussed in relation to heritage conservation in Chapter 1 and the process by which a photographer chooses his or her subject and how to frame and light it. The act of selecting what to include in an image can be seen as a metaphor of what to conserve in heritage, in the sense that both involve decisions about what is significant and what is not; both involve a process by which certain things are brought into the foreground and highlighted as the subject

(of heritage or the photograph) while others are left in the background or neglected as they are seen to be unimportant. This process of selection is important to keep in mind, whether we are looking at a photograph or considering an object, place or practice of heritage more generally.

Many documents (see Chapter 3), places and objects that are conserved as heritage have often been created for purposes entirely different from those for which they are preserved as heritage – they are the quotidian by-products of everyday life. However, once they are designated as 'heritage' and curated, they develop new forms of significance and new ways of acting within society. The next case study looks at the ways in which photographs 'become' heritage through the significance attributed to them by particular people in particular historical contexts.

Case study: the Donald Thomson photographs, *Ten Canoes* and Yolngu heritage

Donald Thomson was an anthropologist and ornithologist who worked with Yolngu **Aboriginal people** in central and north-eastern Arnhem Land in northern Australia in the 1930s (Peterson, 2004). In 1932 a group of Yolngu people were involved in the killings of five Japanese fishermen and three Europeans in retribution for the rape of Yolngu women. A punitive expedition was proposed by the Australian government to establish control of the Yolngu. Thomson, a young anthropologist who had previously worked with Aboriginal people in Cape York, offered to intervene and investigate the cause of the violence. Thomson lived with Yolngu people over the course of seven months in 1932–3, and was ultimately successful in diffusing the violence that had erupted the year before, convincing the Australian government to free the three Yolngu men who had been held for the killings. He lived with the Yolngu for another fifteen months before returning to Melbourne. During this time he developed close bonds with the Yolngu people with whom he lived, later persuading the army to establish a special reconnaissance force of Yolngu to fight against the Japanese in 1941 when they were involved in a series of raids on the northern Australian coastline. Thomson subsequently undertook fieldwork with Aboriginal people in Central Australia and Cape York, and amassed some of the most important ethnographic archives in Australia. In 1964 Thomson was made professor of anthropology at the University of Melbourne.

In the 1930s when Thomson first encountered the Yolngu they had only just begun to be involved in protracted interactions with settler Australians, having remained remote from the centres of European settlement on the northern Australian coast. While Thomson lived with the Yolngu, he took approximately 4000 black and white glass-plate photographs of the Yolngu and

their landscape (Peterson, 2004), along with large collections of ethnographic material culture items (Hamby, 2007a). The images document many aspects of daily life at a time when traditional life was being transformed. They show aspects of material culture, religious and spiritual life, hunting and gathering food, and they document the lives of the many individuals with whom Thomson came into contact in this period. These photographs, which have been described as the most comprehensive record of any traditional Australian Aboriginal group, along with Thomson's extensive ethnographic collections from Cape York and Central Australia, were transferred on loan to Museum Victoria in 1973, where they are currently held.

Since the 1970s a number of these photographs have made their way back to Yolngu language-speaking communities in Arnhem Land, many as a result of the work of anthropologists such as Nicholas Peterson (e.g. 2004), Howard Morphy (e.g. 1991), Louise Hamby (2007a, 2007b) and her colleague Lindy Allen who works at Museum Victoria. To describe the chronological period in which these photos were taken Yolngu have developed the concept of 'Thomson Time' (Hamby, 2007b). But the term also describes the world of the Yolngu as expressed through the photographs, and the ideas that have come to adhere to them since they were taken and that now circulate around them. The photographs allow Yolngu people to re-imagine their present in the light of the past, and form a nexus for discussions about contemporary culture and heritage. David Gulpilil, a Yolngu actor who became famous for his role in the film *Walkabout* (1970), describes the way in which the Thomson photographs became the centre for a programme of cultural imagining for Yolngu people through the medium of the film *Ten Canoes* (2006), directed by Rolf de Heer:

> I showed a photograph from Donald Doctor Thomson to Rolf de Heer and said what do you think? Rolf de Heer started to write that story with Ramingining people, my people, and we started to work together. I had to talk to Gudthaykudthay and Minygululu and Bunungurr and Bunyira and Djigirr and Birrinbirrin and I said okay, we'll make that canoes. All I did when they showed me the film and the film started, I start to cry ... I remember those days, I remember ... and now I can see it in the film. I saw it. I really want to thanks to Rolf, what he done for my people and my people's story and a true Australian story, fair dinkum. That story is never finished that Ten Canoes story, it goes on forever because it is a true story of our people, it is the heart of the land and people and nature.
>
> (David Gulpilil, 2005, quoted in Vertigo, 2006, p. 6)

David Gulpilil met Rolf de Heer, who was in Adelaide preparing to shoot another film, in 2000. He subsequently invited de Heer to spend some time at his home in remote Ramingining in western Arnhem Land, where he raised the possibility of making a film with him and his community

(Vertigo, 2006). In 2003 de Heer returned to Ramingining to discuss the project in more detail with Gulpilil, which is when the events discussed in the quotation above took place.

The title of the film *Ten Canoes* refers to a particular photograph of ten Yolngu men on a magpie goose egg hunt taken by Donald Thomson. The photograph forms the centrepiece of a story-within-a-story in which warrior Dayindi is told a story about a young man in the distant past who coveted his elder brother's wife (Vertigo, 2006). The story is told while the men are travelling on a hunting expedition. The sequences featuring Dayindi, said in the press kit to be set 1000 years ago (Vertigo, 2006, p. 1) but understood by Yolngu to be set in 'Thomson Time' (see Hamby, 2007b), are, like Thomson's photographs, filmed in black and white, while shots set in the mythical 'Dreamtime' past are filmed in colour. Although the film is narrated in English by David Gulpilil, all actors speak in dialects of the Yolngu Matha language. Three versions of the film were produced: the first has Yolngu language dialogue with English subtitles and English storytelling by Gulpilil; the second has both Yolngu language dialogue and storytelling in Mandalpingu by Gulpilil, with English subtitles; and the third is the Yolngu version with no subtitles. The Yolngu language version of the narration is not a word-for-word translation of the English version, but instead each version of the film represents an 'insider' and 'outsider' perspective on the narration. This outcome is said to have been a direct result of Yolngu creative direction in the collaborative film-making process (Vertigo, 2006). Nonetheless, as Hamby (2007a) makes clear, because the film is not viewed as a fictional account by Yolngu but a creative engagement with the past (and at least partially as a 'documentary' film), it is subject to criticism from some people, particularly in areas where the representations within the film are considered to diverge from Thomson's accounts.

Thomson's photographs, and the film that Rolf de Heer made in collaboration with Yolngu people, are seen to be an important part of Yolngu heritage, both as a record of times past, but also as the subject of a collective re-imagination of Yolngu people's sense of identity in the present. Making the film required Yolngu people to rediscover many skills associated with the Thomson photographs, including the traditional manufacture of canoes, so that scenes derived from Thomson's photographs could be reconstructed accurately (Figures 2.14 and 2.15). One of the actors in the film, Bobby Bunungurr, remarked on the way in which the Thomson photographs and the film allowed Yolngu people physically to place themselves in the past, and to feel a connection with the spirits of their ancestors in the present.

> When I'm acting out on the swamp in the canoes, I feel full of life. The spirits are around me, the old people they with me, and I feel it ... I said to myself, why I being like my people from long ago? And I

would think way back and then I feel. Everything, like my hair, I'm going to be like my people and I said 'Yeah!', because I remember ... because the spirit of my older people they're beside me and they're giving me more knowledge.

These old people went through this swamp in the past ... no one can tell you now, but you can feel this, the spirit of the older people giving you more knowledge.

(Bobby Bunungurr, 2005, quoted in Vertigo, 2006, p. 22)

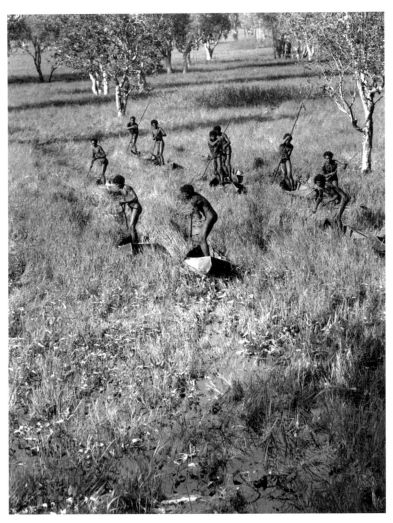

Figure 2.14 Donald F. Thomson, *Djinba and Ganalbingu Men Pole their Way through the Arafura Swamp,* 2 May 1937, photograph. Museum Victoria, TPH 1090. Photo: courtesy of Mrs D.M. Thomson and Museum Victoria.

The film, and the process of actively remembering the Thomson photographs, has spawned a number of additional projects within the community which seek to preserve or promote Yolngu language, culture and spirituality. These include various multimedia and arts-based projects, a music conservation project, and a project to teach young people in the community to use video recording and editing equipment to make their own documentary films (Hamby, 2007b). What began in the 1930s as a process of recording a community of Indigenous Australians being overtaken by western settlement ended with these same documents being used in the production and reproduction of Yolngu culture in the 2000s.

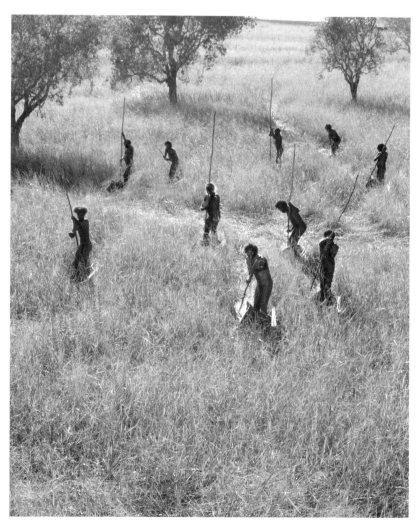

Figure 2.15 Members of the cast on location during the filming of *Ten Canoes*, 2005. Photographed by James Geurts. Photo: James Geurts.

Reflecting on the case study

This brief case study demonstrates some of the ways in which photographs can become heritage. Those Yolngu people who were reunited in recent decades with the Donald Thomson photographs taken in the 1930s would have recognised the names and images of relatives and loved ones, the places that still form part of their homeland, and practices they recognise as being associated with their culture today. They may also have reflected on the various aspects of landscape and culture that are shown in the photographs but that have now changed for them, as indigenous people living in contemporary Australia. What turned these individual recollections and encounters with the photographs into heritage was the Yolngu people's development of a specific collective response to the photographs and their memorialising of them in various forms – both in the film and in various cultural projects aimed at the reproduction of Yolngu community and culture.

We might think of some other more formal mechanisms by which photographs become heritage; for example, when personal photographs are donated to a museum or archive they shift from the personal into the public domain. By their conservation in a public archive they are granted an assumed level of significance in the public eye. Archives and museums are understood to contain 'our heritage', so on viewing these archival photographs we approach them not as personal documents but as collective ones. The reproduction of particular images in the media – through the internet, in film, books and newspapers – also helps to build a level of 'renown' or familiarity with particular images which binds them to a society's sense of collective identity. Once societies begin to see such images as a reflection of themselves and their history they become 'heritage' and function in similar ways to the buildings and monuments that are the object of other formal processes of conservation.

It is not only within indigenous communities that historic photographs can create collective memories which come to be seen as more significant than other memories and other realities. The French sociologist and philosopher Maurice Halbwachs (1992) suggested that all memories are social; that even when we think we remember something vividly in our mind's eye, from our own lived experience, it turns out to have been influenced, if not by a photograph, at least by the way we have rehearsed and performed this memory in telling it to others. We might not agree with this, but there are certainly many photographs that have so seared themselves into public consciousness that they have created memories indistinguishable from lived experience.

Towards a critical heritage studies

The final section of the chapter moves away from the critical analysis of evidence used to interpret heritage and introduces the concept of 'discourse' as an aid to the critical analysis of heritage itself. As was discussed in Chapter 1, much of the scholarship around heritage has focused on the practical aspects of heritage conservation and management, rather than a critical consideration of the ways in which official and unofficial forms of heritage are used within particular societies. Being critical in heritage studies simply means 'thinking about' heritage: why do we value particular objects, places and practices from the past more than others? How does heritage function within society? If we memorialise some aspects of heritage, what other aspects might we forget in the process? To address these questions we need to develop skills that help us to analyse and unpick heritage objects, places and practices and their role within particular historical, political and social contexts. Critical discourse analysis, like the critical analysis of photographs, is a tool that we can use to look critically at the 'texts' or *discourses* of heritage.

The term 'discourse' is most closely associated with the work of French philosopher Michel Foucault, but it has subsequently become popular in a number of academic fields including anthropology, sociology, feminist studies, history, cultural studies and postcolonial studies. Foucault's work involved the critical analysis of various social institutions such as the prison system, medicine and psychiatry. Discourses can be thought of as institutionalised ways of thinking about particular topics, or 'world views'. Foucault used the term to describe forms of communication that require specialised knowledge. He was concerned with demonstrating the connection between language and power, and suggested that discourses have a normative function which influences the ways in which we view the subject of communication, establishing a series of boundaries which *include* particular sorts of attitudes, practices and views while *excluding* others. Discourses do this through the way in which they reinforce particular structures of authority. For example, the discourse of modern scientific medicine reinforces the authority of the doctor while undermining the authority of alternative healers (Frow, 2005, p. 93). Discourses also materialise particular forms of practices and structures that assist in the reproduction of the ideas on which they rest in different social fields. To take this example further, the discourse of modern scientific medicine dictates that medical practices occur within hospitals, doctors' surgeries and clinics, and particular forms of medical treatment are legitimised while others are dismissed as unscientific or unorthodox. All of these different aspects – the scientific texts, the organisations of professional doctors and medical specialists, the medical institutions and practices, as well as the 'truths' and forms of reality that they establish – can be considered to be parts of the discourse of modern medicine, and all work together to influence and define the way in which we view the medical profession and our health as a whole.

Understanding the nature of the discourse relating to a particular topic requires a focus on the ways in which language and power are employed in the 'texts' that underpin the topic. These 'texts' may be written or verbal sources, but they may also be other non-scripted forms of communication – for example, a cultural practice such as drinking tea, or a physical place such as a building. Nonetheless, most discourse analysis relies heavily on the analysis of written or verbal communication, and many approaches to discourse analysis derive from this focus.

Robert Hewison's analysis of heritage (discussed in Chapter 1) can be seen as employing a form of discourse analysis through its focus on the role of heritage in society and his argument that by buying into the heritage industry so wholeheartedly, Britain was allowing its future to be 'taken over' by its past. Through an analysis of a range of different 'texts', including museums, galleries, heritage sites and the visual, auditory and written media surrounding them, he sought to expose the ways in which many of the institutions involved in the management of heritage in the UK were engaged in the production of a past which never 'really' existed. Hewison argued that the nostalgia which gives rise to the desire to root society firmly in the ideals of the past was generated within the specific political and economic circumstances of postwar Britain and a feeling of decline. He argued that instead of providing alleviation from the sense of decline, that the heritage industry as it was expressed in the UK in the early 1980s was actually generating this sense of decline itself as it was backward looking and did not encourage an emotional investment in the future. Instead, Hewison suggested that Britons should be investing in forms of culture which looked to the future, and called for an end to the blind nostalgia which he saw as the source of the heritage industry. As discussed in Chapter 1, in undertaking this analysis, Hewison also linked the rise of heritage with particular right-wing political interests and questioned the political role of heritage in the UK at that time.

A key aspect of contemporary discourse analysis is termed 'critical discourse analysis' (CDA) (Fairclough, 1989, 1995). CDA describes a form of analysis which attempts systematically to relate the structure of language, text and speech to social and political structures in society. Fairclough notes:

> the aim is to map three separate forms of analysis on to one another: analysis of (spoken or written) language texts, analysis of discourse practice (processes of text production, distribution and consumption) and analysis of discursive events as instances of sociocultural practice.
>
> (Fairclough, 1995, p. 2)

CDA recognises that discourses influence the ways in which people organise themselves in society, and that particular practices and institutions in society (such as individual government departments or fields of academic inquiry) have particular discourses associated with them that produce and reproduce the social practices by which they are constituted. Discourses are linked

integrally to the production, maintenance and reproduction of structures of power in the particular social and political contexts in which they are employed. The aim is to map the ideologies and power structures that are contained within, and established by, language and text.

Laurajane Smith (2006) has argued that CDA is a central tool for analysing the messages that surround heritage in contemporary society. Her notion of an authorised heritage discourse (AHD; see Chapter 1) draws closely on the ideas of CDA, particularly in the sense that discourses both reflect and make up a particular set of sociopolitical practices. She believes we can use the structure and messages embodied in the language surrounding heritage to understand the dominant discourse of heritage 'and the way it both reflects and constitutes a range of social practices – not least the way it organises social relations and identities around nation, class, culture and ethnicity' (2006, p. 16). It is this dominant discourse that she terms the AHD.

Theories of CDA are relevant to heritage studies because of the political nature of heritage (see further discussion in Chapters 1 and 5) and the potential for heritage to be the source of significant social change. Critical heritage studies should be concerned with understanding how heritage functions in societies and the relationship between heritage and power. Underlying any such inquiry is the idea that such analysis has the potential to initiate changes in society in the ways we relate to one another, and in particular the ways in which the official structures of heritage affect the everyday lives of ordinary people. For example, by analysing the way in which the AHD has developed a set of structures of authority and expertise, we may allow a space for the increased recognition of competing minority discourses that had previously been disenfranchised. The critical analysis of heritage discourses will be explored further in the chapters that follow.

Conclusion

This chapter has introduced CDA in so far as it has been applied to heritage studies, and presented case studies that have illustrated the process of taking a critical approach to photographs and other visual source materials. We have suggested that such approaches should be seen as the foundation for building a familiarity with critical approaches to other visual and non-visual sources in the study of heritage objects, places and practices. In addition to the need to understand the technologies and techniques that have enabled (and constrained) the production of heritage objects, places and practices, and the traditions that have influenced them, it is also necessary to submit the practice of heritage management to critical analysis. In the chapter we have presented the critical analysis of visual sources as a metaphor for the critical analysis of heritage discourses that have characterised the work of key academic thinkers in heritage studies. The chapters that follow continue this

thread by taking a critical approach to the ways in which heritage is managed, the relationship between official and unofficial practices of heritage management, and the ways in which power is distributed in the official discourses of global heritage.

Works cited

Anon. (1876) 'Character in portraiture', *Photographic News*, vol. 20, no. 947 (27 October), pp. 510–11.

Anon. (1894) 'Rustic pictures', *Photographic News*, vol. 38, no. 1880 (14 September), pp. 584–5.

Anon. (1900) 'Photographic exhibition at Stratford', *British Journal of Photography,* vol. 47, no. 2081 (23 March), p. 185.

Bell, C. (1806) *Essays on the Anatomy of Expression in Painting*, London, Longman, Hurst, Rees & Orme, pp. 5–6.

Burns, J.A. (ed.) (2004) *Recording Historic Structures* (2nd edn), Hoboken, NJ, John Wiley.

Claudet, A. (1861) 'The art claims of photography', *Photographic News*, vol. 5, no. 159 (20 September), p. 47.

Edwards, E., James, P. and Barnes, M. (2006) *A Record of England: Sir Benjamin Stone and the National Photographic Record Association 1897–1910*, Stockport, Dewi Lewis Publishing in association with V&A Publications.

Fairclough, N. (1989) *Language and Power*, London, Longman.

Fairclough, N. (1995) *Critical Discourse Analysis*, Boston, MA, Addison Wesley.

Frow, J. (2005) 'Discourse' in Bennett, T., Grossberg, L. and Morris, M. (eds) *New Keywords: A Revised Vocabulary of Culture and Society*, Malden, MA and Oxford, Blackwell Publishing, pp. 91–3.

Gernsheim, H. (1948) *Julia Margaret Cameron: Her Life and Photographic Work*, London, Fountain Press.

Gower, H.D., Jast, L.S. and Topley, W.W. (1916) *The Camera as Historian*, London, Sampson Low, Marston and Co.

Halbwachs, M. (1992) *On Collective Memory*, University of Chicago Press, Chicago.

Hamby, L. (2007a) 'A question of time: review of *Ten Canoes*', *Australian Journal of Anthropology*, vol. 18, no. 1, pp. 123–6.

Hamby, L. (2007b) 'Thomson Time and *Ten Canoes*', *Studies in Australasian Cinema*, vol. 1, no. 2, pp. 127–46.

Harris, D. (1989) 'Photography and topography: Tintern Abbey' in Weaver, M. (ed.) *British Photography in the Nineteenth Century: The Fine Art Tradition*, Cambridge, Cambridge University Press, pp. 95–101.

Harrison, R., Fairclough, G., Jameson, J.H. Jr and Schofield, J. (2008) 'Introduction: heritage, memory and modernity' in Fairclough, G., Harrison, R., Jameson, J.H. Jr and Schofield, J. (eds) *The Heritage Reader*, Abingdon and New York, Routledge, pp. 1–12.

Linkman, A. and Williams, B. (1979) 'Recovering the people's past: the archive rescue programme of Manchester Studies', *History Workshop*, pp. 111–26.

Marshall, Revd F.A.S. (1855) *Photography: The Importance of its Application in Preserving Pictorial Records of the National Monuments of History and Art*, London, Hering & Remington.

Morphy, H. (1991) *Ancestral Connections: Art and an Ancestral System of Knowledge*, Chicago, University of Chicago Press.

Peterson, N. (2004) *Donald Thomson in Arnhem Land*, Melbourne, Miegunyah Press.

Rejlander, O.G. (1867) 'What photography can do in art', *Yearbook of Photography and Photographic News Almanac*, pp. 50–1.

Robinson, H.P. ([1891] 1973) *The Studio and What to Do in it*, New York, Arno Press.

Scamell, G. (1900) 'National photographic records', *British Journal of Photography*, vol. 47, no. 2098 (20 July), pp. 454–5.

Smith, L. (2006) *Uses of Heritage*, Abingdon and New York, Routledge.

Sontag, S. ([1977] 2002) *On Photography*, London, Penguin.

Thornton, J.J. (1891) 'Rustic life studies', *Photographic News*, vol. 35, no. 1711 (19 June), pp. 451–2.

Vertigo (2006) *Ten Canoes Press Kit*, Adelaide, Vertigo Productions, www.tencanoes.com.au/tencanoes/pdf/Background.pdf (accessed 14 June 2008).

Wall, A.H. (1861) 'The technology of art as applied to photography', *Photographic News*, vol. 5, no. 131 (8 March), pp. 109–10.

Yellot, O.I. (1900) *Street Photography*, The Photo-miniature, vol. 2, no. 14, New York, Tennant and Ward.

Further reading

Barthes, R. ([1981] 2000) *Camera Lucida: Reflections on Photography*, London, Vintage.

Brennan, B. and Hardt, H. (eds) (1999) *Picturing the Past: Media, History and Photography*, Urbana, University of Illinois Press.

Burns, J.A. (ed.) (2004) *Recording Historic Structures* (2nd edn), Hoboken, NJ, John Wiley.

Elwall, R. (1994) *Photography Takes Command: The Camera and British Architecture 1890–1939*, London, RIBA.

Evans, J. and Hall, S. (2003) *Visual Culture: The Reader*, London, Sage Publications.

Gee, P.J. (2005) *An Introduction to Discourse Analysis: Theory and Method*, London and New York, Routledge.

Hall, S. (ed.) (1997) *Representation: Cultural Representations and Signifying Practice*, London, Sage Publications.

Hewison, R. (1987) *The Heritage Industry: Britain in a Climate of Decline*, London, Methuen.

Jaworski, A. and Coupland, N. (eds) (2006) *The Discourse Reader*, Abingdon and New York, Routledge.

Marion, M.W. (2006) *Photography: A Cultural History*, London, Laurence King Publishing.

Pinney, C. and Peterson, N. (eds) (2003) *Photography's Other Histories*, Durham, NC, Duke University Press.

Rose, G. (2006) *Visual Methodologies: An Introduction to the Interpretation of Visual Methods* (2nd edn), Sage Publications.

Smith, L. (2006) *Uses of Heritage*, Abingdon and New York, Routledge.

Sontag, S. ([1977] 2002) *On Photography*, London, Penguin.

Waterton, E., Smith, L. and Campbell, G. (2006) 'The utility of discourse analysis to heritage studies: the Burra Charter and social inclusion', *International Journal of Heritage Studies*, vol. 12, no. 4, pp. 339–55.

Wells, L. (ed.) (2004) *Photography: A Critical Introduction*, London and New York, Routledge.

Chapter 3 Heritage as a tool of government

Anne Laurence

The use made of heritage by governments is explored in this chapter through the example of archives, an aspect of heritage discussed little in the general literature on heritage though extensively explored by historians. Archives have an important role as a badge of nationhood, but they do not convey unproblematically those values of the nation that governments would most like to promote. The case studies of national archives in the UK and Ireland and of South Africa's archives and the Truth and Reconciliation Commission provide examples of government control and offer a critical view of the stated purposes and functioning of the institutions guarding documentary heritage on behalf of governments.

Introduction

Archives are merely one of a host of objects, places and practices controlled by governments. They might seem at first sight to be the archetype of heritage, the historic documents accumulated and preserved by states in national repositories. But the foundation of archives, the choice, preservation and survival of documents in national archives, the concept of the nation represented in such institutions and their policies for access can all be contentious, not least because public archives are government institutions regulated by legislation and with a close relationship with the government departments that provide the raw material of archives.

What are national archives?

The phrase 'national archives' is evocative of ancient parchment and time-honoured institutions. In fact, the majority of visitors in Britain to The National Archives (TNA) at Kew go there in pursuit of their family's history. They consult the registrar general's certificates of births, marriages and deaths, or the records of their ancestors' military service in the First or Second World Wars.[1] Many academics spend months or even years there working on manuscript materials for PhD theses and books – as a postgraduate student I spent months working there on the seventeenth-century records of the

[1] Records of births, marriages and deaths were formerly made accessible through the Family Records Centre. Before that they were kept at St Catherine's House, and before that at Somerset House.

parliamentary army during the English Civil War, thousands upon thousands of pay warrants, signed by Sir Thomas Fairfax and Oliver Cromwell.

But what are national archives for? They are where states deposit records of government and justice, and where members of the public and officials of government bodies may go to find the definitive record of the actions of the government and its agencies, of laws and their implementation. So they are an arm of government and what goes in, what is destroyed, what is closed to access, what is conserved or allowed to decay are all decided by governments. The actual administration of national archives falls to different agencies in different countries – legal officers, ministries of culture or education – and this influences how they interpret their mission.

In the course of their work, governments collect information about individual citizens: they record their births, marriages, divorces and deaths, the tax they pay, their military service, their encounters with law officers and law courts, their passport applications. Some of these records are public (records of births, marriages and deaths for example); some are not (tax and health records for example); and some start by being confidential but become public either by the passage of time or by changes in the law (records of adoptions or the Special Branch for example). Although the individual examples of what is public and what is not may differ from country to country, the scope of national archives' activity is broadly similar in most countries.

In many countries national collections of archives post-date the existence of the state, so they often contain documents that are much older than the institution. Western European national archives are largely creations of the nineteenth century but they often include the archives of earlier royal administrations. Few share the dramatic origins of the French national archives. The revolutionary and Napoleonic governments imposed a national administration, a common set of weights and measures, a common language and a unified legal code to create a single French nation out of an association of territories assembled under the French monarch over the preceding 800 years. Central to that process was the creation by decree in 1790 of a National Archives, followed by a set of regional (departmental) archives in 1794, and the foundation of a permanent collection of works of art in the Musée du Louvre in 1790. The law of 1794 that confirmed the establishment of the National Archives of France identified the following purposes:

- the centralisation of the nation's archives
- reversing the previous custom of conducting affairs of state in secret
- the creation of a national network of archives.

(Archives de France, 2008; translation by author)

Making government business public and providing a centralised archive with regional repositories is seen in the world of archives as one of the great legacies of the French Revolution and, more widely, as a badge of nationhood (Bercé, 2004, pp. 5, 8). Other European nations started to establish archives (though not always as a single institution) in the mid-nineteenth century under the combined pressure of the development of nation-states and the professionalisation of historical writing.

Germany and Italy became nation-states from amalgamations of former independent principalities, dukedoms and cities. Their archives are still largely based in provincial cities which were the capitals of the previously independent territories. The dissolution of the Austro-Hungarian and Ottoman empires after the First World War and the breaking away of the Russian Baltic states after the Russian Revolution in 1917 created more national archives out of what had formerly been territorial or provincial archives. The break up of Yugoslavia and the re-establishment of the Baltic republics following the dissolution of the USSR led in the 1990s and the early years of the twenty-first century to the foundation or reconstitution of national archives in such places as Montenegro, Slovenia and Lithuania. The perceived status of national archives as a badge of nationhood is not confined to the developed world. In 1951 the state of Pakistan, formed in 1947 following the partition of India, established a National Archives. Two years after Bangladesh seceded from Pakistan, the new state set up its own National Archives and Library.

New states create archives to provide themselves with an account of the origins of the state. The development during the nineteenth century of a new kind of history – 'scientific', archives-based historical writing – inspired by the work of Leopold von Ranke, made it necessary for historians to have access to original documents both in archives and in published collections. Throughout Europe, people set about publishing editions of manuscripts, often through the aegis of literary, historical and archaeological societies. Collections of unpublished documents were published in France through the Société de l'Histoire de France, with the Commission ministérielle des Documents inédits founded in 1833. The Calendars (a chronological list and short summary, by period) of the English state papers started to appear in the 1850s. The Historical Manuscripts Commission was founded in 1870 and published listings and transcripts of British historical material in private hands. Pride in the past was further promoted by the official sponsorship of histories demonstrating such important national values as the antiquity of democratic institutions. In France, Napoleon III supported the publication of the papers of his uncle Napoleon I to commemorate the fiftieth anniversary of the first emperor's rise to power, and the government of the Third Republic marked the centenary of the French Revolution by publishing papers relating to the revolutionary Jacobins. In Britain, the Victoria County History was

established in 1899 to write the definitive histories of individual English counties. Subsequently further projects were established to write the history of Parliament, the official histories of the First and Second World Wars and the National Health Service, and unofficial projects such as the Dictionary of National Biography and the Buildings of England (a series providing an architectural description of the most significant buildings in every county) have received government funding. All of these projects have relied on the existence of an orderly and accessible accumulation of records of the past. Without these resources the creation of academic history departments and posts in universities and research institutes would have been difficult. Chairs in history were established in Berlin in 1810, and in Paris in 1812. Modern history (as opposed to the history of classical antiquity) became part of students' curriculum in English and Scottish universities in the mid-nineteenth century.

Tangible and intangible heritage in the archives

The slogan of the International Council on Archives is 'Archives constitute the memory of nations and of societies, shape their identity and are cornerstones of the information society'. It is clear that it regards archives as more than simply the tangible heritage of the contents of the archives. As well as papers, parchment and vellum skins, seals, photographs, recordings and digital files, many archives have considerable collections of objects in their custody. TNA, for example, holds a few tally sticks, the notched wooden sticks that from the thirteenth to the eighteenth centuries were used by the English Treasury to record debts. The old Houses of Parliament were burned down in 1834 when a fire to dispose of unwanted tally sticks got out of control. They also hold unclaimed possessions used as exhibits in the Court of Chancery and bullets from police ballistics analysis.

When we look at the professed mission of many national archives, the more intangible frame of reference is apparent:

- 'Democracy starts here' (USA)
- 'Memory of a nation' 'Illuminating the past; guiding the future' (Australia)
- 'the memory of government' (New Zealand)
- 'Canada's national collection of books, historical documents, government records, photos, films, maps, music ... and more'; 'La collection nationale du Canada comprend des livres, des documents historiques, des dossiers du gouvernement, des photographies, des cartes, de la musique ... et bien plus encore'; 'a treasure house of the memory of Canada'
- 'holding [records] in trust' (India).

These sometimes high-flown sentiments appeared on the websites of the national archives for these countries in 2008. Admirable though they are, they prompt questions that we might want to ask of any national archives. In the first place, who is the nation? You will notice that four of these countries are settler societies with indigenous populations (**first nations**) who have little in the way of written records. The Inuit languages of northern Canada were first written down only in the eighteenth century, and Indigenous Australian languages were rarely written down at all and many are now extinct. The Canadian National Archives' website recognises that both French and English are the country's official languages, the Indian national archives website has a Hindi version but nothing for the other twenty official languages of the modern Indian state, and the US national archives site has a link to a Spanish version. With the exception of New Zealand the languages of first nations make little appearance in connection with these national archives.

The National Archives and Records Administration (NARA) of the USA is an independent agency of the federal government which preserves and documents government and historical records. It was founded 1934 – until then each government agency was responsible for maintaining its own records – and is charged with improving public access to those documents. The body is officially responsible for maintaining and publishing the legally **authentic** and authoritative copies of Acts of Congress, presidential proclamations and executive orders, and federal regulations. The chief administrator, the archivist of the United States, has the authority to declare when the constitutional threshold for the passage of an amendment to the US constitution has been reached.

NARA's magnificent buildings in Washington DC were opened in 1938 and are adorned with allegorical figures in classical style representing such values as the future, the past, destiny, the arts of peace and war, heritage, guardianship, the romance of history and scenes from the early history of the republic (Purdy, 1985, p. 23). At their centre is the Rotunda for the Charters of Freedom in which are displayed the originals of the Declaration of Independence, the Bill of Rights and the Constitution which were transferred there in 1952 under armed guard from the Library of Congress. This dimly lit, secular temple celebrates the documents which, in the eyes of US rulers, assure the country's democratic constitution (Figure 3.1). They are here to be honoured as artefacts in their own right. This is not a place where the trials and tribulations of the US first nations or of the black slave population are noted, though exhibits in the main museum do record these histories.

From the early twentieth century the American Historical Association (founded in 1884) concerned itself with the lack of access to federal records (which had vastly increased in volume during the Civil War of the 1860s), with the conditions of their storage and with the fact that successive fires had destroyed many records in different departments (McCoy, 1985, pp. 2–5;

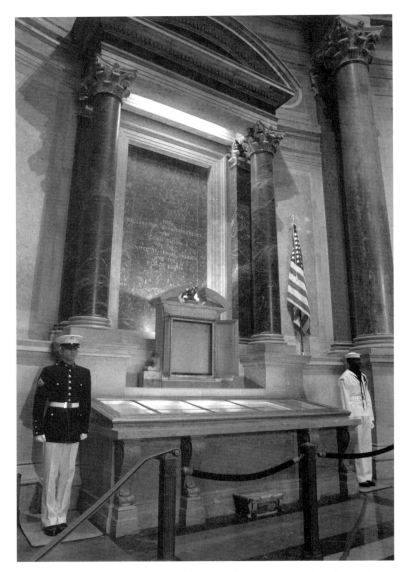

Figure 3.1 Rotunda for the Charters of Freedom, National Archives, Washington DC. Photographed by Alex Wong. Photo: © Alex Wong/ Getty Images. The National Archives Building was designed by John Russell Pope, who was also responsible for the National Gallery of Art and the Jefferson Memorial.

Leland, 1912, p. 9). Quoting the lofty sentiments of the Moscow archives of the Ministry of Foreign Affairs of 1898, that 'the care which a nation devotes to the preservation of the monuments of its past may serve as a true measure of the degree of civilization to which it has attained', the author of a guide to the records of the federal government added in an article that 'the chief monument

of the history of a nation is its archives, the preservation of which is recognized in all civilized countries as a natural and proper function of government' (Leland, 1912, p. 1). He argued that this was not simply a matter for historians but of the state's verification of its own position on both domestic and international affairs.

Note how both Australia and New Zealand emphasise *memory* in their slogans, yet we are bound to ask: whose memory? The archives preserve substantially the records of the settler administration and its post-colonial successors. The Prince of Wales (later Edward VIII) in 1920 laid a foundation stone for an Australian National Archives in Canberra, but no building was constructed after the ceremony and records were collected by the Australian National Library. A separate institution was established in 1961, and finally in 1983 the Archives Act provided for the mandatory preservation of government records. It took a disastrous fire in Wellington in 1952 to galvanise the government of New Zealand to act to preserve its archives and, even then, it was not until 1957 that an Archives Act provided for the transfer of records over twenty-five years old (Cocks, 1965, p. 124). Writing in 1965, a historian of the New Zealand archives noted that 'the growth of national consciousness is of slow development in a young country', and that New Zealanders were more concerned with the present and the future than with the past. But a US archivist, asked to report on the state of New Zealand archives offered a different analysis in 1978: 'the close ties with Great Britain through immigration, trade and defence have had a retarding effect on the development of a distinct sense of national identity and a distinct history' (Smith, W.A., 1978, p. 9).

The Canadian National Archives was founded in 1872 and merged with the National Library in 2004. In the early nineteenth century a Quebec historical society started to collect historical materials in both English and French, but several fires destroyed government records even after their systematic collection began in the 1880s (Lacasse and Lechasseur, 1997, pp. 10–11). The first Public Records Act, providing for the deposit of government archives, was passed in 1912 and a system of regional archives was established during the 1920s. Canada, like the USA and Australia, has a federal constitution, so many government records which in the UK would be found at TNA are to be found there in provincial or state archives.

The emergence in the late twentieth and twenty-first centuries of indigenous **land claims**, boundary disputes and the need to settle claims of abuse has highlighted the importance of government archives (Lacasse and Lechasseur, 1997, p. 22). Federal records – and federal courts – have been actively used in law concerning indigenous land title in Canada, though the province of British Columbia has provided the site for a great many of the cases. Only relatively recently have disputes over indigenous **land rights** in

Alaska, Arizona and some mid-western states of the USA taken place: given the extensive legislative and judicial powers of the governments of individual states in the USA, many of these disputes have not involved the federal government.

Both federal and provincial/state records have been important in establishing the circumstances of the abuse meted out on the Australian 'stolen generation', children taken from their Aboriginal parents in the bush and adopted by white families or brought up in institutions, many of them run by Christian religious bodies, aimed at immersing them in the culture of settler society (predominantly white British and Irish). The Australian archives of the individual states record, too, the seizure of land and its fencing and occupation by settler farmers, land that to them seemed unoccupied because it was not farmed but that had been traversed by Aboriginal families over hundreds, or thousands of years. In 1992, in a landmark legal judgment, the idea of Australia as a *terra nullius* (land belonging to no one) was overturned and a number of Aboriginal land claims have since been settled (Altman, Linkhorn and Clarke, 2005, p. 4).

The New Zealand archives (*Te Rua Mahara o te Kāwanatanga* in Māori) 'ensure that there is an authentic and reliable record of government'. New Zealand, unlike Australia, was not regarded as a *terra nullius* and settlers in the 1830s *bought* land from Māori. The Treaty of Waitangi, concluded in 1840 between the British government and 500 Māori chiefs, forms the centrepiece of the National Archives 'constitution room'. The treaty decreed that Māori peoples would accept the sovereignty of the British monarch and be guaranteed the same rights as any other British subject; they would retain possession of their lands and fishing areas but would accept the new colonial government's right to purchase and sell land. All land transactions were recorded by the government but it soon became clear that settlers flouted the terms of the treaty, especially after the discovery of gold. Wars over land grievances and royal commissions of inquiry in the nineteenth century led to the creation of a Native Land Court in 1865 (now called the Māori Land Court). In the 1960s land protests escalated, with demands for the full implementation of the Treaty of Waitangi, and in 1977 a tribunal was set up to consider violations of the treaty. While, in the course of the past 150 years, the government might have accurately recorded the passage of land from Māori to settlers, records do not necessarily reveal abuses of the treaty, or the ways in which it was manipulated to the advantage of settlers.

Finally, what about India? The India Office in London housed the records of the East India Company from the seventeenth century as well as the records of later British rule in India. These are now part of the British Library, not part of The National Archives. India's own national archives were established under British rule in Calcutta (Kolkata) in 1891 and were transferred to

New Delhi in 1911. But the territories that the British ruled as India are not those of the present-day state. At the time of independence in 1947 the separate state of Pakistan was created and then, in 1973, what had been Eastern Pakistan seceded to form the independent state of Bangladesh. The countries treat these fractures in different ways in the websites on display in 2008. The Indian National Archives refer to 'the freedom struggle in India'; the Pakistan National Archives, established in 1951, refer to the department being 'bifurcated on 8th December 1973, which gave rise to two separate departments' while the National Archives and Library of Bangladesh refer to 'the Liberation of Bangladesh from the Pakistani domination in 1971 [when] the government of the People's Republic of Bangladesh founded the National Archives of Bangladesh in 1973' (National Archives of India, 2008; National Archives of Pakistan, 2008; National Archives of Bangladesh, 2008). So even the basic information about national archives may be political.

National archives, then, are not merely collections of documents but are institutions often understood as embodying values intrinsic to the character of the nation: it is impossible to miss the symbolism of the US National Archives building. There is a more intangible heritage in the records of citizens' rights, and the absence of rights of sections of the population. Writers on heritage, anxious to make a case for the significance of the oral, intangible, remembered aspects of the past, criticise historians for fetishising archive-based research (Samuel, 1994, p. 3). However, the collection, regulation, preservation and storing of archives, and the granting of access to them, should be just as much objects of critical attention as the materials themselves. These activities are subject to cultural process and one which is undergoing a revolution because of the limitless ability to store digital data. The study of authorised heritage tends to focus on the activities of archaeologists and policy makers; archivists, however, are not only custodians of the documentary records of the past but they also arrange them, control access to them and participate in shaping ideas of the past, and they are directed in their work by governments.

Tools of government

How are archives a 'tool' of government? At the simplest level governments make decisions about what records they want to keep, how they will be stored and who shall have access to them. Matters are actually rather more complicated; for example, the national archives of a country such as the USA or Australia with a federal constitution will contain rather different material from the national archives of a country with a centralised administration. The archives of the states of Texas and South Australia will contain records that in other countries would be preserved in a national repository.

Government involvement with the documentary records of the past is highlighted by three pressing concerns: the degree of access to records (often guaranteed by some form of freedom of information legislation); assuring privacy and national security (often protected by closing documents for a period of thirty, fifty or 100 years after their creation, but at odds with the demands of freedom of information); and what to do with and about electronic records.

The US legislature was one of the first to enact legislation for freedom of information; it did this in 1966 (the legislation has since been amended). This enforces the right of citizens of the USA to have access to information held by the federal government and its agencies with certain clearly specified exceptions (including, for example, medical records, commercially sensitive material and records relating to national security or compiled for law-enforcement purposes). The legislation does not mean an absolute right to see an original document or a copy; rather it concerns the right to be given information. It took eight years for matching privacy legislation to be enacted. Individual presidents took different views of the legislation. President Bill Clinton (US president 1993–2001), for example, permitted material relating to national security that was more than twenty-five years old to be released, giving access to US government records concerning the Cold War. However, President George W. Bush (US president 2001–9), following 9/11, through presidential executive orders and through the Patriot Act 2001, much enlarged the categories of material that could be withheld from view on grounds of protecting national security from public scrutiny.

In the UK the Freedom of Information (FOI) Act 2000 (implemented in 2005), gives citizens access to the current records of government and other public bodies. Reversing the example of the USA, privacy legislation had preceded it in the Data Protection Act 1998. The responsibility for the operation of the FOI Act lies with the Lord Chancellor's department (the Department of Constitutional Affairs) so it is aligned with the administration of TNA, but the Act also applies to many public bodies that are not subject to the Public Records Acts (i.e. bodies that do not have to deposit their records with TNA). Records deposited in TNA used to be closed to access for varying amounts of time according to their sensitivity, but normally for thirty years. The FOI Act effectively makes such closure redundant because any citizen showing cause may receive information held in the records.

The implementation of the FOI Act has highlighted the fact that a great deal of information about ordinary citizens is held by a wide variety of organisations without any legally enforceable requirement to deposit their records with TNA. Police records (except for those of the Metropolitan Police) are not the responsibility of TNA, nor are the records of Parliament (both Houses maintain their own record offices). Concern has recently been expressed about the fate of the records of the industries that were nationalised in the 1940s and 1950s and subsequently privatised in the 1980s.

Paradoxically, given the importance in many countries of national archives for the preservation of records of **land tenure**, TNA holds no records of landholding.[2] In the old world where land ownership by individuals has been prevalent for hundreds of years, registration of tenure has been erratic. The Register of Sasines in Scotland is a complete record since 1617 of all transfers of ownership of land; the Registry of Deeds was established in 1708 in Ireland to record all land transfers to ensure that the terms of the penal legislation against Catholics passing on land were observed. But England did not acquire a Land Registry until 1862 and registration of title did not become compulsory until 1990. (Middlesex and Yorkshire had some form of land registration earlier.)

The debate about archiving electronic records has reawakened considerations about the purpose of keeping records. The UK government intended that all records newly created by government bodies should, from 2004, be electronically stored and retrieved. In principle electronic records should be no different from those in any other medium – the archivists' rule is that all records should be considered regardless of format. Electronic records present many advantages. At a stroke, the need to provide large amounts of storage space for fragile materials vanishes; in its place arises a new set of problems to do with the sorting and cataloguing of the material, reading electronic files in obsolete formats and the intrinsic long-term instability of electronic storage media. You may have thrown away your obsolete computer, but some have to be preserved to allow material created on them to be read (see also Ferguson, Harrison and Weinbren, 2010). Until the wholesale move to electronic records it was estimated that around 1 per cent of the records of government business and the law were preserved in TNA.

At the time of writing the possibilities of retaining every written word are horrifying rather than fascinating: security concerns about linking different government-run databases (such as those created by the police, the tax authorities and the National Health Service) are the subject of campaigns by civil rights groups. Since 2008 the UK public has become much more aware of the consequences of keeping records electronically because of scandals about the loss of data from HM Revenue and Customs, the National Health Service, the Driver and Vehicle Licensing Authority and other bodies. No one has yet produced a policy that seems to make sense of the need to keep records but recognises that we do not need to keep everything.

[2] It is noteworthy that the countries that refused to sign the 2007 UN declaration on indigenous rights were Australia, Canada, New Zealand and the USA, all settler societies and all states that have been embroiled in indigenous land rights disputes for at least the last twenty years. Indigenous land claims have been better supported by using international law than by national law.

Governments may place a high value on the documentary heritage of the nation but in return they expect to be able to use it to validate their own activities. Its use can be controversial, contradictory and inconsistent, and governments may even regard the destruction or neglect of the materials of the past as advantageous. The two case studies that follow illustrate the uses of documentary heritage by governments. The first compares the establishment and operation of the national archives in Great Britain and Ireland; the second looks at the relationship between the accumulation of records by the South African Truth and Reconciliation Commission and the national archives of South Africa.

Case study: national archives in the UK and the Republic of Ireland

The National Archives of the UK

The National Archives (TNA) in London is curiously muted about its mission. The heading of its main website in 2008 proclaimed no high-flown slogans but simply 'UK government records and information management'. Its 'vision' is to:

- lead and transform information management
- guarantee the survival of today's information for tomorrow
- bring history to life for everyone.

(The National Archives, 2008a)

This low key-approach echoes something that is a feature of much English (as opposed to British) history. The question of what constitutes the nation whose archives are preserved is considered to be unproblematic, or at least unproblematic for the period before mass immigration began in the late nineteenth century. Questioning what constitutes Englishness or Britishness is a feature of the twentieth century, though the idea of the English as a mongrel nation (Anglo-Saxons, Vikings, Normans with a dash of Celt) has a much older currency.

By the standards of many of the documents it stores, The National Archives at Kew is a relatively young institution. The present organisation is the product of the amalgamation in 2003 of the Public Record Office (PRO) and the Historical Manuscripts Commission. The PRO had been established under the direction of the master of the rolls, a senior legal officer, and fully opened in 1860 in a purpose-built, fire-proof building in Chancery Lane,

London (see Figures 3.2 and 3.3). For the first time, the records of government departments covered by the Public Records Act 1838, such as the Home and Foreign Offices and the Treasury, the administration of the armed forces, and the law courts, including many relating to the royal administration of England from the Norman Conquest and formerly stored in fifty-six different offices, were gathered together in one place (Levine, 1986, p. 101).

The PRO was set up primarily in connection with the law; its location between the Royal Courts of Justice and the Old Bailey (the Central Criminal Courts) shows that clearly. The preservation of legal records does perhaps have a particular importance in common law jurisdictions where legal judgments set precedents for future judicial decisions, as opposed to operating with a written legal code. However, it was not until the Public Records Act 1958 that all government departments were required to transfer records to the PRO.

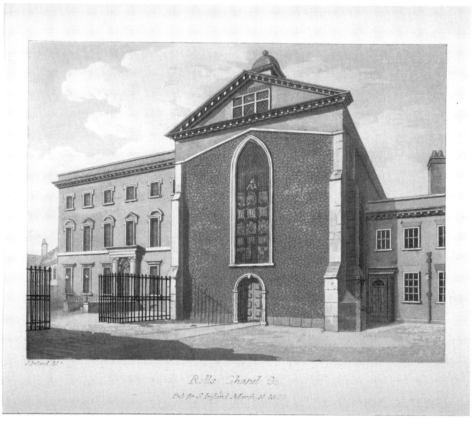

Rolls Chapel
Pub for S Ireland March 31 1800

Figure 3.2 Unknown engraver after Samuel Ireland, *View of Rolls Chapel*, London, 1800, aquatint on paper, length 21 cm. Photo: Guildhall Library, City of London, q282319x. Colen Campbell was the architect of Rolls House in 1724. Rolls House and Rolls Chapel had been used to store records. Rolls House was demolished to make way for the Public Record Office in Chancery Lane.

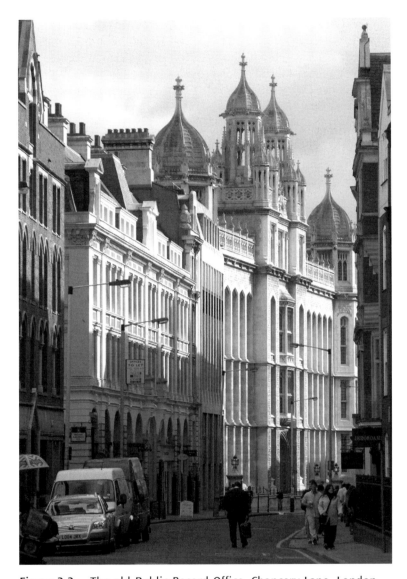

Figure 3.3 The old Public Record Office, Chancery Lane, London. Photographed by Andrew Holt. Photo: © Andrew Holt/Alamy. The first wholly fire-proof building in London, with an iron frame, slate shelves, cast iron walkways in the stacks and zinc ceilings in the reading rooms, it was designed by Sir James Pennethorn and fully opened for use in 1860. The old Public Record Office finally closed in 1996.

The legal business of the PRO was considered to be paramount, but the creation of a single repository encouraged historians to start using it, a fact noted by the deputy keeper of the public records, Francis

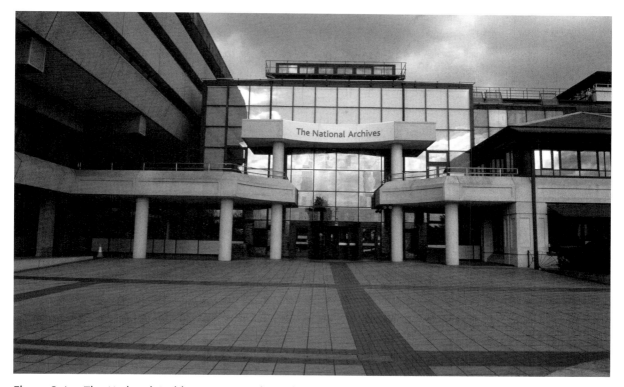

Figure 3.4 The National Archives, Kew, London. Photographed by Jacky Parker. Photo: © Jacky Parker/Alamy. The building was designed by J.C. Clavering and Dermot O'Reilly for the government's Property Services Agency. The slate paving is reclaimed from the shelves of the old Public Record Office at Chancery Lane.

Palgrave, who waxed eloquent praising the virtues and antiquity of English records:

> The materials thus presented to the public possess unexampled value – whether we consider them in relation to antiquity, to continuity, to variety, to extent, or to amplitude of facts and details, they have no equals in the civilized world ... the Documents ... contain the whole materials of the history of this country, every branch and under every aspect, civil, religious, social, moral, or material, from the Norman Conquest to the present day.
>
> (13th Report of the Deputy Keeper of the Public Records, HMSO, 1852, p. 30)

Between 1977 and 1995 the contents of the Public Record Office were transferred to new purpose-built buildings at Kew (Figure 3.4). Set in gardens (a reference to the nearby world-famous botanical gardens), they have a definite emphasis on modernity, clean lines and efficiency. This move has been associated with a mission to make records more accessible. Many resources, especially those such as the censuses used by family historians,

have been digitised and the chief executive (no longer called keeper) announced proudly in 2008 that 'We are leading the world on on-line delivery' (The National Archives, 2008b).

The renaming in 2003 of what had been known since 1859 as the Public Record Office, London, as 'The National Archives of the United Kingdom', created controversy in Scotland. Until the Act of Union of 1707 Scotland had had a Parliament and executive separate from those of England, and had records going back to the thirteenth century. The Scottish Record Office opened in Register House in 1789 (to some protests because of its distance from the law courts) (Figure 3.5). It was renamed the National Archives of Scotland (NAS) in 1999 and is now an agency of the Scottish government.

Wales has been united with England for the purposes of government since the 1530s when its records were merged with those of the English government. A plan was mooted before the First World War to establish a Welsh national archives but was never carried out, so the National Library of Wales has collected manuscripts relating to the history and administration of Wales. The current framework agreement that governs the operation of TNA states that

Figure 3.5 General Register House, Edinburgh. Photographed by Charles McKean. Photo: © Charles McKean/ www.scran.ac.uk. The building was designed by Robert Adam in 1771 and finally completed in 1822.

TNA will act as the national archives of Wales 'pending establishment of separate provision by the National Assembly of Wales' (The National Archives, 2007).

In many countries, regional archives are departments of the national archives. In Britain this is not the case. Local councils have a statutory obligation to preserve their records but not to provide a public archives service. Most counties in Britain have record offices, some have more than one, but what they contain is very miscellaneous since they often house early legal records and take in substantial private collections of local interest as well as the records of local government.

TNA remains under the direction of the lord chancellor, but has moved a great distance from the institution of the 1850s which was used primarily by lawyers. Historians and campaigners have discovered in the archives material on such subversive subjects as British army deserters executed during the First World War, the police strike of 1918, the 173 civilians crushed to death in Bethnal Green tube station in 1943, and the civilians sheltering from the Blitz drowned in Balham tube station in 1940, events that were not publicised at the time.

Perhaps the greatest move towards social inclusion has been prompted by the popular pursuit of family history which has led to the much more ready availability of information about births, marriages and deaths, census data, wills and military records. Academic historians are prone to deplore this development, but there is no doubt that it has led to many ordinary citizens feeling a sense of ownership over the nation's archives as well as a sense of their own family's part in its past. Family historians have also encouraged record keepers and archivists to take a more serious interest in the kinds of record that allow people to investigate the history of families whose lineage is fractured by divorces, adoptions, emigration and desertions. Information about the blood parents of adopted children and the identities of previously anonymous sperm donors is now recorded and accessible.

The National Archives of Ireland

The history of archives in Ireland encapsulates the difficult history of Anglo-Irish relations. Between 1541 and 1800 Ireland was ruled by the monarch of Great Britain and Ireland who appointed the judiciary and the executive which in turn governed Ireland from Dublin Castle with a bicameral Irish parliament. From 1801 Ireland sent MPs to Westminster though there was, throughout the nineteenth century, a developing Irish nationalist movement which wanted, at least, to restore Ireland's parliament and, at most, to establish an independent republic. At Easter 1916 Irish republicans occupied a number of public buildings in Dublin and declared a republic. The rising was quashed by British forces but from 1918 a guerrilla war (the War of Independence) was waged by the increasingly militant and violent republican nationalists. The Anglo-Irish peace

treaty of 1921 proposed the division of Ireland into a 'free state' of twenty-six counties and a six-county province to remain part of the UK. The departure of British forces in 1922 led to the Civil War that lasted until 1923 and was fought between republicans (who opposed the treaty) and nationalists (who supported it) – people who had formerly been united against the British. The Civil War was brought to an end by a ceasefire in May 1923.

The new state, actually established in 1922, had to set about repairing the damage of the Civil War and adopted a conscious policy of Gaelicisation, emphasising an Irish past that owed little to foreign rulers. The constitution adopted in 1922 made territorial claims to the six counties that had remained part of the UK. This claim, which the Free State did not act on, was used to justify a continuing campaign of violence by northern Irish republicans who wanted to cast off British rule. Northern loyalists cited the constitution as evidence of the Irish government's malign intentions. Under the terms of the Good Friday Agreement (1998) the Irish constitution was amended in 1999 to express a desire by the Irish Republic (formerly the Free State) for the peaceful political unification of the island subject to the consent of the people of Northern Ireland. However, the restoration of self-government to Northern Ireland has remained problematic even after the detente between republicans and loyalists symbolised in 2007 by the sight, startling to those who remember the struggles of the 1970s and 1980s, of the loyalist leader Ian Paisley sitting down with the republican Martin McGuinness.

The preservation of and access to the records of such events as the suppression of insurrection against governments or the pursuit of a freedom struggle are always sensitive matters. Records relating to Ireland kept in London were often closed for longer than the customary thirty years; and the preservation in Dublin of records of British rule and of the Irish Civil War, and access to them in the early years of Ireland's independence, were matters of contention.

The formal archiving in Ireland of the administrations' papers started in the eighteenth century (later than England). The Record Commission appointed in England in 1800 to rationalise the preservation of all the records of government and the judiciary set up the Irish Record Commission in 1810, but it was not until 1876 and several fires in the various Dublin record repositories that a Public Record Office was established there (Figure 3.6). In 1988 the Irish Public Record Office merged with the State Paper Office as the National Archives of Ireland and moved to a new building. A Public Record Office was established in Northern Ireland in 1923 following the establishment of the Irish Free State in 1922.

The Irish Public Record Office occupied a building within the complex known as the Four Courts, the seat of the principal law courts of the country, and came under the direction of the master of the rolls of Ireland (Dudley Edwards and O'Dowd, 1985, pp. 132–4; statute 30 & 31 Vict. c. 70). In April 1922 a

Figure 3.6 The old Irish Public Record Office building in the Four Courts, Dublin, *c*.1914. Unknown photographer. Photo: National Archives of Ireland.

small force of irregular anti-treaty republican troops, led by Rory O'Connor, occupied the Four Courts and set up a munitions factory in the record repository (O'Brien, 2004, p. 20).

> In the lower rooms there were explosives, including a large amount of TNT. Electronic detonators, electric wires and explosives were piled between the racks that held the records.
>
> (quoted in Edwards, 2001, p. 117)

The Royal Society of Antiquaries of Ireland wrote to O'Connor about the value of the documents stored there which included not only the records of English rule from the twelfth century onwards but also an irreplaceable collection of early Gaelic manuscripts. Accounts vary as to what happened next. Did O'Connor deliberately detonate a bomb in the basement of the records building? Was he trying to provoke retaliation from the Free State forces? Or was the destruction of the building the result of shelling by the government forces? Was this a deliberate act of destruction against the records of the former oppressors? At all events, the deputy keeper of the public records in Ireland recorded the following in his report:

On the night of Thursday, 13th April 1922, irregular military forces took possession of the Public Record Office as well as of the other offices of the Four Courts. ... By the force of the explosion of the 30th June many documents of the various offices in the Four Courts, including the Public Record Office, were driven up into the air and came down in various parts of the City and suburbs. ... A number of people brought in documents and fragments of documents, but very little of any importance or interest was recovered.

(55th Report of the Deputy Keeper of the Public Records and Keeper of the State Papers in Ireland. Presented to both Houses of the Oireachtas, Dublin, Stationery Office, 1928, pp. 3–4)

One of the ideological objections of the rebels to these materials was that they were substantially the records of the English administration of Ireland – despite the importance of its early Gaelic manuscript holdings. The rationalisation that had taken place in the nineteenth century, bringing together records that had formerly been distributed in a variety of offices, paradoxically contributed to the great losses of 1922 (see Figure 3.7).

The prevailing cultural politics of the governments of Ireland in the period between the foundation of the Free State in 1922 and Ireland's entry into the European Union in 1973 were concerned with an idealised notion of a Gaelic-speaking farmer and an imagined past 'littered with the spirit of heroes' (Crooke, 2004, p. 53). The Gaelic League had been founded in 1893 to avert the decline and promote the use of the Irish (Gaelic) language, and from 1901 the Dublin City Corporation had been gradually installing bilingual street signs (Mac Mathúna, 2004, p. 56). Never in their dreams could the founders of the League have supposed that they would see the introduction of compulsory Irish language teaching in schools, one of the first enactments of the Free State government in 1922. But this emphasis on an Irish past free of the culture, politics and religion of the English also meant that less worth was placed on the surviving contents of the Record Office. Indeed, one historian has gone so far as to write of the Irish government's attempts in the period 1922–72:

to delay almost indefinitely the development of an objective appraisal of many aspects of Irish history. ... to confine the interpretation of the past ... to the perception advanced by the republican revolutionary generation whose warriors had secured the partial independence of southern Ireland in the early 1920s.

(O'Brien, 2004, p. 11)

A more temperate historian merely notes that 'official attitudes to the preservation of archives were lacking in the civic enthusiasm that is the norm for nation states' (Comerford, 2003, pp. 46–7).

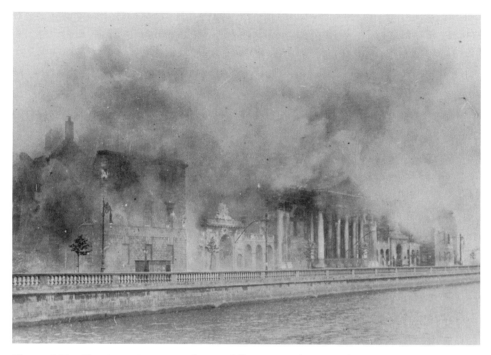

Figure 3.7 The Four Courts on fire, Dublin, 1922. Photographed by W.D. Hogan. Photo: courtesy of the National Library of Ireland.

For the anti-treaty forces of 1922 the public records characterised the culture of an alien oppressor and represented a memory of the nation that they did not want to preserve. For successive Irish governments (made up of government ministers and senior civil servants from the revolutionary generation) of the period from 1922 until Ireland joined the European Union in 1973 the recent memory of the nation was decidedly uncomfortable and often violent. While few records were destroyed after 1922 (except for some Civil War records that were burned in 1932 on the grounds that they would be likely to lead 'if disclosed to unauthorised persons – to loss of life') there was no consistent archiving of records (O'Brien, 2004, p. 196).

Until 1988, when the Irish National Archives was established to bring together the various offices responsible for the records of the government and its agencies, the archival losses of 1922 were not listed. Researchers had to rely on a list made in 1919 and inquire of the staff whether specific documents they wanted had survived. The National Archives' strategic plan for 1996–2001 refers to safeguarding the nation's archives. It uses such phrases as 'housing the records of ... [the] national identity [of the modern Irish state]', and announces that 'a people without a past is a people without a soul'. But to this day the website of the National Archives declines to explain how the records were destroyed (National Archives Council, 1995; National Archives of Ireland, 2008).

The Irish government, despite its indifference to the preservation of records of British rule, was not immune to historical reputation. In 1947 it established the Bureau of Military History to record the personal histories of participants in the crucial years of its struggle for independence from Britain and took more than 1700 witness statements over ten years. The collection had the specific purpose of chronicling the Irish point of view to set the record straight against the British account of the struggle. It had the blessing but not the involvement of the Irish Committee of Historical Sciences, a body of university historians, the government fearing that historians would be too inclined to diminish the importance of the heroic acts of individuals. The terms of reference explicitly excluded the Civil War of 1922–3 and the statements were to be embargoed for twenty-five years after the last statement was taken in 1957 (Ferriter, 2003, p. 39; Gkotzaridis, 2006, p. 113). The material was eventually released in 2003 after the death of the last person to have made a statement. At the same time, the Military Archives in Cathal Brugha Barracks was opened with a great fanfare. The reports, despite having been made thirty years after the event, are an indispensable historical source for the Irish War of Independence; yet the heroes of that war who were members of the government from the 1920s onwards regarded the revelations that these statements might contain as too threatening to the creation myth of the Irish Republic to allow their release.

The Republic of Ireland considers its national heritage to be that of the thirty-two counties that comprise all Ireland, regardless of the fact that six of them remain part of the UK. So at any one time, the Irish state is pulled in several different directions in representing its past. Furthermore, the final resolution of violence is dependent on a vision of Irish culture that can include all religious denominations and all political complexions. Rather than confronting the divisions of the past century, governments have frequently resorted to silence. The divisions of the War of Independence and the Civil War are now the subject of historical scrutiny through the records. But who can say how the records of the Troubles of the later twentieth century have been preserved and will become available – many of them will relate to the security services and to informers. In this subject the experience of the national archives of the UK and of the Republic of Ireland converge.

Reflecting on the case study

The case study has demonstrated the ways in which national archives, which might at first appear to be reasonably systematic and unproblematic collections of documents, are actually the result of changing attitudes towards the past and the nation and are used by governments to include and exclude various histories from the national story. The destruction of the Irish Public Records Office in 1922 provides a dramatic example of the way in which

archives can become symbolically linked to heritage and ideas of nationhood. The example of Ireland highlights the way in which the survival of archives relates as much to historical processes of erasure as to those of recovery and preservation.

Governments, faced with the task of repairing fractures following wars or significant internal upheavals, may seek, in the interests of political unity and civil order, not to conduct detailed examinations of events or to scrutinise any but the most flagrant actions or conspicuous actors in order to enable the postwar state to function. The Civil War that divided the Irish Free State in 1922–3, the treatment of Jews by the Vichy government of France during the Second World War and of 'comfort women' by Japanese troops in the Pacific in the Second World War are all episodes in the histories of those nations that were deeply divisive or discreditable. In all three cases the uncovering of these histories has had to wait fifty years after the events. Such episodes are not air-brushed out of the nation's past but they rarely feature in school textbooks, are not the subject of TV documentaries or museum exhibits, and do not furnish the colourful characters of popular biographies and biopics. The widely used Irish school textbook published in 1960 by Mary Hayden and George A. Moonan (though based on an edition that first appeared in 1921) and 'written by Irish writers for Irish readers, and frankly from the national standpoint' simply does not refer to the Civil War or the problems arising from partition (quoted in MacCarthy, 2002, p. 69). More recently, it was announced in 2005 that Saddam Hussein had been eliminated from the Iraqi school syllabus. In contrast, rather than seeking to forget, some governments have explicitly tried to uncover what happened in recent traumatic episodes and perhaps the most conspicuous example is provided by South Africa's Truth and Reconciliation Commission, which is the subject of the next case study.

Case study: South Africa's archives and the Truth and Reconciliation Commission

South Africa was settled by Europeans – largely Dutch and English – from the seventeenth century and eventually in 1910, after the Boer War, it became a British dominion. From 1948 successive South African governments legislated for the separation of different races under a policy of 'apartheid', granting only limited political rights to non-whites and suppressing political opposition with the utmost ferocity by means of security services, the army and police. The dismantling of this regime began in 1993 and the democratically elected government under the presidency of Nelson Mandela set about trying to create a unified nation out of a divided society.

Setting up the Truth and Reconciliation Commission

The South African Truth and Reconciliation Commission (TRC) was an essential part of this process: it was established by the South African government of National Unity under the Promotion of National Unity and Reconciliation Act No. 34 of 1995 with the explicit aim of collecting testimony about the activities of the apartheid regime. It was concerned both with recovering the history of the period between 1960 and 1994 and with shaping the future.

The TRC was not the first government-backed body to collect testimonies: the Irish government collected military memoirs of the heroes of the War of Independence. Nor was the TRC the first truth commission. The Nuremburg trials (1945–9) conducted by the UK, the USA, France and the USSR following the end of the Second World War in Europe, and the Tokyo War Crimes Tribunal (1946–8) conducted by the USA following the end of the war in the Pacific, established a mechanism for exacting victors' justice and revealing the extent of war crimes. Early truth commissions such as those in Uganda (1974), Argentina (1983), Chile (1990) and El Salvador (1992) were a reaction against victors' justice, recording not only the history of the oppressed, but also of their oppressors (Phelps, 2004, p. 79). A significant difference between truth commissions was whether the states in question saw themselves as reverting to the democratic government of an earlier period, as in the case of Chile, or as developing democratic institutions for the first time, as in South Africa (Phelps, 2004, p. 105).

The South African TRC consisted of seventeen commissioners drawn from all sectors of South African society (Figure 3.8). For the chair of the commission, Archbishop Desmond Tutu, the process of *making* testimonies was instrumental: 'We are searching for the truth, and what we want is actually healing and reconciliation in our land' (quoted in Castillejo-Cuéllar, 2007, p. 23). It is, of course, not obvious that testimonies given in the circumstances of a truth commission are 'the truth', but they are an important step towards making accessible information about – and sharing a common understanding of – a widely-experienced and brutal recent past. One of the novel features of the TRC was the granting of amnesty in return for full disclosure of crimes (Goldstone, 2000, p. viii).

The aims and operation of the TRC changed considerably as time passed. It was intended to collect and present testimony of the past to be used for a variety of different purposes: to reveal the extent and detail of the human rights violations by the previous regime; to identify perpetrators of those abuses; and to allow victims to have their say. Perpetrators of abuses, in a separate process to secure amnesty from prosecution, were required to appear at a formal tribunal to be questioned about their actions. So the TRC created a record of the abuses under apartheid, but within a very specific social context. It also

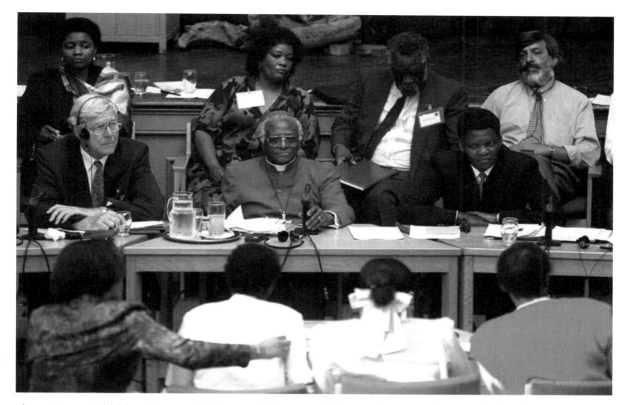

Figure 3.8 Archbishop Desmond Tutu and fellow commissioners listen to witnesses during the Truth and Reconciliation Commission, East London, 15 April 1996. Photographed by Philip Littleton. Photo: © Philip Littleton/AFP/Getty Images.

used that record to write the history of those abuses, to secure reconciliation or prosecution, and to allow both victims and perpetrators to live side by side; and it created a huge archive of testimonies and amnesty hearings. This was a process, not a single event, and perhaps the most important aspect of the work of the TRC was that much of it took place in public.

The TRC was not intended as a mechanism for material restitution, though it provided evidence for the strength of claims to reparations payments. It was also not a mechanism for land redistribution; this was dealt with by the establishment of a Commission on Restitution of Land Rights (known as the Land Commission) in 1995 to examine claims by individuals and communities who had been dispossessed of land under racially discriminatory law and of a court to allocate land. By the end of 1998, 36,458 claims had been lodged, only nineteen of which had been settled. The number of settlements increased greatly in 1999 with a change in the commission's processes (Johnson, 2003, p. 290). Government records of land ownership were vital to the Land Commission's work; for example, it was the release of

documents previously under a ninety-year embargo that made possible claims for compensation by the Griqua people for the loss of land to De Beers in the Kimberley diamond-mining region (Johnson, 2003, pp. 283, 291).

Recording testimonies; airing confessions for amnesty

What kind of evidence was collected by the TRC? Thousands of victims' statements were submitted to the TRC and the commission itself sought out further information from many more people; its staff followed up many testimonies and collected information from perpetrators. If perpetrators could prove that their acts had been politically motivated they were able to apply for amnesty, submitting sworn affidavits and making a full disclosure in public. Ultimately, the amnesty statements assumed a greater significance than the victim statements; the victim testimonies 'triggered a process of truth recovery' but 'had no epistemological weight in the final report' (Castillejo-Cuéllar, 2007, p. 16). In addition, the amnesty hearings took place in public, often transmitted on TV and radio, and were commonly the first occasion for survivors to receive public recognition for their own stories.

The difference between the two sources of information – the narrative accounts of victims and the forensic accounts taken by staff as part of the amnesty process – led to divisions within the TRC. Was it more important to hear the voices of the victims or to assess the damage? Certainly the latter was more readily definable and fitted with the quasi-legal functions of the TRC, leading to a change in the way in which statements from victims were taken. Originally these were voluntarily submitted, open-ended accounts. Then the TRC began to send out trained statement-takers to collect testimony that provided precise identifications of victims, perpetrators, times and places (Castillejo-Cuéllar, 2007, p. 20). Victim accounts came to be rendered as answers to a series of set questions and framed in a way that could be entered in a database. As the work of the TRC continued, changes in process altered the kinds of accounts they received, and the definition of a human rights violation came to be one that fitted into this system of classification (Castillejo-Cuéllar, 2007, p. 12). 'The initial cathartic character of the testimonial experience became an exercise in data extraction' (Castillejo-Cuéllar, 2007, p. 20). The work of the commission became more one of shaping 'the truth' than of collective memory retrieval. This was also a truth defined by specific acts that could be identified as human rights violations rather than more nebulous concepts of community harm. One critic of the process has observed that the interests of the nation as a whole (for political stability and an end to violence) were at odds with the interests of victims and survivors (Walasa, 2000, p. 250).

The TRC report, published in 1998, consisted of 2000 pages in five volumes (with a sixth supplementary volume published in 2003). Over 21,000 victim

statements had been received and scrutinised, and in the course of this process the commission established its definition of what constituted a victim (Ntsebeza, 2000, p. 6). The report published some of the victim narratives, often printed with editorial interpolations; essentially it told the story of the operation of the TRC, with extensive quotation to illustrate the extent, quality and nature of the human rights violations. At the time of the publication of the report, the amnesty process was incomplete.

The TRC and the archives

The South African National Archives and Records Service has extensive holdings representing the activities of the colonial and apartheid-era administrations as well as official records concerning people's resistance and acquiescence to their governors. There are large gaps in the recent records because government departments who believed that they might be subject to investigation about their activities under apartheid set about destroying their records wholesale, and continued to do so as late as 1996 (Haynes, 2001, p. 239). The TRC's report noted that

> The mass destruction of records ... has had a severe impact on South Africa's social memory. Swathes of official documentary memory, particularly around the working of the apartheid state's security apparatus, have been destroyed.

> (quoted in Haynes, 2001, p. 239)

The National Archives and Records Service worked with the TRC to identify the nature and extent of the illegal destruction of public records. It also assisted the Commission on Restitution of Land Rights with assistance and technical support in tracing records that would enable people to reclaim land and property appropriated by the apartheid state.

The TRC registered statements of human rights violations and amnesty applications, creating a database that was 'a rich repository of information about the nature, scale, locations, dates, type and consequences of human rights violations suffered by South Africans. As such it is an essential primary source of valuable historical material' whose care was given to the National Archives and Records Service who is charged with maintaining it (Truth and Reconciliation Commission of South Africa, 2003, vol. 6, section 5, ch. 7, p. 729). The database is available, but what has become of the 21,000 victims' statements themselves? In 2005, five years after the publication of the main report, there was no policy for gaining access to the records and some of them remained in the hands of the Ministry of Intelligence (Harris, 2005, pp. 180–1). The openness of the TRC proceedings has not been sustained in access to its archive. However, one of the National Archives' stated missions is to fill

these apartheid-shaped gaps in the country's social memory by actively collecting non-public records of national significance with enduring value. The charge is to document all those aspects of the nation's experiences that had been neglected, thereby supplementing the information contained in our public records.

(National Archives and Records Service of South Africa, 2008)

Through the National Oral History Programme the National Archives has solicited from the public stories of their experiences and encouraged them to participate actively in the process of forming the collective memory of the whole society (National Archives and Records Service of South Africa, 2008).

One might argue that the National Archives and Records Service of South Africa is certainly carrying out its stated mandate. The 'foremost mission of the National Archives and Records Service', to 'foster national identity and to ensure the protection of rights',

stems from the recognition that the racialised fragmentation of a South African identity and the violation of rights, which had characterised the Apartheid political system, needed to be redressed in order for a post-apartheid democratic social order to become entrenched.

(National Archives and Records Service of South Africa, 2008)

It is, however, difficult not to see the absence of the individual testimonies as an important loss of the country's heritage.

Reflecting on the case study

The National Archives and Records Service of South Africa seems to be split between assisting the claims for restitution of land and failing to preserve the records of the most important measure towards creating a unified post-apartheid society. This dichotomy reflects the ambivalence of the government towards the reconciliation process. Once again, we see the ways in which archives are bound up in notions of nationhood and national identity. In the case of post-apartheid South Africa, the preservation of the country's archival heritage has become at once a tool for reconciliation and a cover up.

The emergence of heritage and tradition as marketable commodities, and the study of how they are purveyed and of their consumers, have tended to overshadow the presence of aspects of heritage, such as archives, which have a much longer history and for which different considerations apply (Smith, L., 2006, p. 195). Governments were preserving the records of the state long before they had an interest in preserving landscape or providing incentives for people to conserve old buildings or not to export works of art. (The interest of governments in private collections of papers is very much more recent. From the late nineteenth century until the 1950s, US magnates such as

Henry E. Huntington and Henry Clay Folger were able to buy collections of family papers from penurious English aristocratic families and export them without objection.) Collections of historic documents in national archives encapsulate governments' concern with reputation and nation building but they also supply material for individuals' interest in identity.

The documents of the past are the tangible evidence of the past (both in their contents and in their physical form); the process of documentation and the institutions and professionals that support the documents, are intangible elements of heritage. Archive collections could be considered to represent the archetype of 'history' with which 'heritage' and 'memory' are contrasted (Lowenthal, 1996, pp. x, 167–9; Samuel, 1994, pp. ix–x, 3–5). But, as the examples of **subaltern** histories and family history demonstrate, national archives can provide a counter-history to that of the nation as represented by government institutions and can give individuals access to their personal past.

National archives and the AHD

Archives feature little in discussions about heritage. Despite the antiquity of many collections, the resources expended by even the poorest states, the miles of shelving and current concerns with electronic storage and retrieval, archives are surprisingly invisible. Yet they have two significant contributions to make. First, there are the collections of documents they store, the palpable materials of the past. But, second, there is also the sum of their contents, what the International Council of Archives in 1996 referred to as 'the memory of the world', often represented by particular types of building and by displays of documents (on websites or in museums) that are considered in some way to embody something about the nation. This is what Laurajane Smith identifies as 'the management and preservation/conservation process' that creates heritage (Smith, L., 2006, p. 3).

Writing about heritage is rarely concerned directly with archives except in the catch-all phrase 'museums, libraries and archives'. Articles in the *International Journal of Heritage Studies* are predominantly concerned with buildings and landscape, museums and zoos, historic sites and performance. Archives, one of the oldest recognisable forms of heritage, get scarcely a look in, perhaps because they are seen primarily as repositories of documents, the formulation of which seems unrelated to other 'official' processes of heritage preservation. Yet they are the purveyors of intangible values about nations and their past as well as contributing to citizens' ability to explore their own sense of identity. But archives are a more problematic aspect of heritage than this neglect by commentators would suggest. They may contain materials that emphasise divisions between citizens or unacceptable aspects of

the past that challenge values of national unity promoted by governments. They may be used by citizens to contest policies conducted by governments over centuries.

Smith emphasises the political control over heritage and the use of heritage places and processes to legitimise claims to identity and the experiences of marginalisation and disenfranchisement of indigenous peoples in settler societies (Smith, L., 2006, p. 281). Her use of the contrast between 'western' and 'indigenous' societies makes little sense in relation to the archival heritage of western Europe and states such as those in the subcontinent of India that had literate and sophisticated record-keeping societies for centuries. It is true that written records document the activity of elites, but it is the work of historians and citizens to use them for uncovering the hidden subaltern histories and for enfranchising the unenfranchised. It is also an act of citizenship to prevent governments from withholding the materials of the past that are less than celebratory about the past, and freedom of information legislation is only one way in which to do this.

Conclusion

The preservation of archives provides societies with the means to confront the past, but dealing with the recent past may require different methods. In Northern Ireland and South Africa there has been an explicit need, recognised by governments, to develop a means by which historic enemies can live together. In South Africa this has been done through the TRC; Northern Ireland has had no such body, though the setting up of a truth commission has been discussed. The museums sector in Northern Ireland has actively considered how to represent the Troubles and the Healing Through Remembering project, established in 2001, has been looking at ways of setting up a permanent display of the history of the Troubles (Crooke, 2005, p. 133; Healing through Remembering, 2008). At the time of writing, exhibitions continue to be temporary because of the contested nature of the events of the Troubles. But it is clear that the history of the Troubles requires community involvement and a move away from the certainties of traditional museum displays if it is to be anything other than material objects offered without interpretation. The history of black South Africans was, until recently, displayed in ethnographic not historical collections. Museums, archives and libraries have found the attempt to tell the history of the process of apartheid to be testing. Interestingly, in both countries there have been significant projects to create museums in prisons, the ultimate institutions of government control.

Works cited

13th Report of the Deputy Keeper of the Public Records, London, HMSO, 1852.

55th Report of the Deputy Keeper of the Public Records and Keeper of the State Papers in Ireland: Presented to both Houses of the Oireachtas, Dublin, Stationery Office, 1928.

Altman, J., Linkhorn, C. and Clarke, J. (2005) Land Rights and Development Reform in Remote Australia, Victoria, Oxfam Australia [online], www.oxfam.org/en/files/landrights_australia.pdf (accessed 8 March 2008).

Archives de France (2008) Historique des archives [online], www.archivesdefrance.culture.gouv.fr/archives-publiques/historique (accessed 16 February 2008).

Bercé, Y.-M. (2004) 'Préface' in Delmas, B. and Nougaret, C. (eds) *Archives et nations dans l'Europe du XIX^e siècle*, Paris, École des Chartes, pp. 5–10.

Castillejo-Cuéllar, A. (2007) 'Knowledge, experience and South Africa's scenarios of forgiveness', *Radical History Review*, no. 97 (winter), pp. 11–42.

Cocks, P. (1965) 'The development of the National Archives of New Zealand', *Journal of the Society of Archivists*, no. 3, pp. 121–6.

Comerford, R.V. (2003) *Ireland: Inventing the Nation*, London, Arnold.

Crooke, E. (2004) 'Revivalist archaeology and museum politics during the Irish Revival' in FitzSimon, B.T. and Murphy, J.H. (eds) *The Irish Revival Reappraised*, Dublin, Four Courts Press, pp. 83–93.

Crooke, E. (2005) 'Dealing with the past: museums and heritage in Northern Ireland and Cape Town, South Africa', *International Journal of Heritage Studies*, no. 11, pp. 131–42.

Dudley Edwards, R.W. and O'Dowd, M. (1985) *Sources for Early Modern Irish History, 1534–1641*, Cambridge, Cambridge University Press.

Edwards, D. (2001) 'Salvaging history: Hogan and the Irish Manuscripts Commission' in Ó Corráin, D. (ed.) *James Hogan: Revolutionary, Historian and Political Scientist*, Dublin, Four Courts Press, pp. 116–32.

Ferguson, R., Harrison, R. and Weinbren, D. (2010) 'Heritage and the recent and contemporary past' in Benton, T. (ed.) *Understanding Heritage and Memory*, Manchester, Manchester University Press/Milton Keynes, The Open University.

Ferriter, D. (2003) 'In such deadly earnest', *The Dublin Review*, no. 12 (autumn), pp. 36–64.

Gkotzaridis, Z. (2006) 'Revisionist historians and the modern Irish state: the conflict between the Advisory Committee and the Bureau of Military History 1947–66', *Irish Historical Studies*, vol. 35, no. 137, pp. 99–116.

Goldstone, Judge R. (2000) Foreword in Villa-Vicentio, C. and Werwoerd, W. (eds) *Looking Back and Reaching Forward: Reflections on the Truth and Reconciliation Commission of South Africa*, Capetown, University of Capetown Press, pp. i–xiii.

Harris, V. (2005) 'Archives, politics and justice' in Procter, M., Cook, M. and Williams, C. (eds) *Political Pressure and the Archival Record*, Chicago, Society of American Archivists, pp. 173–82.

Haynes, P.B. (2001) *Unspeakable Truths: Confronting State Terror and Atrocity*, London and New York, Routledge.

Healing Through Remembering (2008) Living Memorial Museum – Origins [online], www.healingthroughremembering.org/g_subgroups/overview_livingmm.asp?groupID=6 (accessed 24 March 2008).

Johnson, D. (2003) 'Theorising the loss of land: Griqua land claims in Southern Africa, 1874–1998' in Eng, D. and Kazanjian, D. (eds) *Loss: The Politics of Mourning*, Berkeley, University of California Press, pp. 278–99.

Lacasse, D. and Lechasseur, A. (1997) *The National Archives of Canada 1877–1997*, Historical Booklet 58, Ottawa, Canadian Historical Association.

Leland, W.G. (1912) 'The National Archives: a programme', *American Historical Review*, vol. 18, no. 1, pp. 1–28.

Levine, P. (1986) *The Amateur and the Professional: Antiquarians, Historians and Archaeologists in Victorian England*, Cambridge, Cambridge University Press.

Lowenthal, D. (1996) *The Heritage Crusade and the Spoils of History*, London, Viking.

Mac Mathúna, L. (2004) 'From manuscript to street signs via *Séadna*: the Gaelic League and the changing role of literacy in Irish 1875–1915' in FitzSimon, B.T. and Murphy, J.H. (eds) *The Irish Revival Reappraised*, Dublin, Four Courts Press, pp. 49–62.

MacCarthy, A. (2002) 'Writing twentieth century Irish history: Mutabilitie (1997)', *New Hibernia Review*, vol. 6, no. 2, pp. 65–81.

McCoy, D.R. (1985) 'The struggle to establish a National Archives in the United States' in Walch, T. (ed.) *Guardian of Heritage: Essays on the*

History of the National Archives, Washington DC, National Archives and Records Administration, pp. 1–15.

National Archives Council (1995) *A Future for Our Past: Strategic Plan for the National Archives 1996–2001*, Dublin, National Archives Council.

National Archives and Records Service of South Africa (2008) About the National Archives and Records Service of South Africa [online], www.national.archives.gov.za/ (accessed 26 March 2008).

National Archives of Bangladesh (2008) Historical Background [online], www.nanl.gov.bd/history.html (accessed 10 March 2008).

National Archives of India (2008) About us: Holdings, Public and Private [online], http://nationalarchives.nic.in/holdings.html (accessed 10 March 2008).

National Archives of Ireland (2008) Archives held in the National Archives [online], www.nationalarchives.ie/research/archives.html (accessed 3 March 2008).

National Archives of Pakistan (2008) National Archives of Pakistan [online], www.pakistan.gov.pk/divisions/ContentInfo.jsp?DivID=13&cPath= 118_124_250&ContentID=462#one (accessed 10 March 2008).

Ntsebeza, D. (2000) 'The struggle for human rights: from the UN Declaration of Human Rights to the present' in Villa-Vicentio, C. and Werwoerd, W. (eds) *Looking Back and Reaching Forward: Reflections on the Truth and Reconciliation Commission of South Africa*, Capetown, University of Capetown Press, pp. 3–13.

O'Brien, G. (2004) *Irish Governments and the Guardianship of Historical Records, 1922–1972*, Dublin, Four Courts Press.

Phelps, T.G. (2004) *Shattered Voices: Language, Violence and the Work of Truth Commissions*, Philadelphia, University of Pennsylvania Press.

Purdy, V.C. (1985) 'A temple to Clio: the National Archives building' in Walch, T. (ed) *Guardian of Heritage: Essays on the History of the National Archives*, Washington DC, National Archives and Records Administration, pp. 17–31.

Samuel, R. (1994) *Theatres of Memory: Volume 1, Past and Present in Contemporary Culture*, London and New York, Verso.

Smith, L. (2006) *Uses of Heritage*, Abingdon and New York, Routledge.

Smith, W.A. (1978) *Archives in New Zealand: A Report*, Wellington, Archives and Records Association of New Zealand.

The National Archives (2007) *Executive Agency Framework Agreement for The National Archives* [online], www.nationalarchives.gov.uk/documents/executive-agency-framework-agreement.pdf (accessed 16 April 2008).

The National Archives (2008a) *Who We Are and What We Do* [online], www.nationalarchives.gov.uk/about/default.htm?source=about (accessed 16 April 2008).

The National Archives (2008b) *Transformation at the National Archives Complete* [online], www.nationalarchives.gov.uk/news/stories/202.htm?homepage=news (accessed 8 July 2008).

Truth and Reconciliation Commission of South Africa (2003) *Truth and Reconciliation Commission of South Africa Report* [online], www.info.gov.za/otherdocs/2003/trc/ (accessed 26 March 2008).

Walasa, N. (2000) 'Insufficient healing and reparation' in Villa-Vicentio, C. and Werwoerd, W. (eds) *Looking Back and Reaching Forward: Reflections on the Truth and Reconciliation Commission of South Africa*, Capetown, University of Capetown Press, pp. 250–5.

Further reading

Bennett, T. (1995) *The Birth of the Museum: History, Theory, Politics*, London and New York, Routledge.

Flynn, K. and King, T. (2007) 'Symbolic reparation, heritage and political transition in South Africa's Eastern Cape', *International Journal of Heritage Studies*, vol. 13, no. 6, pp. 462–77.

Force, H. (2006) *Preserving Archives*, London, Facet Publishing.

Graham, P. and Howard, P. (eds) (2008) *The Ashgate Research Companion to Heritage and Identity*, Aldershot, Ashgate.

Hobsbawm, E. and Ranger, T. (eds) (1992) *The Invention of Tradition*, Cambridge, Cambridge University Press.

Kitching, C. (1996) *Archives: The Very Essence of Our Heritage,* Chichester, Phillimore.

Phelps, T.G. (2004) *Shattered Voices: Language, Violence and the Work of Truth Commissions*, Philadelphia, University of Pennsylvania Press.

Samuel, R. (1994) *Theatres of Memory: Volume 1, Past and Present in Contemporary Culture*, London and New York, Verso.

Walch, T. (ed.) (1985) *Guardian of Heritage: Essays on the History of the National Archives*, Washington DC, National Archives and Records Administration.

Chapter 4 World Heritage

Ian Donnachie

This chapter provides an overview of World Heritage, its political and cultural origins and the role of UNESCO and other agencies in identifying and listing sites. It identifies and discusses with exemplification the major conventions and protocols affecting World Heritage. It shows how World Heritage expanded from cultural to natural and other sites, as well as embracing landscapes, and intangible and industrial heritages. It provides case studies of New Lanark as industrial heritage, Bath and Edinburgh as World Heritage Cities, and the Tarragona archaeological and historical ensemble as a driver of economic change in the development of cultural tourism. It discusses many issues about World Heritage, some of which are essentially political but also affected by Eurocentric or pro-western cultural norms that are rapidly being challenged by more inclusive views and strategies designed to promote more representative heritages than the previous canon encompassed. The chapter provides an overview and description of the function of World Heritage in preparation for the examination of the ideological issues that manifest themselves in the conflict between the global, national and local objectives of heritage management discussed in Chapters 5–7.

Introduction

In Chapter 1 it was suggested that heritage has become both an 'industry' and an international institution. This chapter provides a survey of the politics, history and workings of World Heritage bodies as one of the bases for investigation and analysis in the chapters that follow.

According to Robert Hewison, heritage can mean anything you want – it can mean everything or nothing (Hewison, 1987, p. 32; see further discussion in Chapter 1). But does his critique of Britain's heritage also apply more widely to World Heritage? Partly perhaps, for investigation of this late twentieth-century phenomenon reveals a vast international bureaucracy that decides what World Heritage is and exercises huge influence over its management. Heading this, and based in Paris, is the United Nations Educational, Scientific and Cultural Organization (UNESCO) World Heritage Centre, which defines, protects and promotes cultural and natural sites, sustained in many instances by large-scale government investment. Its global reach is supported by an array of non-governmental organisations (NGOs) which are politically independent of governments but sometimes funded by them. The great majority derive their mission from UNESCO conventions and protocols to

which their respective countries (or state parties) are signatories. Laurajane Smith (2006, pp. 87–114), following Byrne ([1991] 2008) provides a review of these heritage protocols and the discourse they have promoted. World Heritage in the 1970s was seen as being defined by an essentially European, certainly western, mindset – revisions stuck closely to the original precepts, and diversification, while slow, had speeded and begun to embrace non-western and non-traditional heritages. Natural heritage seems to have been a poor runner-up in the race for **inscriptions** (discussed below), suggesting a secondary role in the World Heritage portfolio. Yet the picture is variable because in the USA, Australia and elsewhere, natural sites dominate the World Heritage List. And, if it means anything, many natural sites are on a massive scale compared with cultural sites.

In this chapter you increase your understanding of what World Heritage is: you learn more about the NGOs that delimit its activities and run it; its complex protocols and procedures; the scope of cultural, natural and intangible heritages; and the wide diversity of World Heritage sites. Three case studies explore examples of industrial heritage, World Heritage Cities and World Heritage in relation to economics. Following this chapter it should be possible to explore particular interests with a better appreciation of the processes and implications of World Heritage strategies for designation, conservation, regeneration, cultural tourism and other issues addressed elsewhere in this book.

This is a huge subject of truly global proportions. Coverage in this book is inevitably limited, and both overviews and case studies are highly selective. Indeed some elements of the world's patrimony, natural or cultural, are of such significance that they would merit inclusion on any list of wonders. Among natural features counted as World Heritage, the Great Barrier Reef off Eastern Australia (as seen in Chapter 1), the Amazonian rainforests, and human artefacts like the Great Wall of China and the Egyptian pyramids fall into this category; but of course there are many other famous sites in the world that do not quite match these in scale or perhaps even in importance. This raises immediate issues: why *World* Heritage? What is big enough or of such importance that it can be considered for inclusion, and does important mean 'biggest and best'? How is inclusion determined, and who decides what's in and what's out? Who maintains and promotes such places, landscapes or cultures, and to what political, social and economic ends? What impact do World Heritage inscriptions and related developments have on communities, indeed on regions and nations? Such questions are discussed and reviewed generally and in the case studies in this chapter.

According to the Venice Charter (ICOMOS, [1964] 1996a) (noted in Chapter 1 and discussed below), World Heritage sites are places or buildings of outstanding universal value recognised by UNESCO as constituting a World Heritage 'for whose protection it is the duty of the international community as

a whole to co-operate'. While the definition has been broadened substantially to embrace many natural and cultural sites, as Chapter 1 suggests, the original ethos and underlying precepts and protocols of the charter prevail. Moreover, as Laurajane Smith (2006, pp. 91–3, for example) indicates, World Heritage has its own vocabulary, using the discourse of international diplomacy. Much of its documentation, originating in French, takes on a mid-Atlantic flavour in English, something readily appreciated from the numerous websites dedicated to the subject. This chapter's review is confined to the major international players but there are many national, regional and local bodies whose activities can be assessed via their websites. This review draws heavily on the writer's personal experience as a historian and heritage practitioner in the UK, Australia and the USA, opinions being his own not those of heritage bodies with which he has been or continues to be associated.

The development of World Heritage

From its inception as a concept World Heritage has been integrally linked to international politics, and those who are excluded, or exclude themselves, from the moral world community have invariably been excluded from decisions about World Heritage (see further discussion in Chapter 5). After the First World War the League of Nations, established in 1920, aimed to promote peace and encourage international cooperation. It was far from inclusive, for despite the enthusiasm of President Woodrow Wilson (US president 1913–21) one of its main promoters, the USA, refused to join. Germany was excluded until 1926 and the USSR denounced it as a capitalist club until it eventually joined in 1934. Although partly undermined by such structural problems and deepening political crises, the league had some modest successes and its international agencies did much to foster internationalism. As far as heritage was concerned, under its auspices in 1931 the International Council of Museums (ICOM) promoted a congress in Athens which established basic principles for an international code of practice for the preservation and restoration of ancient buildings. The congress conclusions and the subsequent Athens Charter (ICOMOS, [1931] 1996b) reflected a growing consciousness about historic sites, and opened up the debate about conservation issues and the nature and value of international heritage. The charter set important benchmarks for future technical and moral cooperation, on the role of education and the value of documentation.

Established near the end of the Second World War to help stabilise international relations, the United Nations (UN) came into being in 1945. As the successor to the league, the UN inherited similar problems, notably the conflicting interests of the five permanent members of the Security Council – Britain, China, France, the USSR and the USA – plus the numerous issues surrounding peace keeping in a world divided by the Cold War between the

capitalist West and the Communist bloc. At the outset many countries we know today were missing from the UN but from the mid-1950s onwards, with the creation of new states, the number of members grew very considerably and the residual colonial position of the leading European powers, notably Britain and France, dwindled. This exercised considerable influence on the UN's many organs, among them the one that came to play a central role in World Heritage. Postwar reconstruction in Europe, the Far East and elsewhere was to include the rebuilding of education systems, and the organisation to facilitate and promote this, UNESCO, was also founded in 1945. The UNESCO mission statement focuses on the promotion of peace and harmony between nations and this has continued to underscore its work. Indeed, it has become one of the key 'uses' of heritage.

From the outset UNESCO also played a role in the promotion and rescue of historic sites. In Europe postwar reconstruction from 1945 to 1955 brought about the large-scale restoration of damaged cities including Dresden, Warsaw, Gdansk, Blois and Vicenza, among others. Concern at the scale of war damage was such that the Hague Convention produced in 1954 a convention on the Protection of Cultural Property in the Event of Armed Conflict, a protocol alluded to in Chapter 5 and which arguably had considerable significance for World Heritage in the longer term.

Another important trigger to further action was the international concern raised by the construction of the Aswan High Dam in Egypt, which would flood the valley containing the Abu Simbel and other temples, significant relics of ancient Egypt. In 1959, following an appeal from Egypt and Sudan, UNESCO instigated a major conservation programme which involved intensive archaeological excavations and the removal, stone by stone, of the temples that were reconstructed on higher ground above the flood line (Figure 4.1). The Aswan project cost US $80 million, half from fifty donor countries, an early indication of solidarity and nations' shared responsibility in conserving outstanding cultural sites. At the time of writing twenty-six international 'safe guarding campaigns' were devoted to saving a range of sites including Venice and its lagoon, the archaeology of Mohenjo-Daro in Pakistan, and restoring the Borobudur temple compounds in Indonesia.

These campaigns are much broader in scope than the preservation of specific World Heritage sites, being more technologically complex and often involving investment of millions of US dollars. The Venice project, dating from 1966, following UNESCO's decision to promote a campaign designed to save the city after the disastrous floods of 1965, is one of the most complex (Figure 4.2). This, as UNESCO notes, was a task requiring time, high levels of technical skill and, above all, money. But the international synergy arising from this project proved a vital inspiration both to the production of the Venice Charter and to the later **World Heritage Convention**.

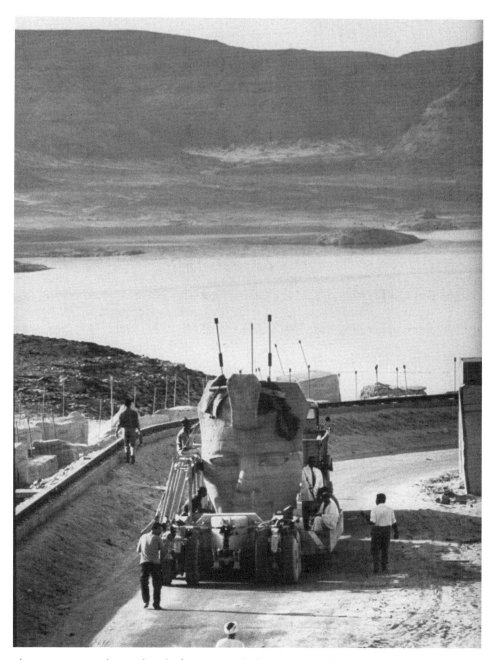

Figure 4.1 Sandstone head of Ramses II being moved to be reassembled at the new site of Abu Simbel, 1966. Photographed by Terrence Spencer. Photo: © Terrence Spencer/ Time and Life Pictures/Getty Images.

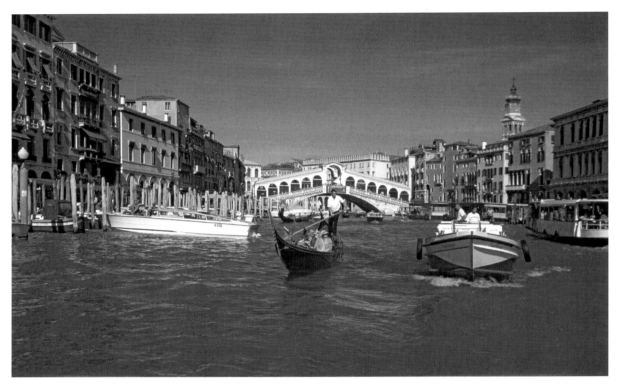

Figure 4.2 The Rialto Bridge, Venice. Unknown photographer. Photo: © Siwiak Travel/Alamy.

Venice came to be associated with the second major protocol concerning conservation, for there in 1964 an international congress of heritage experts produced the Venice Charter (see also Chapter 1). This defines internationally accepted standards of conservation relating to buildings and other sites. It emphasises the importance of authenticity and maintaining the historical and physical context of the site, and makes clear that monuments are to be conserved as historical evidence as well as cultural artefacts. It also spells out a code for restoration and preservation. While concerned mainly with buildings and cultural sites, the Venice Charter continues to be the most influential international conservation protocol.

The Venice Charter became the founding document of the International Council on Monuments and Sites (ICOMOS), another international NGO with roots going back to the First International Congress of Architects and Technicians of Historic Monuments which had produced the Athens Charter. ICOMOS, formed in 1965, assembled a network of architects, historians, landscape architects, engineers, archaeologists, geographers, town planners, anthropologists, conservators, heritage administrators and site managers to help assess sites. It was to provide evaluations of cultural and mixed

properties for inscription in the World Heritage List (see below). The Paris-based ICOMOS, assisted by a growing number of national committees, thus became a key player in World Heritage selection.

At the same time the concept of combining conservation of cultural sites with natural sites was gaining currency in the USA. In 1965 a White House conference in Washington DC called for international cooperation to protect 'the world's superb natural and scenic areas and historic sites for the present and the future of the entire world citizenry'. In 1968 another NGO, the International Union for Conservation of Nature (IUCN), which had been established with its headquarters in Switzerland, developed a similar set of proposals. Presented to a UN Conference on the Human Environment in Stockholm these proposals established international measures of protection and conservation similar to those for cultural sites.

Hence the 1972 Convention Concerning the Protection of the World Cultural and Natural Heritage (or 'World Heritage Convention') developed from the coincidence of separate movements focusing on the one hand on the preservation of cultural sites, and on the other dealing with the conservation of nature. Ultimately a single text was agreed to by all parties and the convention was adopted by the General Conference of UNESCO in November 1972. Since then all countries joining UNESCO have ratified the convention. We will examine further aspects of the convention and its operational guidelines in due course.

The Venice Charter and 'pre-convention' background are vital to an understanding of the relationship between the major heritage charters since 1964. The sheer number of different charters indicates the increasing 'governmentalisation' of heritage over the course of the late twentieth century. This is well illustrated by the graph in Figure 1.3 in Chapter 1 which demonstrates the growth in the number of heritage policy documents during the later twentieth century.

This background also helps de-code what has become politically an increasingly complex field reflected in a large international bureaucracy and a proliferation of related national organisations. On the ground there has been increasing diversification in listings, with more groupings of sites, some in quite interesting ways, like serial (or groups of similar) sites, route ways, industrial heritage, designations of heritage cities and cultural landscapes, the emergence of new heritages (such as intangible heritage), and of large-scale restoration and safeguarding campaigns.

UNESCO claims the World Heritage Convention is not just 'words on paper' but an instrument for concrete action in preserving threatened sites or endangered environments, species and, more recently, cultures.

The convention is an important document and merits close analysis, albeit briefly in this context. In short, it:

- defines the cultural and natural heritage
- calls for national and international protection of the heritage established by the World Heritage Committee (see below)
- calls on states to submit lists
- draws up a World Heritage List
- defines World Heritage in danger
- promotes international assistance, supported by state parties
- sets up a secretariat
- establishes a fund for the protection of cultural and natural heritage
- promotes educational programmes.

Hence the convention established the UNESCO World Heritage Committee, comprised of twenty-one state parties (countries) which are elected for a fixed term by the General Assembly of State Parties. A growing number of countries have ratified the convention: 184 in total by 2007. The convention has encouraged these countries to endorse its objects, and to catalogue, name and conserve sites of cultural or natural importance to the common heritage of humanity. Under certain conditions listed sites can obtain funds from the World Heritage Fund.

While these aims are highly laudable, fulfilment is potentially complex and in some contexts politically sensitive, but there are obvious benefits. The over-arching benefit is being part of a global community dedicated to conserving international cultural and natural heritage. The main rewards are: sharing a commitment to a heritage legacy; raising awareness about preservation in localities and regions; access to funding via the World Heritage Centre, especially for threatened sites (and the list of World Heritage in Danger repays investigation); development of management plans for sites and training in heritage conservation and promotion; the prestige of inscription of national sites; and economic development, especially sustainable (cultural and environmental) tourism (UNESCO, 1972; World Heritage Centre, 2005).

Once more reflecting UN political principles, there is a strong element of international cooperation and goodwill reflected here, plus the obvious influence of World Heritage accolade(s) on attracting initial funds, medium- and long-term investment, and the multiplier effect on the economy, notably through tourism. Although little of this is apparently contentious, it can be, as was the case in 1986 when President Ronald Reagan (US president 1981–9) withdrew the USA, a move interpreted at the time as a reaction to UNESCO's

anti-imperialist messages and accusations of corruption. Margaret Thatcher (UK prime minister 1979–90) followed suit with considerable implications for UK heritage accreditation. Arguably, as many heritage professionals can testify, despite its enormously rich heritage, it took the UK years to recover its influence after Tony Blair (UK prime minister 1997–2007) returned the country to the UNESCO fold in 1997.

Creating a World Heritage site

Nomination

Politics inevitably influence the complex business of nomination to the World Heritage List. While UNESCO sets universal guidelines, in reality the process varies greatly from country to country and highlights very different national priorities and selection procedures. Ironically for a 'world' listing, it is the state parties that propose the sites, so national priorities may well be in conflict with efforts to produce a representative list at a global level.

There are three stages: listing, nomination and designation or inscription. At the outset a country makes an inventory of its most important cultural, natural or other features. This is called the Tentative List and is important because according to the protocols a country cannot nominate properties that have not already been listed here. Second, it selects a site/property from this list to place in a Nomination File, with an entry that is as comprehensive as possible and prepared with the advice of the World Heritage Centre.

The next stage is the evaluation by ICOMOS and/or IUCN, which then make their recommendations to the World Heritage Committee. The committee meets once a year primarily to decide whether or not to inscribe each nominated property on the World Heritage List. Given the complexity of the process and the detailed submissions, the great majority of suggestions are approved, though the committee sometimes defers the decision to request further information or data to enhance the case.

Selection criteria

There are ten Selection Criteria that a place, object or practice of heritage needs to meet for inclusion. Until 2004 there were six criteria for cultural heritage and four for natural heritage. In 2005 this was modified to make one set of ten criteria (and also to take account of intangible heritage). Nominated sites are described as being of 'outstanding universal value' and must meet at least one of the ten criteria.

Cultural criteria

i to represent a masterpiece of human creative genius;

ii to exhibit an important interchange of human values, over a span of time or within a cultural area of the world, on developments in architecture or technology, monumental arts, town-planning or landscape design;

iii to bear a unique or at least exceptional testimony to a cultural tradition or to a civilization which is living or which has disappeared;

iv to be an outstanding example of a type of building, architectural or technological ensemble or landscape which illustrates (a) significant stage(s) in human history;

v to be an outstanding example of a traditional human settlement, land-use, or sea-use which is representative of a culture (or cultures), or human interaction with the environment especially when it has become vulnerable under the impact of irreversible change;

vi to be directly or tangibly associated with events or living traditions, with ideas, or with beliefs, with artistic and literary works of outstanding universal significance. (The Committee considers that this criterion should preferably be used in conjunction with other criteria);

Natural criteria

vii to contain superlative natural phenomena or areas of exceptional natural beauty and aesthetic importance;

viii to be outstanding examples representing major stages of earth's history, including the record of life, significant on-going geological processes in the development of landforms, or significant geomorphic or physiographic features;

ix to be outstanding examples representing significant on-going ecological and biological processes in the evolution and development of terrestrial, fresh water, coastal and marine ecosystems and communities of plants and animals;

x to contain the most important and significant natural habitats for in-site conservation of biological diversity, including those containing threatened species of outstanding universal value from the point of view of science or conservation.

<div align="right">(UNESCO, 2008a)</div>

While subsequent conventions have altered the balance, few would dispute the bias towards cultural sites/artefacts rather than natural/environmental ones, but there is an attempt to be inclusive of many human and natural phenomena. The criteria are certainly open to wide interpretation and one might well question whether fitting only one criterion is enough to justify World Heritage status.

All of this raises some interesting issues about the process, particularly how the selection for nominations is made and, indeed, by whom. According to one analyst, nomination of sites for the World Heritage List largely depends on who takes the initiative. The answer to the question of who initiates nominations differs by country, over time and according to the type of site. Differences between countries are most obvious when sites are selected at the centre, the initiative for nomination being taken at national level, often during the initial period after signing up to the convention and the construction of the Tentative List. Depending on the context, decentralised nominations sometimes replace centralised ones over time. And in general those involved in the cultural field have always been more interested and active than those in natural heritage. While this is suggestive of the view that World Heritage is primarily concerned with elite culture, in some countries (like the USA) state parks and natural or scientific sites were and remain well represented relative to cultural ones.

A recent study of World Heritage nomination (van der Aa, 2005) includes some interesting case studies of the processes in Poland, the Netherlands, Mexico, the USA, Spain and the UK which identify various patterns, including: a 'historical core' of typical sites, as in Poland; the key narrative of the 'battle against water' in the Netherlands (also specifically concentrated in the historical core of the country and dating to the Dutch 'Golden Age'); core sites of pre-Hispanic and Hispanic Mexico, centrally selected (and with belated recognition of Mexico's post-colonial heritage). In the USA a mixed 'best-judgement' list, assembled at federal level but taking account of heritage and environmental professionals at both federal and state levels, has succeeded in highlighting a wide range of representative histories, landscapes and cultures. However, it has also taken account of both the long-established and highly developed system of national parks (referred to below) and sites already on the National Register of Historic Places. In Spain the large degree of autonomy to the regions has ensured strong representation of regional identities and cultures including, in Andalusia and elsewhere, Muslim-oriented sites. Also included is one of the early 'serial sites', the pilgrim route to Santiago de Compostela that runs through five regions and was listed in 1993 (van der Aa, 2005, pp. 58–61).

The UK's approach has also been relatively decentralised, reflecting its constituent countries. In the later 1980s and into the 1990s, backed by statutory bodies like English Heritage and Historic Scotland plus numerous heritage groups and professionals, this process created a list drawn from all parts of the country but with fewer culturally distinct sites than, say, Spain. It seems that although some central responsibility was evident, it was rather a piecemeal operation involving many bodies (500 organisations and individuals were consulted in England alone) and with different working methods in each context, including bodies in Wales and Scotland

(all essentially working separately). Certainly many consultants and experts expressed their views, but the diversity of the UK's heritage made it extremely difficult to focus on anything more than the obvious, the big front-runners, Stonehenge, Westminster, Bath etc. However, the earliest listings in the 1980s comprised essentially elite selections, mainly of English sites. This changed over time to embrace industrial heritage in later listings, for example Blaenavon iron works and landscapes, the other industrial villages of New Lanark and Saltaire, and more natural features such as the spectacular Dorset and East Devon Coast. It is unclear how the list of sites in overseas territories was arrived at, perhaps another example of the essentially 'top–down' approach generally adopted (Department for Culture, Media and Sport, 1999).

Global representation

In 2009 there were 878 World Heritage sites situated in 145 State Parties (countries). Of the total, 679 are essentially cultural, 174 natural and 25 described as mixed properties. As Table 4.1 shows, UNESCO classifies countries into five geographic regions, each perhaps with shared concepts of heritage – Africa, the Arab States (North Africa and the Middle East), Asia and the Pacific (including Australia, New Zealand and Oceania), Europe and North America (USA and Canada), and Latin America and the Caribbean. Note that Russia and Caucasus countries are included in the Europe and North America region. Table 4.1 includes a breakdown of the sites according to these regions and their classification:

Table 4.1 Types of site by region (UNESCO)

Region	Cultural	Natural	Mixed	Total	%
Africa	40	33	3	76	9%
Arab States	60	4	1	65	7%
Asia and the Pacific	125	48	9	182	21%
Europe and North America	372	54	9	435	49%
Latin America and the Caribbean	82	35	3	120	14%

(Source: data from UNESCO, 2009)

Analysis of such statistics needs to take account of the way UNESCO defines its geographic regions, which inevitably skews the data. Indeed, the emphasis on administrative rather than political units makes evaluation difficult beyond the obvious. So where *are* the sites in Asia and the Pacific, Europe and North America, and elsewhere? The overwhelming dominance of Europe and North America, with nearly half the sites, suggests the developed world has been

highly proactive with regard to World Heritage and been suitably rewarded by UNESCO. Second, the prominence of cultural sites, more than three-quarters of the total, is clear, and raises pretty obvious questions about the balance between cultural and natural heritage in the World Heritage portfolio. And it suggests very different views about what constitutes World Heritage in different parts of the globe.

A wider vision? Global strategy

The global and typological distribution of World Heritage sites revealed by these data was historically even more biased than at present. But they also suggest that the initiative launched by the World Heritage Centre in 1994 to promote a global strategy for a more balanced, representative and credible World Heritage List has been at least partially successful. By the early 1990s it had become obvious that despite more than twenty years of work World Heritage lacked balance in the types of property and the geographical areas represented. Of 410 registered sites, 304 were cultural only 90 natural and 16 mixed, the great majority in developed regions of the globe, notably Europe.

It is worth examining this 1994 résumé of UNESCO global strategy, asking three questions as we do so. What were the key objectives of the strategy? Why were they regarded as necessary? What was the outcome?

The objectives of the Global Strategy
By adopting the Global Strategy, the World Heritage Committee wanted to broaden the definition of World Heritage to better reflect the full spectrum of our world's cultural and natural treasures and to provide a comprehensive framework and operational methodology for implementing the World Heritage Convention.

This new vision goes beyond the narrow definitions of heritage and strives to recognise and protect sites that are outstanding demonstrations of human coexistence with the land as well as human interactions, cultural coexistence, spirituality and creative expression.

Crucial to the Global Strategy are efforts to encourage countries to become States Parties to the Convention, to prepare Tentative Lists and to prepare nominations of properties from categories and regions currently not well-represented on the World Heritage List.

Analysis
A global study carried out by ICOMOS from 1987 to 1993 revealed that Europe, historic towns and religious monuments, Christianity, historical periods and 'elitist' architecture (in relation to vernacular) were all over-represented on the World Heritage List; whereas, all living cultures, and especially 'traditional cultures', were under-represented.

At its 28th session in 2004, the World Heritage Committee reviewed more recent analysis of the World Heritage List and the Tentative Lists prepared by ICOMOS and IUCN. Both analyses were carried out on regional, chronological, geographical and thematic bases in order to evaluate the progress of the Global Strategy.

ICOMOS's study found that the reasons for the gaps in the World Heritage List fall into two main categories:

Structural – relating to the World Heritage nomination process, and to managing and protecting cultural properties; and qualitative – relating to the way properties are identified, assessed and evaluated.

IUCN's study pointed out that the natural and mixed sites currently inscribed on the World Heritage List cover almost all regions and habitats of the world with a relatively balanced distribution. However, there are still major gaps in the World Heritage List for natural areas such as: tropical/temperate grasslands, savannas, lake systems, tundra and polar systems, and cold winter deserts.

On-going efforts
Since the launching of the Global Strategy, 39 new countries have ratified the World Heritage Convention, many from small Pacific Island States, Eastern Europe, Africa and Arab States.

The number of countries around the globe that have signed the World Heritage Convention in the course of the last ten years has risen from 139 to 178. The number of States Parties who have submitted Tentative Lists complying with the format established by the Committee has grown from 33 to 132. New categories for World Heritage sites have also been promoted, such as the categories of cultural landscapes, itineraries, industrial heritage, deserts, coastal-marine and small-island sites.

Important conferences and thematic studies aimed at implementing the Global Strategy have been held in Africa, the Pacific and Andean sub-regions, the Arab and Caribbean regions, central Asia and south-east Asia. These well-focused studies have become important guides for the implementation of the World Heritage Convention in these regions.

In an effort to further enhance the under-represented categories of sites and improve geographical coverage, the World Heritage Committee has recently decided to limit the number of nominations that can be presented by each State Party and the number of nominations it will review during its session.

> The World Heritage Committee works in co-operation with every State Party to the World Heritage Convention as well as its three Advisory Bodies: ICOMOS, IUCN and ICCROM [International Centre for the Study of the Preservation and Restoration of Cultural Property], in order to make greater strides in diversifying the World Heritage List and make it truly balanced and representative of the world's heritage.
>
> (UNESCO, 1994)

The most important aims were seen as broadening the definitions of World Heritage, encouraging other countries to sign up, prepare lists or make nominations, especially of categories and regions poorly represented. These steps were obviously necessary because the list was dominated by the European 'canon' of (mainly) cultural sites. In contradistinction to the 'canon' the strategy advocated a more 'representative sample' of heritage sites on the list, improved geographical coverage and the promotion of new heritages. The two advisory NGOs, ICOMOS and IUCN, noted structural and qualitative problems, and the latter also saw major gaps, in particular types of natural environments that remained unrepresented. The outcome was that more countries signed up to the convention, helping the process of diversification.

This suggests much greater diversity in heritages – greater inclusion – but not necessarily a significant move away from essentially elite culture dominated by the European mind set – or at least that of the developed world. But it is obviously a slow process of change, not helped, even the international heritage professionals recognise, by the mountain of bureaucracy World Heritage represents.

Having examined something of the structures and processes in the development of World Heritage we move on to look at various types of heritage backed up with some case studies.

Types of heritage

Natural heritage: large and small

With 174 natural and 25 'mixed' sites out of 878 (in 2009), natural heritage is rather under-represented in the portfolio of World Heritage, at least if raw data are taken as a measure. While the scale and environmental or scientific qualities of many natural sites are such that it is difficult to say whether we are comparing like with like, there are other explanations for the imbalance. The first, it will be recalled, is the relative under-representation of natural heritage specialists on international NGOs; the second, that some countries have a long tradition of national parks or **reserves** along with legislative frameworks for environmental conservation, sometimes enacted long before it began to be

addressed as a serious global issue. In some ways it is therefore surprising that natural sites are so well represented in the USA (and Canada), though in both contexts cultural sites were certainly less prominent than in Europe. In the USA, where national parks were pioneered by a Scot, John Muir, the justifications are highly nationalistic, as the following statement shows:

> For those who seek to grasp the spirit of the nation and understand the vast array of disparate elements that is America, there is no better teacher than the U.S. National Park System. This is one of the country's most valuable inheritances, held in trust for the citizens of the United States and nurtured for enjoyment by future generations.

> **National Pride, Global Significance**
> Through the national parks, the United States preserves its natural, cultural and historic heritage and offers to the world a window on the American experience. It also acts as steward to resources invaluable to the world.

> The secretary of the interior, through the National Park Service, is responsible for identifying and nominating U.S. sites to the World Heritage list. Currently, there are 20 World Heritage sites in the United States, including two sites jointly administered with Canada. Among the U.S. preserves judged important to the entire world are Yosemite, Yellowstone, the Grand Canyon, the Great Smoky Mountains and the Everglades.

> In these and other wild places of North America, the U.S. National Park Service labours to carry forward naturalist John Muir's dream, as expressed in 1901, to preserve 'the beauty, grandeur, and all-embracing usefulness of our wild mountain forest reservations and parks, with a view to inciting the people to come and enjoy them, and get them into their hearts'.

> (Bureau of International Information Programs, US Department of State, 2006)

While the political message is essentially subverted there is a strong emphasis, as one would expect, on the 'spirit of the nation' and preserving national identity, though quite where the Indigenous Americans (many displaced from their lands, including the national parks) fit in is not mentioned. As Harrison (2008) points out, settler colonies like the USA needed to emphasise the distance between natural and cultural heritage to promote the idea of 'wilderness' – a blank, apparently unoccupied country which apart from the politics would justify the historical and moral position of occupation.

The past too can be made to seem like a blank canvas, but with that said the parks are held in trust for the future and the authorities see themselves as custodians of nature on the grand scale. The wild, as Muir envisaged, is to be

enjoyed by all; and there is an obligation on the National Park Service to promote his precepts. Certainly the national parks are well managed, attract large numbers and their contribution to the tourist economy in the USA is known to be substantial.

Elsewhere, for example in Asia or South America, are sites that cover vast areas, and consequently issues of protection, conservation and management which they share with cultural heritage are often more complex and, in crossing boundaries, are both highly political and genuinely transnational in scale.

The scale and ethos of natural heritage conservation in the UK may be rather different, but it does share many of these problems in microcosm, as can be appreciated from the case of the Dorset and East Devon Coast, a World Heritage site since 2001 (Figure 4.3). This site comprises more than 200 miles of undeveloped coastline and countryside, with cliff exposures and rock formations of international geological significance. Its status has had a number of valuable outcomes. First, it has raised awareness internationally, regionally, nationally and locally, generating enthusiasm and pride in the community, which in turn has brought together other sectors in support of initiatives.

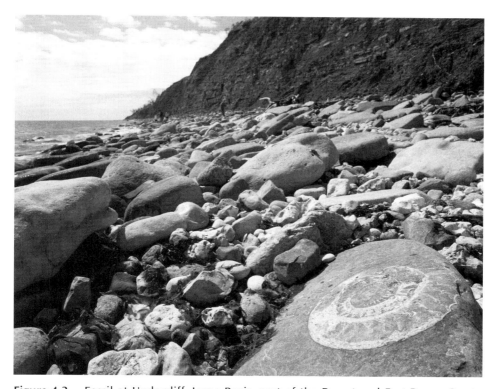

Figure 4.3 Fossil at Undercliff, Lyme Regis, part of the Dorset and East Devon Coast World Heritage site. Photographed by David Noble. Photo: © David Noble Photography/Alamy.

Second, it has helped protect the site by limiting planning applications for inappropriate development. Third, it has encouraged enhanced funding to manage the site, improve transport and develop tourist potential. The spin-offs have been extensive and are thought to have contributed greatly to the local economy, mainly through the large numbers of visitors attracted to the site.

Cultural landscapes

It is appropriate at this point to refer to another interesting concept in the World Heritage portfolio, the cultural landscape, which was influenced significantly by the long tradition of European landscape painting. A great variety of landscapes can be identified with distinctive regions of the earth. Invariably they combine a natural environment modified over the ages by humans, and they have become significant and often politically sensitive because they reflect specific techniques of land use that sustain biological diversity and are under threat from inappropriate development or climate change. Moreover, they are often associated with intangible heritages unique to the communities who live there; examples are religious beliefs, and artistic and traditional customs, perhaps reflecting the spiritual relationship of people with their environment.

In UNESCO's view 'cultural landscape' embraces a diversity of interactions between humankind and its natural environment (see also West and Ndlovu, 2010). Cultural landscapes often reflect specific techniques of sustainable land use that take into consideration the characteristics and limits of the natural environment in which they are established, and a specific spiritual relation to nature. Protection of cultural landscapes can contribute to modern techniques of sustainable land use and can maintain or enhance natural values in the landscape. The continued existence of traditional forms of land use supports biological diversity in many regions of the world.

Three main types of cultural landscape can be identified, the first being the 'intentional' landscape, that is, one designed and created by human intervention. These landscapes include gardens and park landscapes constructed for aesthetic reasons and sometimes associated with religious or other monumental buildings and ensembles. The second is the organically evolved landscape that may have developed for social, economic, administrative and/or religious reasons but that still retains a close relationship to its natural environment. Such landscapes reflect this process of evolution in their form and component features. Two interesting sub-groups merit attention: there is the 'relic' (or fossil) landscape, where an evolutionary process came to an end at some point in the past, either abruptly or over a period. Its significant distinguishing features are, however, still visible in material form. The other sub-group is the 'continuing' landscape, where an active social role in contemporary society is closely associated with traditional ways of life but where the evolutionary process is still underway (though this

may actually fail to preserve the landscape itself). At the same time this landscape exhibits significant material evidence of its evolution over time. The third main type of cultural landscape is described as the 'associative cultural landscape', where significance arises from strong religious, artistic or cultural associations of the natural element rather than from tangible cultural evidence which may be limited or indeed totally absent.

Politics is an important sub-text in examples which indicate the association of landscape heritage with specifically religious rights among tribal peoples. Two of the earliest cultural landscape designations are in the Australasian region: the Tongariro National Park in New Zealand and the Uluru-Kata Tjuta National Park in Australia (Figure 4.4), both essentially spiritual sites. Tongariro, inscribed in 1993, is an area of dramatic landscapes with active and extinct volcanoes and diverse natural environments. At the heart of the park are mountains with strong religious and cultural significance to the Māori people, a feature shared with Uluru, the immense monolith that dominates the vast sandy plains of Central Australia and is linked to belief systems. Clearly these are complex sites, tangible on the ground but at the same time linked to the imaginative and spiritual vitality of their peoples. In such cases cultural

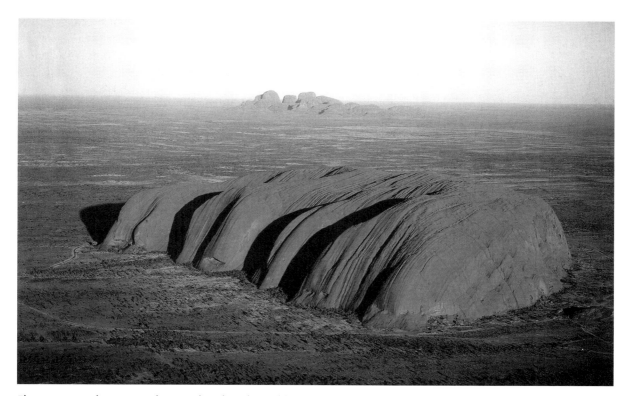

Figure 4.4 Uluru-Kata Tjuta National Park World Heritage site, central Australia. Photographed by David Ball. Photo: © David Ball/Alamy.

landscapes have close associations with the intangible heritage of the peoples involved. And although these examples are no longer under threat from inappropriate development, many others elsewhere are not in such a favourable position, particularly where political decisions often affect resource exploitation for minerals or timber.

Intangible heritage

'The ICH is traditional and living at the same time.'

(UNESCO, 2008b)

This brings us to another category, the 'non-material' intangible cultural heritage (ICH), which recognises the importance of living heritage, cultural diversity and its maintenance for the future as 'a guarantee for continuing creativity'. It came about because of criticism from countries with significant oral, folklore and other cultural traditions where indigenous people thought the list dominated by built or material heritage. According to the 2003 Convention for the Safeguarding of Intangible Cultural Heritage, it is seen in what UNESCO describes as the following 'domains':

- oral traditions and expressions including language as a vehicle of the intangible cultural heritage
- performing arts (such as traditional music, dance and theatre)
- social practices, rituals and festive events
- knowledge and practices concerning nature and the universe
- traditional craftsmanship.

(UNESCO, 2008b)

Such heritage can be seen in the practices, representatives, expression, knowledge and skills that committees, groups and individuals define as part of their cultural heritage. Perhaps rather optimistically UNESCO sees ICH being transmitted from generation to generation, repeated in response to environment, the nature of its history, promoting identity and continuity, respecting cultural diversity and human creativity (as well as human rights), and promoting respect and sustainable development among communities.

Much is transmitted orally and practised collectively, and tradition bearers often have important roles. The open-ended nature of ICH means it is often the most endangered component in World Heritage due to globalisation and the relative lack of interest among the young, language being a prime example. Moreover, ICH is not necessarily fixed to specific communities, groups or individuals, because it can switch from one context to another. All of this raises significant issues as to what ICH actually is and how representative examples can be, but nevertheless several significant initiatives have been undertaken including listings, identifying ICH requiring 'urgent

safeguarding' and a number of projects mainly focused on developing countries. Beyond these, steps to identify Masterpieces of the Oral and Intangible Heritage of Humanity got underway following a proclamation at the UNESCO General Conference in 1997 (see Harrison and Rose, 2010). Between 2001 and 2005, ninety outstanding examples of ICH were identified, including a wide range of phenomena similar to those described above.

One domain that has attracted particular attention is the safeguarding of endangered languages. This programme revealed some staggering and damning statistics about languages as tools of communication and views of the world. About 50 per cent of the world's 6700 languages are in danger of disappearing. Moreover 96 per cent of the languages are spoken by 4 per cent of the global population; one language disappears every two weeks and 80 per cent of African languages have no orthography. UNESCO's Intangible Heritage division supports an Endangered Languages Programme which aims to promote and protect linguistic diversity by such activities as assessing the extent of endangerment, raising awareness about the issues through publications and events, promoting community-based safeguarding projects particularly in Sub-Sahara Africa, and identifying good practice for the preservation of threatened languages and related cultures. A convention similar to that for cultural and natural heritages became operational in 2000.

Some work has also been done in developed countries where older and increasingly marginalised languages have been swamped by majority cultures. These cultures are being promoted in a whole range of contexts, the Celtic languages being an interesting case, seen, for example, in Brittany, Galicia, Cornwall, the Isle of Man, and the Scottish Highlands and Islands. In the last, the Scottish government has supported a project led by the Scottish Museums Council to assess the scope of ICH in Scotland, in particular the position of Gaelic language and culture, which is undergoing a revival.

Defining ICH is no easy matter; like serial and linear sites, it is transnational, and crosses political boundaries, cultures, kin groups and languages. It embraces a wide range of social practices, popular cultures and skills of many kinds. It is also dynamic, and though it derives much from the past (as do most other heritages), it is 'living' heritage. Hence, its vibrancy in many contexts needs to be contrasted with decline in others, raising many problems of record, preservation and promotion.

Other heritage categories

Other items from the growing World Heritage portfolio merit brief discussion. Diversification beyond major cultural and natural sites has resulted in some interesting permutations, such as linear features or ensembles of sites linked in different ways. Best known perhaps is the Camino de Santiago, the Pilgrim

Way to Santiago de Campostela in Galicia, north-west Spain. The old city itself is a remarkable ensemble of Baroque cathedral, churches and civic buildings, designated a World Heritage site in 1985 and the object of a major conservation effort since (Figure 4.5). Described as 'a journey of the soul and spirit', the Pilgrim Way, also known as St James's Way, is in fact several different trails along ancient route ways in France and Spain that all lead to the supposed shrine of St James in Santiago. Here the body of the fisherman and apostle is believed to have been laid to rest in the eighth century. The origins of the route date back to the time when Christian pilgrims, some from distant parts of Europe, would set off to visit and pray at the saint's final resting place. It is one of the most important pilgrimages beyond those of Rome and Jerusalem and still attracts thousands each year to add to recreational walkers. The route is marked with a scallop shell, the symbol of the saint, and the way was declared a European Cultural Route in 1987 and a World Heritage site in 1993.

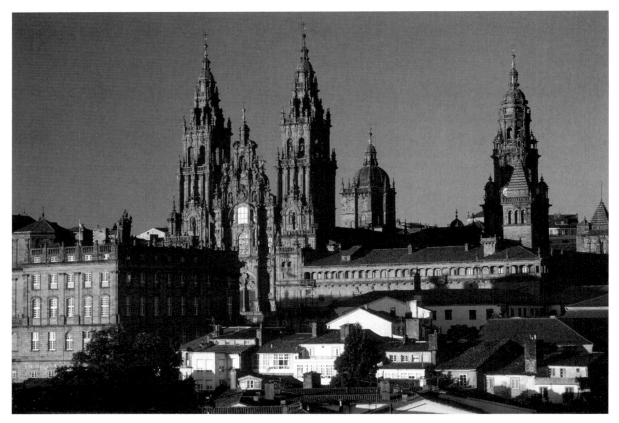

Figure 4.5 The cathedral, Santiago de Compostela. Photographed by David A. Barnes. Photo: © David A. Barnes/Alamy. The cathedral of Santiago de Compostela is a massive exercise in various architectural styles and forms the focus of the World Heritage site.

In sharp contrast perhaps, railways also fall into this category, prime examples being the mountain railways of India, first designated in 1999 and by extension again in 2005. The 'site' includes the famous Darjeeling mountain railway and now incorporates the Nilgiri line in Tamil Nadu state, another remarkable legacy of the colonial era constructed 1891–1908 and still fully operational.

A sub-set is what one consultant planner has described as 'boundaries heritage', which might be linked to cultural or historical landscapes encroached on by others, say through invasion. An interesting example is the initiative by the World Heritage Centre to define and promote the frontiers of the Roman empire transnationally across the Upper German-Raetian Limes and, in the UK, Hadrian's Wall in northern England and the Antonine Wall (listed 2008), linking the Forth and Clyde in Central Scotland. Making excellent walking routes, all three incorporate important archaeological features such as forts, camps and civil settlements (often themselves linked by Roman roads or other historic routes).

Case study: industrial heritage in New Lanark, Scotland

To counter the claims of some that World Heritage is mainly concerned with ancient civilisations and the heritage of dominant elites, World Heritage has also embraced objects, places and practices more closely identified with ordinary people living and working in an industrial world rather than earlier times. Although the famous Wieliczka salt mine in Poland, inscribed in 1978, was the only industrial World Heritage site until the listing of Ironbridge in 1986, the years since have seen a growth in the numbers of such sites internationally. Among them is New Lanark, a former cotton mill, which has inspired me since boyhood. Industrial heritage has its critics, most famously in the UK where Hewison (1987, especially pp. 41–7) explained its growth as a phenomenon reflecting past industrial and technical achievements in a climate of contracting manufacture and economic decline. Its rise, he thought, was partly a response to misplaced nostalgia for working-class life in communities undergoing rapid change and in some cases a response to the cataclysmic decline in heavy industries such as mining and metallurgy.

Despite the critique, and long before Hewison disseminated his ideas, I believed that the 'gilt on the gingerbread approach' to heritage needed revision and became involved in the promotion of industrial heritage in the UK, Australia and elsewhere. As co-editor of a journal devoted to industrial archaeology and history I came into contact with many practitioners committed to broadening the scope of heritage and over the years since have been involved with the team working on the restoration and promotion of New Lanark, one of a clutch of sites inscribed in 2000–1 (Historic Scotland,

2000). Its story illustrates the long-term trajectory that is often required to see such large-scale projects through to a successful conclusion. Even then, issues remain as to how such sites can be managed in future.

At first sight New Lanark looks like a piece of the early industrial revolution frozen in time, but its importance extends beyond the obvious to include important associations with Robert Owen, the social reformer, who used it as a test bed for his ideas (Figures 4.6 and 4.7). Moreover it is located near the Falls of Clyde, like the English Lakes, a major attraction for romantic tourists during the eighteenth and early nineteenth centuries (Donnachie, 2004). The mills, begun in 1785 by David Dale, a prominent Scottish business man, became the largest of their kind for the period, with a workforce of over 2000. The adjacent village, built into the valley sides, provided housing and other facilities for the workers, many recruited from the Scottish Highlands or the cities. Dale was widely celebrated for his philanthropy, particularly in his treatment of child apprentices recruited to work in his mills. While large factories with paternalistic regimes were unusual, New Lanark was already attracting large numbers of visitors, presumably reform-minded, including many from overseas.

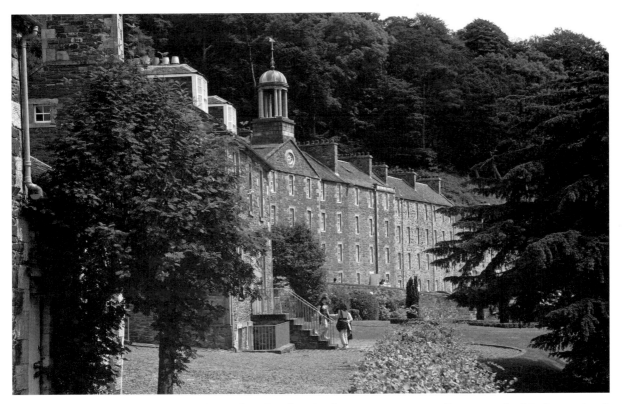

Figure 4.6 New Lanark World Heritage site, showing the former Owen House (foreground) with the workers' housing beyond. Photographed by Findlay. Photo: © Findlay/Alamy.

In 1799 Dale sold the mills to a Manchester firm and Owen, a youthful but successful entrepreneur, became manager. He introduced a raft of workplace and community reforms aimed at improving efficiency, raising productivity, and improving the environment and social conditions. By 1812 he was promoting popular education, in particular 'character formation' which would be a basis for social reform. His ideas found expression in his essay 'A New View of Society' (Owen, 2004) which proposed education as a means of improvement for the working classes, exemplified from his experience at New Lanark, and suggested a plan of social regeneration with national, indeed international, application. In the troubled times following the end of the Napoleonic War these ideas proved attractive to elites who felt threatened by disorder, and after 1817, apparently Owen's 'millennial moment', he was describing an ambitious plan for 'Villages of Unity and Mutual Co-operation' as the basis for social recovery. In 1816 he opened his Institute for the Formation of Character, followed thereafter by a school. He also played a prominent role in factory reform. This frenzied activity and widespread propaganda made Owen famous and thousands descended on his community, though in declining numbers after 1825 when he quit

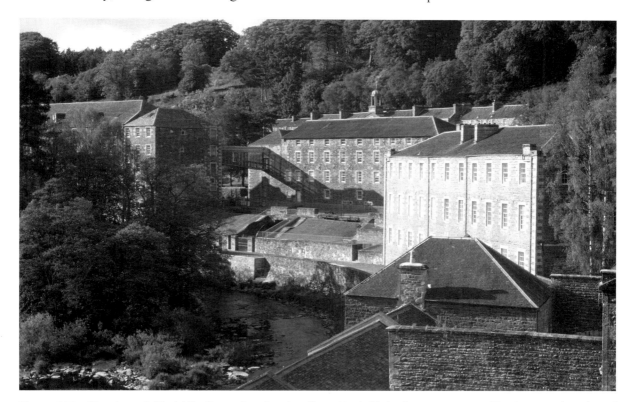

Figure 4.7 New Lanark World Heritage site, showing (from the left) the former cotton mills, the rear elevation of Owen's Institute, and Owen's School for Children. Unknown photographer. Photo: © South West Images Scotland/ Alamy.

New Lanark for another community experiment in the USA (Donnachie, 2004). Owen was always controversial, partly because of his attacks on sectarianism, which he saw as undermining his 'New Moral World' and the promotion of community and cooperation instead of competition. After 1830 the man became a movement with numerous Owenite organisations dedicated to advancing his ideas. In the end Owen made little headway, but his followers proved highly influential in almost every popular reform movement of the nineteenth century including the campaign for compulsory education.

For more than a century after Owen's death in 1858 people were attracted to New Lanark, which was seen as an icon for his ideas on industrial relations, corporate philanthropy, cooperation and social reform. Among the visitors were many from the USA and Japan, which helped maintain the profile of the place and may even have been an inducement to the owners to keep the village in a reasonable state of repair. Although the company and the local authorities were well aware of the village's history, the challenge of refurbishment was beyond their resources. When the factory ultimately closed in 1968, the decay was rapid, though a housing association had started to modernise some of the workers' housing and in 1971 gained a Civic Trust Award for this work and the first formal recognition of the village's architectural importance. Unfortunately, as is often the case, an unsympathetic industry, in this case scrap metal extraction, moved in on the mills and the threat to their future was soon obvious. The turning point came in 1973–4 with the establishment of the New Lanark Conservation Trust, which thanks to local and national support acquired the mills and began the painstaking task of restoration. New Lanark, like many other heritage projects of the period, became a significant player in employment creation, with a major multiplier effect on the local economy.

Work began on the housing, with a mix of rented apartments controlled by the housing association and other tenement blocks restored by private owners to designated plans drawn up by the conservation trust. The communal buildings, including Owen's Institute and School for Children were then restored, while the mills were converted to offices with large areas devoted to a museum and interpretation facilities. In the centre of the village, several of the rooms in Owen's house were restored in period fashion. The basement contains an interpretation devoted to his community experiment at New Harmony in the USA and later ventures in Owenism. Across the street a tenement house was left with its original fittings to display the contrasting living conditions of a typical mill family. The company store was retained to emphasise Owen's concern for fair trade, connection to consumer cooperation and use of profits for the school. The first of Dale's mills, Mill No. 1, was converted to a hotel, which ultimately boasted a conference centre and comprehensive leisure facilities, while a youth hostel opened in one of the tenement blocks at the southern end of the village. A turbine that drove the

machinery in the mills now powers the whole complex and New Lanark is also a net exporter to the national grid. Latterly the trust was assisted by European and Heritage Lottery funding and the Scottish government.

A World Heritage nomination was put forward in 1986 and after a gap of many years (being included in the Tentative List of 1999) the site was inscribed in 2001 (Historic Scotland, 2000). First Minister for Scotland Donald Dewar believed New Lanark had waited too long, and was instrumental in successfully promoting its case. The restoration of the mills and village was thus a long-term project of over 40 years' duration but it has brought enormous benefits (Arnold, 2000; Donnachie and Hewitt, 1999). Revitalisation has had a major impact on the local community and region with Lanark itself the object of building restorations and streetscape schemes, major housing projects, a new green-field agricultural market and the inevitable retail parks. The new developments have, however, put a major strain on infrastructure, notably access roads and other utilities. Some think that New Lanark has received too much attention and investment at the expense of other local projects, a common problem it seems when professionals move in on heritage sites.

Last, although New Lanark does not suffer from the 'pain and shame' of 'difficult heritage', it presents interesting problems of interpretation largely arising from the controversies surrounding Robert Owen. While these are more about history than heritage, they present interesting issues. How and why was a successful capitalist and corporate philanthropist reinvented as the 'Father of Socialism' and what part did New Lanark play in the story? Some of the answers are to be found in the place itself, which beyond interpretation presents many issues of site policy and management common to such monuments.

Reflecting on the case study

New Lanark has been an enormous success and has gained many plaudits and awards for the long-term commitment of its trust and management to restoration. At the time of writing it attracts 350,000 or more visitors per annum, approximately a quarter paying for entry to its attractions. The hotel, conference centre and other facilities are also very successful, and there is a vigorous programme of cultural and other events. There is a strong relationship with bodies promoting the splendid environment and natural history, notably the Scottish Wildlife Trust, which has a visitor centre in the village. New Lanark strikes an interesting balance in the way it presents itself, from its ideological links to workers' welfare, socialism and the cooperative movement on the one hand, to management psychology and corporate philanthropy on the other. The associations with Robert Owen give

New Lanark a unique dimension since interest in his ideas on industrial relations, education, welfare, cooperation, citizenship and environment have resonance with modern global problems. Indeed, Owen and New Lanark seem to transcend the political divide for this very reason. But with that said, New Lanark presents a range of issues about management and interpretation typical of industrial heritage everywhere.

A further interesting spin-off from World Heritage is the World Heritage City, the earliest designations including Kracow (Poland), Quito (Ecuador), Monastir (Tunisia) and Stockholm (Sweden) in 1978. Subsequent designations have created a list of 242 (at the time of writing), of which more than half are located in Europe and North America. Another international organisation set up to service and promote these cities (independent of UNESCO), the Organization of World Heritage Cities (OWHC), is based in Quebec, Canada. Some of these cities are less familiar than others and it would be interesting to know how they made it on to the list (Organization of World Heritage Cities, 2008). Bath and Edinburgh, splendid Georgian creations, have remarkable architectural heritages of that period as well as histories of importance pre-dating the 1700s by many centuries. Together they provide useful examples of heritage cities and the issues they raise.

Case study: World Heritage Cities in Bath and Old and New Towns of Edinburgh

Bath has been a World Heritage site since 1987, recognised as a place of outstanding universal value for its ensemble of architecture, town planning, landscape, archaeological remains and its interesting social history as a place of resort. The history of the place extends over 2000 years, and consequently Bath displays a fascinating array of remains including archaeological evidence of pre-Roman use of the hot springs and the Roman spa itself (Figure 4.8), medieval relics, the impressive Georgian city, civic buildings, parks, gardens and streetscapes. More recent heritage includes Brunel's Great Western Railway with its station buildings and structures, all situated in a magnificent natural landscape. The history of the city is presented and interpreted through a range of museums and galleries devoted to specific aspects of the city's past, including a Georgian house given over to a museum celebrating the life and times of Jane Austen, one-time resident of the city in its heyday as a place of fashionable resort. (Incongruously Austen had mixed feelings about Bath, though it features prominently in several of her novels.)

Like Edinburgh, as a heritage city Bath is clearly a major cultural and economic asset, with a population of 84,000 people: it is a significant regional centre for employment, shopping, entertainment and education. As an international tourist destination, it attracts nearly 4 million visitors per annum,

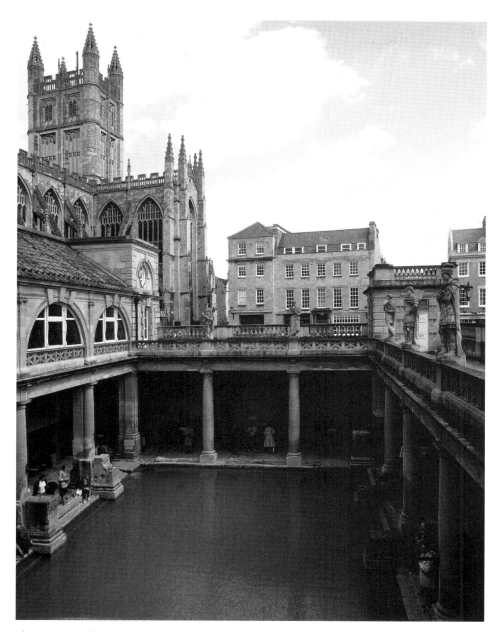

Figure 4.8 The Roman Baths, City of Bath World Heritage City. Unknown photographer. Photo: © Travelshots.com/Alamy.

emphasising the close relationship between the heritage and the success of the modern city. The spa, object of a multimillion pound re-development, continues in use for health and leisure. Maintaining economic performance and vibrancy in the community is seen by the local authorities as essential for the long-term protection of the city's heritage, which in its turn gives

Bath a unique and much-celebrated character. How this is to be sustained in the future is explained in the management plan, briefly summarised as follows:

> The Management Plan aims to provide a framework to conserve the cultural heritage assets of the World Heritage Site of Bath. This wide remit includes protection and enhancement of the architectural, archaeological, landscape and natural assets and their urban and landscape settings, improving understanding of the site, its interpretation and use as an educational resource, and supporting the local community in its cultural, social and economic vitality.
>
> The plan will outline the main issues that challenge the World Heritage Site and the potential opportunities of that status. These issues will be addressed through a series of objectives and actions, specifically intended to fulfil the main aims of the plan. These are:
>
> - Promote sustainable management of the World Heritage Site;
> - Ensure that the unique qualities and outstanding universal values of the World Heritage Site are understood and are sustained in the future;
> - Sustain the outstanding universal values of the World Heritage Site whilst maintaining and promoting Bath as a living and working city which benefits from the status of the World Heritage Site;
> - Improve physical access and interpretation, encouraging all people to enjoy and understand the World Heritage Site;
> - Improve public awareness of and interest and involvement in the heritage of Bath, achieving a common local, national and international ownership of World Heritage Site Management.
>
> (Bath and North East Somerset Council, 2008)

This wide remit emphasises the problems of managing complex heritage sites – particularly the balancing of conservation and development, which is especially challenging in the urban context and evidently an ongoing issue in the city.

The Old and New Towns of Edinburgh site (Figure 4.9) faces similar dilemmas and its website is enlightening in this regard. It seems there are many points of comparison, at least in statements that recognise the challenges and threats, and set out policies to preserve and enhance the site. The plan, like that of Bath, identifies key features, like the unique setting overlooking the Firth of Forth, a dramatic castle perched above the city centre, the contrasting architecture of the medieval Old Town and Georgian New Town, and the history and heritage of Scotland's ancient capital. Challenges and

opportunities abound, for example raising funds for restoration of buildings with diverse functions throughout the designated area, the need to promote the use of traditional materials that are becoming very hard to obtain, and the constant threats arising from inappropriate development. Edinburgh World Heritage has also had to balance the needs of conservation in the New Town with those of the Old Town, which before the eighteenth-century expansion constituted the core of the city. There the Royal Mile links the Castle on its rock with the Palace and Abbey of Holyrood at its foot, now also the location of the Scottish Parliament. After many decades of decay preservation has been a priority for an area that is a major tourist magnet in a tourist city. But the plan is not only about preservation, it is also about promoting Edinburgh as a 'thriving, dynamic, economically successful city'. We might finally note that the plan is supported by a wide range of bodies including the Scottish government, the City of Edinburgh Council, Historic Scotland and various enterprise agencies. What happens in Edinburgh is of considerable consequence politically, and developments there, particularly in terms of policy and the funding of heritage projects, are watched with interest throughout Scotland (Edinburgh World Heritage, 2008; Rodwell, 2007).

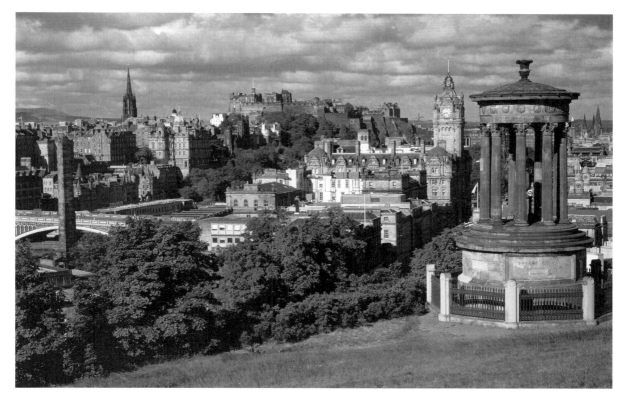

Figure 4.9 The Old Town of Edinburgh (left), linked by North Bridge to the eighteenth-century planned New Town (right). Unknown photographer. Photo: © World Pictures/Alamy.

Reflecting on the case study

Would Bath and Edinburgh ever be anything other than highly attractive places, since they have been attracting visitors for several centuries in modern times and were significant places from antiquity? What benefits has World Heritage status brought that would not have been promoted in the usual course of events? Some injudicious developments, notably shopping complexes, have been allowed in both places, though World Heritage status has perhaps prevented the worst excesses. In reality it is very difficult to see how such complex sites can be managed because of the competing interests of conservation and development (Rodwell, 2007).

In both instances there are also interesting issues of interpretation of the ways in which elite culture was promoted and sustained historically by the middle and upper classes at the expense of the labouring classes in these cities, with large numbers employed in construction, shop work, domestic and other services. In Bath's interpretation the army of servants found above and below stairs in the great resort era seems to be essentially subverted in favour of elites. Edinburgh presents an interesting juxtaposition of the formerly poverty-stricken Old Town tenements with the fine Georgian terraces of the New Town to the north. And while much is made of the Scottish capital's ancient history (especially at the Castle and at Holyrood Palace), the Scottish Enlightenment, driven by educated elites of the eighteenth and early nineteenth centuries, is perhaps more prominent, at least in the city's institutions. Of course, in some ways, Edinburgh is an exceptional case given its capital city status, long significant in its political, cultural and economic standing, and even more so since the opening of the Scottish Parliament.

Is World Heritage City status driven by the tourist agenda? There is undoubtedly a sense of competition among traditional tourist cities that feel if they do not achieve World Heritage status they will be overlooked for somewhere else as a tourist destination. Both these cities rely on tourism as a major contributor to their economies, so their status is undoubtedly of great importance and value.

This brings us briefly to the role of World Heritage in wider social and economic regeneration and in cultural tourism, itself an enormous topic with a substantial literature (for example Smith and Robinson, 2006; Timothy and Boyd, 2003). In Chapter 1 it was suggested that World Heritage sites are perceived as the new 'Seven Wonders of the World' (multiplied many times over), and that listing substantially affects the attraction of sites as tourist destinations and boosts local economies in the process. Here, as in many other places in this book, it is evident that this is one of the most significant aspects of heritage beyond its obvious function of restoration and conservation. It also helps to explain why World Heritage is so highly political.

Case study: World Heritage and the economy in Tarragona, Spain

Tarragona, south of Barcelona, has undergone a period of regeneration and re-positioning thanks to World Heritage listing (UNESCO, 2008c). The most significant urban centre in Roman Iberia, it shows many layers of occupation through to the present, with modern excavations revealing the most important Roman urban town planning and remains in Spain (Figure 4.10). The excavated buildings, in varying states of repair and accessibility, have been developed as spectacular cultural sites, now attracting large numbers of visitors. Restoration is being undertaken as appropriate, extending in time from the pre-Roman to a substantial medieval legacy, including the cathedral and other ancient buildings overlooking the main World Heritage site. Much of the old city is surrounded by a wall, often incorporating later buildings, and forming part of a heritage walk where the wall can be readily and safely accessed. A range of a interpretations, including a remarkable model housed in a restored medieval building near the cathedral, show the extent of the

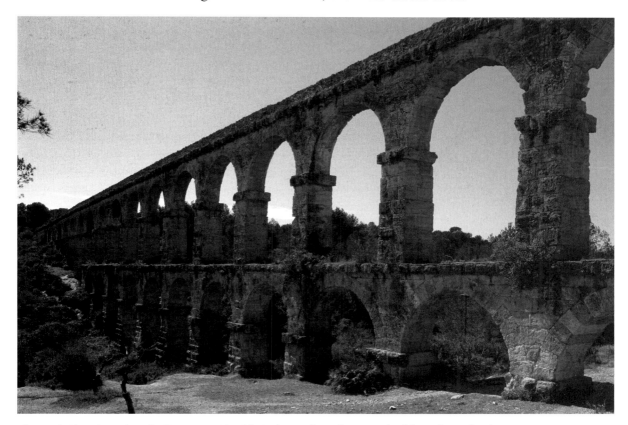

Figure 4.10 Aqueduct in Tarragona World Heritage site. Photographed by Schütze/Rodemann. Photo: © Bildarchiv Monheim GmbH/Alamy.

Roman city, its harbour, shipyards and workshops, and its leisure facilities including circus, chariot-racing track and other features. Excavations at a variety of stages and locations can also be observed by visitors, while an older and very fine classical museum packed with the discoveries of earlier excavations has been revitalised (Museu d'Història de Tarragona, 2008; Museu Nacional Arquelògic de Tarragona, 2008).

Tarragona, already a major tourist destination from the surrounding costas and resorts, has enthusiastically re-invented itself as a cultural destination. Higher education has expanded, leading to the growth of the local university, Universitat Rovira i Virgili, which increasingly attracts large numbers of international students and conferences. The Catalonian government and the Tarragona provincial authorities together with scholars have played a major role in these initiatives. The reaction of locals, I can testify, is generally favourable, since the spin-offs in new kinds of tourism are self-evident. However regeneration has probably brought mixed benefits to some locals and the immigrant community, since heritage projects absorb funds that might otherwise be deployed on housing and other social facilities (a common problem elsewhere, and in Tarragona's case being partially addressed by its structure plan described briefly below). Nonetheless World Heritage status has been a springboard for urban regeneration, perhaps not on the scale of Barcelona to the north, but certainly impressive.

One of the more ambitious schemes arising is the proposal to restore the historical seafront, connecting it again to much of the archaeological ensemble that constitutes the World Heritage site. Beyond the Roman and medieval remains, visible and invisible, later elements have left their mark on Tarragona: extensive urban development, the port, the railway and industrial areas. While always of some importance to the local economy, large-scale industrialisation did not occur until the 1960s and 1970s with the development of a petrochemical complex linked to the port, which has become one of the main cargo-handling ports in the Mediterranean. Since tourism is the other major industry in Tarragona and its region, it is obvious that a tricky balance needs to be maintained between these two key sectors of the economy. Local planners describe Tarragona as being a city out of balance with itself, so the strategic objectives aim to rectify this using heritage as one of the main platforms. According to the strategic objectives the historical and archaeological heritage, rather than being seen in isolation, should be linked to cultural landscapes and natural heritage in and beyond the city, creating an urban inter-city archaeological route that links the different monuments and sites in a cohesive way. Heritage protection can be enhanced by a detailed inventory identifying much that remains hidden under layers of occupation since Roman times, as well as by classification of monuments by age, accessibility and state of repair, and the histories of excavations and finds. All of this presents enormous challenges when the structure plan proposes the

recovery of the seafront by either covering or re-routing the railway and removing other buildings which all act as barriers between parts of the city and the coast.

There is no question that World Heritage status is contributing to a major re-positioning of tourism in Tarragona. As everywhere in Catalonia local and national pride is uppermost, with a strong emphasis on the links to intangible heritage, notably language and culture; in Tarragona this finds expression in a series of annual festivals famous throughout Spain and beyond.

Reflecting on the case study

Tarragona is a good example of World Heritage driving both the re-positioning of an urban regional economy and the development of cultural-educational tourism. Unlike other heritage cities such as Liverpool, Glasgow and Belfast, Tarragona itself is a relatively new industrial centre, but the same challenges of balancing different strategic objectives are evident. At the same time it has substantial advantages in its location close to major tourist areas, also dating from the mid-twentieth century, and also near Barcelona, which began its re-vitalisation earlier and provided something of a model for Tarragona. Like Edinburgh and Bath, it has many of the advantages of a smaller city, the cohesiveness of its archaeological and historic sites in a spectacular location, plus the potential to link these to other economic and cultural developments. At the time of writing a useful start has been made and the strategic plan promises well for the future. As in the examples of New Lanark, Bath and Edinburgh, local, regional and national politics have played a key role both in gaining World Heritage status and in the exploitation of that cachet for the future development of the economy.

Conclusion

Thanks to the work of UNESCO and its associated NGOs since the 1970s, World Heritage is a well-established international concept administered by a formidable army of technocrats. The rise of World Heritage has been responsible for the rescue and conservation of numerous monuments to human values and endeavour and to large areas of unique natural environment and landscape across the globe. It has promoted heritages that have previously been neglected, for example rescuing cultures and languages that would otherwise have disappeared. It has promoted heritage cities, contributing to their regeneration in some cases, and, directly or indirectly, major world sites for cultural tourism. World Heritage has considerable implications for cultural tourism and increasingly for eco-tourism, which are major studies in their own right. There is no question that UNESCO and the other heritage NGOs have

dramatically raised the profile of global heritage and are continuously seeking to redefine heritage beyond its previous Euro-centred and essentially western viewpoints. This now assists less developed regions of the world to raise their game in the World Heritage stakes.

The many positive aspects of World Heritage are perhaps countered by numerous issues about its politics, protocols and impact, some of which will be explored more fully in Chapter 5. The opportunities to follow up on World Heritage are enormous, through both virtual and actual visits to see what makes a site distinctive enough to obtain such status, and to assess what has been achieved in its protection, restoration, conservation, presentation and interpretation, how it impacts on the local/regional community and economy, and many other generic questions arising from the case studies cited here. Having studied this material, it should be possible to visit as more than a tourist, and to deploy a critical eye and useful skills. Chapters 5 and 6 consider further issues relating to the politics of World Heritage in more specific contexts.

Works cited

Arnold, J.E. (2000) 'New Lanark: rescue, preservation and development' in Mays, D.C., Moss, M.S. and Oglethorpe, M.K. (eds) *Visions of Scotland's Past: Looking to the Future*, East Linton, Tuckwell Press, pp. 71–80.

Bath and North East Somerset Council (2008) City of Bath World Heritage Site Management Plan [online], www.bathnes.gov.uk/worldheritage/1.Introduction.htm (accessed 14 January 2008).

Bureau of International Information Programs, US Department of State (2006) Spirit of America Reflected in US Park System [online], www.america.gov/st/washfile-english/2006/April/20060419183242ABretnuH0 (accessed 29 November 2008).

Byrne, D. ([1991] 2008) 'Western hegemony in archaeological heritage management' in Fairclough, G., Harrison, R., Jameson, J.H. Jr and Schofield, J. (eds) *The Heritage Reader*, Abingdon and New York, Routledge, pp. 229–34.

Department for Culture, Media and Sport (1999) *World Heritage Sites: The Tentative List of The United Kingdom of Great Britain and Northern Ireland*, London, Department for Culture, Media and Sport.

Donnachie, I. (2004) 'Historic tourism to New Lanark and the Falls of Clyde 1795–1830', *Journal of Tourism and Cultural Change*, vol. 2, no. 3, pp. 145–62.

Donnachie, I. and Hewitt, G. (1999) *Historic New Lanark: The Dale-Owen Industrial Community since 1785*, Edinburgh, Edinburgh University Press.

Edinburgh World Heritage (2008) Management Plan [online], www.ewht.org. uk/Management-Plan.aspx (accessed 14 January 2008).

Harrison, R. (2008) 'The politics of the past: conflict in the use of heritage in the modern world' in Fairclough, G., Harrison, R., Jameson, J.H. Jr and Schofield, J. (eds) *The Heritage Reader*, Abingdon and New York, Routledge, pp. 177–90.

Harrison, R. and Rose, D.B. (2010) 'Intangible heritage' in Benton, T. (ed.) *Understanding Heritage and Memory*, Manchester, Manchester University Press/Milton Keynes, The Open University.

Hewison, R. (1987) *The Heritage Industry: Britain in a Climate of Decline*, London, Methuen.

Historic Scotland (2000) *Nomination of New Lanark for Inclusion in the World Heritage List*, Edinburgh, Historic Scotland.

ICOMOS ([1964] 1996a) The Venice Charter: International Charter for the Conservation and Restoration of Monuments and Sites [online], www.icomos.org/docs/venice_charter.html (accessed 1 May 2008).

ICOMOS ([1931] 1996b) The Athens Charter [online], www.icomos.org/ athens_charter.html (accessed 14 January 2008).

Museu d'Història de Tarragona – Ajuntament de Tarragona (2008) [online], www.museutgn.com/ (accessed 14 May 2008).

Museu Nacional Arquelògic de Tarragona (2008) [online], www.mnat.es/ (accessed 14 May 2008).

Organization of World Heritage Cities (2008) [online], www.ovpm.org (accessed 29 November 2008).

Owen, R. (2004) 'A New View of Society' in Lavin, C. and Donnachie, I. (eds) *From Enlightenment to Romanticism: Anthology II*, Manchester, Manchester University Press, pp. 107–44.

Rodwell, D. (2007) *Conservation and Sustainability in Historic Cities*, Malden, MA and Oxford, Blackwell Publishing.

Smith, L. (2006) *Uses of Heritage*, Abingdon and New York, Routledge.

Smith, M.K. and Robinson, M. (eds) (2006) *Cultural Tourism in a Changing World: Politics, Participation and (Re)Presentation*, Clevedon and Buffalo, NY, Channel View Publications.

Timothy, D.J. and Boyd, S.W. (2003) *Heritage Tourism*, Harlow, Pearson Education.

UNESCO (1972) *Convention Concerning the Protection of the World Cultural and Natural Heritage*, Paris, UNESCO.

UNESCO (1994) Global Strategy for a Balanced, Representative and Credible World Heritage List [online], http://whc.unesco.org/en/globalstrategy/ (accessed 11 October 2008).

UNESCO (2008a) The Operational Guidelines for the Implementation of the World Heritage Convention [online], http://whc.unesco.org/pg.cfm?cid=57 (accessed 11 October 2008).

UNESCO (2008b) Convention for the Safeguarding of Intangible Cultural Heritage [online], www.unesco.org/culture/ich/index.php?pg=00006 (accessed 14 January 2008).

UNESCO (2008c) Archaeological Ensemble of Tarragona [online], www.unesco.org/en/list/875 (accessed 14 May 2008).

UNESCO (2009) World Heritage List Statistics [online], http://whc.unesco.org/en/list/stat (accessed 13 March 2009).

van der Aa, B.J.M. (2005) 'Preserving the heritage of humanity? Obtaining world heritage status and the impacts of listing', Chapter 3, 'Nominating World Heritage sites', University of Groningen [online], http://dissertations.ub.rug.nl/faculties/rw/2005/b.j.m.van.der.aa/ (accessed 2 December 2008).

West, S. and Ndlovu, S. (2010) 'Heritage, landscape and memory' in Benton, T. (ed.) *Understanding Heritage and Memory*, Manchester, Manchester University Press/Milton Keynes, The Open University.

World Heritage Centre (2005) *Operational Guidelines for the Implementation of the World Heritage Convention*, Paris, UNESCO.

Further reading

Cooney, G. (ed.) (2007) 'The archaeology of World Heritage', special issue, *World Archaeology*, vol. 39, no. 3.

Dallen, J.T. and Boyd, S.W. (2003) *Heritage Tourism*, Englewood Cliffs, NJ, Pearson Education.

Evans, G. (2002) 'Living in a World Heritage City: stakeholders in the dialectic of the universal and particular', *International Journal of Heritage Studies*, vol. 8, no. 2, pp. 117–35.

Fowler, P. (2004) *Landscapes for the World: Conserving a Global Heritage*, Bollington, Cheshire, Windgather Press.

Francioni, F. (ed.) (2008) *The 1972 World Heritage Convention: A Commentary*, Oxford, Oxford University Press.

Graham, B., Ashworth, G.J. and Tunbridge, J.E. (2000) *A Geography of Heritage: Power, Culture and the Community*, London, Arnold.

Harrison, D. and Hitchcock, M. (2005) *The Politics of World Heritage: Negotiating Heritage and Conservation*, Clevedon, Channel View Publications.

Hoffman, B.T. (ed.) (2006) *Arts and Cultural Heritage: Law, Policy and Practice*, Cambridge, Cambridge University Press.

Howard, P. (2003) *Heritage: Management, Interpretation, Identity*, London, Methuen.

Kirshenblatt-Gimblett, B. (2006) 'World Heritage and cultural economics' in Karp, I., Krantz, C., Szwaja, L. and Ybarra-Frausto, T. (eds) *Museum Frictions: Public Cultures/Global Transformations*, Durham, NC, Duke University Press, pp. 161–202.

Labadi, S. (2007) 'Representations of the nation and cultural diversity in discourses on World Heritage', *Journal of Social Archaeology*, vol. 7, no. 2, pp. 147–70.

Leask, A. and Fyall, A. (eds) (2006) *Managing World Heritage Sites*, Oxford, Butterworth-Heinemann.

White, R. and Carman, J. (2007) *World Heritage: Global Challenges, Local Solutions*, Oxford, Archaeopress.

Chapter 5 The politics of heritage

Rodney Harrison

This chapter considers the ways in which heritage can both stimulate and act as a symbol of political struggle, and how ownership of heritage objects, places and practices might be considered to give their possessors political power. The case study of the destruction of the Bamiyan Buddhas in Afghanistan by the Taliban in 2001 demonstrates the thorough entanglement of international politics and heritage. It shows what happens when the World Heritage List and the ideas it perpetuates about heritage come into conflict with alternative views of heritage and its role in the production of national histories and local religious and cultural practices. The case study on repatriation of cultural objects by UK museums shows how the 'ownership' of heritage conveys the right to control access to objects, places and practices, and examines the ways in which ideas about who should 'own' heritage are influencing museums in contemporary society.

Introduction

Previous chapters have introduced heritage and heritage studies, developed the idea of critical approaches to heritage via an extended discussion of ways of reading photographs, and built some skills in visual discrimination and taking a critical approach to heritage source materials. We have also looked at heritage at national and international levels, and the ways in which processes of listing may potentially interfere with and cut across local processes of heritage. The next four chapters of the book are concerned with a series of interlinked themes that engage with issues of the politics of heritage and the past, specifically nationalism, postcolonialism and class. Central to these chapters is the notion that alongside globalisation there has been an increasing emphasis in the modern world on national identity and 'heritage'.

The object of this chapter is to introduce the connection between heritage and the politics of the past. Politics can be thought of as the formal processes by which groups of people make decisions, and of course there is a strong relationship with authority and power. The chapter revisits what will by now be a familiar theme – the relationship between official heritage and power or control. In contemporary society the power to control heritage is the power to remake the past in a way that facilitates certain actions or viewpoints in the present. Chapter 4 looked at the influence of UNESCO and the World Heritage List on official heritage management throughout the world. It took a deliberate line in describing the official processes of World Heritage listing while glossing over some of the more overt ideological issues that manifest

themselves in the conflict between global and national objectives of heritage management. In this chapter you are presented with a different set of ideas about heritage management which focuses on power relations and conflicts between global, national and local politics. On the one hand, we need to focus on the ways that World Heritage might impose a 'universalising' trend on local diversity in heritage and culture. On the other, we should also be mindful of the ways in which world organisations sometimes step in to protect diversity, particularly from strongly homogenising tendencies of the nation-state. In this chapter you look at the ways in which the tensions between these two aims of global heritage management are played out in the real world.

One of the ways in which the idea of World Heritage has most strongly influenced global ideas about heritage is through the notion of 'universal heritage value'. This found official recognition in the adoption of the World Heritage Convention by the General Conference of UNESCO on 16 November 1972, as discussed in Chapter 4. If something has universal heritage value it implies that the importance of an object, place or practice is such that it transcends local boundaries, and its preservation becomes a 'common concern' of humanity: an external determination has been made that it is of global importance. If an individual or organisation has the power to suggest such importance, it privileges their interpretation of the past. There is potentially a conflict here between the preservation of cultural diversity, which would emphasise decision-making processes that are 'internal' to the cultures and societies concerned, and the preservation of World Heritage objects, places and practices as the 'common concern' of the world and therefore determined by an outside body.

Some of these issues are explored here in two case studies. The first looks at the relationship between heritage and global politics through the example of the Taliban's intentional destruction, in 2001, of the awe-inspiring Bamiyan Valley Buddha statues in Afghanistan. This case study examines what happens when heritage becomes embroiled in international political conflicts. It looks at the ways in which the World Heritage List and the ideas it perpetuates about heritage, or authorised heritage discourses (AHD), come into conflict with alternative views of heritage and its role in the production of national histories and local religious and cultural practices. We will extrapolate from this to look at the ways in which particular notions of heritage might exclude specific forms of living cultural practices associated with heritage objects, places and practices. The second case study explores the political issues surrounding the ownership of museum objects that have been removed from their source country, and what happens when that country asks for them to be returned. It looks in detail at the ways in which UK museums have dealt with requests from the Greek government for the return of the Parthenon Marbles on the one hand, and with Indigenous Australians who have requested the return of ancestral human remains held

by the museum on the other. The second case study raises issues concerning the 'ownership' of heritage and the power that such ownership conveys on the owner.

Case study: the destruction of the Great and Little Buddhas of the Bamiyan Valley, Afghanistan

The heritage values of the Buddhist remains of the Bamiyan Valley were first made known to UNESCO when a nomination dossier for the archaeological sites and monuments was first submitted by the Afghanistan government in 1981, but the property's inscription was deferred by the World Heritage Committee in 1983 due to the lack of definition of an appropriate boundary for the site to protect its archaeological remains. In the 1990s, the site became embroiled in a global heritage scandal which was to have wide-reaching implications not only for UNESCO and the management of 'World' heritage, but also for international politics and global diplomatic relations.

A description of the archaeological remains of the Bamiyan Valley

The Bamiyan Valley is located in the mountainous region of central eastern Afghanistan, approximately 230 km (143 miles) north-west of the capital of Kabul. Sited in an area that formed a crossroads from China in the east, India in the south, and Persia in the west, the valley was first occupied in the third century CE at the time of the height of Buddhist culture in central Asia, and soon became an important monastic centre for Buddhism during the fourth to the eighth centuries CE. During this time two enormous monumental standing figures of the Buddha, now known as the Great and Little Buddhas, were carved into niches in the limestone cliffs at Bamiyan. Standing 55 metres and 38 metres tall respectively, these statues formed a striking monumental reminder of the Buddhist past of the valley, and were the largest standing Buddha carvings in the world. The monumental standing figures were accompanied by a series of seated Buddha figures which sat in between them. In the Bamiyan, and surrounding Folodi and Kakrak Valleys, over 1000 humanly made caves, grottoes and niches were also carved into the soft limestone of the hillsides. They functioned as shelters and temples for the Buddhist monks and contained elaborate carved decoration and painted wall art (this section after Higuchi and Barnes, 1995 and UNESCO, 2003). The caves were generally built in isolated places away from towns and villages, and were primarily used by monks for the private practice of Buddhism. Originally they would have had a wooden facade; however these have long since deteriorated. This series of archaeological sites, and the caves and

frescoes associated with these valleys, document the area as a major urban centre associated with the practice of Buddhism throughout this period (Figures 5.1 and 5.2).

The Bamiyan Valley appears to have been an important early settlement associated with several powerful Buddhist saints who were buried there. The monumental Buddha sculptures are believed to have been carved into the cliffs between the third and sixth centuries CE. The eastern complex of caves, the 38 metre Buddha, and a **stupa** were built between the third and fourth centuries CE, while the 55 metre Buddha is thought to date from the fifth or sixth centuries CE. Historic records refer to celebrations held each year that attracted numerous pilgrims and travellers to the statues, and during which offerings were made to them.

The monuments were described by a number of travellers and pilgrims who visited the Bamiyan Valley. The Chinese pilgrim Xuanzang wrote a description of the Bamiyan monuments and the social and religious life in the valley after visiting it between 629 and 645 CE. The Korean monk Huichao

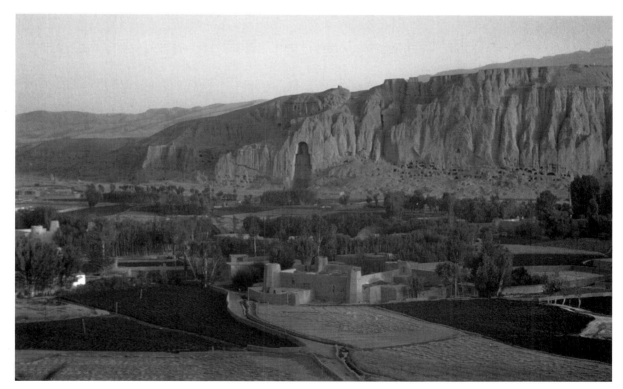

Figure 5.1 The Bamiyan Valley, with the modern city of Bamiyan in the foreground and the niche of the Great Buddha in the background, 1975. Unknown photographer. Photo: © Roger Viollet/Getty Images.

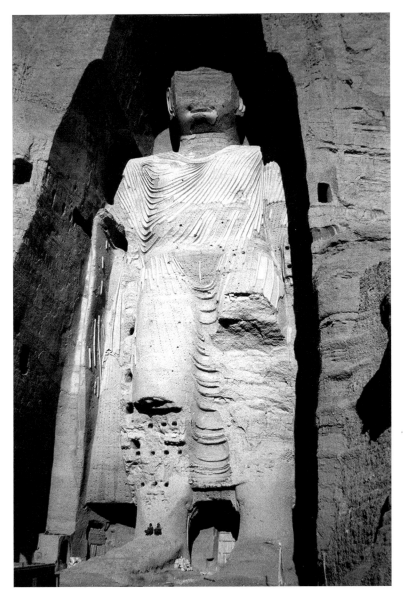

Figure 5.2 The Great Buddha at Bamiyan, 1997. Photographed by
Jean Claude Chapon. Photo: © Jean Claude Chapon/AFP/Getty Images.

also made reference to the Kingdom of Bamiyan when he passed through in
727 CE, describing it as powerfully independent despite the dominance of
Arab armies to the north and south of the region.

Central Afghanistan embraced Islam under the rule of the eleventh-century
Sultan Mahmud of Ghazna, and this was to have a lasting effect on the
occupants and monuments of Bamiyan. Islamic art and architecture appeared

in the eleventh century, reflecting the conversion of its inhabitants to Islam. The town of Bamiyan and the Buddhist monasteries were ransacked in the early thirteenth century. Although the Buddhist monuments were not ruined, they sustained some damage at this time, and individual acts of iconoclasm occurred over the intervening years. The Mughal emperor Aurangzeb, a religious fundamentalist, reportedly ordered his army to shoot off the legs of the large Buddha with cannons during the seventeenth century. This action mirrors the later destruction of the statues by the Taliban. Although there were no practising Buddhists in the Bamiyan Valley at this time (or subsequently), the statues were seen as a powerful reminder of an alternative religious past, triggering attempts to deface the statues as a symbolic way of showing the power and dominance of the valley's new political leaders.

The valley remained deserted for a long time after the Mughal invasion until people from different regions of Afghanistan began to use its fertile land for agriculture. At this time the caves began to be used for shelter for people and their animals. In 1964 the governor of Bamiyan convinced the inhabitants to leave the caves and build houses in the new city of Bamiyan. The caves were again unoccupied from 1964 until their destruction in 2001.

The history of the Buddhas' systematic documentation is a reflection itself of twentieth-century global politics. Although the caves and monuments first came to the attention of the West during the nineteenth century when European travellers and explorers reported their existence, the first systematic archaeological investigation of the area was not carried out until the 1920s and 1930s, when the French colonial Mission Délégation Archéologique Française en Afghanistan was undertaken. Subsequently a series of Japanese scholars undertook detailed documentation of sites in the Bamiyan, Kakrak and Folodi Valleys in the 1960s and 1970s. The Kyoto University's work at Bamiyan was terminated by the Soviet military occupation of Afghanistan in 1979. Since the 1970s Afghanistan has been the subject of a continuous period of civil war. Prior to 2001, some of the cave temples at Bamiyan were being used as powder stores and barracks by anti-government military groups. By the mid-1990s, the statues, although standing, were reportedly in poor repair and had lost most of their faces, hands and feet due to the combined effects of erosion and intentional destruction (UNESCO, 2003).

The destruction of the Bamiyan Buddhas

The Taliban, a Sunni Islamist movement, took Kabul by force in 1996 by overthrowing the regime of President Burhanuddin Rabbani (president 1992–6) and his defence minister Ahmed Shah Masood. They ruled most of Afghanistan until 2001, when their leaders were forcibly removed from government by a military coalition of the Northern Alliance (Afghanistan),

USA, UK, Canada and Australia. The Taliban had originated in southern Afghanistan and western Pakistan, and were predominately Pashtuns or ethnic Afghans. They first came to prominence in 1994 when their leader, village clergyman Mullah Mohammed Omar, promised to stamp out corruption, restore peace and re-establish shariah, or Islamic law, once in power. They extended their influence from south-western Afghanistan by targeting the mujahidin, feuding military leaders who had previously forced Soviet troops out of the country. By 1998 they were in control of approximately 90 per cent of Afghanistan (BBC News, 2006).

Once in power, the Taliban established a hard-line, authoritarian government, and re-established traditional Islamic punishments including public executions for those convicted of murder, and amputation of the limbs of thieves. Men were ordered by law to grow beards and all women were required when in public to wear the burqa, a garment covering the whole of their body with only a thin gap at eye level for them to see through. Television and music were banned, and girls over the age of 10 were removed from school. Human rights abuses committed by the Taliban's religious police who were put in place to enforce the new laws were reported in the western media by observers, and the government failed to find recognition from the international community for its hard-line policies and its apparent connections with global terrorism.

It is worth pointing out here that despite the failure of the international community to sympathise with them, the Taliban saw themselves as carrying out historically authorised judgements and beliefs. It's tempting to see them as religious zealots, and that is certainly the way they were portrayed in the western media; but clearly the Koran and other religious documents are open to interpretation, so the Taliban might properly be thought of as pursuing what they believed to be an authentic heritage. This was certainly the way in which they themselves represented their mission within Afghanistan, as well as to the international media. It is possible to see intangible practices of heritage, such as the wearing of beards and the burqa, interacting with local politics here as much as with global politics.

On 17 April 1997 Mullah Mohammed Omar declared that the Taliban would destroy the Bamiyan Buddhas, as icons and religious imagery were forbidden by Islamic law. Following appeals by the UN secretary-general and the UNESCO director-general to political and military leaders in Afghanistan urging them not to harm the Buddhas, the Taliban embassy in Islamabad, Pakistan, issued a statement on 28 April 1997 that the Taliban would not destroy the Buddhas and that they would conserve cultural heritage in accordance with existing international conventions.

However, on 26 February 2001 Mullah Mohammed Omar again stated that the Taliban would destroy the statues 'so that they are not worshipped now or in

the future' as part of an edict to destroy all statues in Afghanistan which, as human representations, the Taliban view as non-Islamic. The *New York Times* reported the Taliban statement as follows:

> All the statues in the country should be destroyed because these statues have been used as idols and deities by the nonbelievers before ... they are respected now and may be turned into idols in future, too.

> (Agence France-Presse, 2001)

The UNESCO director-general responded by sending a telegram to Mullah Mohammed Omar, urging him to reconsider the decision to destroy all the statues of Afghanistan, and subsequently sought the support of representatives of other Islamic countries including Saudi Arabia, the United Arab Emirates, Qatar, Iran and Tajikistan, as well as the president and the secretary of the Organization of the Islamic Conference. All agreed to do what they could to stop the destruction of the statues. Once the media were alerted, there was an outcry against the Taliban in the western press. However, by 3 March 2001 the Taliban stated officially that they had begun the task of destroying the statues and associated cave temples. The statues were destroyed over the course of several weeks. Anti-aircraft weapons and machine guns were used to shoot at the statues, and dynamite and land mines were placed strategically to bring them down completely. Ultimately, all that remained were the niches that had housed the statues. Some of the cave temples survived; however, these also sustained much damage. Video footage of the statues being blasted by dynamite and subsequent photographs of the empty niches were released by the Taliban to the western media to document the official process of their destruction (see Figure 5.3).

Commentators have noted that the destruction of the Bamiyan Buddhas by the Taliban marked a turning point in the regime and influenced the decision by the US-led coalition to invade and overthrow it in October 2001. The influence of al-Qaeda on the Taliban's leaders is said to have been critical in the decision to destroy the statues. The act of destroying the statues came to be viewed as an explicit defiance of international conventions and the rest of the world. Although early statements suggested that the destruction had been ordered on religious grounds, in a subsequent interview with the *New York Times* another possible alternative was offered by Sayed Rahmatullah Hashimi, who said that the decision had been made in an angry reaction to a foreign delegation that had been sent by UNESCO to investigate the destruction of objects in the Kabul Museum, who had offered to provide funding for the statues' preservation:

> The scholars told them that instead of spending money on statues, why didn't they help our children who are dying of malnutrition? They rejected that, saying, 'This money is only for statues'. The

scholars were so angry. They said, 'If you are destroying our
future with economic sanctions, you can't care about our heritage'.
And so they decided that these statues must be destroyed ... If we
had wanted to destroy those statues, we could have done it three
years ago. So why didn't we? In our religion, if anything is harmless,

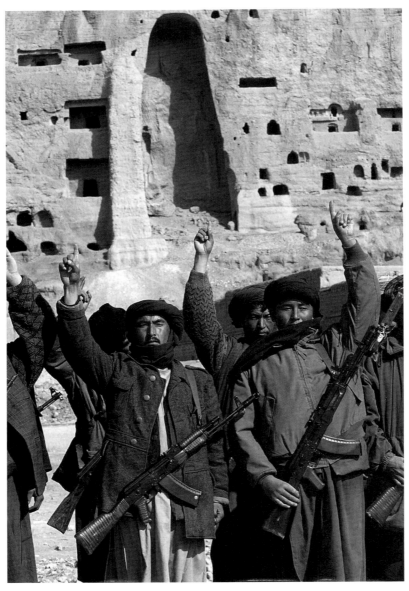

Figure 5.3 The niche of the Great Buddha following the destruction of
the statue by the Taliban in 2001. Photographed by Paula Bronstein.
Photo: © Paula Bronstein/Getty Images.

we just leave it. If money is going to statues while children are dying of malnutrition next door, then that makes it harmful, and we destroy it.

(Sayed Rahmatullah Hashimi quoted in Crosette, 2001)

The destruction of the Buddhas, and the later responses to it, all operated at a fairly remote political level. There was little concern for the ways in which the destruction might have affected local people, or for the significance of the Buddhas as Buddhist religious icons. It became subsumed within a global political discourse that focused on the refusal of the UN and other countries to give the Taliban official recognition, along with economic sanctions imposed in 1999 and 2000 by the United Nations Security Council due to alleged links with Islamic terrorism and allegations that the Taliban were harbouring al-Qaeda insurgents, including the al-Qaeda leader Osama Bin Laden. These remote political arguments must have played a role in this very political act of defiance. Only three countries – Pakistan, Saudi Arabia and the United Arab Emirates – recognised the Taliban as the legitimate government of Afghanistan, and in the months following the destruction of the statues, Saudi Arabia and the United Arab Emirates also withdrew their support. All three countries protested against the destruction of the statues.

Bamiyan and the World Heritage List

As previously noted, the inscription of the Bamiyan Buddhas was deferred by the World Heritage Committee in 1983 due to the lack of definition of an appropriate boundary for the site to protect its archaeological remains. It was not until 2003, well after Taliban forces deliberately destroyed the large Buddha sculptures along with most of the Buddhist statues and wall paintings in the Bamiyan Valley in the spring of 2001, that the more secular and more internationally oriented transitional Islamic State of Afghanistan submitted a new nomination for urgent consideration by the UNESCO World Heritage Committee. At the committee's 27th session in June 2003 the remains of the Buddhas' niches and other archaeological remains of the valley were finally simultaneously inscribed on the World Heritage List and the List of World Heritage in Danger.

Ironically, it was the fact that the Taliban were not recognised by the UN as the legitimate government of Afghanistan that made it impossible for them to nominate the Bamiyan Buddhas to the World Heritage List while they were in power. The language of the appeals not to destroy the Buddhas in 1997 and 2001 is noteworthy. At its 83rd plenary meeting the UN General Assembly adopted Resolution A/RES/54/185 in which it

> Expresses its deep concern at reports of attacks on and looting of cultural artefacts in Afghanistan,

> Emphasizes that all parties share the responsibility to protect their *common heritage*, and
>
> Requests all Member States to take appropriate measures to prevent the looting of cultural artefacts and to ensure their return to Afghanistan [emphasis added].
>
> (United Nations, 2000)

The idea of the Bamiyan Buddhas as part of the universal or common heritage of humanity played an important role in the way in which the media reported their destruction. This was an issue in which all people on the earth were seen to have a stake or interest. Newspapers reported 'world outrage' at the decision to destroy the statues. The *New York Times* quoted Rakhaldas Sengupta, the retired former head of an Indo-Afghan team that was involved in restoration work at Bamiyan in the 1970s, who called it the destruction of the 'heritage of mankind' (Bearak, 2001). The abuses against 'World Heritage' were one of a series of issues (including alleged links with terrorism and human rights abuses) that can be seen to have lent to the subsequent NATO military operation of October 2001 a position of 'global moral fairness'. It is arguable that these appeals against the destruction of the common heritage of humanity facilitated the political position which allowed the coalition team to invade and remove the Taliban from power. Such a suggestion sees the focus of World Heritage move beyond a simple list of modern 'wonders' or the great canon of heritage to a global emblem used by the Taliban to draw attention to their feelings of political oppression and exclusion on a world scale, and subsequently used by NATO to direct the West's anger against them.

Iconoclasm: World Heritage as a global target

Iconoclasm, literally 'image-breaking', is a term that refers to opposition to the religious veneration of images. It is perhaps most closely associated with a Christian theological debate in the eighth and ninth centuries CE involving the Byzantine Church and state. The literal interpretation of Old Testament prohibitions against worshipping graven images (Exodus 20:4) led to the imposition of legislation that banned the production and use of figurative images in churches and their veneration. Despite this, many traditions in the Christian Church continued to make images, hence the fame of Eastern Church traditions of icon making.

For Protestants anxious to establish their difference from Roman Catholics after the Reformation the removal of images of saints and of the crucified Christ (both statues and in stained glass) was an important symbolic action. This iconoclasm was not simply popular fury but in England was often led by clergy and was reinforced by royal injunctions in 1538 and 1547 attacking the

cult of saints (Duffy, 1992, pp. 408, 450). English monarchs Henry VIII, Edward VI and Elizabeth I all promulgated orders to remove visible signs of Catholic worship. Painted images on the walls were whitewashed over and, by an order of 1561, rood lofts that had carried images of the crucified Christ, the Virgin Mary and St John were dismantled. Further iconoclasm took place in the 1640s, during the Civil Wars, and was associated with the religious and political divisions between Royalists and Parliamentarians, although this was not widespread and, where it took place, was usually encouraged by particularly enthusiastic local civilian officials (Porter, 1994, pp. 131–2). Since many images of saints had already been removed, the damage was more likely to be to tombs; sometimes it was no more than the fortunes of war – soldiers being billeted in churches while on campaign, for example.

In contemporary use, the term 'iconoclasm' has come to include any example of one political or religious regime erasing the images of another. Modern examples include the destruction of both religious and secular images during the French Revolution, and the destruction of images that occurred in China as part of the Cultural Revolution.

Iconoclasm has a close connection with heritage, although it may at first glance be seen as its opposite, or a form of 'anti-heritage'. Iconoclasm is a process by which people acknowledge the connection between particular objects, places and practices and collective memory. The process of destroying or removing an object, place or practice is not only a destructive process but a process by which an attempt is made to clear the way for the creation of new collective memory (see Benton, 2010). However, while it is an active process of removal it is also a tacit acknowledgement of the symbolic power of the image being removed – if the image had no symbolic power, it wouldn't need to be erased. While the West might view the destruction of perceived World Heritage as incredibly negative, we need to also think of iconoclasm as a judgement of value, in the same way that other judgements of value are made about heritage. Just as museums must make decisions about which objects to continue to conserve and which to de-accession, so iconoclasm involves a decision of value about which places (and memories) to keep and which to erase. The difficulty lies in understanding the motivations of such actions, and their impact on living religious and cultural expressions.

Throughout the period during which the statues were being threatened, UNESCO and the western media consistently drew attention to the impact of this loss on 'the world's heritage'. The idea of the world's heritage derives from a model that assumes a canon of heritage, and that the values of heritage are intrinsic, rather than given to objects, places and practices by people in the present (see further discussion in Chapter 1). It is extremely difficult in this case to assess such a loss. To the Taliban, the statues were an abomination to Islam, and an unwelcome reminder of a pre-Islamic past. To the rest of the world, they

were breathtaking and spectacular artefacts. Although they were not the subject of active worship, I am sure their loss would have been felt particularly by Buddhists in other countries. This raises issues about whether there is any way in which such losses could possibly be weighed against one another.

In any discussion of iconoclasm, the perception of the act is coloured by whatever is the contemporary dominant political or religious point of view. An example that helps us to think about this phenomenon is the widespread practice of building Christian churches over the sites of former religious centres throughout Europe by the Roman empire and during subsequent periods into the Middle Ages. These churches would now be held to be heritage sites in their own right, and there would be no question of removing them and rebuilding the original temples or religious structures. On the other hand, we could think of Jerusalem here as a highly contested example of superimposed religious sites, which is a live issue because the dominant political power is highly contested. In another example, Spanish mosques that have been converted into churches are perceived to be neutral because the dominant power is in line with the last episode of rebuilding. In the UK, Roman Catholics have not yet demanded the return of pre-Reformation churches, because it is highly unlikely that they could possibly win against the Church–state alliance. One argument might be that iconoclasm is best viewed as part of an organic process by which heritage is created in the present, and a process by which new powers express, and perhaps most importantly, *maintain* their sovereignty over old ones. Some of these general issues are discussed further in Chapter 6.

The Taliban, at least on an official level, defined the Buddha statues as icons, and cited their destruction as a result of their particular interpretation of Islamic law in the context of a widespread crack-down on images and icons throughout the country. But this must also be seen as an action that resulted in the virtual erasure of the country's pre-Islamic past. Indeed, it has been suggested that the Taliban's decision to destroy the Bamiyan Buddhas is best viewed as a form of iconoclasm aimed not at the statues themselves but at World Heritage in general, and the United Nations in particular. World Heritage, as a symbol of the universalising cultural tendencies of the United Nations, would have made a tempting target for a political regime that was feeling excluded from politics on a world scale. The attack on the Bamiyan Buddhas was not only an attack on the statues but also an attack on what some would see as a form of western imperialism, the imposition of a set of materialistic values on the state of Afghanistan by a world community that would not even recognise its legitimate rule:

> Like the emblem developed in the 20th century to signal monuments worthy of special protection, the notion of world heritage, intended as a shield, may instead act as a target. This is hardly surprising.

The history of iconoclasm shows abundantly that the act of symbolizing – tying certain objects to certain values – sometimes has contradictory effects. It recommends certain objects to the care of those who share these values but attracts the aggression of those who reject them or who feel rejected by them.

(Gamboni, 2001, p. 11)

Archaeologist Lynn Meskell has noted that both Afghanistan and the USA have refused to sign the 1954 Hague Convention, which states that 'damage to cultural property belonging to any people whatsoever means damage to the cultural heritage of all mankind, since each people makes its own contribution to the culture of the world':

The language of UNESCO conventions reinforces western notions of values and rights, while the ownership and maintenance of the past is suffused with concepts surrounding property ... it erases the centrality of cultural issues whether social, political or religious ... any real success of world heritage will depend upon the degree to which the Enlightenment inspired universalism gets sanctioned as truly universal.

(Meskell, 2002, pp. 568–8)

Meskell notes that the concept of damage or destruction to cultural heritage is a culturally specific one. For example, some groups of Indigenous Australians would consider the excavation of skeletal remains and cultural artefacts as damaging, whereas some archaeologists have used the argument that if museum collections of artefacts and skeletal remains are returned to indigenous people, this amounts to a destruction of them (see further discussion below). Certainly, within contemporary western societies culture and belief often act against the aesthetic or historic values of objects, practices or places. In such cases, censorship or religious change may cause objects to be destroyed or mutilated with more or less public approval.

Some commentators have suggested that there is an irony in the widespread denouncement of the Taliban for destruction of World Heritage sites in Afghanistan, and the absence of critique of the way in which UK and US forces have destroyed numerous important archaeological sites in Iraq in the period 2003–8. The *Guardian* newspaper reported in 2007 that US forces were destroying important archaeological sites through excavation and building projects in Iraq:

Fly into the American air base of Tallil outside Nasiriya in central Iraq and the flight path is over the great ziggurat of Ur, reputedly the earliest city on earth. Seen from the base in the desert haze or the sand-filled gloom of dusk, the structure is indistinguishable from the mounds of fuel dumps, stores and hangars. Ur is safe within the base compound. But its walls are pockmarked with wartime shrapnel

and a blockhouse is being built over an adjacent archaeological site. When the head of Iraq's supposedly sovereign board of antiquities and heritage, Abbas al-Hussaini, tried to inspect the site recently, the Americans refused him access to his own most important monument.

(Jenkins, 2007)

Perhaps this is not the same as the wilful destruction of the Bamiyan Buddhas, but it does raise the potential for the destruction of World Heritage to become a political contest in which those governments who are more powerful and who adhere to western principles of heritage conservation are able to point the finger at those who are politically marginalised, while finding themselves immune from blame. The politics of the past is clearly interwoven with much more complex issues to do with the relationships within and between nations, in addition to the legal structures that surround heritage, and particularly World Heritage, itself.

Negative heritage

The worldwide attention directed towards the Buddhas of Bamiyan has seen them become symbols of the fragility of World Heritage and its role in conflict situations, as well as symbols of global terrorism. The poignant, hollow recesses that remain in the cliff walls of Bamiyan speak almost as strongly as the presence of the Buddhas themselves ever could have done. The Taliban destruction of the statues is now seen as part of the site's heritage significance. Among the criteria for inclusion on the list is the statement:

> **Criterion (vi)**: The Bamiyan Valley is the most monumental expression of the western Buddhism. It was an important centre of pilgrimage over many centuries. Due to their symbolic values, the monuments have suffered at different times of their existence, including the deliberate destruction in 2001, which shook the whole world.

(UNESCO, 2003)

Ironically, the destruction of the Buddhas by the Taliban, which was intended to undermine the principles of UNESCO and western cultural materialism, has done more for the global hegemony of World Heritage and UNESCO than the Buddhas could have achieved if they had never been threatened. The Buddhas have become a global symbol of UNESCO and World Heritage – a 'poster site', if you like, for the need for global heritage initiatives. We could think of such places that have become famous for their destruction using Meskell's term 'negative heritage' (2000). She suggests the site of the World Trade Center in New York City, which was destroyed in an al-Qaeda terrorist attack on 11 September 2001, is another site of negative heritage. Such places have been exposed to such enormous quantities of global media attention that they become symbols and places of commemoration for the physicality they no longer possess.

Since the inclusion of the Bamiyan site on the World Heritage List and the List of World Heritage in Danger in 2003, a number of projects have been initiated there to document the damage and consolidate the remaining archaeological sites. At the time of writing there are ongoing discussions about rebuilding the Buddha statues, and a proposal has been put forward by the Afghanistan government to commission the Japanese artist Hiro Yamagata to project between 160 and 240 images of the Buddhas using coloured lasers on to the Bamiyan cliff faces. Although scheduled for 2012, the project is awaiting UNESCO approval. These initiatives demonstrate the continuing significance of the site to an international community, and its symbolic importance as a place associated with World Heritage and its conservation.

Reflecting on the case study

The case of the Bamiyan Buddhas draws some of the issues surrounding heritage and politics into marked relief. Are there objects, places and practices (for example, religious, aesthetic, representational, social) that transcend national boundaries? Who should care for such objects – 'object professionals' such as archaeologists, architectural historians and conservators, or site managers or political advisers? And what is the relationship between ownership of heritage and power?

In the case study it was suggested that the destruction of heritage might be understood not as the opposite of heritage but as part of the same process of remembering and forgetting, or re-authoring the past in the present. The process of selecting and promoting one object, place or practice as heritage for preservation ('remembering') always implies passing over or neglecting another as less worthy of preservation ('forgetting'). But is it pushing this concept too far to see the deliberate destruction of heritage as part of the same process of selection? You will remember in Chapter 1 we discussed the ways in which the management of heritage might be seen as a way of fossilising and distancing people from objects, places and practices. How might cultures with radically different ideas about how to conserve or preserve what is significant from the past deal with these issues? Could the rebuilding of heritage also be seen as a kind of deliberate destruction?

It might also be worth pausing here to reflect on how judgements are made all the time that give some things greater 'life expectancy' than others. An example that springs to mind is the floods in London in 1928 when everything stored in the basement of the old Tate Gallery (those things considered to be of secondary quality) was damaged by water. Without constantly renewed judgements of value, works of art and heritage fade away and disappear in the same way that they might through wilful acts of iconoclasm.

UNESCO and western ideals of heritage conservation

We have already discussed some of the potential problems with concepts of universal heritage values and the ways in which places on the World Heritage List can become embroiled in broader political issues. Another area where notions of universal heritage value become problematic is in the case of countries whose concepts of conservation of heritage differ radically from those that form the authorised heritage discourse (AHD) of UNESCO. Archaeologist Denis Byrne ([1991] 2008) has noted that appealing to the universal or transcendent category of heritage is a means by which people with a particular interest in heritage places are excluded from having a role in managing them. He draws on case studies to suggest that notions of 'universal' heritage value have been employed to operationalise western notions of heritage management in the non-western world, suggesting that these might conflict with local practices and living cultural traditions in non-western countries.

Thai stupa and alternative notions of heritage conservation

Byrne (1995) discusses the place of Buddhist stupa in Thai religious practice as an example of a situation where western conservation measures have the potential to cut across local religious customary practice. Stupa are dome-shaped buildings constructed over the site of relics that are reputed to be associated with the Buddha. They are effectively stylised burial mounds, and occur throughout India, Asia and south-east Asia (where they are sometimes known as *chedi*) (Figure 5.4).

The worship of stupa is central to the practice of Theravada Buddhism (one of the earliest forms of Buddhist religious practice). Theravada Buddhists revere the image of the Buddha, and worship involves making offerings of flowers, food, lit candles or other objects to the Buddha's image. Stupa are dome-shaped structures that are believed to contain relics of the Buddha. They are usually designed with a series of terraces around which the pilgrim circumambulates before reaching the centre of the stupa, on which the relics will be stored on a plinth or raised pillar. Pilgrims leave their offerings either at this central pillar or at one of the images of the Buddha that are customarily found on the terraces surrounding the stupa. A stupa may become a focus for local, regional or long-distance pilgrimage depending on the extent to which it is known to be powerful in fulfilling the prayers and requests of pilgrims. Requests are made by reading portions of relevant religious texts before a relic or image of the Buddha held within a stupa. In this way, a stupa develops renown for its efficacy, which is the main source of their significance within Thai society. Renown circulates in the form of stories or gossip about the requests that a stupa has fulfilled in the past.

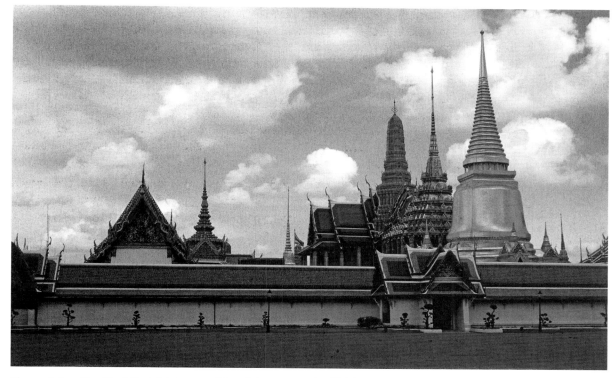

Figure 5.4 The Thai Buddhist stupa 'Phra Sri Rattana Chedi' (The Golden Chedi) at Wat Phra Kaeo in Bangkok, Thailand, 1999. Photographed by Rodney Harrison. Photo: © Rodney Harrison.

Groups living in the Chao Praya Valley of central Thailand had developed a trading relationship with India by the first millennium CE, and archaeological evidence suggests that the practice of Theravada Buddhism had been adopted in Thailand by at least as early as the seventh century. Theravada Buddhism became the common religion of Thai people during the fourteenth century in the kingdom of Sukhothai and is practised by approximately 94 per cent of modern Thais.

Byrne suggests that the decay, abandonment and eventual ruin of Thai stupa represent a chain of events arising from opposing sets of maintenance and restoration processes. The balance between these processes depends on such factors as the power of a stupa to bestow favours on its followers, the wealth of its local patrons, acts of war (which have often ravaged stupa) and the ability of abbots and monks to generate patronage of it. A stupa's decay becomes an important way in which people read its power or sacredness – a well-kept stupa represents a place of power and wealth, while a decayed stupa shows evidence of exhausted merits.

At the point when the powers of stupa have been exhausted it is common for farmers to loot them for sacred amulets contained within their walls.

These amulets take the form of small tablets of fired clay that have been imprinted with famous images of the Buddha, of revered monks and kings, or of other famous stupa. People wear these amulets around their necks for protection, as they are believed to confer the power of invulnerability on their wearer. They are the most common everyday articles of Buddhist religious faith in Thailand. Amulets derive their power from the rites of sacralisation performed over them at the time of their manufacture, and they can develop more power as they become old and rare because of their association with particular places, events or people. The renown and stories that circulate about the power of amulets is integrally linked to the significance and power of stupa in the everyday practice of Thai Buddhism.

Byrne argues that large numbers of amulets were originally sealed within stupa when they were built as a way of protecting and making the stupa durable and powerful. However, should the power of the stupa decline, liberating the amulets is a way of pouring forth their power into the world, releasing their benefits, which are otherwise smothered in the stupa that has lost its power. This action, which archaeologists might view as a form of 'looting', is actually a way of releasing the energy stored within old stupa that have lost their ability to effect change in the world. Thai people would see this as a form of conservation practice: objects accrue power or efficacy as a result of their contact with (or imitation of the form of) other objects of power or renown, and it is this which forms the most important and sacred aspect of stupa heritage, not necessarily their physical form. It is a form of heritage conservation through the restoration and redistribution of objects and forms of power.

Clearly, such a practice is in contradiction to UNESCO principles, which stress the significance of the fabric or material aspects of heritage. By actively destroying an ancient stupa to release its powerful amulets, Thais would be in breach of the Venice Charter. The model of heritage employed within the Venice Charter presents heritage as complete, untouchable and 'in the past', as well as embodied within tangible things such as buildings and artefacts. Such a model of heritage is based on the idea that the values of heritage are inherent and unchanging (see further discussion in Chapter 1). In contrast, for Indigenous Thais, their model of conservation practice derives from an alternative, non-western way of viewing the relationship between material objects and people, and a concern with the social role of heritage within society.

Examples of similar issues can be found in the widespread practice in the Far East and in India of rebuilding religious structures afresh every twenty years or so. Paradoxically, this practice, which troubles western notions of 'authenticity', has arguably preserved iconographic practice and the appearance of temples more precisely than the processes of alternating decay and restoration prevalent in the discourse of World Heritage. It is worth

pursuing some of these points further, if only to see how far the arguments might extend. If the test of value in the case of the Thai stupa is religious power, then clearly dismantling outworn stupas for their amulets would be justified. But could this principle be extended to the vandalising of tombs for artefacts that can be sold for large sums on the antiquarian market? Have builders down the ages been wrong to re-use cut stone from ruined temples and churches to make new places of religious worship? These are rather sensationalist talking points, but they help us to focus on where the privileged value of heritage lies.

In Chapter 1 of this book it was suggested that heritage studies was concerned with the study of two processes and the relationship between them. The first concerns the ways in which ideas and ideals about official heritage, or authorised heritage discourses, are involved in the production of a 'heritage industry' that controls the distance between people and the past. The second involves the production of identity and community at the local level, which relates both to official and unofficial practices of heritage and has the potential to transform society. The Bamiyan Buddhas and Thai stupa are cases of conflicts between different value systems and ways of perceiving the significance of heritage objects, places and practices. In the case of the Bamiyan Buddhas, these different value systems became the subject of intense international political debate. It is likely that most people would feel that holding World Heritage sites to ransom to make a political point is inappropriate, and legally wrong. But how far can the moral reach of UNESCO principles be extended? The case of Thai Buddhist stupa presents a situation in which the wilful destruction of heritage sites could be viewed from within that culture as a legitimate, even necessary, conservation practice. Clearly then, there is a grey area when the western principles of conservation enshrined in the Venice Charter are applied to non-western contexts.

In the case of the Taliban and the Bamiyan Buddhas, we have seen how heritage can become a symbol of a particular western, materialistic approach to heritage. In some cases, as in the Thai stupa, it could be argued that this approach is contrary or in conflict with the ongoing, living significance of heritage places in the local groups who use them. Another way in which heritage can become embroiled in local, regional or international politics concerns the ownership, both legal and symbolic, of cultural objects that have been removed from their original context. This is a particular issue for museums, many of which hold objects that were obtained during periods of history in which other countries were subject to military occupation or external sovereignty. Some of these issues will resurface in Chapter 7 on heritage and postcolonialism. But for now, the next case study looks at how museums in the UK have dealt with requests to repatriate two very different sorts of cultural object – the Parthenon Marbles from Greece and Indigenous Australian human remains.

Case study: museums, politics and the return of cultural objects

The Parthenon Marbles

The term 'Parthenon Marbles' is used to describe a series of marble sculptures and friezes removed from the Acropolis of Athens in Greece between 1801 and 1810 by Lord Elgin, during the period when he was British ambassador to the Ottoman empire. The bulk of this material derives from the Parthenon, a temple to the Goddess Athena built on the Acropolis between 447 and 432 BCE. The marble sculptures, showing scenes from Athenian mythology, are considered to be among some of the most important works of ancient art in the western canon. The temple fell into ruin but was revived as a Christian church around 500 CE. After the thirteenth-century Ottoman conquest it was used as a mosque. Significant damage to the temple occurred when the city was under siege by the Venetians in 1687, at which time the Parthenon was used as a

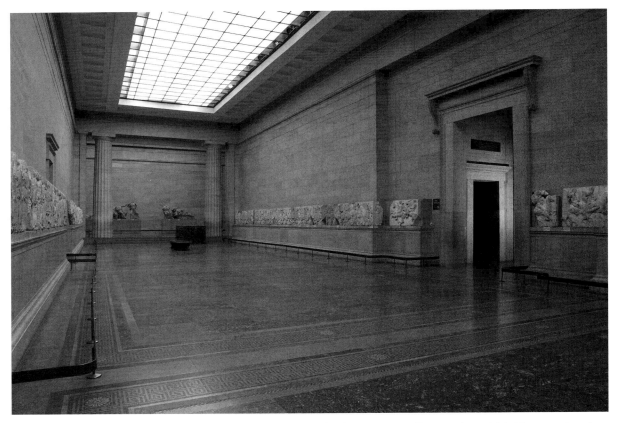

Figure 5.5 Frieze from the Parthenon Marbles on display in the Duveen Gallery at the British Museum, London, 2007. Unknown photographer. Photo: © The Trustees of the British Museum.

gunpowder store. An explosion within the building destroyed the roof and a significant number of the remaining sculptures. By the time Elgin was in Athens the temple was in ruin and approximately half of the sculptures had been lost (Hitchens, 1998). He is estimated to have sent around half of what was left to Britain. For this reason, the Parthenon Marbles held by the British Museum are sometimes referred to as the 'Elgin Marbles'.

Following their transportation to Britain, the sculptures were purchased by the British Museum in 1816. A Parliamentary Select Committee inquiry was held prior to the museum's receipt of the marbles as to whether or not Elgin's acquisition of them was 'legal'. The committee found that he had acted lawfully in removing the sculptures with the permission of the Ottoman government. Since 1962, the marbles have been housed in the purpose-built Duveen Gallery at the British Museum, built by Lord Duveen in 1938 and designed by architect John Russell Pope (King, 2006) (Figure 5.5).

The Acropolis is arguably the most important tourist attraction in Athens, and some sculptural elements still remain on the temple itself, while others are held in a nearby museum. Sculptural elements from the Parthenon temple are now distributed across the world; however, the largest collection is held by the British Museum. Table 5.1 shows the British Museum's published information on other holdings of material from the Parthenon.

Table 5.1 Parthenon sculptural elements held in museums other than the British Museum

Athens	Extensive remains of the metopes (especially east, north and west), frieze (especially west) and pediments; less than 50% is on public display and some is still on the building, including the finest metope
Paris, Musée du Louvre	One frieze slab; one metope; fragments of the frieze and metopes; a head from the pediments
Copenhagen, National Museum	Two heads from a metope in the British Museum
Würzburg, University of Würzburg	Head from a metope in the British Museum
Palermo, Museo Salinas	Fragment of frieze
Vatican Museums	Fragments of metopes, frieze and pediments
Vienna, Kunsthistorisches Museum	Three fragments of frieze
Munich, Glyptothek	Fragments of metopes and frieze; not on display

(Source: British Museum, 2008a)

Although there was significant debate about the appropriateness of their acquisition in Britain at the time of their purchase, and subsequent calls throughout the nineteenth and twentieth centuries by individuals for their

return, it was not until 1965 when the Greek minister of culture called for the return of all Greek antiquities to Greece that the Parthenon Marbles became the subject of international political debate. Actress Melina Mercouri, who became Greek minister of culture in 1982, was a vocal and active champion for the return of the Parthenon Marbles to Greece, making the issue a major feature of national and international Greek government policy. In October 1983, a formal bilateral request for the return was made by the Greek government to the UK government. Following discussion with the British Museum, this request was formally rejected by the UK government in April 1984 (King, 2006).

The British Museum has recorded the subsequent developments, and its summary is worth reproducing here in full.

> At the UNESCO World Conference on Cultural Policies in Mexico of 1982, at Ms Mercouri's instigation, a vote on a resolution calling for the return of the Parthenon marbles and their reincorporation on the building was passed, although there were many abstentions, including Italy and France, and many absentees. In October 1983 a formal bilateral request for the return was made by the Greek Government to the British Government – the first ever made. Following discussion with the Director and Trustees of the British Museum, this request was formally rejected by the British Government in April 1984. It was followed in September by a further submission of a claim through UNESCO, which was similarly rejected in 1985, after consultation with the British Museum. Successive British governments have held the position that this is a matter for the Museum's Trustees who are the legal owners of the Parthenon Sculptures.
>
> In May 1997, following a further direct appeal by the Greek government, the then Secretary of State in the Department for Culture Media and Sport, the Rt. Hon. Chris Smith MP, affirmed the Government's position that the issue was a matter for the trustees of the British Museum and that the Government would not seek to have them returned to Greece. This is still the policy of the British Government.
>
> In October 1999 the Culture, Media and Sport Committee of the House of Commons announced its intention to conduct an enquiry into the return of cultural property and the illicit trade. Following the submission of written evidence and visits to the British Museum, Greece and Italy the Committee held oral sessions, at one of which the Greek Foreign Minister, Mr. George Papandreou, presented the Greek position. The full report was published in March 2000 and the Select Committee advocated no change to the present status of the Parthenon Sculptures in the British Museum.

This position has been reinforced by subsequent cross-party statements, by letters to the British Committee for the Restitution of the Parthenon Sculptures and MEPs from the former Minister for the Arts, the Rt. Hon. Alan Howarth, and by the Prime Minister, the Rt. Hon. Tony Blair, in an interview with the Greek newspaper *To Bima* (March 2001).

In November 2002 Evangelos Venizelos, Greek Minister of Culture, came with a delegation to meet Sir John Boyd, Chairman of the Trustees of the British Museum, and Neil MacGregor, the Director, to present for the first time to the Museum a proposal that the Parthenon Sculptures in the British Museum should be removed to Athens to a new museum being built near the Acropolis, either as a long term loan or as an annex of the British Museum. This proposal was elaborated at a UNESCO committee meeting in March 2003, with the addition of a linkage with the forthcoming Athens Olympics of August 2004.

(British Museum, 2008a)

The Greek government became increasingly concerned with the return of the Parthenon Marbles in the years leading up to the Olympic Games in Athens in 2004, the time at which the statement quoted above was written by the British Museum. The Greek government claimed that the marbles should be returned to Athens on moral grounds, despite the fact that it was no longer possible to reposition them on to the Parthenon. As part of the campaign, it commissioned a New Acropolis Museum, designed by the Swiss-US architect Bernard Tschumi, which was planned to hold the Parthenon sculptures arranged in the same way as they would have been on the Parthenon (Organisation for the Construction of the New Acropolis Museum, 2008) (see Figures 5.6 and 5.7). Although the museum was due to be finished for the Athens Olympics in 2004, it suffered a series of setbacks which saw its completion put back to 2007, at which time the process of moving the parts of the collection in Greek ownership to the new museum began. It was originally suggested that the spaces designated to the Parthenon Marbles and other overseas sculptures should be left empty in protest; however, it was subsequently decided to insert casts which are clearly marked as such in their sequence within the new museum alongside those original pieces already held by the Greek government (Hellenic Ministry of Culture, 2007) (Figure 5.8).

UNESCO, through its UNESCO Intergovernmental Committee for Promoting the Return of Cultural Property to its Countries of Origin or its Restitution in Case of Illicit Appropriation (see UNESCO, 2001), has consistently recommended the return of the Parthenon Marbles to their country of origin and have sought to promote bilateral dialogue between Greece and the UK as UNESCO states parties. The British Museum has consistently argued that it is restrained from returning the marbles by the British Museum Act 1963, which

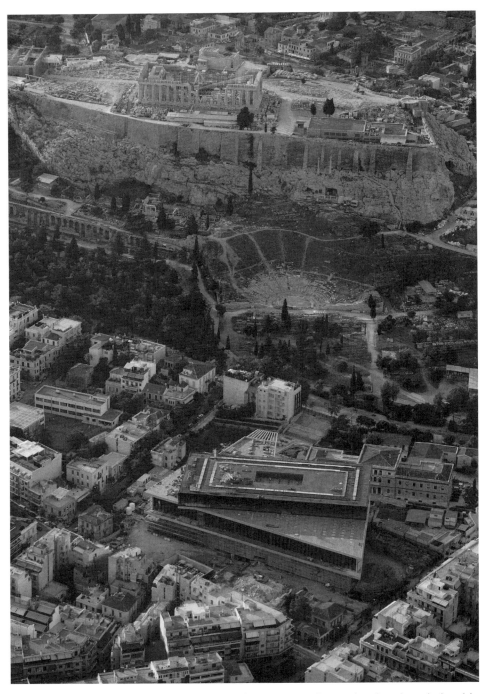

Figure 5.6 Aerial view of the New Acropolis Museum, Athens, showing the relationship between the Acropolis (top), the Theatre of Dionysus (centre) and the New Acropolis Museum (bottom), 2007. Photographed by Nikos Daniilidis. Photo: courtesy of the Archives of the Organization for the Construction of the New Acropolis Museum.

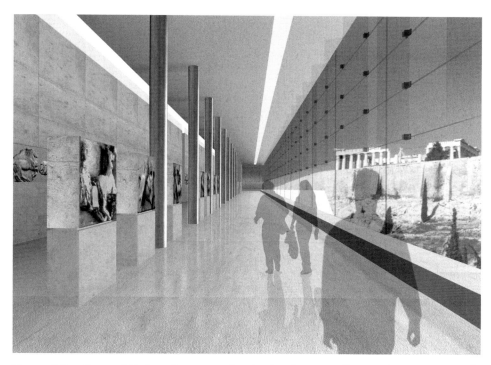

Figure 5.7 Bernard Tschumi's concept for the Parthenon Gallery at the New Acropolis Museum, showing the marbles as they would have been mounted within the temple. Image: courtesy of the Archives of the Organization for the Construction of the New Acropolis Museum.

requires the collections of the national museums to hold objects from their collections in perpetuity and to retain and preserve their assets for study. In 2005 the UK High Court ruled that the Act could not be over-ridden to justify the return of four Old Masters drawings looted by the Nazis from a private owner in Czechoslovakia and acquired after the Second World War by the British Museum. However, provisions of the Human Tissue Act 2004, which came into force in 2006, do allow for the de-accessioning and return of ancestral skeletal remains to indigenous people, and some returns from the British Museum were made to Indigenous Tasmanian people under these provisions in that year (this is discussed further below).

The British Museum's trustees argue that the Parthenon sculptures are integral to the museum's purpose as a world museum telling the story of human cultural achievement. They argue that within the museum Greece's cultural links with the other great civilisations of the ancient world, especially Egypt, Assyria, Persia and Lycia, can be clearly seen, and that the vital contribution of ancient Greece to the development of later cultural achievements in Europe, Asia and Africa can be followed and understood. This, the museum's trustees

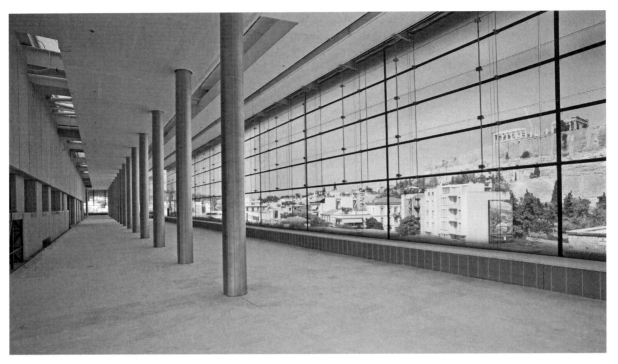

Figure 5.8 Interior of the New Acropolis Museum, 2007. Photographed by Nikos Daniilidis. Photo: courtesy of the Archives of the Organization for the Construction of the New Acropolis Museum. While those marbles that are held by the Greek government will be displayed in their original position within the gallery, at the time of writing, the issue of the return of the Parthenon Marbles held by the British Museum remains unresolved.

believe, is an arrangement that confers maximum public benefit for the world at large. On the British Museum website, they note:

> The British Museum exists to tell the story of cultural achievement throughout the world, from the dawn of human history over two million years ago until the present day. The Museum is a unique resource for the world: the breadth and depth of its collection allows the world public to re-examine cultural identities and explore the complex network of interconnected world cultures.

> Within the context of this unparalleled collection, the Parthenon Sculptures are an important representation of ancient Athenian civilisation. Each year millions of visitors, free of charge, admire the artistry of the sculptures and gain insights on how ancient Greece influenced – and was influenced by – the other civilisations that it encountered.

(British Museum, 2008b)

The trustees of the British Museum have responded to the Greek government's call for the marbles to be returned to the space they had been allocated within the new Acropolis Museum as follows:

> The Trustees of the British Museum welcome the building of the new Acropolis Museum which will allow the Parthenon Sculptures that are in Athens to be appreciated against the backdrop of ancient Greek and Athenian history. The new museum, however, does not alter the Trustees' view that the sculptures are part of everyone's shared heritage and transcend cultural boundaries. The Trustees remain convinced that the current division of the surviving sculptures allows different and complementary stories to be told about them and their significance for world culture.

(British Museum, 2008b)

At the time of writing, the issue remains unresolved (Organisation for the Construction of the New Acropolis Museum, 2008), despite a series of recommendations by the UNESCO Intergovernmental Committee for Promoting the Return of Cultural Property to its Countries of Origin or its Restitution in case of Illicit Appropriation at almost every meeting since 1984 calling for an amicable resolution to the dispute, and encouraging the development of bilateral negotiations between the UK and Greece over the issue.

Reflecting on the Parthenon Marbles

The Greek government believes that the Parthenon Marbles should be returned to Athens. It believes it has, if not a legal claim to ownership, a moral one. The Acropolis plays an important role as a national symbol and is one of Greece's main tourist attractions. It also notes the support of UNESCO for the return of cultural property to its country of origin, and the fact that fragments of the monument have already been returned in the light of this from the Museum of Ethnography, Sweden, the University of Heidelberg, Germany, and the Getty Museum in Los Angeles, USA. The Greek government has built a world-class museum in which to store the objects, so there could be no argument that they would not be as well cared for and accessible as they are at the British Museum.

The British Museum cites legal reasons that it says prohibit it from de-accessioning materials, although, as noted above, the Museum Act 1963 has been over-ridden by other recent legislation in relation to human skeletal remains (see further discussion below). The British Museum says that the significance of the marbles transcends cultural boundaries and that, as they belong to the 'common heritage' of humanity, they are best held in a location where they can be appreciated by all people. It notes that entry to the British Museum is free to support this.

The Parthenon Marbles provide another example of the ways in which notions of universal heritage value are tied up with politics, nationalism and colonialism. The arguments are complex, and for this reason you may find it difficult to give your full allegiance to either side. On the one hand, many people would feel sympathy with the Greek government, as the Parthenon has clearly become an important national symbol that it wishes to display and interpret as fully as possible. On the other hand, the British Museum has a legal claim, and possibly also a moral one, as the marbles have become a part of the 'heritage' of the museum itself and, by extension, part of its reputation as a museum of world culture. One could, perhaps rather cynically, also consider as part of this issue the economic contribution of tourism to view the marbles. The ownership of heritage confers on the owner not only the right to interpret and control access to heritage places but also rights to the economic values of heritage. As discussed in Chapters 1 and 4, the economic values of heritage can never be underplayed in such debates.

How can we weigh claims that an object, place or practice belongs to the common heritage of humanity against claims of the local, regional or national groups for whom it holds important symbolic value, or a role in ongoing religious or cultural life? These issues of the ownership and control of heritage become even more poignant when we consider the thousands of ancestral human remains held in museums worldwide that were removed from settler colonies such as Australia during the eighteenth, nineteenth and twentieth centuries.

Many people would see the return of cultural objects quite differently from the return of human remains, perhaps feeling more sympathetic towards calls for the **repatriation** of human remains while remaining sceptical that such a rule should always be applied in the case of cultural objects. This certainly appears to be the case in the UK, where calls for the return of indigenous ancestral remains have generally been seen in a more positive light than the return of other sorts of objects from museums. In the continuation of the case study, it is interesting to look at the ways in which arguments about the return of indigenous ancestral remains track arguments about objects that have been raised in the case of the Parthenon Marbles in the British Museum.

UK museums and indigenous ancestral human remains

The remains of Indigenous Australians and other indigenous people throughout the world were collected from the countries in which the European nations declared sovereignty during the period of colonial expansion (see further discussion in Chapter 7). Europeans were interested in the different 'racial' characteristics of indigenous people, and in the different forms of society and technology they possessed. Indigenous people and their remains were considered to be a means of understanding the development of civilisation from barbarism, and their skeletons and other human remains were

collected for study as part of the emergent science of physical and social anthropology. As Tom Griffiths (1996) notes, many of the remains of Indigenous Australians were collected using dubious means – such as robbing the graves of the recently deceased, some of whom were murdered by European settlers in disputes and punitive expeditions – and sent to museums overseas. Before the late 1960s Indigenous Australians were not legally considered to be 'citizens' of Australia. The practice of collecting Indigenous Australian human remains and sending them to overseas museums was common as recently as the 1920s and 1930s.

The idea that Indigenous Australians and other hunter-gatherers are 'primitive' humans, and indeed, that civilisation is the end result of human societal development, was extensively challenged and subsequently discarded throughout the course of the twentieth century. New ways of looking at the diversity of human societies suggested that hunter-gatherer peoples could be thought of as 'the original affluent society', as they spent comparatively the shortest time in the quest for food, leaving them 'time-rich' for recreation and social and religious activity (Sahlins, 1968). Nonetheless, reference collections of skeletal remains from around the world continue to provide important sources of information to scientists and archaeologists who study human evolution, prehistory and human diversity.

For Indigenous Australians, the association between people and land is fundamental. The land is the fundamental source of both spiritual and economic well-being, while the land's custodians are significantly involved in undertaking spiritual and physical maintenance activities to take care of the landscape and continue its processes of regeneration. During the 1970s and 1980s Indigenous Australians became increasingly aware that the remains of people they consider to be their ancestors had been removed from their traditional country. With the increased politicisation of communities in the context of the land rights struggle that emerged in the 1970s, Indigenous Australians began to band together to form political action groups, many of them associated with Aboriginal Land Councils, to campaign for the return of ancestral human remains. In Australia throughout the late 1970s and 1980s a number of major collections of human skeletal remains were returned to groups of Indigenous Australians with whom the remains were affiliated. Since the mid-1990s, it has been the practice of all Australian museums that indigenous skeletal remains are returned to communities with whom they hold a cultural or social affiliation when the request is made, and when there are no conflicts over the ownership of the remains between indigenous groups that cannot be resolved by arbitration. Strong over-arching federal policies facilitating the return of Indigenous Australian cultural materials have been in place in Australia since that time.

The first requests for the return of human remains from UK museums were received in the mid-1980s from the Tasmanian Aboriginal Centre (TAC) and the Foundation for Aboriginal and Islander Research Action (FAIRA), who drew considerable media attention to the number of human remains from Australia held in European museums (Fforde and Parker, 2001). Initial calls for the return of skeletal remains were generally met with resistance. The Natural History Museum (NHM), which held almost 500 of the estimated 2000–2500 full and partial sets of indigenous skeletal remains in UK museums (MacAskill, 2000), consistently argued that it was prohibited by the British Museum Act 1963 from repatriating remains. However, some institutions, such as Edinburgh University, Exeter City Museum and Art Gallery and Liverpool Museum, did return items of human skeletal material and other artefacts to individual groups of indigenous people over the 1990s. These museums were not restricted from doing so by the Act, as it applies only to nine 'national' museums.

However, it was not just the law that stopped skeletal material being returned from the NHM and the British Museum, among others. Neil Chalmers, then director of the NHM, noted that 'the Indigenous human remains were used to study human origins and evolution, human diversity, diet and disease. We can do this because we have the whole collection together.' Asked if the scientific benefits outweighed the cultural ones, he said, 'The scientific benefits are global in their importance' (MacAskill, 2000).

In 1999 the UK government convened a House of Commons Select Committee to consider issues relating to the Return and Illicit Trade in Cultural Property. The committee recommended that the Department for Culture, Media and Sport seek commitments 'from all holding institutions in the United Kingdom about access to information on holdings of indigenous human remains for all interested parties, including potential claimants' (Department for Culture, Media and Sport, 2000a, para. 164) and appointed a Working Group on Human Remains in March 2001 to

- examine the current legal status of human remains within the collections of publicly-funded museums and galleries in the UK;
- examine the powers of museums and galleries governed by statute to de-accession, or otherwise release from their possession, human remains within their collections and to consider the desirability and possible form of legislative change in this area;
- consider the circumstances in which material other than, but associated with, human remains might properly be included within any proposed legislative change in respect of human remains;
- take advice from interested parties as necessary;

- consider the desirability of a Statement of Principles (and supporting guidance) relating to the care and safe-keeping of human remains and to the handling of requests for return. If the Panel considers appropriate, to draw up the terms of such a Statement and guidance; and to

- prepare a report for the Minister for the Arts and to make recommendations as to proposals which might form the basis for a consultation document as part of the procedure required under the Regulatory Reform Bill.

<div align="right">(Department for Culture, Media and Sport, 2000b)</div>

Another development around this time was the issuing of a joint prime ministerial statement by John Howard (Australian prime minister 1996–2007) and Tony Blair (UK prime minister 1997–2007) in which they agreed to increase efforts to repatriate human remains to Indigenous Australian communities.

The Department for Culture, Media and Sport published the report of the Working Group on Human Remains in November 2003. The report found that a total of 132 of the 146 responding UK museums held human remains. Between them, these collections housed at least 61,000 human remains. Around half (64) had fewer than 50 items; a quarter (34) had fewer than 10; and larger collections of over 500 items were held by 25 institutions. The key recommendations of the working group were that the law prohibiting the return of indigenous human remains should be changed and a National Human Remains Advisory Service should be established with the power to make recommendations on all issues relating to the return, retention, treatment, handling, use, safekeeping and control of human remains. It was this same law prohibiting national museums from de-accessioning artefacts that has been frequently cited as one of the reasons the British Museum has not repatriated the Parthenon friezes to Greece, as discussed previously.

The National Human Remains Advisory Service was established in 2004, and in the same year the Human Tissue Act 2004 was passed (the service was disbanded in 2008 after it received only a single inquiry). Section 47 of the Act legislated to allow nine named national museums to move human remains from their collections. It gave these museums the power to de-accession human remains where they are those of a person reasonably believed to have died less than 1000 years before the date that Section 47 came into force. While no other museums in the UK are thought to have been subject to this legislative restriction, some museums hold constitutional documents that prohibit de-accessioning, and all museums have since the enacting of this legislation been encouraged to remove such impediments to the repatriation of indigenous human remains. This Act essentially removed any legal impediment to the return of indigenous ancestral remains from museums in

the UK (see Department for Culture, Media and Sport, 2005), while at the same time opening up the possibility that claims could be made on the remains of British ancestors held by these museums.

During the period leading up to, and immediately following, the passing of the Human Tissue Act 2004, the UK press was full of interviews with archaeologists and indigenous people stating the case for and against the repatriation of skeletal remains from UK museums. For example, archaeologist Chris Stringer from the Natural History Museum was quoted in the *Observer* newspaper as saying 'This would be very damaging. We would see whole areas closed off to research if we lost key specimens' (Harris, 2003). The same newspaper article quoted Indigenous Australian activist Rodney Dillon, at that time a commissioner of the Aboriginal and Torres Strait Islander Commission, as saying 'We Aborigines were not put on this earth for British scientists to do research on.' He went on to note, regarding the reburial of Njarringeri (Indigenous South Australian) remains from the Royal College of Surgeons in 2003, 'The spirit of those people was not meant to end up in a cardboard box in some museum. It was meant to look out over the earth' (Harris, 2003).

Museums responded in different ways to the new legislation and guidelines, and the commensurate moral shift towards the right of indigenous people to have their ancestors' remains repatriated. For example, the British Museum issued a policy document (British Museum, 2006; see also British Museum 2008c) acknowledging that, although there were no longer legal impediments to repatriating indigenous human remains, 'the Trustees of the British Museum consider that claims are unlikely to be successful for any remains over 300 years old, and are highly unlikely to be considered for remains over 500 years old, except where a very close geographical, religious and cultural link can be demonstrated'. On the other hand, during 2003 (before the legislation was passed) both the Royal College of Surgeons and the Manchester Museum made major repatriations, in the case of the Royal College of Surgeons of the partial remains of seventy-five Indigenous Australians collected during the late nineteenth century, predominately from Yorta Yorta country in south-eastern Australia.

Despite their staunch stance on the repatriation of human remains throughout the 1990s and early 2000s, in a press release dated 25 March 2006, the British Museum noted that its trustees had

> decided to transfer two Tasmanian cremation ash bundles to the Tasmanian Centre in response to the claim from the Centre made last year. The two bundles, each containing some ash from a human cremation site, are wrapped in animal skin. They were acquired by George Augustus Robinson in about 1838 (Robinson was appointed as conciliator of Aborigines in Tasmania in 1828). They were taken at a time when the Aboriginal population of Tasmania was suffering

greatly from the impact of the European settlement, resulting in substantial population loss. The bundles entered the collection of the British Museum only later via the Royal College of Surgeons in 1882.

(British Museum, 2008d)

This was a historic moment as it marked the first return of Indigenous Australian human remains from a national public museum in Britain. The TAC responded in a media release, calling it

> [a] historic victory for Tasmanian Aborigines ... Tasmanian Aborigines are very happy with this decision to return the two bundles of cremation ashes of our ancestors. These bundles were made to contain ashes remaining after the cremation of the dead, and were worn on the body as talismans against pain, sickness and ill fortune ... This historic occasion – the first British public Museum to return human remains to Aborigines – fulfils the intention of the joint Howard and Blair Prime Ministerial statement of 2000, supporting the repatriation of Australian Aboriginal ancestral remains from the UK. Now the British museum has made this landmark action, we look forward on behalf of all Aborigines to the release of all Aboriginal human remains from all British public museums.

(Maluga, 2006)

However, this historic victory seemed short-lived, setting up what was to be a bitter battle with the NHM over the return of Indigenous Tasmanian human remains from their collections. Although the trustees of the NHM agreed in November 2006 to return the remains of seventeen Indigenous Tasmanian people from its collection, they also made a decision to undertake a range of tests to collect data from the skeletal remains before doing so (Natural History Museum, 2006, 2007a, b). The TAC said that they did not agree to the invasive data collecting techniques proposed, including the extraction of DNA, and sought an interim injunction against the museum, which was granted on 12 February 2007 in the High Court of England and Wales. An article in the *Tasmanian Examiner* newspaper reported TAC director Michael Mansell as saying that

National History Museum

> the museum planned a range of tests for the remains – including taking DNA samples, X-rays and cutting away portions of bone, hair samples and tissues – which was unacceptable to Tasmanian Aborigines. 'It is absolutely contradictory to Aboriginal tradition,' he said. 'They should hand over the remains unconditionally.'

(Lowe, 2007)

The museum retaliated by seeking legal advice as to how to challenge the injunction. The battle culminated in a series of protests held on the steps of the museum by indigenous activists from Tasmania, and a number of other British

Museum directors speaking out against the approach of the NHM in the media. The following account is from *The Sunday Age* newspaper on 11 March:

> The fury emanating from the Tasmanian Aboriginal community is countered by the science-focused response from the NHM's director, Michael Dixon. Mr Dixon says the museum must balance the claims of the Aboriginal community with its duty to the international scientific community, to study the remains via modern research means. He says the research has become more important because the remains will no longer be available to science after their return to Tasmania ... But other museum leaders criticise the NHM's position. A former director of the Manchester Museum says the NHM is breaching ... the principle relating to respect for the interests of originating communities and involving them in decisions about how collections are used. 'The decision by the NHM to carry out further research on the remains ... was unethical,' he says. 'It's not rocket science. If you've got something that doesn't belong to you, you give it back and you treat the true cultural owners with proper consideration.'

(May, 2007)

The use of the term 'belong' is interesting here. In the sense of property rights, it could be argued that the museum owned the skeletal remains and held them lawfully. However, in the wake of postcolonialism and changing perceptions of the implications of imperialism, the idea that objects of heritage are more truthfully owned 'culturally' has become increasingly important, and is one of the global moralities that has helped bring about the end of colonialism in the modern world. Ideas about heritage and postcolonialism are explored further in Chapter 7.

The NHM and TAC went into mediation over the remains in May 2007, and reached an agreement after three days (Figure 5.9). It was decided that the remains and the DNA extracted from them would be handed over immediately to the TAC, but that certain of the remains on which testing had not been completed would be held in Tasmania under the joint control of both the TAC and the NHM, pending further discussion. Of particular interest to the scientists from the NHM were the DNA remains, but the TAC will hold the right to allow access to these in the future. A protest that had begun more than twenty years earlier had finally reached some form of conclusion. However, at the time of writing the TAC continues to protest over Indigenous Tasmanian human remains held in other UK museums, including those held by Cambridge University.

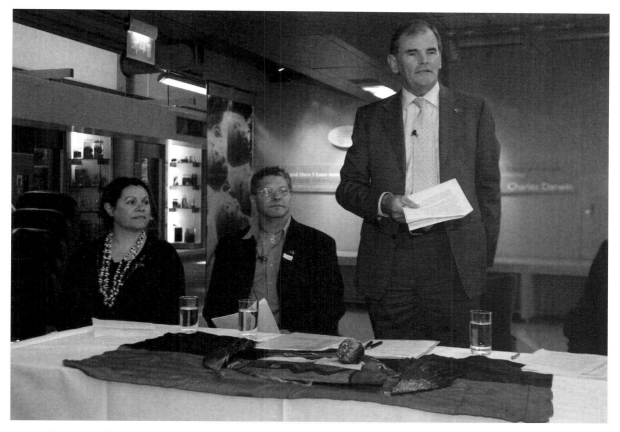

Figure 5.9 Caroline Spotswood (left) and Greg Brown (centre) from the Tasmanian Aboriginal Centre (TAC) look on as Oliver Stocken (right), chairman of the board of trustees for the Natural History Museum in London, talks during a ceremony to mark the agreement with TAC to return human remains to Australia, London, 11 May 2007. Photographed by Lefteris Pitarakis. Photo: © Lefteris Pitarakis/AP/PA Photos.

Reflecting on the case study

Ownership confers rights to control income and access, and to use heritage to tell particular kinds of stories about the past. Some museum staff and archaeologists who oppose repatriation believe that research into human evolution and human diversity requires modern collections of human remains, and that if remains are repatriated, new scientific techniques developed in the future cannot be used to study them. They are concerned that indigenous people might re-bury the remains and that they would be lost to science; and they cite the argument that the collections are part of the universal heritage of humankind.

On the other hand, Indigenous Australians arguing for the return of remains note that museums in the UK have no more 'moral' right than the legitimate

ancestors of these people to determine what is most appropriate for them, and that holding these human remains represents an exploitation of unequal colonial power relationships from the past. They say that all people have the right to have their ancestors laid to rest in a culturally appropriate manner. Indigenous people do not recognise that the 'age' of cultural remains distances them from custodianship of them, and for this reason the custodianship of these remains is integral to their religious and cultural values.

As in the other examples discussed in this chapter, there are no easy answers. As a reader you might find that you sympathise more with one or other of these viewpoints, but I hope that you can see there are clear arguments both for and against repatriation of cultural materials from museums. The question remains how far such arguments can be extended, and whether they signal the demise of the museum as a collecting institution for overseas materials. At the time of writing, the UK government has passed legislation on returning human remains, but this has not been extended to other artefacts. Clearly, there is a perception that the political argument in the case of human remains over-rides the 'scientific' and 'curatorial' arguments, as fundamental beliefs about life and death are at stake. In the case study a strong distinction has been noted between politics on the one hand and professional arguments about the 'scientific' values of heritage on the other. It remains unclear what the future consequences of these debates will be, especially with regard to the moral claims for repatriation, but it is worth reflecting on how far these arguments might be extended to cover the whole process of colonialism and conquest, issues which receive more attention in Chapter 7.

World Heritage and universal values

The concept of universal heritage value that lies at the heart of the UNESCO World Heritage Convention can be seen to be problematic in several ways. In the first instance, it assumes a particular (western) model of heritage in which the values of an object or place are inherent in its physical fabric. We have seen in the case of the Thai stupa how such notions are not necessarily shared across all global societies. This can lead to conflicts in the management of heritage that is perceived to be of 'world' significance. In the case of the Bamiyan Buddhas we have seen how the opinions of those on the 'right' side of UNESCO, as well as those countries that are more powerful in global politics, will find it easier to have their ideas about the correct management of heritage accepted at an international level. We have also seen how, in such circumstances heritage (especially World Heritage) becomes a powerful symbol that those who feel politically threatened might hold to ransom in order to gain a space within an

international political arena. Such actions are not new – for an earlier example we need only think of the 'Baedeker raids' in the Second World War, in which German bombing raids were carried out on cities and sites that had been identified as picturesque in the Baedeker guidebooks. What has changed is the way that heritage has become increasingly caught up in global politics through formal conventions and statutes, and the ways that it has increasingly become linked to expressions of nationalism by various nation-states. This makes heritage a volatile target for attack and global terrorism by those seeking to draw attention to their alternative political positions.

The concept of universal heritage value is also problematic in that it assumes that the management of World Heritage for the needs of the world community should necessarily over-ride local interests. While UNESCO has put much energy into addressing issues of global diversity and conflicts between local and global interests, there remains a fundamental problem with the concept of World Heritage: as Lynn Meskell reminds us, it overwrites the local cultural context of heritage with a language and method of management focused on the idea of international ownership, access and values. In many cases, such as the British Museum's argument regarding the Parthenon Marbles, this idea of universal values is used to over-ride local interests. Nonetheless, in other cases, such as the return of Indigenous Australian skeletal remains, indigenous people have been able to make use of the global networks of heritage to highlight their plight for the attention of much larger audiences, using an authorised language of heritage that has ultimately seen them triumph and have cultural materials returned. This case study has raised important issues regarding heritage in settler and colonial contexts which will be pursued further in Chapter 7.

Conclusion

This chapter has discussed a series of case studies in the politics of heritage. Once heritage moves into the political arena it becomes a symbol of something else – nationalism, culture, class – a touchstone around which people can muster their arguments and thoughts. Such a way of viewing heritage seems a long way from the apparently 'objective' judgements that UNESCO and the World Heritage Committee suggest should be taken in assessing the significance of heritage. But this chapter should have helped underline for you why people think heritage is important, and the ways in which heritage comes to stand for political principles. In the chapters that follow you will have the chance to look in more detail at the relationships between the politics of heritage, nationalism, colonialism, postcolonialism and class.

Works cited

Agence France-Presse (2001) 'Decree from Taliban orders destruction of statues', *New York Times*, 27 February [online], www.nytimes.com/2001/02/27/world/27AFGH.html?ex=1202878800&en=ad6c2e9efda4456b&ei=5070 (accessed 11 February 2008).

BBC News (2006) Who are the Taliban? *BBC News Online*, http://news.bbc.co.uk/1/hi/world/south_asia/1549285.stm (accessed 12 February 2008).

Bearak, B. (2001) 'Over world protests, Taliban are destroying ancient Buddhas', *New York Times*, 4 March [online], www.nytimes.com/2001/03/04/world/04AFGH.html?ex=1202878800&en=8616ae683eeed445&ei=5070 (accessed 12 February 2008).

Benton, T. (2010) 'Heritage and changes of regime' in Benton, T. (ed.) *Understanding Heritage and Memory*, Manchester, Manchester University Press/Milton Keynes, The Open University.

British Museum (2006) The British Museum's Policy on Human Remains [online], www.britishmuseum.org/PDF/Human%20Remains%206%20Oct%202006.pdf (accessed 14 February 2008).

British Museum (2008a) The Parthenon Sculptures: Facts and Figures [online], www.britishmuseum.org/the_museum/news_and_debate/debate/parthenon_sculptures/facts_and_figures.aspx (accessed 13 February 2008).

British Museum (2008b) The Parthenon Sculptures: The Position of the Trustees of the British Museum [online], www.britishmuseum.org/the_museum/news_and_press_releases/statements/the_parthenon_sculptures/parthenon_-_trustees_statement.aspx (accessed 13 February 2008).

British Museum (2008c) Human Remains [online], www.britishmuseum.org/the_museum/news_and_debate/debate/human_remains.aspx (accessed 14 February 2008).

British Museum (2008d) Request for Repatriation of Human Remains to Tasmania [online], www.britishmuseum.org/the_museum/news_and_press_releases/statements/human_remains/repatriation_to_tasmania.aspx (accessed 14 February 2008).

Byrne, D. ([1991] 2008) 'Western hegemony in archaeological heritage management' in Fairclough, G., Harrison, R., Jameson, J.H. Jr and Schofield, J. (eds) *The Heritage Reader*, Abingdon and New York, Routledge, pp. 229–34.

Byrne, D. (1995) 'Buddhist stupa and Thai social practice', *World Archaeology*, vol. 27, no. 2, pp. 266–81.

Crosette, B. (2001) 'Taliban explains Buddha demolition', *New York Times* (19 March) [online], www.nytimes.com/2001/03/19/world/19TALI.html?ex=1202878800&en=d4a08c68da5a00a3&ei=5070 (accessed 11 February 2008).

Department for Culture, Media and Sport (2000a) *Report and Proceedings of the Committee on Culture, Media and Sport, Seventh Report*, London, The Stationery Office.

Department for Culture, Media and Sport (2000b) *Fourth Special Report: Cultural Property: Return and Illicit Trade: Initial Government Response to the Seventh Report from the Culture, Media and Sport Committee, Session 1999–2000*, London, The Stationery Office.

Department for Culture, Media and Sport (2005) *Guidance for the Care of Human Remains in Museums*, London, Department for Culture, Media and Sport.

Duffy, E. (1992) *The Stripping of the Altars*, New Haven, CT and London, Yale University Press.

Fforde, C. and Parker, L.O. (2001) 'Repatriation developments in the UK', *Indigenous Law Bulletin*, Austlii [online], www.austlii.edu.au/cgi-bin/sinodisp/au/journals/ILB/2001/10.html?query=Repatriation%20Developments%20in%20the%20UK (accessed 3 December 2008).

Gamboni, D. (2001) 'World Heritage: shield or target?', *Getty Conservation Institute Newsletter*, no. 16, pp. 5–11.

Griffiths, T. (1996) *Hunters and Collectors: The Antiquarian Imagination in Australia*, Cambridge, Cambridge University Press.

Harris, P. (2003) 'Vital evidence "will be lost for ever" if ancestral remains are returned', *Observer* (1 June).

Hellenic Ministry of Culture (2007) Restitution of the Parthenon Marbles [online], http://odysseus.culture.gr/a/1/12/ea120.html (accessed 13 February 2008).

Higuchi, T. and Barnes, G. (1995) 'Bamiyan: Buddhist cave temples in Afghanistan', *World Archaeology*, vol. 27, no. 2, pp. 282–302.

Hitchens, C. (1998) *Imperial Spoils: The Curious Case of the Parthenon Marbles*, London and New York, Verso.

Jenkins, S. (2007) 'In Iraq's four-year looting frenzy, the allies have become the vandals', *Guardian* (8 June) [online], www.guardian.co.uk/commentisfree/2007/jun/08/comment.iraq (accessed 12 February 2008).

King, D. (2006) *The Parthenon Marbles*, London, Hutchinson.

Lowe, M. (2007) 'Legal action over remains', *Tasmanian Examiner* (12 February).

MacAskill, E. (2000) 'Britain pressed to return Aboriginal bones: Australian PM asks Blair for 2000 remains to be repatriated', *Guardian* (5 July).

Maluga, T. (2006) 'Historic Victory for Tasmanian Aborigines', Tasmanian Aboriginal Centre Media Release (24 March).

May, J. (2007) 'High cost of bitter battle of the bones', *The Sunday Age* (11 March).

Meskell, L. (2002) 'Negative heritage and past mastering in archaeology', *Anthropological Quarterly*, vol. 75, no. 3, pp. 557–74.

Natural History Museum (2006) Human Remains to be Returned [online], www.nhm.ac.uk/about-us/news/2006/november/news_10019.html (accessed 13 February 2008).

Natural History Museum (2007a) Museum Offers Alternative Human Remains Resolution to TAC [online], www.nhm.ac.uk/about-us/news/2007/february/news_10686.html (accessed 13 February 2008).

Natural History Museum (2007b) Agreement on Aboriginal Remains Reached [online], www.nhm.ac.uk/about-us/news/2007/may/news_11682.html (accessed 13 February 2008).

Organisation for the Construction of the New Acropolis Museum (2008) New Acropolis Museum [online], www.newacropolismuseum.gr/eng/ (accessed 13 February 2008).

Porter, S. (1994) *Destruction in the English Civil Wars*, Stroud, Alan Sutton.

Sahlins, M. (1968) 'Notes on the original affluent society' in Lee, R.B. and DeVore, I. (eds) *Man the Hunter*, New York, Aldine Publishing Company, pp. 85–9.

UNESCO (2001) *The Return or Reconstitution of Cultural Objects Information Kit*, Paris, UNESCO.

UNESCO (2003) Nomination file for the Cultural Landscape and Archaeological Remains of the Bamiyan Valley [online], http://whc.unesco.org/en/list/208/documents/ (accessed 12 February 2008).

UNESCO (2008) Intergovernmental Committee for Promoting the Return of Cultural Property to its Countries of Origin or its Restitution in Case of Illicit Appropriation Archives [online], www.unesco.org (accessed 13 February 2008).

United Nations (2000) Resolution A/RES/54/185 [online], www.unama-afg. org/docs/_UN-Docs/_ga/_resolutions/ares54185.pdf (accessed 2 December 2008).

Further reading

Bianchi, R. and Boniface, P. (eds) (2002) 'The politics of World Heritage', special issue, *International Journal of Heritage Studies*, vol. 8, no. 2.

Carman, J. (2005) *Against Cultural Property: Archaeology, Heritage and Ownership*, London, Duckworth.

Cleere, H. (2000) 'The uneasy bedfellows: universality and cultural heritage' in Layton, R., Stone, P.G. and Thomas, J. (eds) *Destruction and Conservation of Cultural Property*, London and New York, Routledge, pp. 22–9.

Fforde, C., Hubert, J. and Turnbull, P. (eds) (2002) *The Dead and their Possessions: Repatriation in Principle, Policy and Practice*, London and New York, Routledge.

Greenfield, J. (1996) *The Return of Cultural Treasures* (2nd edn), Cambridge, Cambridge University Press.

Hoffman, B. (ed.) (2006) *Art and Cultural Heritage: Law, Policy, and Practice*, Cambridge, Cambridge University Press.

Hubert, J. and Fforde, C. (2005) 'The reburial issue in the twenty first century' in Corsane, G. (ed.) *Heritage, Museums and Galleries: An Introductory Reader*, London and New York, Routledge, pp. 107–21.

Karlström, A. (2005) 'Spiritual materiality: heritage preservation in a Buddhist world?', *Journal of Social Archaeology*, vol. 5, pp. 338–55.

Karp, I., Krantz, C., Szwaja, L. and Ybarra-Frausto, T. (eds) (2006) *Museum Frictions: Public Cultures/Global Transformations*, Durham, NC, Duke University Press.

Littler, J. and Naidoo, R. (eds) (2005) *The Politics of Heritage: The Legacies of 'Race'*, London and New York, Routledge.

Macdonald, S. (ed.) (1997) *The Politics of Display: Museums, Science, Culture*, London and New York, Routledge.

Meskell, L. (2002) 'Negative heritage and past mastering in archaeology', *Anthropological Quarterly*, vol. 75, no. 3, pp. 557–74.

Renfrew, C. (2000) *Loot, Legitimacy and Ownership: The Ethical Crisis in Archaeology*, London, Duckworth.

Skeates, R. (2000) *Debating the Archaeological Heritage*, London, Duckworth.

Smith, L. (2004) *Archaeological Theory and the Politics of Cultural Heritage*, London and New York, Routledge.

Weiss, L. (2007) 'Heritage-making and political identity', *Journal of Social Archaeology*, vol. 7, no. 3, pp. 413–31.

Chapter 6 Heritage and nationalism

Richard Allen

This chapter explores the relations between heritage and nationalism particularly in the period after the change from colonial rule to independence in India. It does this through three case studies – the Taj Mahal, the National Museum in Delhi, and the Babri Masjid (or Babar's Mosque) in Ayodhya. India is a large and diverse country, and the approach is selective. The chapter does not aim to consider the relationship between heritage and nationalism across India as a whole. All three case studies are from central-northern India. This approach provides for a degree of depth in the treatment and enables understanding as certain themes recur. The case studies also raise issues concerning the basis on which heritage is to be defined. Is it, as perhaps in the case of the Taj Mahal, on the basis of aesthetic criteria or on the basis of historical significance that is unrelated to nationalism (one might argue that the Taj Mahal is part of the heritage of Afghanistan and Iran more than India)? Nationalism is a political force. To what extent are political ideas an appropriate means of defining whether or not an object is heritage, and how are they to be compared with, for example, arguments from archaeology? The concluding discussion relates issues raised by the case studies to the question of the relationship between heritage and nationalism more generally.

Introduction

At midnight on 14 August 1947 the modern republic of India came into existence. The new prime minister, Jawaharlal Nehru, began his speech to the Constituent Assembly of India, delivered in English, with these powerful words:

> Long years ago we made a tryst with destiny, and now the time comes when we shall redeem our pledge, not wholly or in full measure, but very substantially. At the stroke of the midnight hour, when the world sleeps, India will awake to life and freedom. A moment comes, which comes but rarely in history, when we step out from the old to the new, when an age ends, and when the soul of a nation, long suppressed, finds utterance.

(Nehru, 1947)

Though Nehru's choice of words may seem driven by rhetoric, it is significant: the soul of *a* nation, *India* will find utterance at *a* moment. Implicit in this speech is a recognition of the contrasts between the old and the new. Nehru made no reference to the simultaneous independence achieved by

Pakistan, or that two key areas – Jammu and Kashmir, and Hyderabad – which had never been part of British India, had still not agreed to be part of the new nation.

In evoking 'the soul of a nation', Nehru had in mind ideals as well as pragmatic and political matters. In a speech on 15 August he said, 'One first and immediate objective must be to put an end to all internal strife and conflict'. He reinforced this objective in a speech delivered to the Assembly in November of the same year when he proclaimed, 'if India lives, all parts of India also live and prosper. If India is enfeebled, all her component elements grow weak'. For almost ten years his aim remained the same: 'My profession,' he wrote, 'is to foster the unity of India' (King, 1998, pp. 102, 132).

To speak of 'the soul of a nation' is not the same as to speak of the heritage of a nation, yet the terms have much in common. There are many accounts of the origin and development of nationalism in its modern form but the most generally accepted is that it 'became prevalent in North America and Western Europe in the latter half of the eighteenth century' (Hutchinson and Smith, 1994, p. 5). In those contexts it was involved in the creation of new nations. Laurajane Smith writes that in the nineteenth century 'national and racial discourses coalesced and naturalised a link between concepts of identity, history, and territory to establish a doctrine of "blood and land" ... It is within this context of the developing narrative of nationalism and of a universal modernity that a new, more pointed concern for what we now identify as "heritage" emerged' (Smith, 2006, p. 18).

There is a strong alignment between the nineteenth-century ideas that Smith evokes and Nehru's idea of 'the soul of a nation', and it is not surprising that Nehru should speak in such language. The Indian National Congress, which became the dominant force in the struggle for independence, is generally taken to date from December 1885 when a group of activists met in Bombay to develop a more coordinated campaign against British rule. But they had a further task to undertake: 'The first major objective of the founders of the Indian national movement was to promote this process, to weld Indians into a nation, to create an Indian people' (Chandra et al., 1989, p. 74).

The mission of the Indian National Congress then contained national and local political action of all kinds but it also featured a mission to create or recreate something akin to what Smith describes as an authorised heritage discourse (AHD), namely the 'forg[ing of] a sense of common identity based on the past' (Smith, 2006, p. 29). The tragedy of Indian nationalism was that it achieved its objective not through the creation of the nation envisaged in 1885 or a common identity but through Partition, the division of British India into the separate states of India and Pakistan (including then both the present Pakistan and the former East Pakistan, now Bangladesh). The states were divided essentially on the basis of religion, but the result was that many people

found themselves in the 'wrong' state (Hindus and Sikhs in Pakistan, Muslims in India). Violence erupted in the vast migrations that followed, and a million people died (Butalia, 1998, p. 3).

Meanwhile there were also divisions among Hindus in India. The Rashtriya Swayamsevak Sangh (the National Volunteers organisation, known usually by its initials RSS) was founded in 1925. The RSS and its allies expressed ideas in an extreme fashion, sometimes clearly modelled on the European fascist ideologies and plainly very different from the ideals of Hinduism put forward by Gandhi. One of the most notorious events in the history of this divide was when on 18 January 1948 Gandhi was assassinated by a RSS member because of his continuing advocacy of religious tolerance. These divisions continue to have a force and moved to a new level in 1980 when a mainstream political party, the Bharatiya Janata Party (BJP), was formed with the aim of creating an explicitly Hindu India.

And yet through all these divisions the ideals set out by Nehru remain the dominant force in Indian culture and a point of strong belief for many millions of Indians from all classes. In his speech on the sixtieth anniversary of independence Manmohan Singh (Indian prime minister 2004–) spoke of these ideals and his aspirations for India. His vision includes 'An India that is united despite its many diversities ... An India that is not divided by caste, creed or gender' (Singh, M., 2007).

Rather than a general survey of heritage and nationalism in India, this chapter offers three case studies. The first, concerned with the Taj Mahal, focuses on a building which represents the existence within India of what to many might seem a relatively unproblematic 'heritage'; from a number of points of view nationally and internationally it seems ideally suited to the heritage management processes set out in Chapter 1. The second case study focuses on the National Museum in Delhi. Museums played an important role in colonial and imperial societies. The British Museum in London and the Louvre in Paris, for example, both expressed the power of their respective states to appropriate materials from across the world and collect them in a metropolitan city that in this way proclaimed itself to be at the centre of the world. Any country gaining independence has to strike back against this, especially through the creation of a museum in the country itself in which the key events and artefacts of its own culture are collected. As a new museum is created choices are made: about how things are to be displayed, what is to be displayed, and what kinds of explanation are to be provided which define the heritage of the country as it appears there. The third case study focuses on a building but also on events. The building is a mosque, the Babri Masjid at Ayodhya. The events are the struggle for ownership by Hindus, the eventual destruction of the mosque in 1992, and the claims and counter-claims about the destruction.

Case study: the Taj Mahal

The Taj Mahal (literally but quite inappropriately the 'Crown Palace') is situated in Agra in North India, approximately 200 km south of the Indian capital Delhi (Figure 6.1). It was built at the command of the Mughal emperor Shah Jahan as a tomb and memorial for his beloved wife Mumtaz Mahal who died in 1630, and was completed in 1643 (Koch, 2006, p. 84).[1] Following a period of illness, and a dynastic struggle, Shah Jahan was succeeded in 1658 by his son, Aurangzeb. Shah Jahan was imprisoned by his son in the Red Fort at Agra from which he could see – but never visit – the tomb of Mumtaz Mahal. The site as it is seen today, centred on the tomb itself and its flanking buildings, is much reduced from the original, as large parts have disappeared under the surrounding houses and lanes.

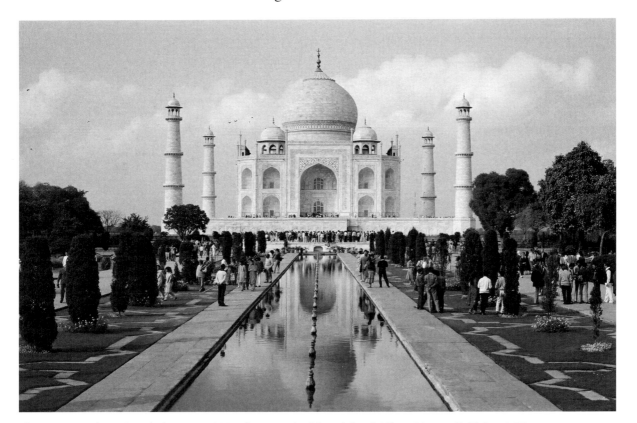

Figure 6.1 The Taj Mahal, Agra, 1990. Photographed by Richard Allen. Photo: © Richard Allen.

As a monument today the Taj Mahal is extremely accessible: it offers a relatively compact history, and a unified and highly symmetrical group of buildings. The tomb itself is faced entirely in marble; parts carry inscriptions

[1] I depend heavily in this discussion on Professor Koch's magnificent study.

from the Koran, and parts are decorated with inlays to show flowers. The marble is not polished but does reflect the light. The tomb thus subtly changes colour as the day goes on; by moonlight it is strikingly atmospheric. Although the Taj Mahal is set in a city of well over 1 million people, and the monument has around 3 million visitors a year, the site overall retains a surprisingly tranquil atmosphere, partly because motor traffic is banned from the surrounding streets but also because it overlooks the Yamuna river.

The Taj Mahal has a clear official heritage status. In British India it fell within the care of the Archaeological Survey of India, through the Ancient Monuments Preservation Act 1904. After independence this was restated through the Ancient and Historical Monuments and Archaeological Sites and Remains (Declaration of National Importance) Act 1951, and developed further through the Ancient Monuments and Archaeological Sites and Remains Act 1958. Without doubt the Taj Mahal falls within the category of 'archaeological sites ... declared to be of national importance' as set out in the 1958 Act (Government of India, [1958] 2008a, p. 5). Since 1983 it has also had World Heritage status as site 252 under Criterion (i); that is, it 'represent[s] a masterpiece of human creative genius (UNESCO, 1983, 2008a, 2008b). The 'heritage' of the Taj Mahal is managed as a conservation project and is a significant part of a tourism industry that has always been an important source of foreign exchange earning (see D'Monte, 2007).

What does the Taj Mahal heritage 'regulate'?

In her examination of 'regulatory' aspects of heritage Laurajane Smith writes,

> The authorized heritage discourse ... focusses attention on aesthetically pleasing material objects, sites, places and/or landscapes that current generations 'must' care for, protect and revere so that they may be passed to nebulous future generations for their 'education', and to forge a sense of common identity with the past.

(Smith, 2006, p. 29)

The phrasing here coincides with parts of Jawahlal Nehru's Independence Day speech quoted at the beginning of the chapter. How does the Taj Mahal as it exists as a public monument, a World Heritage site, today 'forge a common identity with the past'?

A religious monument and a secular nation and heritage

Hinduism is and has long been a powerful force in India, but the Indian constitution, developed under the leadership of the Indian National Congress, declares India to be a secular state. As noted, the Taj Mahal is now in the care of the Archaeological Survey of India, an agency of the secular state. To visit

the Taj Mahal is, accordingly, generally a secular experience. Visitors are required to remove their shoes at the main platform and the central building itself, but plastic overshoes are provided, which minimises the observance. The secular nature of the experience has perhaps been further reinforced by the closing of the room below the platform in which the actual tombs of Mumtaz Mahal and Shah Jahan stand. Now only the highly decorated cenotaph memorials are seen, at platform level. Even when the lower room was open, however, the crush of visitors was by no means conducive to any kind of religious meditation.

Historically, it can be argued, it is appropriate that the monument stands now as a generally secular heritage object. As Ebba Koch explains, although the Taj Mahal stands in a line of development of large Mughal tombs, the building of such tombs is not orthodox in Muslim tradition: 'to orthodox eyes, large domed mausoleums were the most objectionable form of monument' (Koch, 2006, p. 85). Shah Jahan himself ruled in a way that emphasised great buildings – 'highly aestheticised form was used consistently as an expression of his specific state ideology, where central power and hierarchic order were seen to bring about balance and harmony' (Koch, 2006, p. 13). Mumtaz Mahal's death was therefore celebrated while Shah Jahan ruled and while the mausoleum was being built, but during the reign of his son Aurangzeb, for whom 'religious orthodoxy was the dominant theme of his reign' (Robinson, 2007, p. 160), the mausoleum and any kind of religious observance inside was viewed with less favour. Though the mausoleum itself is flanked by a mosque there is also almost no history of religious observance inside the buildings, and certainly by the late eighteenth century the mosque was treated as just a pavilion and used for banquets by British visitors (Koch, 2006, p. 181).

The secular aspects of the AHD of the Taj Mahal however also regulate meanings in a religious context. From a historical point of view, they work to exclude the fact that the great figures of Mughal history were outsiders and conquerors, and incorporate them into the Indian heritage that existed before British rule. From a present-day point of view, the secularism of the site goes some way to mitigating the potentially problematic circumstance of a largely Hindu state being represented globally by a Muslim monument. This secularisation is not, however, always completely effective. Extreme Hindus claim that the building is not truly a Mughal monument: as one website has it:

> The writer Abdul Hamid has stated that Taj Mahal is a temple-palace taken from Jaipur's Maharaja Jaisigh and the building was known as Raja Mansingh's palace. This by itself is enough proof to state that Tejo Mahalaya [the Taj Mahal] is a Hindu structure captured, plundered and converted to a mausoleum by Shah Jahan and his henchmen.
>
> (Khan, n.d.)

This interpretation, however, flies in the face of all the evidence.

An image of heaven, Afghanistan (or England)

It is usually said that the buildings and gardens of Shah Jahan's dynasty were designed to echo the symbolism and the style of gardens in Afghanistan, where their dynasty originated. They embody an image of heaven; the open balconies and formal gardens provide cool breezes and the play of water, which contrast with the desert heat and dryness. But seeing the Taj Mahal and its gardens in terms of a story of Mughal India also suppresses other stories. The original craftsmen did not limit themselves to Islamic models but took advantage of an international trade in culture; the design of some inlaid marble panels copies European models (see Figure 6.2). The gardens are also the result of long-term conservation by the Archaeological Survey of India. Their form reflects current ideas of conservation at least as much as it reflects some historic reality. The Archaeological Survey of India's thinking on matters of archaeology and conservation was built on principles and leadership exported from Britain to the empire. Though influential figures such as Sir John

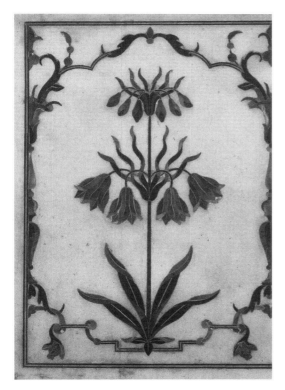

Figure 6.2 Detail of pietra dura on the plinth of the cenotaph of Shah Jahan, Taj Mahal, 1992. Photographed by Jean-Louis Nou. Photo: © akg-images, London/Jean-Louis Nou. The flower depicted is a *Fritillaria imperialis* (a Crown Imperial). Such depictions have a long history in Muslim art, but images such as this have almost certainly a double cultural history because they are probably influenced by French and Dutch flower paintings imported by the Mughal emperors and members of the courts.

Strachey had been active in the 1880s, perhaps the key figure here was Lord Curzon, viceroy from 1898 to 1905 who invested a huge amount of energy and resources on conservation in India, and particularly in Agra where he is said to have spent £50,000 on renovation (Gilmour, 1994, p. 181). Curzon was an exceptionally well-informed amateur in these matters. After his return from India, for example, he restored Montacute House (Somerset), Bodiam Castle (East Sussex) and Kedleston Hall (Derbyshire). But whereas Koch notes carefully that 'in our present state of knowledge, we can only guess at the Mughal planting to a certain extent', Curzon's Report to the Legislative Council in 1904 announced confidently that 'the discovery of old plans has enabled us to restore the water-channels and flower-beds of the garden more exactly to their original state' (Koch, 2006, p. 138). Visitors to the Taj Mahal today, admiring the lamp that hangs in the central chamber of the mausoleum, may not realise that it owes its origin to Curzon '[who had] it made in Cairo after a "Saracenic" design he had "found in a book" on the Islamic monuments of that city' (Koch, 2006, p. 166). It can be argued that the AHD in independent India has everywhere to regulate understandings of past interactions between India and Britain.

'My Taj'

The final example of the AHD which the Taj Mahal creates negates that history to make the Taj Mahal very much a building of the moment. This heritage goes back to the beginning, and to the immense strength of the love for Mumtaz Mahal that drove Shah Jahan to order the building of the mausoleum and take such an interest in its completion. This personal and emotional heritage meaning has been fuelled in recent years not only for visitors but also for Indians by the meaning ascribed to a visit made to the Taj Mahal by the late Princess Diana, then still married to Prince Charles, in February 1992. Diana was asked to sit on a bench in front of the mausoleum for a photo opportunity; when the photograph was reproduced some combination of elements allowed it to be read as expressing the essence of her heart (Figure 6.3). As the caption on the BBC website has it: 'during a trip to India with Charles, Diana is pictured alone at the Taj Mahal – the image is seen to symbolise a failing marriage' (BBC News, 2008). The Taj Mahal's own website's caption is more direct: 'away from her husband Prince Charles she visited, perhaps the greatest monument to love, alone' (Taj Mahal, 2008).

Visitors to the Taj Mahal will know how strong a hold this moment still has, and that the guides will encourage those in their charge to emulate Diana's photographer – if not Diana herself. The strength of the pattern is shown in the following report from the *Indian Express* of 27 January 2008 of a visit by Nicolas Sarkozy (French president 2007–), not long before his marriage to Carla Bruni.

Accompanied by a large delegation and dogged by rumours about girlfriend Carla Bruni joining him, Sarkozy kept his date with the Taj Mahal on Saturday afternoon. Spending more than the 30 minutes listed in his programme, he even posed for the mandatory photo op on the bench, all the while 'looking a bit upset' ... [the flurry of activity] ... all died down when Sarkozy quietly sat on the bench, alone.

(Nagaraj, 2008)

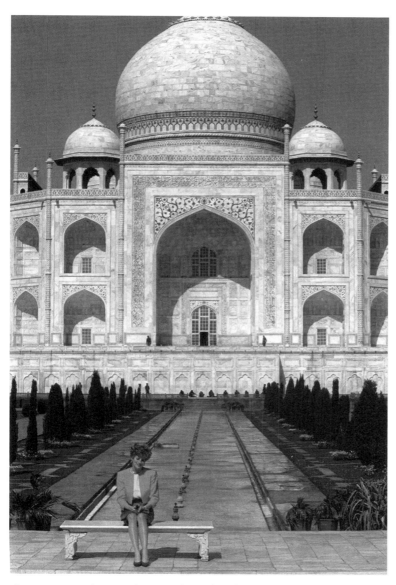

Figure 6.3 Princess Diana at the Taj Mahal, 11 February 1992. Photographed by Udo Weitz. Photo: © Udo Weitz/AP/PA Photos.

Reflecting on the case study

The Taj Mahal is in many ways typical of a large and well-developed heritage site in which a number of meanings interact. These include aesthetic meanings and the significance of the Taj historically, as well as commercial meanings. The Taj is a major source of revenue in the area from international tourism and this, alongside a concern for the preservation of the marble, has resulted in decisions to exclude industry from the proximity and even discussion of a no-fly zone overhead. The historical interacts with the political: a small but vocal minority in India today argues – against the extensive evidence in the records of the Mughal court – that the Taj Mahal has its origins in the majority Hindu culture rather than in the minority Muslim culture. Official heritage also interacts with the personal, bringing together the melancholy aspects of the original memorial meaning of the tomb with present-day romance and the breakdown of that romance.

Case study: the National Museum, Delhi

Laurajane Smith summarises the function of the modern museum as follows, and again shows the links between museums, heritage and nationalism:

> [in the modern museum] rationality and national and cultural identity became embedded in exhibition and collection practices. Museums took on a regulatory role in helping to establish and govern both social and national identity, and the existence of national collections demonstrated the achievements and superiority of the nation that possessed them.

(Smith, 2006, p. 18)

Indian people living in India, members of the Indian **diaspora** living abroad (known often as NRIs, non-resident Indians) and international tourists visit the government-owned National Museum to see the best of Indian art and culture. But as in all museums, what we see is the result of selection and interpretation.

Museums in India before independence

Before the introduction of direct government rule in India after 1858, the East India Company ruled through three centres – the Bombay Presidency, the Madras Presidency and the Bengal Presidency (based in what they called Calcutta). In the second half of the nineteenth century there was also a very strong British presence in Lahore because of perceptions of the threat on the North-West Frontier of India. (Lahore is now part of Pakistan. The North-West Frontier is the area of the North-West Frontier Province and the federally administered Tribal Areas of Pakistan.) In some sense Bombay, Madras and

Calcutta (now Mumbai, Chennai, and Kolkata) were British constructions. Madras had existed as a city for many centuries, but was transformed by the Company. Bombay and Calcutta were both collections of villages until the British settled there. After 1858 the British governed India as a single entity, based on Calcutta, but all three of these centres continued to be very important and in all of them what one might describe as official state museums were created. Chennai and Kolkata both claim the title of being the oldest. The Indian Museum in Kolkata was founded by the Asiatic Society of Bengal in 1814, and claims to be the ninth oldest museum in the world. It moved to its present buildings in 1878: when Calcutta was the British capital it was readily regarded as the principal Indian museum. The Government Museum in Chennai cordially disputes the Indian Museum's claims; it was founded officially in 1851, but housed in the Pantheon complex of buildings that had been a gathering place for the British since 1789. Mumbai has two museums. The Victoria and Albert Museum (now restored and reopened as the Bhau Daji Lad Museum) was founded in 1872. The Prince of Wales Museum in Mumbai was finished in 1915 but it was then used as a children's welfare centre until after 1918 and was not inaugurated as a museum until 1922. The influence of ideas of the museum in Britain was strong in all this: the Victoria and Albert Museum in Bombay followed its namesake in London in being designed to display modern technical achievements as well as ancient objects, and having an associated schools of arts and crafts. Similar principles were followed in the Lahore Museum, founded 1894, which features in Rudyard Kipling's novel *Kim* and where the novelist's father was the curator (see Singh, K., 2009).

In 1911 the British government decided to move the capital of British India from Calcutta to Delhi. Over the next twenty or so years a large new area of land was developed to provide a new government complex, shops, and bungalows for politicians and officials – the whole now referred to as New Delhi. The government complex is built around a central axis designed for processions – the Rajpath ('King's Path', formerly the Kingsway) leading from the then viceroy's residence to the India Gate – with a main crossroad – the Janpath ('People's Path', formerly the Queensway). Looking back, the completion of the grandiose design seems shot through with irony – the symbolic embodiment of an imperial rule that many saw as being already close to collapse. It makes more sense perhaps if one understands that the British government's vision then was of India as a dominion alongside Australia and Canada, anglophone countries 'equal in status [and] ... united by a common allegiance to the Crown and ... members of the British Commonwealth of Nations' (Porter, 1997, p. 301). The blend of eastern and western architectural styles creates a symbolic heritage of this continued sharing of power. The design for New Delhi did include a museum, to stand at the intersection of the Kingsway and the Queensway as part of a group of

buildings. The only one of these built to the plan before 1947 was the Imperial Record Department – now the National Archives of India – transferred from Calcutta to a new building on Janpath in 1926.

Indian heritage in London in 1947

Why was the planned museum not built in the period of British rule? Faced with the diversity of India and the increasing unrest in the 1930s and 1940s perhaps the British felt unable to create something that would represent – in Smith's words – a single 'social and national identity'. More pragmatically, perhaps the existing museums were too powerful and too reluctant to give up any of their holdings to a new museum in Delhi. However this may be, the events that led to the eventual creation of the museum happened largely outside India and from beyond the government. The groups involved were the Royal Asiatic Society, the Royal Society of Arts and the Royal India Society – all based in London. Conversations between these societies and the Royal Academy in London about an exhibition to show Indian works took place in the 1930s but were put on hold because of the Second World War. In 1946 the plans were revived and resulted in an *Exhibition of Art Chiefly from the Dominions of India and Pakistan*, held at Burlington House, London in the winter of 1947–8. The idea was to display the art and craft of India and Pakistan as part of a British dominion heritage, and it was possible in Britain – it seems – to hold to that vision even in 1948. True, there was no longer a viceroy in India, but the last holder of that title – Lord Mountbatten, made an earl in October 1947 and close to the British royal family – still presided over India, now with the title governor-general, and many British people were still based in India.

The introduction to the exhibition catalogue tells visitors that they can expect to see 'the technical and aesthetic qualities of Indian art ... [and recognise] its deep spiritual significance. It is the visible expression of the life, thought and religious experience of the peoples of India' (Royal Academy of Arts, 1947, p. ix). This quotation brings together key British ideas about Indian heritage. Of particular importance are the references to 'deep spiritual significance' and 'what that country has stood for through the ages'. British understandings of their imperial role in India were immensely complex, but one strand involved taking on an imperial duty to modernise a culture and a country that had an ancient history and tremendous spiritual value but that had slipped into decline under the later Mughal rulers. In the opening words there are also echoes of the 'Victoria and Albert Museum' ethos referred to above. In these carefully crafted words one can also hear echoes of the times and the difficulties under which the organisers worked. Between the inception of the exhibition in January 1946 and its opening in November 1947, Indian independence had become a reality, as had Partition. Interestingly the catalogue introduction

invites visitors to admire 'Indian art', while the title of the Exhibition itself refers to the 'Dominions of India and Pakistan'. One can reasonably speculate that for the organisers, 'fostering a still better acquaintance' with this culture was part of the project of maintaining a relationship between Britain and both independent India and Pakistan within the British empire (India because of its size as a market for British goods, and Pakistan because of the concerns for security on the North-West Frontier).

The exhibition presented objects in a broadly chronological sequence, from the Indus Valley civilisations of around 2000–3000 BCE to paintings of the modern period. Objects of different kinds were brought together in many rooms. Pride of place in the Central Hall of the Royal Academy went to something old, the Rampurva Mauryan Capital, and something modern, a display of carpets from Jaipur.

The exhibition brought together artefacts from a wide range of sources. The largest lenders overall were public museums in India, including the three major museums referred to above, but there were very significant numbers of items from private collections in India. British collections also figured largely. The organisers secured artefacts from the royal collections, from public museums in Britain and from private collections, but the largest lender was the Victoria and Albert Museum, London. The largest number of objects from Britain were to be found in the rooms where Indian paintings of the seventeenth, eighteenth and nineteenth centuries were shown, and this no doubt reflected a pattern of collection and appropriation of objects by British administrators, traders and soldiers who had found such things easy to ship back to Britain. In contrast, almost none of the materials in the rooms from before the medieval period (mostly sculpture) were from Britain.

The origin of the National Museum

The next stage in the development of the National Museum can be summarised through a quotation from the museum's own description of its history:

> The blue-print for establishing the National Museum in Delhi had been prepared by the Gwyer Committee set up by the government of India in 1946. When an Exhibition of Indian Art consisting of selected artefacts from various museums of India ... was on display in the galleries of Burlington House, London during the winter months of 1947–48, it was decided to display the same collection under a single roof in Delhi before the return of exhibits to their respective museums. Accordingly, the exhibition was held in the state room of the Rashtrapati Bhawan [the President's Palace], New Delhi in 1949, and

it turned out to be a great success. ... The Government [then] ... felt [able] to retain the exhibits on show to form the holdings of the National Museum and the plan was sent to all the participants of [the] London exhibition.

(National Museum of India, 2008a)

Everything here speaks of the creation of a new national heritage and an AHD. The Gwyer Committee was led by Sir Maurice Gwyer, formerly chief justice of India, in 1947 vice-chancellor of Delhi University and one of the few members of the British governing class trusted by the nationalists. The exhibition was transferred to the President's Palace, and inaugurated on the anniversary of independence by the governor-general. There it remained until the opening of the present purpose-built museum in December 1960 (Figure 6.4).

Figure 6.4 The National Museum of India, Delhi, 2007. Photographed by Richard Allen. Photo: © Richard Allen.

According to the Indian archives, the transition was not always straightforward. Sometime in the 1950s the government approached private and museum lenders requesting that they make a gesture to the nation by donating their loans to the prospective National Museum. Most refused. Only in the 1960s did the government accept that the museum would have to buy items.[2]

[2] Information provided by Professor Kavita Singh.

The heritage of India in the National Museum in 2008

How, then, does the National Museum present a heritage for India – in the words of the constitution a 'sovereign socialist secular democratic republic' (Government of India, 2008b, p. 1)? The three floors of the museum contain a wide variety of artefacts, ranging from ancient archaeology to armour, paintings and tribal art (National Museum of India, 2008b). Most first visits centre on a group of interconnected rooms on the ground floor which together present a chronology of the culture of India – not dissimilar to that of the 1947 exhibition – from ancient times to the nineteenth century. This is a story of the ancient culture of India and of great civilisations – a national heritage of which modern India could be proud. The main galleries are as follows (Galleries 1–3 are now used for offices):

Gallery 4: Harappan civilisation

Gallery 5: Mauryan, Sunga and Satvahana art

Gallery 6: Kushan (Gandhara, Mathura and Ikshavaku art)

Gallery 7: Gupta art

Gallery 8: Gupta terracotta and early mediaeval art

Gallery 9: Bronzes

Gallery 10: Late mediaeval art

Gallery 11: Buddhist art

Gallery 12: Indian miniature paintings.

Galleries 4–10

The Harappan civilisation, discussed below, takes the story back to 3000 BCE, while the galleries displaying artefacts from the Mauryan, the Kushan and the Gupta periods take the story forward, after a gap, to the sixth century CE. The Gupta dynasty is particularly important to the heritage story of India as it presents a Hindu culture that was successful and widely recognised for its culture and tolerance. Galleries 8 and 9 flow into a late mediaeval collection, which contains a high proportion of works from South India. North and South India can seem historically quite divided, with an Aryan culture and ethnicity in the North and a Dravidian one in the South, but these galleries present a national heritage that is in essence culturally unified.

Gallery 11: Buddhist Art

This presentation of unity seems broken by Gallery 11, which is devoted to the art of one religion, but this room has an important point to make. Although Buddhism has never been a major religion in India, judged by the number of its followers, it has a strong place in modern Indian culture. First, there is a pride that India is one of the key sources for Buddhists across the world; the

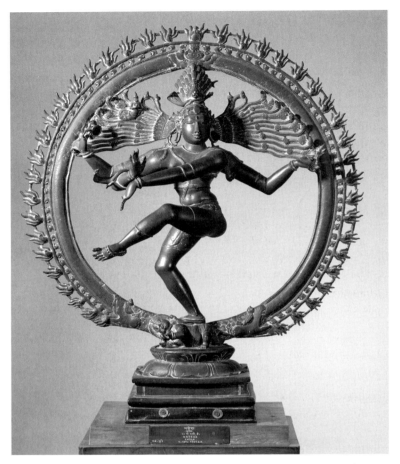

Figure 6.5 Statue of Shiva Nataraja, twelfth century, bronze, from Gallery 9, 97 × 83 cm. National Museum of India, Delhi. Unknown photographer. Photo: National Museum of India, Delhi/ The Bridgeman Art Library.

Buddha spent a large part of his life in North-East India, which at Sarnath and elsewhere contains some of the most important sites of his life and teaching. Relics from this period of antiquity are aesthetically some of the finest things in the museum.

Buddhism also has an importance in the nationalist struggle and the history of independent India. One of the major principles of the teachings of Gandhi during India's struggle for independence was to improve the situation of the lowest caste in society, traditionally called 'untouchables'. Another major figure in the independence struggle, Dr B.R. Ambedkar, himself an 'untouchable', urged members of his caste to fight their oppression by rejecting the Hindu beliefs that sustained the caste system and converting to Buddhism. In a mass conversion in 1956 Ambedkar and, by some accounts,

no fewer than 500,000 people converted to Buddhism (see Chandra, Mukherjee, A. and Mukherjee, M., 2000, p. 446). The display of Buddhist art is thus constructed securely within the AHD of independent India.

There are, however, ways in which the contemporary authorised discourse has to manage more volatile meanings, relating to the situation of Tibet and the relations between India and China. In the early years of independence India pursued friendship with China. When Nehru signed the Panch Sheel ('Mutual Respect') Treaty of 1954 he formally accepted that Tibet was part of China. In 1959, after a revolt in Tibet, the Dalai Lama (one of the most important and sacred figures for Buddhists) fled to India where he was given asylum but prohibited from establishing a government in exile. Over the years relations at government level have improved; however, the high profile of the Dalai Lama, his continued presence in India, more activist refugees and memories of 1962 when Chinese troops briefly encroached on Indian territory, mean that there are tensions. The Buddhism gallery is caught up in this. Gallery 11 is, for example, better lit and better kept than most in the museum – the result one assumes of private donations. The museum also allows visitors to this gallery to treat the artefacts here as devotional objects. Visitors regularly kneel to pray before the cases in a way that seems to subvert both the conventions of a modern museum, which the National Museum claims to embody, and the secular nature of the constitution. The visitors' guide says of this gallery:

> Of special importance are the images of *Kapardin* Buddha from Ahichchhatra, Buddha – *pada* (footprints) from Nagarjunakonda, Distt. Guntur in Andhra Pradesh and Buddha's life scenes from Sarnath in Uttar Pradesh as well as ritualistic objects from the trans-Himalayan reign. These objects stimulate a sense of devotion, dedication and love for humanity.
>
> (National Museum of India, 2008b)

In this the gallery seems to express a support for Tibetans that official policy would not allow, but it is difficult to believe that it could be done without the agreement of the government.

Gallery 12: Indian miniature paintings

In the chronological sequence of the history of India the visitor now arrives at the post-medieval period when India was increasingly dominated by the Mughal empire. At first glance a gallery of paintings seems appropriate since miniature painting is seen by many as having reached a high point in the sixteenth and seventeenth centuries under the patronage particularly of Shah Jahan's father Jahangir, and his grandfather Akbar. Strikingly, however, the National Museum's collection of Mughal paintings are put into the context of a much wider range of paintings, including a particularly fine collection of Pahari paintings from the Punjab, many of which have explicitly Hindu

subjects. For a first-time visitor, then, the gallery reconstructs the period of Mughal rule as a period of broader national unity, in which differences of religion and different ways of seeing the world (reflected in the differing styles of the paintings) are drawn together within a single genre.

Harappa in the National Museum

Within this sequence presenting a unified history of a unified Indian heritage, Gallery 4 showing the Harappan civilisation has been the only real source of controversy. The gallery was reworked in 2000. Revising a display in a museum can signal changes in knowledge, an increase in the collection, changes in museum practice, or changes in the interpretation of artefacts. All of these have had a part to play in the changes made in 2000, but it is the last that is of particular interest here. As with the display of Buddhist art, the questions it raises concern India's national identity in the present.

Until the late 1950s the orthodox view was that the dominant force in the creation of modern India was an invasion by people known as Aryans, who came from Central Asia via Afghanistan. It was thought that these invaders displaced, or in some views overcame, an earlier Harappan civilisation. There was certainly clear evidence that dominant features of Indian culture as it has developed – the importance of the Veda hymns (equivalent to sacred books) in religion, and the caste system – derived from this Aryan culture. The key point here is that the origins of Indian culture were seen to lie outside the present India. Even the indigenous culture that was believed to have been overcome – the main Harappan cities that had been discovered in 1922 by Sir John Marshall – were, after 1947, in Pakistan, not India. Since 1947, however, intensive excavations have taken place in India that have identified the Harappan civilisation as occupying a much larger geographical area within the present India, and as being more dispersed and much older. In the 1970s an early farming community was discovered at Mehrgarh dating back to 6500 BCE. The picture of 'Harrapa' as a relatively contained civilisation that had come to an end was replaced by one in which a part of the civilisation had come to an end because of the shifting patterns of rivers.

The significance of these details is that they have enabled an alternative story of the origins of Indian heritage to be told. Now, it can be argued that the ancient origins of Indian religion and culture lie within its own borders and within the Harappan civilisation. These views have the strong backing of organisations that advocate an India whose essence in law and everyday practice is Hindutva (or Hindu-ness). One of these, the Vishva Hindu Parishad (VHP), includes on its websites work by a US academic, David Frawley, who writes:

> Current archeological data do not support the existence of an Indo
> Aryan or European invasion into South Asia at any time in the pre or

protohistoric periods ... The early Vedic literature describes not a human invasion into the area, but a fundamental restructuring of indigenous society.

(Frawley, 2008)

In this history, supposedly conclusive evidence for the existence of antecedents of Hinduism in Harappa is offered in the claim that Shiva-lingam – the phallic object which now sits at the heart of Hindu temples – have been discovered in excavations. Seals have also been found marked with tree deities that can be read in terms of Hinduism. Of particular importance to the VHP-supported account is the finding of

the famous so-called 'Proto-Shiva' who is seated in the typical pose of a meditating man. He has three heads, an erect phallus, and is surrounded by animals who were also worshipped by the Hindus of a later age.

(Kulke and Rothermund, 1998, p. 17)

The problem here is that at the moment there is no evidence that can provide certainty of interpretation. The Harappan ruins are extensive but their condition is such that, except for domestic objects, relics are seldom found in a clear context. Although some inscriptions have been found, they are insufficient to provide a reliable written record of the Harappan civilisation.

How do these matters relate to the heritage of independent India? Nehru's iconic comment with which the chapter began provides the essence of the answer: Indian nationalists undoubtedly sought a changing and modernised world of one kind or another, but it was important that it embodied also 'the soul of a nation, long suppressed'. The cultural historian Stuart Hall provides an amplification of this position in his essay 'Cultural identity and diaspora' (1990). He writes that

'cultural identity' [means] ... one, shared culture, a sort of collective 'one true self', hiding inside the many other, more superficial or artificially imposed 'selves', which people with a shared history and ancestry hold in common ... stable, unchanging and continuous frames of references and meaning, beneath the shifting divisions and vicissitudes of actual history ... Such a conception of cultural identity played a critical role in all post-colonial struggles which have so profoundly reshaped our world.

(Hall, 1994, p. 393)

The interpretations of the Harappan civilisation both offer and refuse the 'shared history and ancestry'; a European textbook on archaeology concludes that 'until the Indus script is deciphered and its social organisation understood better ... the end of the civilisation is likely to be as enigmatic as its origin'

(Coningham, 2005, p. 538). An enigma hardly fits easily within the desire for 'stable, unchanging and continuous frames of references'. The challenge for the National Museum has been to create an articulate display within these tensions.

One of the marvels of the Harappan cities is their great size and the sophistication of their streets and houses, something that can only be represented in a museum through plans and photographs. Very large numbers of artefacts have been discovered but most are relatively small. As already mentioned, early excavations took place in an area of British India that became part of Pakistan, and before 1947 the natural place to exhibit these objects was Lahore. At independence the partitioning of the Punjab between Pakistan and India related not just to land but also to materials ranging from government typewriters to museum goods. The contents of the Lahore Museum were divided in a ration sixty to forty between India and Pakistan. To compensate for the loss, the Indian government built a new capital for the Indian Punjab at Chandigarh, including a museum, and placed its share of the Lahore Museum materials there. The result is that many important older Harappan finds are unavailable to the National Museum, and developing a display has been difficult.

When Gallery 4, Harappan civilisation, opened at the National Museum a number of scholars objected to what they considered to be an alignment with history as told by the VHP and the presentation of an Indian heritage whose origin lay entirely within India. In protest, senior Indian academic historians took a case against the museum to the Indian Supreme Court. Particular controversy was created by the identification of one stone object as a Shiva-lingam. As a result of the court case and other pressure the display was changed but in a way that avoided the issue rather than resolving it. The visitor now finds only a case labelled 'Ritual Objects' that has at the centre a stone around 45 cm tall with indeed the characteristics of a Shiva-lingam, but equally possibly the characteristics of a pestle for grinding corn, surrounded by other smaller unlabelled objects. Photography is forbidden in this gallery, unlike the other sculpture galleries. The AHD here seems to involve a regulatory process that is so strong as to have silenced heritage.

Reflecting on the case study

This case study has shown some of the complexities associated with the creation of the National Museum: the challenge of how to embody the heritage of independent India and complications caused by decisions taken under British rule – particularly the decisions to establish museums with a strong official status in Kolkata, Chennai and Mumbai, to move the capital to Delhi, and finally to partition British India into India and Pakistan. It has also explored how the National Museum in New Delhi establishes, in the sequence

of ground-floor rooms, a chronological heritage story that aims to reflect the different religious and ethnic cultures of India but also to bind them into a single story. Not surprisingly this has been and is at times a contentious process. What the visitor sees is sometimes more the result of political questions and issues than of practices arising from collecting and conservation.

Case study: the Babri Masjid, Ayodhya

Religion remains a central issue in the contested definitions of an authorised heritage in India. There is not a single contest, but a series of overlapping tensions: between the idea of a secular state embodied in the constitution and the notion of a Hindu India created by the partition of British India; between Hindus, Sikhs and Muslims; between Hindus and Christians; and between a traditional craft and village heritage associated with Gandhi and a modernising heritage associated with Nehru. The BJP, for example, is closest to fundamentalist Hinduism and in most respects to conservative values but when it came to power in government in 1999 it was also most active in fostering economic liberalism. One commentator wrote:

> the market is opening wide, while the space for cultural plurality is shrinking ... I think it is clear that there is a continuing ... pressure on a party like the BJP, as they open the market, to find new ways of establishing their credentials as the trustees of cultural sovereignty, of cultural purity, cultural authenticity.
>
> (Appadurai, [2001] 2008, p. 212)

This case study explores one of the most famous, or infamous, events in modern India when religious tensions exploded in the destruction of the Babri Masjid ('Babar's Mosque'; Figure 6.6) at Ayodhya on 6 December 1992. Hindu Kar Sevaks (activists) led, it is believed, by officials of the RSS (introduced above) entered the compound surrounding the mosque (Figure 6.7). The entire mosque was reduced to a pile of rubble by the end of the day. Communal (Hindu–Muslim) riots across India followed, especially in the major cities of Mumbai, Kolkata and Bhopal, and more than 3000 people were killed (Chandra, 2000, p. 442). The government eventually took control of the situation but at the time of writing its legacy continues. The disputed site remains quarantined behind a security barrier, a symbol perhaps of the failure so far of attempts to resolve a heritage for India.

The history of the mosque can be sketched briefly. It was built in 1528 in the early years of what is usually called the Great Mughal dynasty. No conflict is recorded until after 1858 when the British formally established British India. From this time, with increasing regularity, there were claims that the mosque was built on top of an ancient Hindu temple marking the birthplace of Lord Rama, a key figure in the Hindu pantheon. Hindu fundamentalists

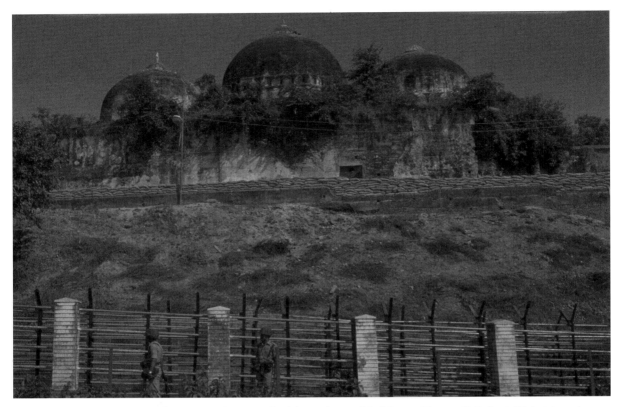

Figure 6.6 The Babri Masjid, 1990. Photographed by Robert Nickelsberg. Photo: © Robert Nickelsberg/ Time & Life Pictures/Getty Images.

became particularly active after 1947. For them, the destruction of the mosque and the construction (or as they would say reconstruction) of a temple would signify throwing off the yoke of the British empire and the preceding Mughal empire as well as the unsatisfactory basis on which India was established in 1947.

In the following sections of the case study I present briefly the various arguments that have been used to justify or criticise the destruction of the mosque, and through these explore the basis on which an authorised heritage in independent India might be founded. There are five perspectives: religious beliefs; history; contemporary law; political action and the will of the people; and archaeology and science.

Religion as a basis for heritage?

Assertions that the prime heritage meaning of the Babri Mosque site derives from its Hindu religious importance are based on the belief that the site is the birthplace of Rama, and that there was a temple there for many years

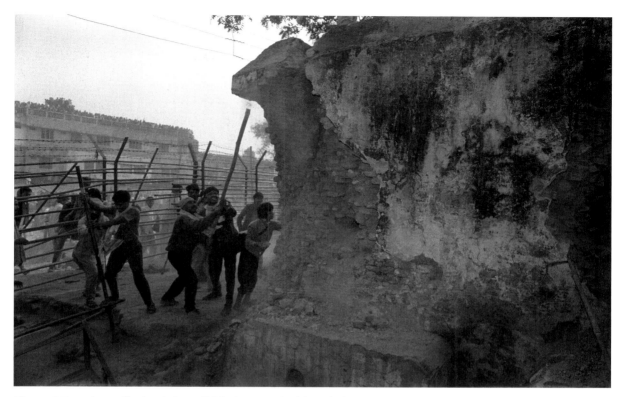

Figure 6.7 The wall of Babri Masjid being attacked by Hindu activists, 1992. Photographed by Douglas E. Curran. Photo: © Douglas E. Curran /AFP/Getty Images.

before 1528. Rama was the seventh reincarnation of the Supreme Being Vishnu; his story is told in the Hindu sacred book the *Ramayana* and Ayodhya has been celebrated for hundreds, even thousands, of years as his birthplace. His story is best known in India today in a prose version, the *Ramcharitmanas* of Tulsidas, dating from the 1570s, but the *Ramayana* was first established in written form as a long poem in Sanscrit by Valmiki around 400 BCE. The evidence is that there was an older oral version. These works date the birth of Rama, king of Ayodhya, to 'the *Tetra Yuga*, that is, thousands of years before the *Kali Yuga* which is supposed to have begun in 3102 BC' (Noorani, 2003, vol. 1, p. 29).[3] Basing a heritage on an ancient religious tradition raises questions of authenticity. The tradition and the location of Ayodhya may be seen as a matter of fact, or in effect a symbolic location.

The destruction of a pre-existing Hindu temple in 1528 might seem to be more verifiable. The belief that the Mughals were vengeful enemies of the Hindus is important and, in the case of a number of Mughal rulers, accurate. One of the most prominent examples, used as an analogy to the Babri Masjid, is the

[3] This section is particularly indebted to Noorani's volumes for documentary sources.

temple at Somnath in Gujurat. A Hindu temple was established here more than 2000 years ago but from around 1000 CE it was destroyed by Muslim invaders and rebuilt a number of times. In the final iteration, a mosque that stood on the site in 1947 was moved and a grand new Hindu temple built to restore the heritage. To the builders of the new temple, almost any mosque represents a suppressed Hindu heritage. However it is appropriate to note that according to evidence Babar himself did not encourage the destruction of temples. His will, written as a secret letter to his son in the same year as the building of the mosque, includes the following:

> It is incumbent on thee to wipe all religious prejudices off the tablet of thy heart, administering justice according to the ways of every religion ... Do not ruin the temples and shrines of any community which is obeying the laws of Government ... The cause of Islam can be promoted more by the sword of obligation than by the sword of tyranny.
>
> (R. Prasad, 1947, quoted in Noorani, 2003, vol. 1, p. 1)

History as a basis for heritage?

Historical records from before the date of the building of the mosque could provide a powerful basis for an authorised heritage at Ayodhya, but these do not exist. Mughal records do, however, exist which show reasonably clearly that the Babri Masjid was built in 1528 or very close to that date. But they say nothing about any earlier building. Historical records, then, do not support the claims made on the basis of religion, but do provide evidence for a different heritage. Although in some accounts the mosque was built on the direct orders of the Emperor Babar (great-grandfather of Shah Jahan, builder of the Taj Mahal), a closer reading of the evidence suggests that the mosque was built on the orders of a member of Babar's court. Rather than marking a decision by the emperor to obliterate a major Hindu temple, it may simply mark Babar's passing close to Ayodhya.

Nineteenth-century British historiography set in motion a different narrative. By the middle of that century the mosque had been identified as the actual site of Rama's birth as a matter of fact, and this in turn was duly recorded and authorised by British administrators. Crucially, the historical narrative also began to include details of the destruction of a Hindu temple when the mosque was built. A British account of 1870 refers, for example, to the Mughals building mosques on the top of destroyed Hindu shrines elsewhere at Ayodhya, in accord with the 'well-known Mahomedan principle of enforcing their religion on all those whom they conquered'

(Noorani, 2003, vol. 1, p. 58). The *District Gazetteer of Faizabad* of 1905 shows this narrative to be well established:

> In AD 1528 Babar came to Ayodhya (Aud) and halted a week. He destroyed the ancient temple (marking the birthplace of Rama) and on its site built a mosque, still known as Babar's Mosque.
>
> (Noorani, 2003, vol. 1, p. 26)

Why did historiography take this turn when there was so little evidence? Post-independence scholarship suggests that these kinds of historical narrative came from the common sense that developed in British India. In his introduction to *Making India Hindu*, for example, David Ludden argues that differences that had existed formerly in complex and overlapping patterns were systematised into an opposition of Hindu and Muslim. Thus 'colonial officials wrote separate Hindu and Muslim law codes' and 'made it a policy to consult Hindu and Muslim leaders separately'. Colonial officials in the field, often lacking real knowledge of local customs and issues, found it also very easy to reach for the communal Hindu–Muslim conflict when describing problems that arose (Ludden, 2005, pp. 10–11). It is argued further that this use of communal divisions and the nature of Christianity – a monotheist religion – had an effect on the nature of Hinduism. From the middle of the nineteenth century, as 'the European Christians tried to universalise their Christian tradition, Indian Hindus did the same with their Hindu tradition'. For all its emphasis on many Gods and a diversity of practices, Hinduism paradoxically took on a monotheistic quality alongside the two other monotheistic religions, Christianity and Islam (see van der Veer, 2001, pp. 45, 29).

Such an account provides its own basis for an authorised heritage in independent India which would be very different from that based on the notion that the true heritage of India from ancient times was a unified Hindu heritage, overthrown by a unified Muslim heritage. Instead we would see historical records as demonstrating that the creation of a new heritage – a new master-narrative – was a key part of British rule. Communalism is a part of a British Indian heritage and should be discarded in an independent India.

Law as a basis for heritage?

The political entity 'India' was also created by British imperial rule. Mention has been made of the creation of Hindu and Muslim codes of law by the British colonisers; particularly after 1858 the British also created more general legal structures which remain a key part of the colonial heritage in India today. Though jury trial was abolished in 1960, local and state judiciaries still exist in clear relation to a national judiciary culminating in the Supreme Court. In all this, independent India's heritage is that of the western Enlightenment, in which problems are solved through rational investigation and authorised

expert rulings. Laws prescribe land rights, and regulate the transfer of property, as well as prescribing the rights of different religions. Here surely is a heritage that offers the prospect of resolution of the conflicts at Ayodhya. In the events of 1949 this heritage can indeed be seen in action. Previous actions by Hindus had brought the situation at the Babri Masjid close to a crisis in public order of the kind that the law is designed to meet. A regulated situation had emerged in which the mosque was available for worship but was kept locked at other times, while Hindus had been allowed to establish a small temple in the surrounding graveyard. To disturb this balance was to go against the law. This happened in December 1949 when Hindus, led by members of the RSS, broke the locks on the mosque, installed Hindu idols and, according to the police report of the time, 'scribbled sketches of Sita, Ramji etc. in saffron and yellow colours on the inner and outer walls of the Mosque' (Noorani, 2003, vol. 1, p. 210). This was plainly illegal, and the processes of law began with the local magistrate showing exemplary speed in attempting to prevent a further breach of the peace (see Noorani, 2003, vol. 1, pp. 210, 218).

However, Hindu nationalists then pursued their own case, claiming in the Civil Court in Faizabad on the 16 January 1950, wrong action by 'five Muslims and the state of Uttar Pradesh, the Deputy Commissioner and the Police Superintendent of Faizabad' (*Indian Express*, in Noorani, 2003, vol. 1, p. 225). As the case could not be settled there it was referred to the High Court at Allahabad. As the cases moved through the courts it became clear that while an enlightened and modern legal system could hold apart the parties disputing the ownership of the mosque, it could not provide a unifying heritage that would bring them together. According to the constitution the mosque site should be held by a Mosque Board, but the High Court ruled that the government of the state in which Ayodhya is located – Uttar Pradesh – should hold the land. The Hindu idol was left in place in the Mosque but 'no [Hindu] structure of permanent nature shall be put up' (quoted in Noorani, 2003, vol. 1, p. 344).

The matter reached the courts again just before the mosque was destroyed in 1992 but once more with no conclusive outcome. The situation at Ayodhya has continued to occupy the sustained attention of the State High Court and the National Supreme Court. An extensive judgment in the Supreme Court in 2003 led to a simple requirement to hold to the stand-off status quo:

> we are of the view that the order made by this court on 13.3.2002, as modified by the order made on 14.03.2002, should be operative until disposal of the suits in the High Court of Allahabad ... [that is] we direct that on the ... land ... [which since 1950 has been] vested in the Central Government, no religious activity of any kind ... shall be permitted ... Furthermore, no part of the aforesaid land shall be handed over by the government to anyone.
>
> (Noorani, 2003, vol. 2, pp. 307, 297)

The heritage of Ayodhya can, it seems, again be expressed only in negative terms.

Political action and the will of the people as the basis for heritage?

Stuart Hall's comment that decolonisation brings with it the search for 'one, shared culture, a sort of collective "one true self", hiding inside the many other, more superficial or artificially imposed "selves"' (Hall, 1994, p. 393) provides a starting point here. The re-establishing of that shared culture through the collective will of the people seems on the face of it to create a new heritage for the independent country. Problems arise, however, when the collective will is divided and contested. As the contested heritage was brought into the legal arena in the 1950s, so it was brought into the political arena in the 1980s after the founding of the BJP. In an early policy statement the party asserted:

> The meeting takes the presence of *masjids* at holy places of Hindus as the symbol of cruelty, intolerance and attack on Hindu society. It was the prime duty of the national government in power after independence to remove the *masjids* from these places and construct temples on these spots.
>
> (Noorani, 2003, vol. 1, p. 257)

The secular-led coalition then in power took these challenges seriously and made a vigorous response. When Kar Sevaks attacked the Babri Masjid site in 1990,

> The police opened fire at three different places in this temple town, killing at least eleven people and injuring over a hundred others. With complete breakdown of law and order, the district administration decided to hand over the disputed site to the army which was asked also to stage a flag march [a show of strength] in neighbouring Faizabad.
>
> (Noorani, 2003, vol. 1, p. 331)

The stakes were high. This attack took place during a *rath yatra* (a journey of faith) across India by the BJP leader L.K. Advani. Advani's strategy involved urging supporters to take bricks from wherever they lived across India to Ayodhya, literally to build a new Hindu heritage in the form of a new temple on the Babri Masjid site. The government seemed intent on seeing this only as public disorder to be met through the force of law – around 150 people were killed in the rioting that accompanied this journey (Figure 6.8). On both sides there seems to be a replaying of colonial history and heritage rather than the developing of new heritage. Thus Advani and the BJP were evoking memories of Gandhi's march to the sea in 1930 and the nationalist struggle generally. The government's response seemed to show them inheriting British methods and evoked the British persecution of nationalists before 1947.

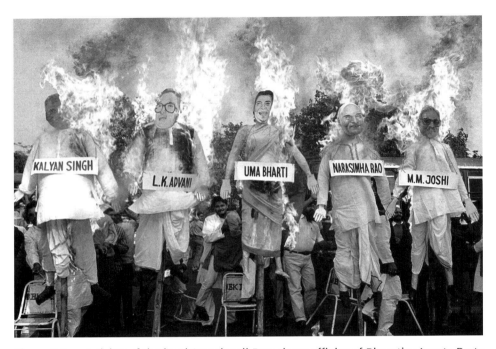

Figure 6.8 Activists of the local Samajwadi Party burn effigies of Bharatiya Janata Party (BJP) leaders in Kolkata, 2000. Unknown photographer. Photo: © Reuters. The Samajwadi Party opposed the BJP and destruction of the mosque. The effigies represent Kalyan Singh, L.K. Advani and M.M. Joshi (all still serving senior members of the BJP), Uma Bharti (at times a senior member of the BJP but expelled more than once for advocating policies more extreme than those of the party hieracrchy), Narasimha Rao (a member of the Congress Party but included here because of his perceived unwillingness to take firm action against those who attacked the mosque).

At other times, however, the government did seem to be attempting to achieve a consensus and a shared heritage. A National Integration Council had been founded by Nehru in 1961 as a conference-style body that could bring politicians and other leaders of civil society together outside the political arena to discuss and resolve communal and regional conflicts. (The nature of the council can be seen from the document giving official notification of its reconstitution in 2005 (Government of India, [2005] 2008c).) It had met only occasionally between 1961 and 1980 but then met more frequently through the 1980s. In 1992 the congress government referred the Ayodhya dispute to the National Integration Council. Addressing the council on 23 November 1992, P.V. Narasimha Rao (Indian prime minister 1991–6) said:

> we all agree that a grand Rama temple should be constructed in Ayodhya ... The issues on which there are differences of opinion are the plan of construction, the safety of the existing structure and

compliance with Court orders on the subject[4] ... We would consider any option that respects the basic democratic values and constitutional principles.

The meeting of the council produced no new resolution and seemed to prove only that it was another organ of civil society that could not resolve the problem or define India's true heritage (Noorani, 2003, vol. 1, pp. 397–8). More recent events again indicate that political action has been unable to resolve the contested heritage. After an attack on the barriers surrounding the site in 2005, Prime Minister Manmohan Singh announced:

> In today's meeting, we propose to spend a fair amount of time discussing the challenge posed by communalism. For centuries, our society has been characterized by a spirit of tolerance. This has been a value which has been at the core of our civilization, at the core of our very concept of a nation ... As we have grown as a nation, this value which has been enshrined in our constitution has become one of the defining features of our nation.

> (Singh, 2005)

But in July 2008 Praveen Togadia, general-secretary of the VHP was reported as follows:

> on construction of the Ram temple at Ayodhya, Togadia said it will be done by an act of Parliament. 'The temple will come up and we will see to it that such an act is brought in the next Lok Sabha [Parliament]'.

> (quoted in *Express India*, 2008)

Archaeology and science as the basis for heritage?

Archaeological investigations are regularly used to settle the authenticity of heritage sites. Though the British had introduced scientific archaeology to India, there had been no systematic excavation at the mosque site before 1947. Over the years many Indians on both sides have hoped that scientific investigation would provide a certainty that could resolve at least the contested Babri Masjid site, for example, by proving definitely whether there had been a major and ancient Hindu temple on the site before 1528. In 1969 excavations began as part of a project 'Archaeology of the Ramayana Sites' – an official project carried out under the auspices of the Archaeological Survey of India and led by its director-general B.B. Lal. (Lal continued the project after his term as director-general ended.) Finds of fragments of a very

[4] This implicitly indicates that the temple to which Narasimha Rao referred can almost certainly not be built at the exact location of the destroyed mosque since the courts had determined at this point that it was Muslim-owned ground.

distinctive pottery used generally in North India to date activities at sites (polished black ware and painted grey ware) enabled Lal to conclude that there had been *some* habitation in the area in the sixth century BCE. More substantial structures were found that were dated to the third century BCE, that is, after the *Ramayana* had been written down by Valmiki. Initially, however, it seemed that the finds were not substantial enough to provide evidence one way or the other.

In October 1990, just as L.K. Advani was due to arrive in Ayodhya in his *rath yatra*, Lal published a summary of his work over the previous twenty years. He continued to qualify his conclusions, but now overall they seemed much more decisively to support the position of the Hindu nationalists. The report stated that 'the archaeological evidence ... does indicate that the *Ramayana* is not a figment of somebody's imagination but may have had a kernel of truth at its base' (*Manthan Monthly*, quoted in Noorani, 2003, vol. 1, p. 87). Lal pointed particularly to the discovery at the site of a series of what he called 'brick built bases which evidently carried pillars' (p. 86). He linked these brick bases to the black stone pillars that could be seen embedded in the structure of the mosque, and speculated that they might be relics of the temple that had preceded it. One of his colleagues, S.P. Gupta, took things further and concluded assertively:

> at the controversial site a Hindu temple was built in the 11th century which continued to be in use till the very end of the 15th century, Then suddenly, in the early 16th century, it was demolished and its debris was partially used in the construction of a mosque, now called Babri Mosque.
>
> (*Indian Express*, 3 December 1990, quoted in Noorani, 2003, vol. 1, p. 89)

Archaeology had, it seemed, answered the question and provided solid evidence of a Hindu heritage at the mosque site that had been destroyed by the invading Mughals and should now be recovered.

Unfortunately, other historians and archaeologists were less than impressed by these apparently scientific conclusions. They were disputed both on the grounds of the political partiality of Lal and Gupta, and on their archaeological accuracy. Alongside the more lengthy rejoinders, Suraj Bhan of Kurukshetra University wrote to the *Hindustan Times* to report that he had tackled Lal in person on the issues and that, when challenged, Lal had agreed that conclusions such as those set out by Gupta went too far. Notwithstanding these criticisms, Hindu activists sought further substantiation of their heritage claims from archaeology later when the mosque was destroyed. Their conclusions were, not surprisingly, that Gupta's position was entirely solid. In particular, more stones were discovered – they claimed – that showed the existence of an ancient Hindu temple. However, to professional archaeologists

the evidence was almost useless since there was no record of where stones found in the heap of rubble had come from, or even whether all the rubble originally came from the site. The Hindutva activists claimed that inscriptions and even an image of a Hindu deity had been found in the rubble. Those opposed to the activists poured scorn on the authenticity of these artefacts, claiming that they showed no signs of having been buried at the mosque site.

The Archaeological Survey of India had played a perhaps surprisingly small part in all this. It had been involved in Lal's original work but had done no further digging at the site. However, in 2003 the Supreme Court required it – as the senior scientific body in India – to be involved again and to undertake a full archaeological survey, using for the first time ground-penetrating radar to search for buried structures. It might be expected that a survey carried out by the official guardians of heritage and authorised by the supreme guardian of the constitution might lead to closure of the dispute. However this was not the case. The Archaeological Survey of India was charged by its opponents with being partial and acting only as an arm of the now BJP-controlled government. In addition, the company hired to carry out the radar survey was said to have had little experience of such work. The same opponents were very ready to claim that the evidence that did appear proved no more than that the mosque was built over another building, which in fact was as likely to have been an earlier Muslim building as a Hindu temple.

Reflecting on the case study

While a Congress-led government remains in power nationally in India it seems the situation at the Babri Masjid will remain as I describe it above – in essence a heritage that dispute has rendered a negative. However, powerful forces are in play and the situation may change rapidly. Violent communal riots in Gujarat in 2002 show how communal violence can flare up rapidly. Newly rich Hindu patrons are ready, too, to spend large sums on new temples (such as the Akshardham Temple in Delhi and the Shri Swaminarayan Mandir Temple in London).

On the other hand, huge numbers of sites across India are successfully and uncontroversially maintained as part of the national heritage by the Archaeological Survey of India. Some, such as the Red Fort in Delhi, the Taj Mahal and the Sun Temple at Konark, are successfully invested with a major national heritage meaning without significant controversy. For many in India, the memory of Gandhi provides a third force in these disputes. Two official sites in Delhi demonstrate this. First, close to the government buildings on Mother Theresa Crescent is the memorial to the salt march by Devi Prasad Troy Chaudhary. This shows Gandhi leading representatives of all Indian peoples in the salt march to the sea in 1930. The other, better-known

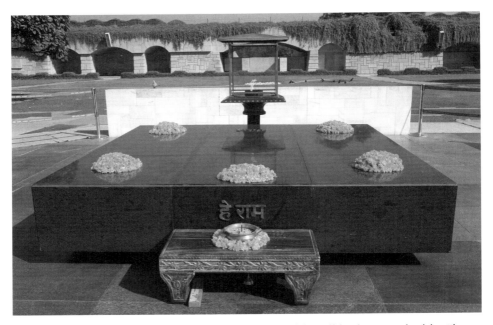

Figure 6.9 Raj Ghat, the Mahatma Gandhi memorial, Delhi. Photographed by Eitan Simanor. Photo: © Eitan Simanor/Alamy.

memorial is built on the site of Gandhi's cremation in 1948 at the Raj Ghat close to the Jamuna River in Delhi. From here urns, each containing a portion of his ashes, were distributed across India to stand as memorials to a leader who aimed to bridge religious, caste and ethnic divides.

The memorial is an extremely simple monument; a black marble slab is at the centre of a square of raised walkways surrounded by gardens (Figure 6.9). Nearby are memorials to two other assassinated Indian leaders. For most people, however, the simple and silent memorial at the Raj Ghat has great force, conveying an Indian heritage that sees a unity in India in everyday events rather than in high politics. This is not a memorial that loudly presents an official vision or prompts large parades, but one that people enjoy as individuals both at the memorial and in the surrounding gardens.

Heritage and nationalism

Taken together, the case studies in this chapter show the interactions of heritage and nationalism in independent India to be paradoxical and even contradictory, and certainly at times extremely volatile. This is striking, given that the case studies are drawn only from an area that is reasonably culturally coherent, a Hindi-speaking area of North India. Extending the geographical range would have involved further differences of culture (particularly between the Aryan North and the Dravidian South) and language (India recognises

twenty-three languages including English). All this clearly challenges any model of heritage that suggests a government or organisations related to government can set a single authorised heritage discourse. That said, this model does have relevance in India. The Taj Mahal, for example, provides an example of the Indian government seeking to identify its heritage with World Heritage. Twenty-five sites have been listed in India since the listing of the Taj Mahal and the Agra Fort in 1983; given the size of India, this number – equal to the UK and rather less than France – seems still relatively small. Meanwhile, establishing the National Museum in a building that matches the British-designed government buildings around and opposite the National Archives in New Delhi shows the central government intent on what we can call an AHD. Even here, however, there are signs of ambivalence that can be related back to the independence struggle and the crucial role played by Gandhi. One of the central elements in his campaign was the demand that India be free of British manufactures, particularly cloth; he regularly spun cotton which was woven into homespun garments, and he urged his followers to do likewise. Craft work thus gained an important part in the defining of independence, even as Nehru drove through major programmes of industrialisation. A second track in the AHD was opened when the government inaugurated the Crafts Museum among a group of post-independence buildings close to one of the old forts of Delhi.

In the life of large numbers of people in India these and other similar authorised buildings and their discourses play a much smaller part than the issues discussed in the third case study. The events and tensions surrounding the Babri Masjid are replicated or echoed elsewhere in India, including Delhi, where the vast new Akshardham Temple is said to be a model of what advocates of Hindutva think should be built at Ayodhya (see Akshardham Temple, 2008; Mathur and Singh, 2008). Here the notion of an AHD begins to lose traction amid the competing claims of secularism, Hinduism, modernisation, localism and globalisation. Is this simply something that arises from the particulars of India and Indian culture? There is much to suggest that it may be true. Independent India was a genuinely new entity in 1947; at the same time its roots could be traced both to the era of the Vedas and the Harappan civilisation, to the Persian empire of Tamberlaine, and the ancient Tamil cultures of South India. India and Pakistan were divided by religion in 1947 but there are now almost as many Muslims in India as in Pakistan. Independent India is – especially in the cities – shot through with the heritage of British rule which refuses to depart – Rajpath has displaced Kingsway, but asking your taxi driver for Connaught Circus is a more reliable way of reaching Delhi's central area than asking for Rajiv Chowk. The Partition of British India is a continuous presence but it is also a silence – there are no significant memorials to the millions who died.

Conclusion

These particularities do not displace the argument that India offers a persuasively different model of heritage and nationalism from models that are derived from anglophone and European-oriented states. The notion of an 'authentic heritage' and what might be called a 'binary' model (in which an authorised heritage is opposed by a resisting heritage) are displaced by a model that involves a variety of contesting heritages. Questions of origin, authenticity and meaning are important but we study them so as to understand how differences and contestations are managed rather than as a means of validating one or the other as truth. Thus the investigation of how several different heritages are managed together becomes the business of heritage studies. The value of these case studies then lies not just in what they tell us about Indian nationalism and heritage but also in how they prompt questions about heritage and history in other societies, and the processes of heritage generally.

Works cited

Akshardham Temple (2008) What is Akshardham? [online], www.akshardham.com/whatisakdm/index.htm (accessed 10 December 2008).

Appadurai, A. ([2001] 2008) 'The globalisation of archaeology and heritage: a discussion with Arjun Appadurai' in Fairclough, G., Harrison, R., Jameson, J.H. Jr and Schofield, J. (eds) *The Heritage Reader*, Abingdon and New York, Routledge, pp. 209–18.

Archaeological Survey of India (2008) History: From 1901 [online], http://asi.nic.in/asi_aboutus_history.asp (accessed 20 June 2008).

BBC News (2008) 'February 1992' in *Timeline: Diana, Princess of Wales* [online], http://news.bbc.co.uk/1/hi/uk/3868403.stm (accessed 10 December 2008).

Butalia, U. (1998) *The Other Side of Silence: Voices from the Partition of India*, New Delhi, Penguin.

Chandra, B., Mukherjee, M., Mukherjee, A., Panikkar, K.N. and Mahajan, S. (1989) *India's Struggle for Independence*, New Delhi, Penguin.

Chandra, B., Mukherjee, A. and Mukherjee, M. (2000) *India after Independence*, New Delhi, Penguin.

Coningham, R. (2005) 'South Asia: from early villages to Buddhism' in Scarre, C. (ed.) *The Human Past: World Prehistory & the Development of Human Societies*, London, Thames & Hudson, pp. 518–51.

D'Monte, D. (2007) 'Monumental folly' in Rangarajan, M. (ed.) *Environmental Issues in India*, Delhi, Dorling Kindersley, pp. 429–36.

Express India (2008) VHP Deprecates Govt's Position before SC on Lord Ram (28 July) [online], www.expressindia.com/story.php?storyId=341464 (accessed 10 December 2008).

Frawley, D. (2008) The Myth of the Aryan Invasion of India [online], www.hindunet.org/hindu_history/ancient/aryan/aryan_frawley.html (accessed 11 December 2008).

Gilmour, D. (1994) *Curzon*, London, Macmillan.

Government of India, Ministry of Culture ([1958] 2008a) The Ancient Monuments and Archaeological Sites and Remains Act 1958 [online], http://asi.nic.in/pdf_data/6.pdf (accessed 14 December 2008).

Government of India, Ministry of Law and Justice (2008b) Indian Constitution, New Delhi [online], http://lawmin.nic.in/coi/coiason29July08.pdf (accessed 10 December 2008).

Government of India, Ministry of Home Affairs ([2005] 2008c) National Integration Council, New Delhi [online], http://mha.nic.in/pdfs/NICmaterial020707.pdf (accessed 10 December 2008).

Hall, S. (1994) 'Cultural identity and diaspora' in Williams, P. and Chrisman, L. (eds) *Colonial Discourse and Post-Colonial Theory: A Reader*, London, Harvester Wheatsheaf, pp. 392–403.

Hutchinson, J. and Smith, D. (1994) 'Introduction' in Hutchinson, J. and Smith, D. (eds) *Nationalism*, Oxford, Oxford University Press, pp. 1–14.

Khan, Z. (n.d.) Taj Mahal – A Hindu Temple-Palace [online], www.flex.com/~jai/satyamevajayate/tejo.html (accessed 11 December 2008).

King, R.D. (1998) *Nehru and the Language Politics of India*, New Delhi, Penguin.

Koch, E. (2006) *The Complete Taj Mahal and the Riverfront Gardens of Agra*, London, Thames & Hudson.

Kulke, H. and Rothermund, D. (1998) *A History of India*, London and New York, Routledge.

Ludden, D. (2005) 'Introduction. Ayodhya: a window on the world' in Ludden, D. (ed.) *Making India Hindu: Religions, Community and the Politics of Democracy in India*, New Delhi, Oxford University Press, pp. 1–25.

Mathur, S. and Singh, K. (2008) 'Reincarnations of the museum: the museum in an age of religious revivalism' in Desai, V.N. (ed.) *Asian Art History in the Twenty-First Century*, New Haven, CT and London, Yale University Press, pp. 149–68.

Nagaraj, A. (2008) Sarkozy Watches Monument of Love Alone, Says He'll Be Back, *Indian Express* (27 January) [online], www.indianexpress.com/story/265859.html (accessed 10 December 2008).

National Museum of India (2008a) History [online], www.nationalmuseumindia.gov.in/history.html (accessed 10 December 2008).

National Museum of India (2008b) Collection [online], www.nationalmuseumindia.gov.in/collection.html (accessed 10 December 2008).

Nehru, J. (1947) Message to the Nation on Independence Day ('Tryst with Destiny' Speech) [online], www.hindustantimes.com/news/specials/parliament/Tryst%20with%20Destiny.pdf (also www.youtube.com/watch?v=JLPDisHlmb8) (accessed 20 June 2008).

Noorani, A.G. (2003) *The Babri Masjid Question 1528–2003*, 2 vols, New Delhi, Tulika Books.

Porter, B.J. (1997) 'Dominion status' in Cannon, J. (ed.) *The Oxford Companion to British History*, Oxford, Oxford University Press, pp. 301–2.

Robinson, F. (2007) *The Mughal Emperors*, London, Thames & Hudson.

Royal Academy of Arts (1947) *Exhibition of Art chiefly from the Dominions of India and Pakistan*, London, Royal Academy.

Singh, K. (2009) 'Material fantasy: the museum in colonial India' in Sinha, G. (ed.) *Art and Visual Culture in India 1857–2007*, Mumbai, Marg Publications pp. 40–57.

Singh, M. (2005) Prime Minister's Address to the National Integration Council (31 August) [online], http://pmindia.nic.in/speech/content.asp?id=174 (accessed 10 December 2008).

Singh, M. (2007) Prime Minister's Speech on Independence Day [online], www.hindu.com/nic/pmspeech070815.htm (accessed 20 June 2008).

Smith, L. (2006) *Uses of Heritage*, Abingdon and New York, Routledge.

Taj Mahal (2008) [online], www.taj-mahal.net/augEng/textMM/seatengN.htm (accessed 10 December 2008).

UNESCO (1983) Taj Mahal Advisory Body Evaluation [online], http://whc.unesco.org/archive/advisory_body_evaluation/252.pdf (accessed 20 June 2008).

UNESCO (2008a) Taj Mahal World Heritage List Description [online], http://whc.unesco.org/en/list/252 (accessed 20 June 2008).

UNESCO (2008b) World Heritage: The Criteria for Selection [online], http://whc.unesco.org/en/criteria/ (accessed 14 December 2008).

van der Veer, P. (2001) *Imperial Encounters: Religions and Modernity in India and Britain*, Princeton, NJ, Princeton University Press.

Further reading

Anderson, B. (2006) *Imagined Communities: Reflections on the Origin and Spread of Nationalism* (revised edn), London and New York, Verso.

Ashworth, G.J. and Larkham, P.J. (eds) (1994) *Building a New Heritage: Tourism, Culture, and Identity in the New Europe*, London and New York, Routledge.

Boswell, D. and Evans, J. (eds) (1999) *Representing the Nation – A Reader: Histories, Heritage and Museums*, London and New York, Routledge.

Butler, B. (2007) *Return to Alexandria: An Ethnography of Cultural Heritage Revivalism and Museum Memory*, Walnut Creek, CA, Left Coast Press.

Edensor, T. (2002) *National Identity, Popular Culture and Everyday Life*, Oxford, Berg Publishers.

Gillis, J.S. (1996) *Commemorations: The Politics of National Identity*, Princeton, NJ, Princeton University Press.

Graham, P. and Howard, P. (eds) (2008) *The Ashgate Research Companion to Heritage and Identity*, Aldershot, Ashgate.

Hobsbawm, E. and Ranger, T. (eds) (1992) *The Invention of Tradition*, Cambridge, Cambridge University Press.

Kohl, P.L. and Fawcett, C. (eds) (1995) *Nationalism, Politics and the Practice of Archaeology*, Cambridge, Cambridge University Press.

Meskell, L. (ed.) (1998) *Archaeology Under Fire: Nationalism, Politics and Heritage in the Eastern Mediterranean and Middle East*, London and New York, Routledge.

Mizoguchi, K. (2006) *Archaeology, Society and Identity in Modern Japan*, Cambridge, Cambridge University Press.

Munasinghe, H. (2005) 'The politics of the past: constructing a national identity through heritage conservation', *International Journal of Heritage Studies*, vol. 1, no. 3, pp. 251–60.

Olwig, K.R. (2008) '"Natural" landscapes in the representation of national identity' in Graham, P. and Howard, P. (eds) *The Ashgate Research Companion to Heritage and Identity*, Aldershot, Ashgate, pp. 73–88.

Smith, A.D. (2001) *Nationalism: Theory, Ideology, History*, Cambridge, Polity Press.

Chapter 7 Heritage, colonialism and postcolonialism

Rodney Harrison and Lotte Hughes

It could be argued that many of the most important developments in critical heritage studies have occurred as a result of the particular nuances of heritage in colonial environments, and postcolonial responses to them. This chapter briefly introduces colonialism and postcolonialism in a historical context, prior to looking at the ways in which heritage functions within these settings. The chapter contains a detailed case study written by historian Lotte Hughes on heritage in postcolonial Kenya. This focuses on the ways in which heritage is employed in the official discourses of the National Museums of Kenya and in two community-led heritage initiatives, and compares their different perspectives. The chapter considers the relevance of colonialism and postcolonialism not only to 'new world' countries but also in terms of their influence on the nature of heritage and its politics globally.

Introduction

For a period of 500 years from the mid-fifteenth century various European countries – principally Spain, Portugal, Britain, France, Germany and the Netherlands – were involved in an unprecedented period of expansion that saw a large proportion of the world come under their administration and control. This period of expansion reached its zenith in the nineteenth century, when the British empire became the largest empire in human history. Indeed, although such ideas are still being debated by historians, it is possible to argue that the process of colonialism essentially *created* the modern world as we know it as well as modern ideas of nationalism and culture that underlie the entire mission of contemporary cultural heritage management. As Dirks (1992) notes:

> The anthropological concept of culture might never have been invented without a colonial theatre that both necessitated the knowledge of culture (for the purposes of control and regulation) and provided a colonised constituency that was particularly amenable to 'culture'. Without colonialism, culture could not have been so simultaneously, and so successfully, ordered and orderly, given in nature at the same time that it was regulated by the state. Even as much of what we now recognize as culture was produced by colonial encounter, the concept itself was in part invented because of it.

Culture was also produced out of the allied network of processes that spawned nations in the first place. Claims about nationality necessitated notions of culture that marked groups off from one another in essential ways, uniting language, race, geography, and history in a single concept. Colonialism encouraged and facilitated new claims of this kind, re-creating Europe and its others through its histories of conquest and rule.

(Dirks, 1992, p. 3)

The processes of colonialism can be seen to have 'created' not only the political and economic boundaries of the modern world but also its national characteristics. It could be argued that 'Europe' was defined (both economically and conceptually) as an entity by colonialism as much as those countries that were colonised by it.

The term 'colonial' is sometimes used to describe a period of time in history ('the colonial period') or aspects of material culture ('colonial architecture'). However, the term 'colonialism' is most often used to describe the process by which one nation extends its sovereignty over another nation's territory and establishes either settler colonies or administrative dependencies between the host nation and the colonial metropole (a term used to describe the geographic and symbolic seat of an empire's power). The displacement and administrative subjugation of indigenous populations often occurred as a direct result of this process.

Empires are defined as states that maintain control over their population using coercion or force, and that extend control over people who are ethnically or culturally distinct from those people who are at the core of power. Empires may be land-based, in which case they maintain a single, continuous area of land, or sea-based, in which case they maintain a dispersed series of colonies and territories.

Forms of colonialism

Scholars recognise various different forms of colonialism, each of which had different historical effects on indigenous populations and the cultural and economic make-up of the colonial state. 'Settler colonialism' describes a situation in which groups of people who are culturally or ethnically separate settle in a new place, establishing a political organisation that is administratively linked to the metropole. Examples of settler colonies include Australia, New Zealand, Canada and North America. The term 'internal colonialism' was first developed to refer to a state with equal citizenship, but which is structured socially and economically in such a way that certain areas and populations are at a disadvantage. It has subsequently come to refer more generally to a sub-set of settler colonialism in which the large-scale movement

of people within a particular territory displaces the prior occupants. Recent examples include the movement of ethnic Chinese into Tibet and Turkestan, the movement of Israelis into the West Bank and Gaza, and ethnic Arabs into Iraqi Kurdistan.

In some cases there is no mass migration of colonisers, but instead the colony is maintained by a small group of administrators who control the labour and resources of indigenous populations. Examples include the British Indian empire (see Chapter 6), the Japanese colonial empire and the Dutch East Indies. Under such circumstances, indirect forms of colonial rule might be employed, in which local systems of authority or power were grafted on and used by administrators. Such indirect forms of colonial rule were a feature of the colonial expansion of the nineteenth and twentieth centuries into south-east Asia and Africa. Other forms of colonialism include plantation colonies (such as Barbados and Jamaica) where European colonisers imported African slaves who came to outnumber both the colonial administrators and (where they existed) indigenous populations, and trading posts (such as Singapore, Hong Kong, Macau) in which the primary purpose of the colony was to establish a trading point rather than to settle or utilise the country's economic resources.

Clearly, all of these varied countries have had quite different histories, and for this reason, scholars sometimes argue about whether they belong to one or another category (or, indeed, develop new systems for categorising them). Some scholars, for example, would suggest that India should not be seen as an example of indirect rule. Others might counter that Europeans only ever touched the surface; that despite the destruction of handicrafts, by the First World War the Indian bourgeoisie was already re-establishing itself and challenging colonial rule. What is important is the widespread experience of different forms of colonialism in the modern world and its potential influence on heritage as a state-led initiative, and this is the focus of the chapter. In this regard, the chapter will deal largely with settler colonies, that is, societies where the settlers became the numerical majority and ultimately acquired power. Included in this category are occupation colonies that had aspirant settler enclaves, even where these ultimately may have failed, as there are many similarities in the ways in which heritage has been employed to deal with decolonisation in both instances.

Decolonisation and postcolonial studies

From the eighteenth to the twentieth centuries a process of 'colonial independence' or 'decolonisation' occurred in which many former colonies gained independence from their metropoles, beginning with the European colonies in the Americas in the eighteenth and early nineteenth centuries. Despite this, another period of intensive colonisation occurred in the late

eighteenth and nineteenth centuries in South Africa, India and south-east Asia, and Africa. Following the First World War the German, Austro-Hungarian, Ottoman and Russian empires were decimated and their overseas colonies distributed among the victorious countries. After the Second World War another intensive period of decolonisation occurred in Asia and Africa. As Dirks (2005) points out, colonial independence was often won as a result of violent military resistance to colonial rule, particularly in Asia and Africa. On the other hand, in India, Pakistan, Burma, Singapore, Malaya, British West Indies, much of French West Africa, Macau, Hong Kong, Australia, New Zealand and the former Soviet Union, we can see examples of colonial independence that were won *without* violence. And in the case of Yugoslavia violence for many followed, rather than preceded, independence. So throughout the course of the nineteenth and twentieth centuries there have been a wide range of circumstances in which colonies were decolonised. What connects these postcolonies in terms of heritage is the need to forge new national identities in the wake of decolonisation.

The term 'postcolonial studies' emerged during the second half of the twentieth century to describe a body of theory and literary criticism that concerns itself with how individuals and societies deal with the aftermath of colonial rule. Many scholars consider Palestinian literary and cultural critic Edward W. Said's book *Orientalism* (1978) to be the founding and most influential postcolonial text; however, it is clear that the roots of his writing lie in the work of earlier authors such as the Martinique psychiatrist Frantz Fanon. Said argues that the historical relations of power and domination between coloniser and colonised both produced and were produced by a perception of the colonial subject as 'other' to the West. The relationship between the 'other' and the West (or 'East' and 'West' in Said's terms) was characterised as a dichotomy of female versus male, emotional versus rational, nature versus culture, and in terms of the essential inferiority of the 'other' in every way. Said, and the tradition of postcolonial writing he inspired, has demonstrated the ways in which colonial forms of literature, science, anthropology, history and cartography have acted together to create this sense of difference as if it is entirely natural. More recently, work by scholars such as Indian-born postcolonial theorist Homi Bhabha (1994) has contributed significantly to the spread of postcolonial theory as a distinct field of study, blurring the line between cultural studies, migration studies, literary criticism, economic and political critique, and postcolonial studies. Postcolonial theory is concerned primarily with unveiling, contesting and changing the way that colonialism structured societies, and the ideologies associated with colonialism. In this context Bhabha's work is concerned with rejecting hard binary opposites, such as those imposed by colonial divide-and-rule policies and racial hierarchies, and replacing them with the subtleties, nuances and 'hybridity' that colonial categories tried to constrain or reshape.

One of the fundamental outcomes of colonialism is the rise of multicultural politics, which may often result from migrations of colonial-born citizens to the metropole. A feature of writing on multiculturalism has been to draw attention to the increasing lack of coherence between race, ethnicity and national identity in the twentieth and twenty-first centuries (Ang, 2005). A major concern of postcolonial literature is thus identity, and in particular the ways in which both individual and collective identity are formed. This theme of identity is one area in which postcolonial literatures overlap with and inform heritage studies. At the same time that identity has emerged as an important issue for postcolonial nations, it has also become an increasing concern at a global level as a result of the impact of globalisation and transnationalism. As we have seen in previous chapters of this book, heritage plays an important role in helping people to identify both who they are as individuals and the collectives to which they belong. Such collectives hold particular aspects of the past and its artefacts in common, and it is these aspects that help them define who they are as a group (and conversely, who they are *not*).

Colonialism, postcolonialism and heritage

As already mentioned above, postcolonial literary criticism has been concerned with revealing the role of colonial anthropology (and by extension, archaeology) in creating an 'other'. This notion has underpinned a major source of criticism of heritage in colonial (and particularly in settler) societies. Some authors have argued that heritage in settler societies needs to be 'predatory' in the sense that it needs to erase (or present as inferior) memories of prior indigenous occupation to justify ongoing occupation and settlement by outsiders (Harrison, 2008). It is now widely acknowledged that anthropology as a scholarly discipline was born out of the desire to characterise racial and cultural differences to legitimise the rule of colonial societies. Archaeologists such as Denis Byrne (1996) and Laurajane Smith (2004) have shown how archaeological heritage management in settler societies such as the USA and Australia has marginalised indigenous people: by distancing them both practically from the everyday management of their own heritage, and conceptually by conspiring in the concept of 'prehistory' which posits a break in the lives of indigenous people before and after contact. By promoting the idea that the period prior to European contact was a sort of untouched 'golden age', in opposition to the period following European contact when indigenous cultures were seen to have been impacted or destroyed by the influence of the dominant culture, a wedge is placed between contemporary indigenous people and their own past. This has allowed certain scientific 'experts' to assume the right to determine the management of this heritage.

Research into the historical archaeologies of indigenous people in settler societies has been promoted by some indigenous people, archaeologists and

heritage managers as an answer to this problem. What has emerged from research into the archaeology of the colonial period in settler societies has been a greater understanding of the entanglement of settler and indigenous lives in colonial contexts, and the complex ways in which indigenous people have sought to maintain connections with their traditional languages, lifeways and landscapes, despite government policies aimed at preventing them from doing so (see, for example, Harrison, 2004). The historical archaeology of indigenous societies is also gaining increased visibility in a legal context, where it has become an important source of evidence in proving continuity between colonial and pre-colonial land-use patterns in relation to indigenous **native title** and land rights claims.

In many settler societies, particularly Australia, New Zealand, the USA and Canada, the 1960s and 1970s saw a period of increased pressure from indigenous people for official recognition of their pre-colonial common law rights in land, and the ways in which these were illegally usurped by settlers. In Australia, for example, the land rights movement saw Indigenous Australians demand not only recognition of their common law rights in land but, as seen in Chapter 5, also greater levels of control over the material remains of their past, through requests for the return or repatriation of human remains and cultural materials from museums and archaeologists. From the 1970s, Indigenous Australians began to appear at conferences and to publish alternative viewpoints in archaeological journals, questioning the relevance and methods of archaeologists and applying political pressure to have greater levels of power to determine when and under what circumstances archaeological excavations and fieldwork should occur (Smith, 2004). This has precipitated the contemporary situation in Australia where archaeologists and others who wish to disturb archaeological sites must consult with indigenous representative bodies and document the approval of these groups prior to undertaking archaeological research.

The indigenous challenge to colonialism and to the methods of cultural heritage management in colonial countries has been influential in drawing attention to the politics of ownership and control of the past, as well as to the state's use of heritage to establish various legal fictions which allow for the ongoing moral occupation of settler colonies. This has led scholars to query the process of heritage management and the relationship between the state and heritage management more generally. The category 'indigenous' is used here to refer to those peoples who are defined as such by the UN and indigenous rights bodies, those who self-define as indigenous peoples, as well as the non-European inhabitants of former colonised territories who form a larger and all-encompassing group.

One might assume that after colonialism the natural reaction would be to establish more inclusive forms of heritage that reflect the complex ethnic and

cultural mix of the postcolonial state. However, the opposite has often been the case, as the need to establish a national identity as a 'postcolony' has led to the suppression of complex, alternative or competing histories and heritage. In the case study that follows we see the ways in which new initiatives at the National Museums of Kenya attempt to develop a unified national narrative by avoiding recent contested aspects of history and continuing an old fashioned, 'imperial' approach to the museum displays.

Case study: a comparison of state- and community-led heritage in Kenya

This case study explores some of the tensions that exist between state-led national heritage management and localised community-led heritage activities in a contemporary African context. There is, however, some overlap between the two sectors; the relationship should be seen as nuanced, rather than sharply dichotomous. The case study draws heavily on oral testimony, particularly in the sub-section on Lari Memorial Peace Museum.

The past

Kenya is a former British colony in East Africa which achieved independence in 1963. European settlers began moving there in the 1900s, largely in order to farm, run plantations, hunt big game, prospect for minerals, establish missions or work for the colonial government. In the early days of British East Africa (or the East Africa Protectorate – Kenya was formerly known by both names), more white South Africans than British flocked there, fleeing postwar depression at home. But British settlers soon predominated, led by aristocrats such as Lord Delamere who received very large land concessions from a government keen to encourage a certain sort of immigrant. Settlers tried their hardest to create a self-governing white colony, centred on what they called the 'white highlands', the most fertile part of the country. This attempt was ultimately quashed, but the struggle between settlers and administrators for control of the colony characterised life in Kenya for decades – at least from a European point of view. Settler numbers were never large (for example, there were 1183 farmers or planters by 1923).

The building of the Uganda Railway that linked Mombasa on the coast to Uganda, to the east of the country, made European settlement and agricultural production possible. After 1902 the 'interior' became accessible, and farm produce and other goods could be sent to market by train. A journey that had taken three months on a tortuous trade caravan route now took a few days. The Maasai, nomadic pastoralists (stock-keepers) who were seen to pose a threat to both railway and settlement, were swept aside – moved forcibly into reserves – in order to make way for the railway and European settlement in the

lush Rift Valley. Forced relocations of other African communities followed. Thousands of landless Africans became squatters on European farms, where they traded their part-time labour in exchange for the right to cultivate and graze their livestock, but they had no rights to land title. Over time, Africans faced increasingly oppressive land and labour laws, high taxation, restrictions on movement, forced culling of livestock, forced agricultural 'betterment' schemes and other controls, which led to growing resentment.

The seeds of colonial Kenya's downfall arguably lay within the colonial state itself; it foundered on its own in-built contradictions. Having forced many Africans into reserves, administrators had to induce them to come out again and work on European farms, or engage in other types of wage labour, in order to produce economic growth. Settlers were always desperately short of labour, and Africans could withhold it, or vote with their feet by leaving employers who treated them badly. Mission-educated Africans began to question and challenge the system that oppressed them, and formed fledgling political parties. Agitation was crushed, and protesters were often sent into internal exile.

The settler economy was never strong, except in the 1920s when agricultural export prices stabilised, and Kenya increasingly came to rely on African peasant production. As Lonsdale writes:

> Colonial rule entrenched power; it also enlarged markets. The African poor could exploit the new demands for their produce and their labour because there was also new competition for the prestige of their protection ... As workers they were oppressed but as dependants they benefited from the rivalry for their service among a wider range of patrons.

(Lonsdale, 1992, p. 15)

Colonial rule led to class formation (see also Chapter 8), which ultimately produced a class of literate Africans who would challenge and replace their masters.

Though other African resistance predated this, by the early 1950s one particular resistance movement posed the biggest challenge yet to government. It was called Mau Mau[1] by the British, but its predominantly Gikuyu (also spelled Kikuyu) leaders called it the 'struggle for lands and

[1] It is not clear where the name comes from. Some say it derives from the Gikuyu 'pig-latin' words '*uma, uma*,' meaning 'out, out', shouted when police broke into an oathing ceremony at Naivasha, in the Rift Valley. Others say it comes from the word for oath, *muma* (Gikuyu), or that an African preacher referred to the movement using a children's anagram that meant 'a childish thing' (Edgerton, 1990, pp. 56–7). Some say it comes from the Swahili: Muzungu Aende Ulaya, Mwafrica Apata Uhuru, roughly translated as 'Let the white man go back overseas, so that the African can get his independence.'

freedom'. They demanded an end to British rule, the expulsion of white settlers and the return of land to Africans. Though other types of opposition, including intellectual, also played a part in the struggle for independence, Mau Mau paved the way. The revolt was brutally put down by the British, and a state of emergency enforced from 1952 to 1959.

Nationalist leader Jomo Kenyatta (who the British wrongly thought was behind Mau Mau) became independent Kenya's first president in 1963. He was replaced in 1978 by Daniel arap Moi, whose dictatorial regime lasted twenty-four years. Multi-party politics was restored in the early 1990s, but forty years of rule by the KANU Party (Kenya African National Union) ended only in 2002 with the landslide victory of Mwai Kibaki, leader of Narc (National Rainbow Coalition). Kenyans had high hopes that this heralded the dawn of a new, democratic era. But disillusionment grew as Narc fell apart, beset by internal squabbling and corruption scandals. It is estimated that up to $1 billion was lost to corruption between 2002 and 2005. Having lost a crucial referendum on a new draft constitution in 2005, President Mwai Kibaki faced his biggest challenge at the 2007 polls from former colleague Raila Odinga. Popularly known simply as 'Raila', he was widely tipped to win both the presidency and Parliament for the Orange Democratic Movement (ODM). The election struggle was bitter, and mired in ethnic name-calling; Kibaki, who heads the Party of National Unity (PNU), is from the majority Gikuyu ethnic group, Raila from the smaller Luo community, though he attracts more cross-ethnic support than his rival.

The December 2007 general elections were widely condemned as rigged, and Raila rejected Kibaki's declared victory. A post-electoral crisis resulted, involving widespread violence and a humanitarian disaster. The violence was wrongly characterised by the western media as 'tribal' or 'ethnic', when in fact it was largely politically instigated. More than 1200 people died and around 600,000 were displaced from their homes. The crisis was resolved, and calm restored, only after a flurry of international mediation led by former UN secretary-general Kofi Annan. A power-sharing deal was reached on 28 February 2008.

The present

At the time of writing (July 2008) a Grand Coalition government rules Kenya, led by President Kibaki and Prime Minister Odinga. Cracks are showing in this coalition, and many problems remain at every level of society, exacerbated by rampant inflation, food shortages (partly because the post-electoral crisis affected agricultural production) and a growing gap between rich and poor. But the country is now on course for a new constitution, a national peace and reconciliation commission, draft laws against 'tribalism', and a national land policy to tackle some of the underlying problems that led

to the crisis. The crisis was both constitutional and political, but also more fundamentally a crisis of nationhood, identity, history, memory and heritage which will take far longer to resolve. This wider crisis is manifested, for example, in political speeches, public debates, protests, peace pilgrimages and other expressions by citizens, media, human rights groups, NGOs and Church leaders, who make up what is called civil society. Almost overnight, Kenyans are crying out for a unifying history in order to safeguard a notional nationhood. I use the word 'notional' because historians and political scientists argue that Kenya as a postcolonial nation has never existed. It cannot be induced all of a sudden, just because external midwives (mediators and western powers) badly want a resolution of post-electoral problems. The building of nations is essentially a work of imagination, but Kenya is yet to be imagined, and the requisite imagination may be lacking – especially among leaders.

Ordinary Kenyans are hurting. They speak bitterly, some telling me (on a visit in May to June 2008), 'our leaders are now taking tea with each other, and shaking hands, but they don't understand what we went through'. The post-electoral wounds will take a long time to heal. It is not at all clear whether people from certain communities will be able to live together again; some are refusing to leave camps set up for internally displaced people, citing continuing insecurity in their home areas. At national level, there is talk of state-driven peace and reconciliation, but this has many meanings and may not trickle down to the grassroots. Kenyans remain worried, and deeply suspicious and sceptical of their politicians and one another. Their faith in democracy, electoral processes, and the very idea of the Kenyan nation – and hence what it means to be Kenyan – has been badly shaken.

Whose history?

A multiplicity of sub-national histories – of different communities and the land they live on – passes for 'national' history in Kenya, but these are often ahistorical and compete with one another, challenging the authenticity and validity of other people's histories, stories, identities and heritage. They can be seen as constructions of ethnic identity, tied to particular territory, and shaped in part by colonial policies of divide and rule which included placing some Africans in reserves and barring other ethnic groups from settling there. British administration of sub-groups as separate 'tribes' (for example, among Nandi-speaking peoples, who include Kipsigis, Tugen, Kalenjin and other sub-groups) aided the construction of 'tribe' over time. These legacies became clear during the post-electoral crisis, as people from different ethnic groups asserted their right to live in certain places and drive others out, invoking

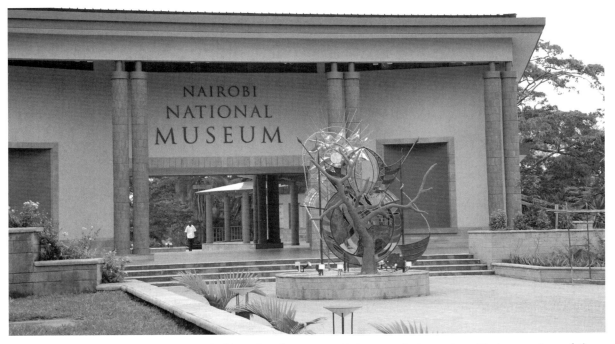

Figure 7.1　The new entrance to Nairobi National Museum. Unknown photographer. Photo: courtesy of the National Museums of Kenya.

'historical' arguments that were often factually incorrect. Ethnic groups are in fact historically porous and fluid, not monolithic or rigidly bounded. Communities are made up of people who are the product of generations of inter-marriage, and should not be thought of as 'racially pure'.

Long before the current crisis, Kenya was not alone among postcolonial states in standing at a crossroads in its management of national heritage. From Zimbabwe to New Zealand, the postcolony is striving to cast off colonial legacies and forge a national identity. This is most evident in makeovers of national museums, which may be said to hold up a mirror to national identity. The state-run National Museums of Kenya (NMK) has recently undergone (2005–8) a major, EU-funded renovation of its flagship Nairobi National Museum; the makeover process was called 'Museum in Change' (Figures 7.1 and 7.2). This included creating a history gallery, whose curators were (long before the electoral crisis) already struggling to produce an inclusive 'story of Kenya' on which everyone could agree. This project became all the more necessary after the crisis, but may be even harder to achieve, especially now that the EU funding has run out. By mid-2008, the museum had only partially re-opened; out of thirteen galleries, only four had opened to the public with new permanent exhibitions. The Kenyan government has pledged more money so that the renovation process can continue.

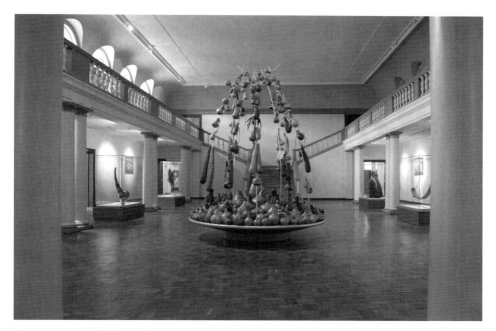

Figure 7.2 A display of calabashes in the Hall of Kenya, Nairobi National Museum. Unknown photographer. Photo: courtesy of the National Museums of Kenya.

Like many other museums of its kind, until very recently NMK followed imperial agendas which included heavy emphasis on the preservation of material culture and antiquities, the classification of 'tribal' peoples in order to facilitate their control, and the collection and show-casing of fossils, fauna and flora, and items of material culture. This type of museum has been called a European transplant. It originally catered mainly for the white settler community and European tourists, and has long reflected the research interests of influential individuals, in this case those of the Leakey family (famous palaeontologists Louis, Mary and their son Richard). It was first established in 1910 by a colonial natural history society, whose successor is still represented on the management board.

Much of Kenya's pre- and post-independence sociopolitical history is not mentioned in the museum, which prefers to focus on non-controversial subjects. As a result of these legacies, it is said NMK has 'failed to address issues of immediate relevance to the citizenry', including the colonial experience and struggle for independence (Munene, 2005). This is a big turn-off: Kenyan visitors (apart from schoolchildren and some students) have largely stayed away, both from the main museum and NMK's regional museums. However, an effort is now being made by the curators of the history gallery at Nairobi National Museum to gather oral histories from Mau Mau veterans and place these in the new exhibition space, when it is ready. This exercise is not without its own problems, for example whose testimony is to

be featured, and whose left out? Is there a danger that by focusing on Mau Mau fighters other contributions to the struggle for independence, such as intellectual ones, are marginalised or overlooked? As veteran Kenyan historian Bethwell Ogot has asked, 'Must one have been in the forest to be a hero?' (2005, p. 505).

Other features of national heritage management in Kenya include: state concern with controlling citizens whose activities are regarded as a threat to national heritage; displays of power in ostentatious public ceremonies at memorial sites; catering for elites; and framing heritage in commercial terms as an earner of foreign exchange from tourism. The constitution does not recognise cultural rights, such as the legal entitlement to a cultural past. (A new draft constitution, rejected by Kenyans in a 2005 referendum, would have included this.) Kenya appears to follow a European tradition of using national heritage to 'consolidate a sense of national identity and to assimilate or dispense with competing regional or minority challenges' (Kockel and Craith, 2007, p. 9). For example, the state uses emblems of Maasai-ness to brand Kenya (such as the shield on the national flag), yet simultaneously marginalises this community, and dismisses indigenous and minority peoples' rights and claims to land and natural resources. Until very recently there has been total silence at state level about certain events, notably Mau Mau and the struggle for independence. NMK is trying to redress this, as mentioned above. But state-orchestrated amnesia continues. At the height of the post-electoral crisis President Kibaki echoed First President Jomo Kenyatta in saying 'Let's all forget the past and preach peace and reconciliation' (*Standard*, 2008; Ogot, 2005, pp. 504–5 for Kenyatta's earlier stance). Since then, Raila Odinga and other political leaders have made similar exhortations to 'forget the past'.

In the run-up to these elections, constructions of history, memory and identity were used in political discourses around heritage. For example, incumbent President Kibaki and others launched a new Party of National Unity, which traded on the idea that only they could unite the many different ethnic groups. Presidential challenger Raila Odinga portrayed himself as 'the bridge that links the historic moments of the past to the bright future ahead' (a reference to his late father, Jaramogi Oginga Odinga, who was briefly vice-president in the mid-1960s) (*Standard*, 2007). Raila stood on a *majimbo* ticket, meaning he promised to introduce 'regionalism', a form of decentralised government that some Kenyans fear could lead to fragmentation along ethnic lines, but which would be welcomed by minority communities who want to see resources diverted to their regions. This idea has been around since the late 1950s. The plan was quietly dropped after the coalition government formed, but renewed talk of *majimbo* reflected 'a fundamental tension between region and nation that was not adequately addressed in the independence settlement' in 1963 (Anderson, 2005a) – a tension evident in the dichotomous heritage sector.

In an attempt to woo voters, the previous government accelerated plans to create a Heroes' Acre, an idea first mooted in 1994. It sent a task force around the country in 2007 to canvass people's views on who should be publicly commemorated as a hero or heroine in Uhuru Gardens, Nairobi. (Uhuru means 'freedom' in Kiswahili, the national language together with English, though fewer people speak English.) A government committee set certain criteria, but at the time of writing had not announced a decision. Tensions around the legacy of Mau Mau, in particular, were evident in these public debates. There was also a sudden spate of mausoleum and statue building, to commemorate national heroes including Mau Mau fighter Dedan Kimathi. A statue of him was erected on Kimathi Street, Nairobi. The date of the unveiling, 18 February 2007, was fifty years after Kimathi was executed by the British (Figure 7.3).

But citizens' efforts to participate in heritage as a cultural right, and to run heritage activities of their own making, tend to be dismissed as illegitimate. Control of non-state actors is central to the National Museums and Heritage Act 2006, which enshrines NMK as the only legitimate museum in the country and bans non-licensed people from collecting artefacts. It effectively gives NMK a monopoly on heritage. In theory, the law allows for private museums so long as they register with the government. But community and private museums fear it could criminalise their activities.

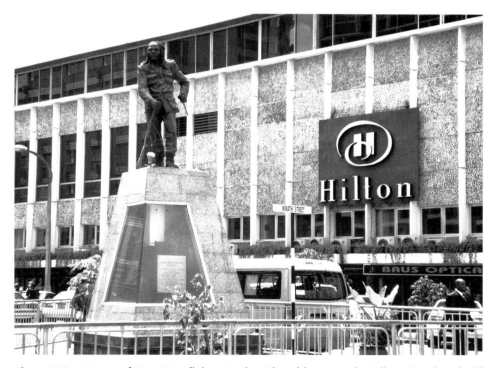

Figure 7.3 Statue of Mau Mau fighter Dedan Kimathi next to the Hilton Hotel, Nairobi city centre. Photographed by Karega Munene. Photo: © Karega Munene.

Community and peace museums

Meanwhile, small community-led museums and sites of memory are springing up all over the country (Figure 7.4). The people involved in them (who are not professional museologists but ordinary members of the public) say they regard the objects in NMK as 'dead' and irrelevant. In the absence of official recognition of cultural rights, they are asserting their rights to heritage and culture. These museums (which may be better described as cultural resource centres) are not – with a few exceptions – targeted at tourists, but rather at local citizens. Some are in people's own homes and backyards; others are not built edifices but natural spaces, including sacred forests. Many sites have an environmental focus, which can include community ecological governance. (This involves communities in taking responsibility for conserving local environments, especially those they regard as endangered.) The peace museums aim to use 'traditional' methods to achieve social healing and reconciliation in communities still struggling to come to terms with past conflict (notably Mau Mau, see Lari Memorial Peace Museum, below) – though the fallout from the 2007/8 crisis has added a new dimension to these efforts. The methods include planting peace trees and holding earth-cleansing ceremonies. None of these museums is funded by the state, but run by local NGOs and community-based organisations (CBOs), some supported by foreign donors.

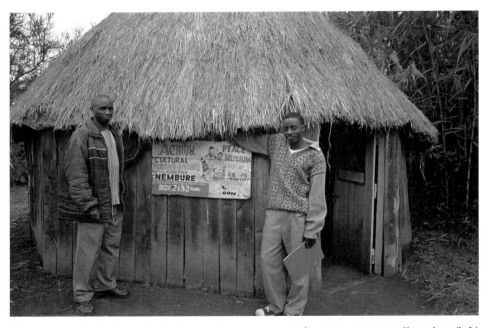

Figure 7.4 Embu Community Peace Museum, near Embu town. Curator Njiru Njere (left) with volunteer Stephen Nyaga. Photographed by Lotte Hughes. Photo: © Lotte Hughes.

These community-driven initiatives are a relatively new phenomenon in Kenya, though they build on earlier ones. Research by Open University (OU) scholars (in partnership with Kenyan academics, museologists and citizens) shows that community museums appear to signify a renaissance of civil society activism around new forms of struggle. Heritage actors seem to be challenging state systems of knowledge and power, as well as expressing a craving for memorialisation and reclamation of history and heritage that reflects:

- emergence from a long period of official suppression of public memory
- the legacy of conflict, especially Mau Mau (early 1950s)
- the flowering of civil society, concerned about environment, human rights, participation, social healing, African spirituality, and preservation of culture (Figure 7.5).

The activities also appear to reflect a backlash by formerly colonised subjects against being taught to despise their own cultures and languages. People say they want to bridge knowledge gaps caused by the estrangement of elders and youth. (This has come about partly because many children go to boarding school, and no longer learn about culture and history by talking to their grandparents. Also, the national curriculum does not really cover cultural

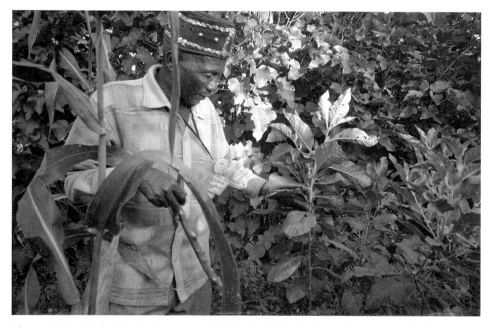

Figure 7.5 Herbalist Dr Mwongo M'rimberia in his herb garden, Meru District. Photographed by Lotte Hughes. Photo: © Lotte Hughes. Preservation of indigenous knowledge and the natural environment is an important part of community-led heritage activities.

history.) To compare state-led 'stories' with community-led ones, these grassroots activities are also producing plenty of 'stories' about the past, which are not necessarily any more coherent or uncontested than the dominant, nationalist narrative. There are many internal wrangles within as well as between the communities and groups involved in these grassroots heritage activities.

Two examples of community-led heritage initiatives

Lari Memorial Peace Museum, Kiambu West District, Central Province

Lari is a small town in the Rift Valley, north-west of the capital Nairobi. This tiny museum was created in 2001 by local people who were on opposing sides during the Mau Mau conflict of the early 1950s – loyalists and Mau Mau resistance fighters. The aim was to heal the wounds of social conflict that have torn the Lari community apart ever since a double massacre which took place here in March 1953. The ideas behind the museum came from local NGOs the Community Peace Museums Programme (CPMP) and African Initiative for Alternative Peace and Development (AFRIPAD), whose work was inspired by a former ethnographer at National Museums of Kenya, Dr Sultan Somjee. Both groups are now defunct; they broke up and people left to form other NGOs. But my visit, as a British researcher from the OU, was facilitated by these groups. The museum is now part of the Community Peace Museums Heritage Foundation.

The massacre has been called the 'greatest bloodletting of the entire Mau Mau war' (Anderson, 2005b, p. 119). Loyalists were those Kenyans who stayed 'loyal' to Britain during the Mau Mau emergency, declared in October 1952 and lifted in November 1959. Many joined the Home Guard, a citizens' militia armed and organised by the British colonial government to protect villages from attack and support the police and army in their operations against Mau Mau. After years of official suppression of public history and memory Mau Mau remains a highly contested subject in Kenya. As an organisation, it was unbanned only in 2003.

Though ostensibly a resistance movement against British rule, aimed largely at ending colonial rule and reclaiming lost land, the struggle became a civil conflict in which loyalists were pitted against Mau Mau fighters and sympathisers. What happened at Lari was also internecine. One section of the community turned on another, largely because of land grievances which had left many people landless while others (such as chiefs) had done well, usually as a result of British patronage. In what became a double massacre, the first wave of killings (seventy-four fatalities) on the night of 26 March involved Africans killing Africans, many of them neighbours. Loyalist

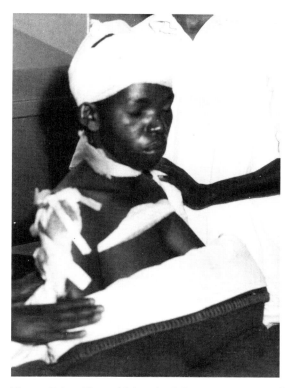

Figure 7.6 The British colonial government used photographs to spread propaganda about Mau Mau and the Lari massacres. The caption originally supplied with this archive photograph read: 'A bandaged Kikuyu woman, one of the few survivors of the Lari massacre carried out by Mau Mau fighters, recovers in hospital', March 1953. Photographed by Elspeth Huxley. Photo: © Elspeth Huxley/Images of Empire.

victims were carefully chosen, flushed out of their burning houses and hacked to death. They included many women and children. The second massacre, the next morning, involved Home Guards and African police under British command hunting down and taking instant revenge on suspects (*c*.200 deaths). The true figures were probably much higher (Figure 7.6).

These events have never been forgotten. People talk about them as if they happened yesterday – but not publicly. Intermarriage between the children of former Mau Mau fighters and supporters, and those of loyalists, is taboo. Even fraternising is frowned on. The enmity is evident in everyday life.

The museum is a grassroots attempt to heal these wounds. It occupies a tiny room in a small row of shops, and houses official British propaganda photographs (for example, showing massacre victims, British government officials visiting the massacre site), items connected to colonial rule (such as the hated *kipande* or registration papers that male Africans had to carry), and

cultural artefacts from Gikuyu and other ethnic groups, especially artefacts used in peace making. On one wall is a long handwritten list of those who died. No one is allowed to repeat these names publicly outside this room.

Stanford Chege, a member of the management committee, says its objectives are to

> collect, document and preserve artefacts for posterity as well as rewriting our history which has often been found to be lopsided depending on those who write and on which side they served ... The main objective of the museum was to bridge the divide between the two opposing sides.
>
> (Chege, 2007)

Curator Waihenya Njoroge describes it slightly differently – as a 'cultural and peace resource centre'.

The story of Lari (or rather, two individual experiences of it) was told to me by two elderly members of the management committee who were on opposing sides during Mau Mau – one a Home Guard (Douglas Kariuki Wainana), the other a former fighter (chairperson Joseph Kaboro Tumbo). Mr Tumbo narrowly escaped the gallows, winning a last-minute reprieve in his trial on murder charges. Their stories are moving. However, stories like this must be read with caution; they are partial and invariably partisan. What is left out of this kind of testimony (oral or written) is as important as what is left in – what is remembered, versus what is 'forgotten'. We need to ask ourselves why stories are constructed in certain ways, and compare them with other types of historical record. Just as there is a need to be critical when deconstructing photographs, as discussed in Chapter 2, we must treat oral testimony with caution. It is the product of a particular process, and needs to be interpreted together with available evidence. The aim of the process may be, for example, to concretise certain myths (especially those about origins), or to privilege one kind of story over another, or to suppress other information or stories that remain unsaid.

Also, remember that the telling of oral history is a kind of performance – in this case, the two men were 'performing' in front of me, the young curator, two Kenyans (both Gikuyu) from CPMP and AFRIPAD (the NGOs that were then supporting the museum), a Maasai friend of mine and a Gikuyu woman actor/theatre director from Nairobi who happened to accompany me on this trip. They were also performing to each other; maybe their accounts might have been different if the other had not been there. From discussions I have since had with community museums groups, it is possible that both elders and curator – mistaking me for a western donor – thought that a 'good' performance might elicit funding.

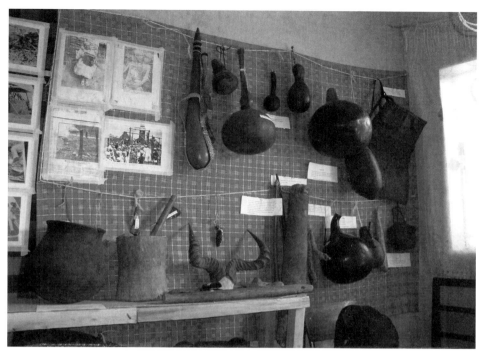

Figure 7.7 The Lari Memorial Peace Museum. Photographed by Annie E. Coombes. Photo: © Annie E. Coombes. The exhibits include British propaganda photographs of the aftermath of the massacre (top left), as well as cultural artefacts from different ethnic groups, which are used in peace making (right, and on shelf below photos).

The following conversation took place in the museum, next to the photographs of Lari massacre victims (Figure 7.7). It took several hours; this is a short, edited excerpt. The form it took was less a formal interview, more a telling of 'life' stories, at a pace dictated by the speakers. My thanks for translation go largely to curator Waihenya Njoroge, and to Kariuki Thuku and Mumbi Murage who then worked for CPMP/AFRIPAD. Remember, too, that translation is a filter and may be inexact. Possible errors or omissions (deliberate or otherwise) in translation, as well as my transcription, should be factored into the analysis. I have added explanatory remarks in square brackets, to aid comprehension.

DOUGLAS WAINANA (BORN 1931): I came and I joined the Home Guard, and I was number 116. I wore that number round my neck. So I was not fighting the colonialists. Then there started a big uprising, when we were being fought.

WAIHENYA NJOROGE (CURATOR): Then the Home Guard worked together with the Tribal Police to fight the Mau Mau.

DOUGLAS WAINANA: Then Mau Mau in Lari were revenging the Home Guard leaders, because of the torments the Mau Mau were getting

from us. Someone by the name of Waruhiu, he was the division chief here. [Government-appointed paramount chief for Central Province, murdered 7 October 1952 by Mau Mau.] On 26 March 1953 the Mau Mau planned on how to come and kill the Home Guards within Lari, and our leader Joseph Karuga knew about this. He notified us and we hid ourselves in the police station premises. A white man by the name of x [name deliberately omitted] picked us and took us to the nine homesteads where the killings had occurred during the night. And so in the morning at 8 a.m. on the 27th we started revenging by killing the Mau Mau. We arrested some of them and took them to the police station. They were being taken from their homes, because we already knew them; we were picking them up. The Home Guard were very strong because we had the back-up of the colonial government and we kept this power, destroying and killing Mau Maus.

But the colonial power gave power to the Mau Maus [that is, at independence], and we became paupers. Even after independence, the Mau Maus were the ones who took power and the Home Guards were treated as if they were not humans. We started this museum to unite the Mau Maus and the Home Guard again. We, the elders of the museum, have brought into light where the Mau Mau gravesites are and we even took the media to those sites. At the same site, the president [Mwai Kibaki] came and planted trees.

We who are aged want to bring into light what resources we have underground, so that they may be brought up. We need not only to get it verbally but also in writing so that future generations can learn about history, because so many people have been giving out false information about Home Guards, people who were not taking part in it [the conflict].

[He repeatedly used the phrase *bring into light*, which he said meant shining a light on 'things that have been bringing enmity'. But it may also link to beliefs, in this deeply religious community, about Christian redemption.]

The wounds are really starting to heal. We have been doing this [healing] in collaboration with other communities in Kenya, talking together about peace cultures [traditional methods of peace making.]

[He went on to talk about the need for a truth and reconciliation commission, mooted several years ago but abandoned by the previous government in 2003. There are renewed calls for such a commission following the 2007/8 post-electoral crisis.]

INTERVIEWER: Are the activities of peace museums a form of grassroots truth and reconciliation, in the absence of a state-sponsored process?

WAIHENYA NJOROGE: Yes, we are doing it for ourselves, because Home Guards are seen as enemies in the community, even after independence they were still being seen as enemies. If you called someone a Home Guard it was too bitter, it was as if you were bringing up a new wound. People are now saying they don't want to die in pain; they have been harbouring that pain for so long.

DOUGLAS WAINANA: I would really support that idea of bringing out the truth and forgiving each other. That's why I myself have been telling this truth that I myself was a Home Guard. Not many people would admit that, even to date.

JOSEPH TUMBO (BORN 1922): It is good that you [the interviewer] have come from UK now. We have to talk afresh now, about the reasons why we fought. I was a foot soldier in the Second World War. We went fighting Hitler and Mussolini for the British. Later, every able-bodied young man from this area was picked up and taken to Madagascar to fight the Japanese. We fought the Japanese and they fled away to Burma and Ceylon. And the black people were killed in Madagascar because they were the first ones to have sunk in the sea. When we came back home in September 1945, we were not given anything after doing this. We went home empty-handed, even after having sacrificed our lives. I was only getting 65 Kenya shillings a month as the most senior mechanic in charge of a [British army] garage in Nairobi.

When we came back we found our land had already been taken over by the whites; every white man already had his share. Everywhere was under the British, everywhere where the land was fertile. Part of the Rift Valley became the 'white highlands'. Our people were chased away and had their herds of cattle taken away; we were told we must only keep a certain number of sheep or goats. [A reference to regulations applied to squatters living on European-owned farms.] Those people were chased from the Rift Valley [that is, squatters driven off white farms] and came to Lari, and people started to ask for their land [so-called *mbari* land collectively or individually owned by a Gikuyu descent group], but they were denied. There was no employment apart from white farms, and we could go and pick pyrethrum [aromatic plant, whose dried flowers are used to make insecticide]. We tried to petition the British to get our land back, but we failed. We became paupers.

We, having come from the Second World War, declared that we were not going to be slaves any more. Because the whites had already

denied us everything, every privilege, and our grandfathers had already died, [we decided] it was better we die and save our generation from this embarrassment. We said we can sacrifice ourselves, even if it means we die so that we save our children. Those who had trained as soldiers trained the rest in how to shoot guns. We formed militant groups and started fighting the British. We knew the whites had guns in their homes, and policemen also had guns, and we went and got guns from them. Household servants [in European homes] would help us.

[He talked about tough laws aimed at quelling the growing resistance, including bans on illegal meetings. Though hatred of British rule was increasing, he and his friends saw loyalists – fellow Africans – as the prime enemy, because they sided with their oppressors.]

We decided that unless we eliminated the Home Guards, and remained only with the whites, we couldn't achieve anything. That's why on the 26th March the houses [of loyalists, especially chiefs] were burned. [He described how they targeted Chief Luka, who] had been allocated a big piece of land at Githirioni by the colonialists. The black people thought Luka had betrayed them by taking their land. By eliminating these people, they thought they could now take back their land.

[On the wall above, official British propaganda photographs show the body of Chief Luka with his feet cut off. The caption reads: 'Mau Mau pangas [machetes] severed his limbs and left him to his fate.']

We thought it would be all over in a single night. But in the morning, when we had gone back to our homes, the colonialists brought machinery, tribal policemen and Home Guards with weapons to try and revenge for what had happened during the night. Then we Mau Maus were attacked by these forces. Each male child over the age of 16 was picked up and taken to Uplands police station [a few miles away]. I was also picked. While we were in the police station the people who were collaborating with the whites beat us, killing some of us within the station. Even the white women were coming there to kill. Other people were shot dead inside Kiriita Forest.

[The secretary of state for the colonies, Oliver Lyttelton, visited Lari in May 1953 to investigate what had happened.]

I was very close to where Lyttelton [and others] were standing in the police station, and I heard him say that in England it was against the law to kill anyone for being suspected of a crime without being tried in a court. [Mr Tumbo described the identity parade, in which Home

Guards, widows and children of victims were asked to point to the alleged killers.] I was one of those who were pointed at; I was actually the second to be picked out. Twenty-seven of us were identified as having participated and we were given over to the CID. I was charged with killing Penina x [name deliberately omitted], the wife of a chief. One of us was beaten to death, a man called Moses Igamba, and so we remained twenty-six.

[There were nineteen mass trials in all, of 309 alleged murderers, of whom seventy-one were hanged. The trials were highly flawed, according to scholars – reliant on confessions made under torture, and unreliable evidence from survivors, including children, while defence lawyers (many of them Asian, working without payment) were obstructed by officials and European settlers. See Anderson 2005b.]

We were first brought to the High Court at around midnight to be charged. We saw there were no black men apart from the interpreter. We thought we would be hanged the same same night. [Kenyans often repeat the word twice.] When we met later we were very happy.

[He was later sentenced to hang at Githunguri Teacher Training College, where an emergency gallows was erected next to the court. Out of this particular group of accused, he and four others were acquitted on appeal at the eleventh hour. Mr Tumbo ended by saying he never usually speaks about these things, and never gives out – even to his own children – the names of people identified as Lari massacre perpetrators.]

WAIHENYA NJOROGE: Our job is to bring healing, and do as Desmond Tutu said: 'There is no future without forgiveness.'

Reflecting on the role of the Lari Memorial Peace Museum

It is worth pausing here to consider what all of this has to do with 'heritage'. Although it is called a 'museum', the Lari Peace Museum is different from the museums with which most people would be familiar. The museum commemorates an event through the display of material which it would be taboo to discuss outside its walls. It has a specific objective, to heal long-held historical divisions in a village that was involved in a bloody and violent past which emerged directly as a result of British colonial manipulation of local loyalties. The circumstances of Lari raise some of the general problems of dealing with the local, lived experience of history in the wake of postcolonialism. While Mau Mau and their activities were suppressed under

British colonial rule, they are now perceived as freedom fighters in changed political circumstances. The contribution of land-based feuds to the polarisation of the community, which led in turn to the massacre, appears to have left a legacy of enmity between loyalists and Mau Mau. The museum, unlike NMK, aims to air the town's 'dirty laundry' in a context that is removed from everyday life, and is hence an authorised space in which to talk about the painful events of 'history'. But we should also read these accounts, as compelling as they are, as partial. For example, at no point did Mr Tumbo say whether he was guilty as charged, nor did Mr Wainana admit beating or killing any Mau Mau suspects on British orders.

Note, too, how Mr Wainana does not mention the root cause of the conflict – land insecurity – though Mr Tumbo lays the blame largely on this. Mr Wainana's narrative rapidly moves forward in time from the events of 1953 to independence (1963), when nationalist leader Jomo Kenyatta became president – though he was never a Mau Mau fighter, as the British believed, and went on publicly to denounce Mau Mau. Throughout his time in power Kenyatta orchestrated public amnesia about Mau Mau, ostensibly for the sake of 'nation building'. In Mr Wainana's view, Mau Mau fighters were subsequently lionised while loyalists were sidelined, which is only partly true. It is only relatively recently that Mau Mau veterans were eulogised as national heroes, and many lament that they have lived and died in poverty, not having benefited from the fruits of independence.

Could the fact that the interviewer was British have influenced the stories these men chose to tell, and the way in which they told them? In a spirit of truth and reconciliation, they asked her to ask the British government to say 'sorry' for how they dealt with Mau Mau. Simultaneously, a separate group of Mau Mau veterans was trying to bring a lawsuit against Britain, seeking compensation for alleged human rights abuses in Mau Mau detention camps. This background information also needs to be factored in; it helps us to understand the wider context.

Community eco-mapping of Karima Sacred Forest

In the forests of Othaya, near the town of Nyeri in Central Province, people from the Gikuyu community are eco-mapping with the use of geographical information systems (GIS). This is one of five forest-mapping exercises being pioneered in different areas of Kenya (and among different ethnic groups) by local NGO the Porini Association. 'Porini' means 'natural wilderness' in Kiswahili. The association was founded in 2005 by young people who had quit the Community Peace Museums Programme and AFRIPAD, the two groups mentioned in the previous case study about Lari Memorial Peace Museum. Porini also supports community-led peace museums, and other cultural and environmental heritage initiatives around sites of memory.

What's the idea behind it? Porini's broader vision is that

> effective environmental conservation is a function of cultural wisdom
> and commitment from local communities. This thinking is coming
> from the fact that despite Kenya having some good laws on
> environmental protection, degradation continues unabated. However,
> where cultural norms on conservation are upheld, local environments
> continue to thrive and their integrity is sustained.

<div align="right">(Porini profile, undated copy supplied to Lotte Hughes)</div>

Porini works with community members to develop community-led ecological
governance, which ostensibly involves protecting both communities and
environments. In this case, the 'community' consists of about 12,000 people
living around a 270-acre forest, which lies in the eastern Aberdare Mountains.
The forest is said to be owned by four 'indigenous' clans who base their
claims of belonging on stories about an ancestor called Mbaire, said to have
lived here in the mid-seventeenth century.

This part of 'the story of Karima' is problematical from a historical point of
view, because Gikuyu did not migrate to this area until much later. Mbaire was
more likely to have been a member of a community of forest-dwelling hunter-
gatherers called Athi, who occupied these forests before the Gikuyu arrived,
and who were either displaced or assimilated by Gikuyu. Also, although the
word 'indigenous' is increasingly used by Porini and community members
here to describe themselves, according to UN definitions the Gikuyu do not
'qualify' as indigenous people in the sense that they were not aboriginal first-
comers to this territory, are not marginalised within the nation-state (on the
contrary, Gikuyu elites have long dominated Kenya politically and
economically), do not as a whole self-define as indigenous, and are not
recognised as such by other indigenous peoples.

But to continue the story, the forest contains two shrines that have been
gazetted by NMK. The shrines are near sacred fig trees (called *mugumo* in the
Gikuyu language), which are very important in Gikuyu cosmology.

Each tree was a 'holy space', not only for communion with God but also for
peace making. It was taboo to kill birds or other animals there, which provided
them with a haven. These particular shrines are in a 75-acre plot, planted with
indigenous trees; this 'island' is surrounded by exotic tree species said to have
been planted in the 1950s by the colonial government.

The larger portion of the forest is managed in trust by the local Othaya Town
Council, which has leased out land to a tea factory that uses the timber to roast
tea leaves. (Trust lands are a category of public land, vested in county
councils; in colonial times they included land in African reserves.) Porini says
no direct benefits from these activities trickle down to the community, and it

wants the tea factory to stop destroying the forest. It has threatened to bring in traditional spiritualists to curse both council and factory, if they do not stop the degradation and allow the community to manage the forest.

Through eco-mapping, communities are said to be learning to 'define their territory, cultural identity and traditional knowledge, their past, present and future. It will help them in their advocacy work for better governance of their natural resources' (Muchire, 2007). Communities say they are mapping in order to 'know' their heritage, and to 'know' what heritage they have in their territory. Porini contrasts this with state-led mapping, which it says is usually used to *separate* people from their land.

Why are these activities happening now? A fairly new Forest Act 2005 has raised people's concerns about the 'security' of forests, and their ability to access and manage them. Communities that register as 'forest communities' under the Act can apply for permission to co-manage state or local authority forests. Once approved, these associations can protect sacred groves, for example, and enjoy user rights including the collection of medicinal herbs, honey and timber harvesting, as well as 'ecotourism and recreational activities' in forests. This sounds generous. But many communities feel that this is not enough – the forests are rightfully theirs, they believe, since they have strong spiritual and historical ties to them.

Eco-mapping involves producing three-dimensional models of forests, both at Karima and at other sites. Elders can use the models to map important trees, shrines, streams, rivers, boulders and so on, and tell stories about these landmarks. This has made some state forestry officials uneasy – because they fear they will be used by communities to make more ownership claims.

These activities may at one level be read as exercises in the reclamation of cultural heritage. References to the links between cultural and natural heritage are not only made in discourses on eco-mapping but also feature in, for example, speeches made at an alternative World Environment Day in June 2008, organised by Porini, which drew hundreds of local schoolchildren and their teachers to Karima Hill to plant indigenous trees and learn about environmental issues (Figure 7.8).

But the frequency with which the word 'indigenous' is beginning to crop up in storytelling by Porini and community members here suggests a different dynamic, linked to global constructions of indigeneity. These are being nurtured by international and regional NGOs and UN agencies concerned with indigenous rights. Constructions of memory, identity and indigeneity connect in turn to the politics of gain – in other words, people may be keen to present themselves as indigenous in order to receive benefits from western donor organisations. These assertions connect to wider, globalised discourses around environmentalism, land rights and cultures that are perceived to be endangered.

Figure 7.8 Schoolchildren planting indigenous trees at an alternative World Environment Day organised by Porini Association at Karima Sacred Forest, June 2008. Photographed by Lotte Hughes. Photo: © Lotte Hughes.

As a historian, I must also place these activities in a broader historical context. Eco-mapping and the debates around it connect to a variety of postcolonial legacies, which include discourses about the alleged culpability of Africans for environmental degradation. Reconstructing the community as righteous guardians of nature may be seen as a belated response 'from below'. Broadly speaking, colonised peoples were constantly blamed for wilful desecration and supposedly 'wasteful' and 'unsound' use of land.

Also, the headquarters of one of the four divisions of the colonial Forest Department was established at nearby Nyeri town before the First World War. Though more research is needed to document and analyse the history of community relationships with the colonial forest administration in this area, we can assume that local people have long experience of forest controls and interventionist policies, whose continuities can be traced to the present day. Suspicion of government forest policy runs deep, as does suspicion of land policy in general – because it has so often meant land loss, and loss of user/ access rights. The first forestry laws were passed in 1902, paving the way for forest reserves. The Forest Department was established the same year. Early forest laws outlawed 'any cutting, grazing or trespassing [in forests] without a permit', and many other activities. This led to the criminalisation of forest users and dwellers, the curbing of user rights, and people's alienation from forests as communal resources.

Forests have long been a site of struggle, both here and across the British empire. In the Caribbean, for example, indigenous Caribs used the forests of St Vincent and Tobago as military bases and hide-outs while resisting British controls from the late eighteenth century onwards (Grove, 1995). Colonial officials saw a connection between lawlessness and forests, while anti-colonial rebels saw forests as a source of spiritual inspiration and empowerment. Carib use of forests as resistance refuges was echoed in the Mau Mau emergency in Kenya; fighters hid out for months (in some cases years) in camps deep in the forests of central Kenya, from which they fought their guerrilla war. They were famously denounced as 'debased creatures of the forest' by settler politician Michael Blundell.

This brings me back to Karima. It is no coincidence that efforts to conserve this sacred forest are being led by a former Mau Mau fighter, Paul Thuku Njembui – father of Kariuki Thuku, leading light of Porini (Figures 7.9 and 7.10).

A garrulous 80-something, he also chairs the management committee of the Agikuyu Community Peace Museum at Nyeri. For him, the forest clearly remains a key site of struggle, but equally a source of knowledge, power and inspiration. In 1955 Karima Forest was said to have been set alight by the British in an attempt to flush out Mau Mau fighters. Later, local people were forcibly recruited for a reforestation project that involved replacing the lost indigenous trees with exotic species. No wonder the forest is a focus for high emotion. In the talk that swirls around Karima, past abundance is also sharply contrasted with present poverty and resource scarcity.

'After a couple of seasons,' Mr Thuku explains,

> elders of this village suspended all activities on the hill from grazing to collection of firewood. They had a strong belief that the hill, like a human being, gets tired and thus needs time to rest. Our earth is so tired and fatigued, but is the western consumerism thinking ready to give it a period of rest? How can a mother give birth to a child every other year for all the years? Government has to understand that our sacred hill is at the moment under stress.

Other elders voice similar worries: 'Who is creating the scarcity of everything good in the world?' asks Mr Guchanwo, aged 90. 'If you know his name just let us know and we shall deal with him. Scarcity breeds frustrations; abundance creates hope for the coming generations. Scarcity and shortage are the two most common words today yet they irritate me a lot. This community has a lot of resources.'

To set this within a deeper historical context, a mass of evidence was given by Africans to the Kenya Land Commission in 1932–3. This evidence (oral and written) illuminates indigenous relationships between nature and culture, and

Figure 7.9 Elder Paul Thuku Njembui addressing community members after an eco-mapping exercise at Karima Sacred Forest. Photographed by Lotte Hughes. Photo: © Lotte Hughes.

Figure 7.10 Community members listen intently to Mr Thuku and other speakers after an eco-mapping exercise at Karima Sacred Forest. Photographed by Lotte Hughes. Photo: © Lotte Hughes.

the bewilderment felt by many Africans about colonial conservation controls and **land alienation**. It may be used to excavate the roots of grievances that are still being played out in the forests, highlands and sacred sites of Kenya. There are, for instance, pages of evidence from Africans in South Nyeri District, including Othaya Division, which includes Karima. Gikuyu witnesses supplied maps to the commission to prove their points about boundaries, reserves and excisions of land. But they had to augment these verbally, because paper maps were inadequate. Their long experience of counter-mapping started here, it seems, as well as their struggle with state cartography and official versions of 'reality' on the ground.

The complaints brought by Gikuyu witnesses in these pages may be summarised as:

- loss of rights following the creation of forest reserves
- loss of customary rights and land titles under the Crown Lands Ordinance 1915, which had made them 'mere tenants at will of the Crown'
- government's lack of respect for traditional land tenure
- lack of respect for historical boundaries between ethnic groups
- failure to compensate owners or their descendants for land given to non-Africans in areas set aside for Gikuyu.

(Kenya Land Commission Evidence and Memoranda, HMSO, 1934)

Caves, trees, springs and rivers, sacred and sacrificial sites – all these landmarks are now being feverishly inscribed again on 3-D models by the forest mappers. It is tempting to see historical continuities in this process.

Reflecting on the case study

The case study raises a number of problems of postcolonial heritage, including the definition of heritage itself in postcolonial contexts. Do we even know what postcolonial heritage is, and what its role should be? Clearly, heritage works best when it is tied closely to a nationalist agenda and it knows who it is addressing and representing. In multi-ethnic and multicultural societies this issue becomes far more complex. While NMK attempts to deal with creating a national identity for postcolonial Kenya, it has tended to steer clear of controversial topics and thus fails to address the issue of colonial experiences and the lived experience of the struggle for colonial independence. (Although this is now being remedied, to some extent, through state support for the production of histories by a group of Mau Mau war veterans, which raises other questions around authenticity, objectivity and Gikuyu domination of 'the story' of Kenya's independence struggle. Other former Mau Mau fighters, including Mr Paul Thuku Njembui, have disassociated themselves from this

particular group.) Community-led local museums tackle these issues head-on, but are considered to be a threat by the state, which wishes to control the discourses of heritage produced within Kenya, and to develop unifying discourses that emphasise national histories and allegiances over local ones. Indeed, it is possible to see the Lari Memorial Peace Museum as a specific locally-led intervention that challenges the discourse of national heritage produced by NMK.

In this case study we also see something of the ways in which heritage can form a way of mobilising ideas about the connection between people and places to build a sense of community at a local level, as discussed in Chapter 1. We see the ways in which people's religious and spiritual beliefs structure their conception of, and engagement with, heritage as a concept. The process of forest mapping as described appears to be as much about reinscribing a sacred landscape on to the forest maps as it is about mapping forest resources. This is because those undertaking the mapping do not make a clear distinction between natural and cultural heritage, or between economic and spiritual values and resources. In Chapter 1, it was argued that the uncoupling of natural and cultural heritage was part of a discourse of heritage that emerged in the West with the World Heritage Convention in 1972, which undermined other, non-western ways of perceiving the world.

Renegotiating tradition: global issues, local futures

The issues raised in the case study go beyond Kenya, and suggest the need for people to renegotiate tradition as part of the process of dealing with the consequences of colonialism. While the case study has focused on the implications for the postcolonial state, we should not forget the commensurate need for the renegotiation of tradition by the former empire. Indeed, it has been suggested earlier in this chapter that one of the fundamental outcomes of colonialism is the rise of multiculturalism as a result of the migration of colonial-born citizens to the metropole. What it means to exist in a postcolonial situation is a concern for both postcolonised *and* postcoloniser.

The political situation in Kenya is as much a result of globalisation as it is of Kenya's postcolonial circumstances. It has been noted that one of the perceived outcomes of globalisation is a growth in inequality between nations, classes and regions. In such circumstances, as Arjun Appadurai notes, 'many states find themselves caught between the need to perform dramas of national sovereignty and simultaneous feats of openness calculated to invite the blessings of Western capital and the multilaterals' (Appadurai, 2006, p. 22). We can sympathise with NMK's attempts to establish a national narrative that conforms to western conventions of heritage and western expectations of what a museum 'should be' as part of the need both to develop a clear national

narrative and to engage with the global discourse of heritage. But we can also see that such initiatives are unlikely to have any of the social efficacies that local initiatives, such as the Lari Memorial Peace Museum, will have.

In the case study we can also see the ways in which Gikuyu eco-mappers are engaging in local processes of community building in opposition to the state's activities through their uses of global discourses of 'indigeneity' and heritage. While this community-led process of heritage management draws on traditional spiritual relationships with trees and the forest, it also involves a creative process of delineating and coming to 'know' landscapes through the process of mapping them. While the relationship described draws on traditional relationships with the forest, it is described in terms that connect it to global discourses around heritage, the environment, indigenous land rights and the plight of endangered cultures. In the case study we see the ways in which both the local and the global are in a constant state of tension with the state over heritage.

Conclusion

We have seen that both indigenous people in former settler colonies and local communities in Kenya have challenged centralised, state-led initiatives to create 'safe' or unifying narratives that exclude their own needs and versions of the past. In both settler and occupation colonies we see the state struggling to redefine heritage in a postcolonial age in a way that liberates alternative narratives and groups, with those groups either setting up their own 'heritage' or requiring states to acknowledge and incorporate their concerns. Part of the problem is that post-independence states often try to continue a nineteenth-century vision of a nation in territories that were cobbled together from disparate groups by European colonisers, or made more divided as part of the process of European colonisation.

Many contemporary initiatives in global heritage management have been forged out of such debates. Chapter 4 considered the ways in which UNESCO has increasingly moved towards more inclusive models of heritage that acknowledge the importance of landscape, attachment to place, intangible aspects of heritage and the importance of diversity in heritage. These movements directly relate to the postcolonial critique of state-led regimes of heritage management presented in this chapter.

Works cited

Anderson, D. (2005a) '"Yours in struggle for Majimbo": nationalism and the party politics of decolonization in Kenya, 1955–64', *Journal of Contemporary History*, vol. 40, no. 3, pp. 547–64.

Anderson, D. (2005b) *Histories of the Hanged: Britain's Dirty War in Kenya and the End of Empire*, London, Weidenfeld & Nicolson.

Ang, I. (2005) 'Multiculturalism' in Bennett, T., Grossberg, L. and Morris, M. (eds) *New Keywords: A Revised Vocabulary of Culture and Society*, Malden, MA and Oxford, Blackwell Publishing, pp. 226–9.

Appadurai, A. (2006) *Fear of Small Numbers: An Essay on the Geography of Anger*, Durham, NC, Duke University Press.

Bhabha, H. (1994) *The Location of Culture*, London and New York, Routledge.

Byrne, D. (1996) 'Deep nation: Australia's acquisition of an indigenous past', *Aboriginal History*, no. 20, pp. 82–107.

Chege, S. (2007) 'The challenges of running a private community-based museum: Lari Memorial Peace Museum', paper presented at a workshop on heritage at United States International University (USIU), Nairobi (20–1 July) [online], www.open.ac.uk/Arts/ferguson-centre/ memorialisation/index.html (accessed 1 December 2008).

Dirks, N.B. (1992) 'Introduction: colonialism and culture' in Dirks, N.B. (ed.) *Colonialism and Culture,* Ann Arbor, MI, University of Michigan Press, pp. 1–26.

Dirks, N.B. (2005) 'Colonialism' in Bennett, T., Grossberg, L. and Morris, M. (eds) *New Keywords: A Revised Vocabulary of Culture and Society*, Malden, MA and Oxford, Blackwell Publishing, pp. 42–5.

Edgerton, R.B. (1990) *Mau Mau: An African Crucible*, London, Tauris.

Grove, R.H. (1995) *Green Imperialism: Colonial Expansion, Tropical Island Edens and the Origin of Environmentalism*, Cambridge, Cambridge University Press.

Harrison, R. (2004) *Shared Landscapes: Archaeologies of Attachment and the Pastoral Industry in New South Wales*, Sydney, University of New South Wales Press.

Harrison, R. (2008) 'The politics of the past: conflict in the use of heritage in the modern world' in Fairclough, G., Harrison, R., Jameson, J.H. Jr and Schofield, J. (eds) *The Heritage Reader*, Abingdon and New York, Routledge, pp. 177–90.

Kenya Land Commission Evidence and Memoranda, London, HMSO, 1934.

Kockel, U. and Craith, M.N. (2007) (eds) *Cultural Heritages as Reflexive Traditions*, Basingstoke, Palgrave Macmillan.

Lonsdale, J. (1992) 'The Conquest State of Kenya, 1895–1905' in Berman, B. and Lonsdale, J. (eds) *Unhappy Valley: Conflict in Kenya and Africa, Book 1: State and Class*, London, James Currey, pp. 13–44.

Muchire, W. (2007) 'Mapping system launched', *Sunday Nation*, Nairobi (1 July).

Munene, K. (2005) 'Exploring a new role for museums in Africa: an example from East Africa', paper presented to the Twelfth Congress of the Pan-African Archaeological Association for Prehistory and Related Studies, University of Botswana, July.

Ogot, B.A. (2005) 'Britain's Gulag', review article, *Journal of African History*, vol. 46, no. 3, pp. 493–505.

Said, E. (1978) *Orientalism*, New York, Pantheon Books.

Smith, L. (2004) *Archaeological Theory and the Politics of Cultural Heritage*, London and New York, Routledge.

Standard (2007) Raila Odinga, Nairobi (16 November).

Standard (2008) President M. Kibaki, Nairobi (13 January).

Further reading

Ashworth, G.J., Graham, B. and Tunbridge, J.E. (2007) *Pluralising Pasts: Heritage, Identity and Place in Multicultural Societies*, London, Pluto Press.

Beinart, W. and Hughes, L. (eds) (2007) *Environment and Empire*, Oxford, Oxford University Press.

Byrne, D. (2007) *Surface Collection: Archaeological Travels in Southeast Asia*, Walnut Creek, CA, Alta Mira Press.

Coombes, A.E. (2003) *History after Apartheid: Visual Culture and Public Memory in a Democratic South Africa*, Durham, NC, Duke University Press.

Hall, C.M. and Tucker, H. (eds) (2004) *Tourism and Postcolonialism: Contested Discourses, Identities and Representations*, London and New York, Routledge.

Jacobs, J.M. (1996) *Edge of Empire: Postcolonialism and the City*, London and New York, Routledge.

Kockel, U. and Craith, M.R. (eds) (2007) *Cultural Heritage as Reflexive Traditions*, Basingstoke, Palgrave MacMillan.

Littler, J. (2008) 'Heritage and "race"' in Graham, P. and Howard, P. (eds) *The Ashgate Research Companion to Heritage and Identity*, Aldershot, Ashgate, pp. 89–104.

Marschall, S. (2008) 'The heritage of post-colonial societies' in Graham, P. and Howard, P. (eds) *The Ashgate Research Companion to Heritage and Identity*, Aldershot, Ashgate, pp. 347–64.

Murray, N., Shepherd, N. and Hall, M. (eds) (2007) *Desire Lines: Space, Memory and Identity in the Post-Apartheid City*, Abingdon and New York, Routledge.

Shaw, B.J. and Jones, R. (1997) *Contested Urban Heritage: Voices from the Periphery*, Aldershot, Ashgate.

Shepherd, N. (2007) 'Archaeology dreaming: post-apartheid urban imaginaries and the bones of the Prestwich Street dead', *Journal of Social Archaeology*, vol. 7, no. 1, pp. 3–28.

Smith, L. (2004) *Archaeological Theory and the Politics of Cultural Heritage*, London and New York, Routledge.

Tunbridge, J.E. and Ashworth, G.J. (1996) *Dissonant Heritage: The Management of the Past as a Resource in Conflict*, Chichester, Wiley.

Waters, A. (2006) *Planning the Past: Heritage Tourism and Post-Colonial Politics at Port Royal*, Lexington, MA, Lexington Books.

Winter, T. (2007) *Post-conflict Heritage, Postcolonial Tourism: Culture, Politics and Development at Angko*, Abingdon and New York, Routledge.

Chapter 8 Heritage and class

Susie West

Heritage and class are explored here through the heritage of class relations, as a historic category linked to the emergence of industrial capitalism. The first case study explores working-class housing in Glasgow to see how official practices of heritage recognise and curate this type of domestic building. This reveals how the authorised heritage discourse (AHD) can be seen in action, prioritising the aesthetic values identified for selected housing. The second part of the chapter asks how our relationship to heritage could be experienced through our class positions, and introduces Pierre Bourdieu's concept of how cultural capital works. The second case study takes up the challenge of how heritage visitors relate to the AHD and class positions, using sociological methods for a survey of visitors to English country houses.

Introduction

Throughout this book we have been testing the proposition that a narrow set of ideas about what heritage is, framed by the bureaucratic structures of western states, has been made to stand for all possible global heritage. Now it is time to explore a slightly different angle of the AHD and ask if there is a hegemonic discourse *within* western states that makes selected heritage stand for all class experiences. For instance, would you expect to find material heritage that is made for working-class people inside national art museums? And if not, why not?

The politics of class and the heritage industry

In 1987 Robert Hewison wrote a depressing condemnation of the role of heritage in the UK in the 1980s in which he described the growth of a new cultural force he called the heritage industry (see also Chapter 1). The UK was in a period of economic decline and it seemed to him to be the only growth industry. Hewison identified a coalition of official heritage interests (the heritage industry) that operated on their own terms without reference to wider social interests. He was scathing of the confidence trick that he alleged was being imposed on ordinary people, the substitution of a vibrant and future-oriented creative nation by a nostalgic, falsifying, static cultural economy (Hewison, 1987, p. 140). Most of his invective was focused on the official structures charged with conservation, whether through government

ministries, public institutions (following Patrick Wright's argument in his book *On Living in an Old Country* (1985), discussed in Chapter 1) or independent bodies such as the National Trust. They were accused of fostering the 'social programme of the heritage industry' as 'a return to a Georgian England where an agreeable pastoral and small country town life is somehow fenced off from the deprivation, squalor and crime of the major inner cities and now semi-derelict industrial areas' (Hewison, 1987, p. 140).

Hewison's book was written in a time of intense political debate in the 1980s, a period that was charged with class analysis heightened by the political response to deindustrialisation and the decline of the coal industry in the UK (the site of literally violent encounters). Hewison was on the side of 'the farmer of Dartmoor and the car-workers of Cowley' as well as the 'black inhabitants of Bristol's St Paul's area' (the location of riots in 1980, the first of several in severely deprived urban areas), in resisting the official collusion to impose a past that never existed on to an impoverished present. For Hewison, the 1980s were a dreadful conjunction of the rise of the heritage industry that had generated a 'single closed tradition' of a particular understanding of how to present the past (an AHD) and its 'appropriation by the Right' in the form of radical Conservative government. The national story had been hijacked to claim a past that never existed as the template for imagining a less troubling present, ignoring class tensions and painful economic inequities (Davison, [2000] 2008, pp. 33–5).

Hewison positioned a broad range of what we might term 'heritage producers' such as museum directors, arts administrators, ministers of State, conservation officers and local government planners as a unified and organised body. There seemed to be no active role for any dissenting movement; the voters of Wigan and Liverpool, two of his favourite case studies, seemed to have swallowed the confidence trick. The experts (the middle and upper classes) were ranged against the workers. Raphael Samuel developed a response to this point, by insisting that it was possible to trace strong progressive or liberal origins in many conservation movements: 'heritage cannot be assigned to either Left or Right' in the monolithic way that Hewison attempted (Samuel, [1994] 2008, p. 284). Conservation movements spring up as innovative or reactive, their responses change over time just as the given meanings to heritage objects mutate (Samuel, [1994] 2008, p. 284). Samuel rebutted the notion that the heritage industry was a particular expression of currents in British political life (Samuel, [1994] 2008, p. 287). Indeed, all the chapters of this book have been exploring political uses of heritage across a global spread of histories and contexts. But capitalist nations all have variations on the class structure and this chapter explores some of the effects of the UK class system on creating and understanding heritage.

Understanding class: economic, social and cultural

Class is a set of economic, social and cultural differences between groups found within capitalist economies. Theories of class were formalised in the early nineteenth century by Karl Marx and Friedrich Engels and these remain possibly the most contested analyses of social structure. We can only gesture towards a brief account of some essential terms that are deployed in the case studies. In essence, these class categories represent different types of capital. Social class is a marker of the identity we take on from our position in the labour market. Historically, it has invoked ideas of deference, 'looking up' to someone in a higher social class. For instance, a university teacher would traditionally be positioned in the middle classes (an amalgam of earnings relative to other income groups, the history of access to education, and something about likely cultural values). Fifty or sixty years ago, you would also be able to predict that a university teacher spoke English with the accent called Received Pronunciation, and acquired that accent from their middle-class parents. Today social class tells you much less about parents' social class/es. Social class is the identity we take from membership of a group. This aspect of class will be explored particularly with reference to the middle classes in the second case study on visitors to **English country houses**.

Economic class is a marker of our rewards from participating in the labour market or of the lack of rewards if we are unable to participate. It represents our access to capital; one of the distinctive features of the 1980s UK Conservative government agendas was to extend popular ownership of shares and thus participation in capital. Economic class used to be rigidly aligned to social class, so as manual labourers plumbers were always defined as working class. It is popularly believed now that plumbers can earn considerably more than middle-level university teachers; and economic class now tells us little about social class. But occupations have been powerful labels of individual identity and this aspect is particularly strong in the first case study on working-class housing in Glasgow, which included divisions within the working classes (and lower middle classes) according to occupation.

Culture in relation to class was not taken into account by Marx but later thinkers have theorised its importance for our sense of identity. In this sense, culture is a marker of how we use the economic rewards and social platform of our other class attributes to turn them into a form of 'knowledge capital' or asset. Culture might be intangible, found in a set of values, aspirations and political affiliation. It also has strong material expressions concerned with how we choose to participate in cultural activities, broadly defined as ranging from mass entertainments and sports to culture in the narrow sense of classical arts (which also come within the AHD). Cultural capital is an important way of understanding how we participate in or consume heritage activities; it is a

major aspect of what visitors say they get from visiting country houses, for example (see further discussion below).

Class relations do not form part of many everyday discussions of heritage, probably because class relations themselves are no longer in the foreground of our sense of personal or national politics. Modern democracies are much more interested in two other key aspects of identity politics: ethnicity and religious affiliation, which seem more pressing in the early twenty-first century. Class and gender have dropped down the order of priority in terms of the ways most of us think about the big issues of global politics. It might be suggested, however, that our lives are still heavily influenced by all four categories (class, gender, ethnicity and religion) which come in and out of focus as our personal contexts change. Both case studies in this chapter draw in some aspects of the difference that gender can make to the experience of class.

Class and world class heritage

To start us thinking about how we might look for class relations in objects of heritage, we can take a quick look at the World Heritage List of sites. How is working-class heritage represented here?

UK World Heritage sites with dominant working-class associations include Blaenavon industrial landscape, Wales, inscribed in 2000 under criteria (iii) and (iv), for its nineteenth-century mining heritage. Saltaire, England, is a late nineteenth-century factory town and New Lanark, Scotland, is an early nineteenth-century industrial community (discussed in Chapter 4). It would seem that working-class heritage of global significance is viewed in strongly industrial terms, celebrating monuments of the industrial revolution rather than working-class communities per se. Urban settings where people lived and developed communities more organically, outside the planned settlements that these sites represent, are absent, with the notable exception of Liverpool. This English port city is recognised for its global commerce but there is no industrial city to parallel the World Heritage medieval towns. Industrial-era sites are not recognised for their aesthetic qualities either, the classic AHD terms of reference. The case study of Glasgow in this chapter looks at a city that has both a medieval centre and a highly developed nineteenth-century industry, now coming to terms with twentieth-century economic shifts. We examine the impact of these shifts on working-class housing and how some aspects have become heritage.

Housing and heritage

Housing is a good example of a physical structure that has an almost inevitable connection with class. Working-class housing in the UK is probably being considered as heritage now more than ever before, featuring in the National

Trust's property portfolio in a way that Hewison would not have predicted. The idea of representativeness, where types of heritage are collected so that individual examples come to stand for the whole, is particularly appropriate for housing. It is a way of defining what makes a particular sort of house 'typical' for its date, area, occupants, construction and context. The further down the economic class scale you go, particularly before the mid-twentieth century, the fewer material traces of individuals there are. Those living in poverty simply owned fewer possessions, and most people did not own cameras, commission portraits, keep diaries or habitually write and keep correspondence. The most enduring representations of the working classes and the destitute are their workplaces and housing. Arguably, these are also the most vulnerable categories of built heritage, subject to less protection and more rapid redevelopment than buildings regarded as being of greater aesthetic or historic value. The experience of Glasgow illustrates this and prompts us to reflect on how we use the idea of heritage to capture intangible losses.

Case study: working-class housing in Glasgow, UK

This case study explores a long-standing Scottish urban form of housing, the tenement. The tenement, or apartment block, was the dominant form of urban housing in central and inner suburbs in cities across the industrialised western world, the few exceptions being located in England, the Low Countries and some former British colonies. Engels' Manchester, for instance, favoured long terraces of workers' houses, usually of two storeys of two rooms each and a small yard at the rear.

Tenements (apartments or flats) relate to economic class quite obviously by their varying size and by their location in more, or less, wealthy areas. The working-class area chosen for study here is the Gorbals, an inner-city district of Glasgow. What happened to tenements in the Gorbals will be contrasted with a lower middle-class tenement that is now presented as a heritage site. The study concludes with some heritage work produced around the successor schemes to the working-class tenements that were redeveloped as the public housing estates of the 1950s and 1960s.

Glasgow tenements

Glasgow housing has been well documented through the recording and survey activities of the Royal Commission on the Ancient and Historical Monuments of Scotland (RCAHMS), whose photographic archive supported an exhibition *Glasgow Working-Class Housing 1890–1990* in Glasgow's year as City of European Culture. The accompanying book *Tenements and Towers* (Horsey, 1990) sets out a clear narrative of the tensions between political and architectural viewpoints on public housing provision. There

were massive shifts in the physical form of new working-class housing as a result of the interaction of city and national politics. This is a history structured by socio-economic class, preserved in the archive as evidence from politicians, medical boards, architects and planners, all members of the middle and upper classes, who controlled discourses about a voiceless class of workers in social housing.

Glasgow's rapid expansion created economic class districts, delineated by occupations. In the decades leading up to 1890, industrialised Glasgow had a late medieval city centre of working-class districts infilled with industry, interspersed with middle-class areas and mixed-class areas. New suburbs, annexing older outlying villages, were being developed with working-class and lower middle-class tenements. The dominant housing form for working- and middle-class urban dwellers was the tenement block, three or four storeys high with access to the flats from a communal stair (Figure 8.1). The number of rooms and the provision of private services (toilets, bathrooms and kitchens) indicated the basic economic divisions between tenement developments.

Initially this great expansion of Glasgow's housing by new rental properties and the sub-division of older properties into one-room flats for the poorest urban families was provided entirely by private landlords. The expanding

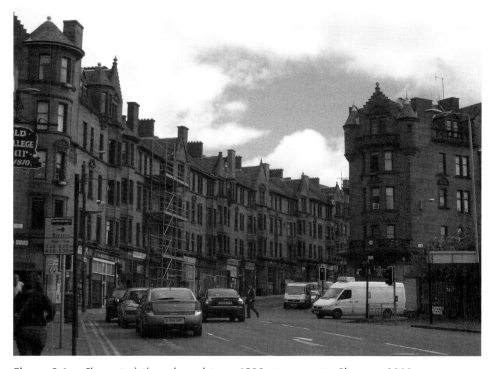

Figure 8.1 Characteristic red sandstone 1890s tenements, Glasgow, 2008. Photographed by Susie West. Photo: © Susie West.

economy relied on the migration of unskilled workers and their families from Ireland and the Scottish Highlands, who settled in to former middle-class urban housing in the centre and inner suburbs. This older housing was the worst type of sub-divided cheap rental accommodation without basic facilities, creating slum conditions. Religious tensions were also exacerbated at this time between Catholics and Protestants.

The high population density and lack of amenities resulted in massive social health problems in these central districts, which were tackled by the first slum clearances. This resulted in the dispersal of the unskilled poor: new tenements built in the cleared areas were let to the skilled working class. The first transition to housing provided by the local authority occurred during the 1920s. Rehousing by occupational class was not always successful; up to 30 per cent of tenants rejected their new flats, preferring to return to the 'vitality and turbulence' of slum dwelling (Horsey, 1990, p. 20). Post-1945 policies resulted in the first tower blocks and deck-access housing, some erected in established suburban areas with their own class distinctions and others rising out of slum-clearance areas within the dense urban centre. Tensions arising from relationships within and between social groups continued, resulting in a widespread dislike of these estates by occupants, neighbours and politicians.

The experiences of living in different localities in Glasgow have changed radically over the past century of industrial peak, decline and reformulation. The most highly disadvantaged social groups, the unskilled and unemployed, are least able to choose and shape their living environments. However, their life experiences (and lifestyles) are enshrined in their built environments. The impulse to preserve something out of rapid change is an important motivation for creating heritage, noted by the geographer David Lowenthal: 'In the face of massive change we cling to the remaining familiar vestiges. And we compensate for what is gone with an interest in its history' (Lowenthal, 1985, p. 399). But who are 'we' in the case of Glasgow: heritage officials, rehoused inhabitants or academics? What has been re-presented as heritage and what uses are being made of it?

Introducing the Gorbals

The Gorbals is a district whose industrial success in the nineteenth century turned to rapid economic distress and decay in the twentieth. It became a byword for harsh living conditions, but it also became mythologised in biographies and fiction for the strong personalities living there. Following two phases of clearance of streets of tenements that had declined into slums and rebuilding in notoriously sub-standard estates, the population had declined by 1991 from 90,000 to 10,000. It has now entered the third period within sixty years of attempted urban regeneration (Figures 8.2 and 8.3).

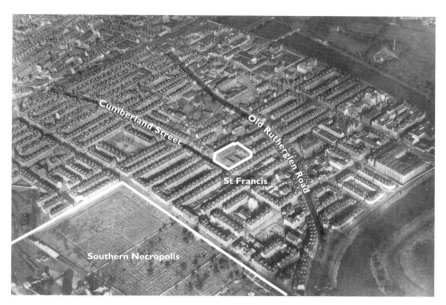

Figure 8.2 Aerial view of the Hutchesontown-Gorbals Comprehensive
Development Area before clearance, 1956. Unknown photographer.
Photo: © Glasgow City Archives & Special Collections, Mitchell Library,
Culture & Sport Glasgow.

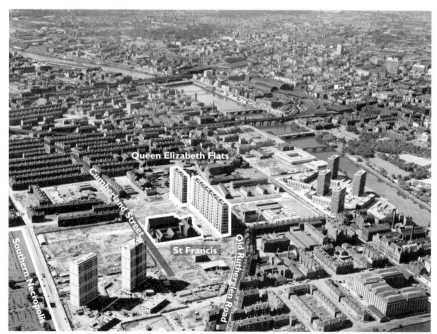

Figure 8.3 Aerial view of the Hutchesontown-Gorbals Comprehensive
Development Area during redevelopment, showing Queen Elizabeth flats
(demolished 1993), 1965. Unknown photographer. Photo: © Royal
Commission on the Ancient and Historical Monuments of Scotland.

'The significance of the city's physical character to the sense of place, security, and stability of its inhabitants is now well established and has become a prime rationale for conservation ... But one person's landmark may be an object of indifference or hostility to another' (Tunbridge, [1984] 2008, p. 236). The geographer John Tunbridge is drawing attention to the problem of whose heritage is conserved in urban populations. He points out that people in cities are no more homogeneous than the buildings, and he goes on to discuss the political problem of selective conservation of city districts, using examples from multicultural, settler and postcolonial cities. Some of these issues are visible in Glasgow streets.

The last tenement in Gorbals Street

Official protection allowed the last tenement in Gorbals Street (formerly called Main Street, Gorbals), the British Linen Bank and tenement, 162–170 Gorbals Street, to survive demolition by 1970 (Figure 8.4). The building was given a Scottish Category A listing in recognition of its architectural interest, being built by a prominent Glasgow architect, James Salmon, from 1899. Its official status is because it is representative of his work (although it may also be representative of the lost district), and fits the AHD's interest in canonical buildings. As a representative of the lost district it stands for the high point of the Gorbals' thriving nineteenth-century economy, but its unofficial values

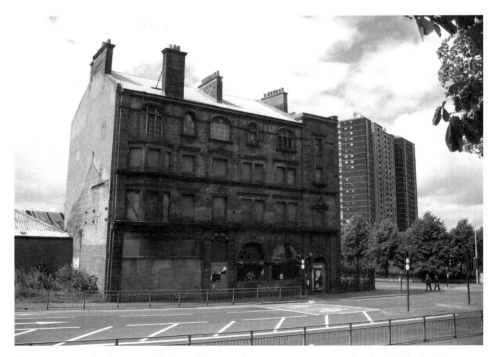

Figure 8.4 The last remaining nineteenth-century tenement in the Gorbals, Glasgow, 2008. Photographed by Susie West. Photo: © Susie West.

(**social value**) also come from its setting in the present, creating a counterpoint between phases of the Gorbals' recent history and a commentary on their relative failures. Its immediate neighbour was a 1960s tower block, demolished weeks before my visit in 2008. Although the tenement has a heritage champion working on a plan to reuse it, its future is still tied to the resolution of social planning issues for the area.

It now sits stranded on a busy main road, the wrong side of the disused railway which currently marks the boundary of the regenerated area. However, it is on the same road as the Gorbals' major cultural institution, the Citizen's Theatre (an 1870s theatre building with modern frontage). The area of the Gorbals redeveloped by 2008 centres on Cumberland Street with a mixture of public and private housing in wide, tree-planted streets with ample car-parking (Figure 8.5). Some of the most expensive housing uses the red sandstone typical of nineteenth-century Glasgow tenement design. There is now a mixture of terraced houses and tenement blocks, and plenty of space. Previous development has been selectively retained – groups of 1960s tenement developments up to four storeys high, and two of the smaller tower blocks have been refurbished. There is lack of infrastructure beyond the primary school and police station. Where are the shops and cafes and newsagents? Older structures stand out: the massive church complex, now the St Vincent centre, the southern necropolis for the more prosperous

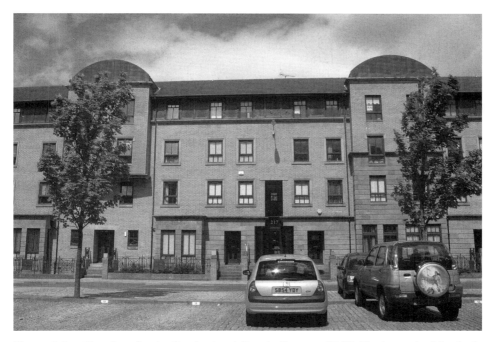

Figure 8.5 New housing in Cumberland Street, Glasgow, 2008. Photographed by Susie West. Photo: © Susie West.

nineteenth-century community, the tower of the burned-out Caledonia Road church (by Glasgow's most famous nineteenth-century architect, Alexander 'Greek' Thomson).

There are some historical references to past building styles in the new housing and there are a few more monumental reminders of the older Gorbals: some tangible continuity. But the impact of successive housing rebuilds on the intangible heritage of a community is hard to conceptualise. Stuart Hall, sociologist and cultural theorist, has listed the steps he thinks should be taken to remedy a 'heritage-less' black presence in multicultural Britain: archives, exhibitions, critical apparatus, definitive histories, reference books, comparative materials, recognition of achievement within communities, oral histories and 'daily life' artefacts (Hall, [1999] 2008, pp. 226–7). This is a useful checklist to bear in mind for the recovery of Glasgow's working heritage, black and white, Protestant and Catholic.

Miss Toward's Tenement

Crossing the river Clyde towards the city centre, tourists visit a tenement flat in its original setting. This is curated by the National Trust for Scotland (NTS) at 145 Buccleuch Street, central Glasgow (Figure 8.6). The building is in a red

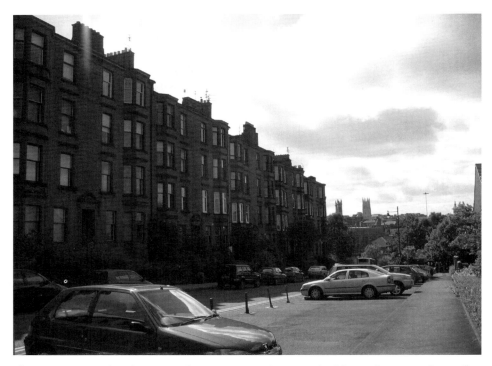

Figure 8.6 Buccleuch Street, Glasgow, 2008. Photographed by Susie West. Photo: © Susie West.

sandstone terrace of tenements built four floors high with two flats on each floor; the north side of the street has been torn down and redeveloped. The NTS shows a first-floor four-roomed apartment as the home of Miss Agnes Toward, who moved there in 1911. The tenement had been built in 1892, the year that legislation required landlords to provide indoor toilets. Miss Toward's flat had its own bathroom and, although small, its four rooms were considerably more comfortable than the one-room flats that many Glasgow families lived in (discussed further below). Miss Toward's father was a commercial traveller who died when she was 3 years old; her mother was a dressmaker. Miss Toward earned her living as a shorthand-typist with a shipping firm. These occupations suggest an upper working-class/ lower middle-class family. Miss Toward's father's occupation places him within social class 3, skilled manual and clerical, which covered about 45 per cent of working adult males in Scotland when she was born in 1886.

The parlour in the Tenement House, Glasgow

The visit begins by entering the front door to the block which leads into a narrow corridor with typical glazed tiles on the walls. The NTS owns a flat on this floor, which is used as a visitor reception and exhibition area. Visitors are directed up the stairs to ring the bell on Miss Toward's front door, painted in imitation wood grain like the other doors, a sombre effect. Inside, the small hallway sets the tone of the presentation of the flat: the contents were saved after Miss Toward's death by an inspired individual before the Trust took over in 1982. A handsome nineteenth-century chest of drawers, an oil portrait and a tall clock immediately suggest the past and their own status now as antiques to the visitor. What did they mean to Miss Toward? Small gas lights hiss discreetly. The four rooms leading off the central hall are small but elegant, particularly the parlour with its marble chimneypiece, rosewood piano and large rug (Figure 8.7). The only clues that this is a small dwelling come from the bed visible behind the cupboard door. There is another bed alcove in the kitchen, behind a cheerful cotton curtain. So although there is one bedroom, a four-room apartment could provide three sleeping areas.

The rooms are comfortably furnished, with plenty of small objects on shelves and tables, but there is little storage space, indicative of the relatively few personal possessions of its original occupants. Miss Toward kept many of her documents: rent books, household accounts and bills, theatre programmes, photos. A selection of these is on display in the exhibition flat, illustrating her life story. The NTS makes it clear that they took the decision not to show the flat as it was by 1983. They removed later decoration in favour of new wallcoverings to match fragments from the first layers found, and reinstalled gas lights (taken out in 1960). The dateline of its 'heritage' presentation is

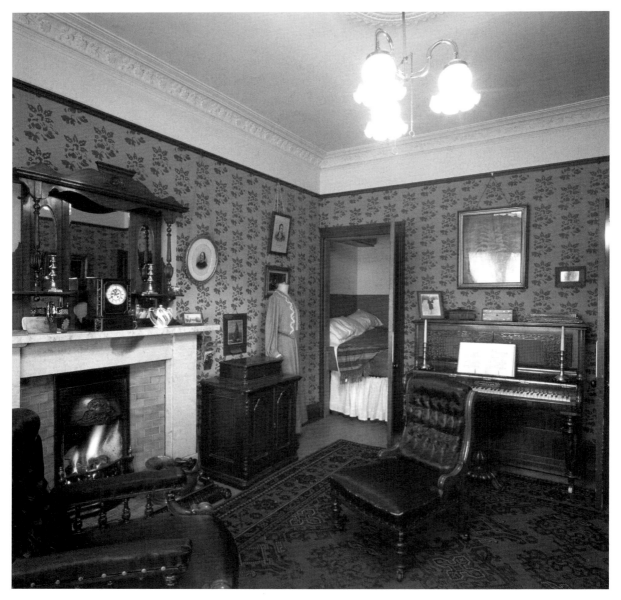

Figure 8.7 Miss Toward's Parlour, Tenement House, National Trust for Scotland. Photographed by Douglas MacGregor. Photo: © Douglas MacGregor and The National Trust For Scotland.

roughly 1911–39 (arrival of the Towards, death of Miss Toward's mother). Aspects of this presentation are therefore reconstructed, but evidence-based, and the atmosphere is highly evocative. It is as clean and tidy as Miss Toward would probably have wished and it represents many of the lower middle-/upper working-class tenements demolished in the first redevelopment of the Gorbals.

A single-end tenement

Equally clean and tidy, but in a very different context, is the representation of a tenement flat in a museum gallery. The People's Palace is a museum and winter gardens built in 1898 specifically for the benefit of the working people in an industrial area of central Glasgow just over the river from the Gorbals. It is Glasgow's social history museum. The *Housing in Glasgow* gallery presents the smallest, one-room tenement flat, known locally as the single end (Figure 8.8). These were formed out of older tenements, sub-divided by landlords.

The single end in the People's Palace is a reconstruction, furnished with original objects and fittings, such as the cast-iron range, the wooden dresser, the quilt on the bed (Figure 8.9). In contrast to Miss Toward's flat, the provenance of these objects is varied. The size and layout of the single end is remarkably similar to Miss Toward's kitchen with its bed alcove. The room is displayed without extra beds on the floor, and is accompanied by a cheerful narrative from an anonymous male occupant, who recalls aspects of life here from the 1930s up to the slum clearances of the 1950s. Parts of the room are lit up at appropriate moments to direct the visitor's attention, but otherwise a single gas light over the range illuminates the room. The room appears to be in good order, with a red patterned lino floor covering, food packages in the cupboard, plenty of pots, pans and a china tea set by the sink.

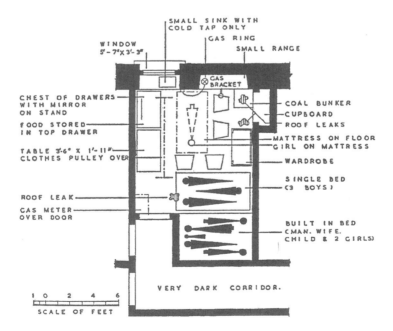

Figure 8.8 Plan of a single end, *c.*1945, drawing. Photo: © Glasgow City Archives & Special Collections, Mitchell Library, Culture & Sport Glasgow. This plan is taken from a report called 'Scottish Housing Advisory Committee, Choosing Council Tenants'.

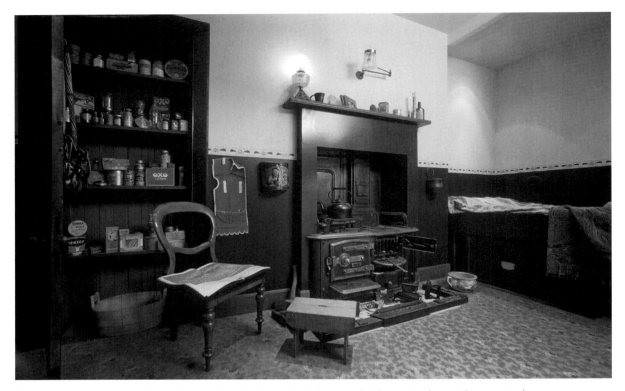

Figure 8.9 Reconstruction of a single end, People's Palace and Winter Gardens, Glasgow. Unknown photographer. Photo: © Culture and Sport Glasgow (Museums).

The fact that the visitor encounters this room at the end of a hard-hitting exhibition may explain my desire for more disorder in the reconstruction. The permanent exhibition charts the social history of working-class housing in Glasgow from the nineteenth century. It considers how people constructed their lives in these settings. It is strongly themed around gender relations, sexuality, age groups, health and poverty. Objects and many oral history quotes are used to make its points, and the narrative does not shy away from referring to domestic violence, drug use or current unemployment statistics.

The exhibition sits well in a museum whose mission is to collect and represent the history of working- and under-class life in Glasgow. When the exhibition comes to be renewed, as every museum gallery is periodically, I wonder what will be the fate of the single-end reconstruction. The contrast with the National Trust tenement comes from the ability there to focus on one life, played out in four rooms. Is this conventional display the best way to evoke the impact of sharing a one-room home with parents and baby siblings? Are visitors just being shown how people cooked on ranges before microwaves? It is a tough curatorial challenge to deliver the impact of the provocative narratives available in the rest of the exhibition.

Intangible heritage of tenement life: the role of oral history

The *Housing in Glasgow* exhibition uses many quotes gathered from oral testimonies as one form of intangible heritage. Oral histories of life in working-class tenements allow the occupants' testimonies to become a potential resource for working-class communities to represent their own past. Oral history requires just as much critical engagement from historians as analysis of texts, material objects and images, with careful consideration of the nature, purpose and format of the evidence. As an official form of heritage activity (collecting and curating social history) it is one of the important ways that the AHD has unbent in recent decades. It follows the move from canonical to representative approaches to collecting.

A recent example is a compilation of reminiscences of Glasgow and Edinburgh working-class tenement women, tellingly called *She was Aye Workin'* (she was always working) (Clark and Carnegie, 2003). This was collected for two museums, including the People's Palace. A major reason for focusing on women's experience, particularly of living in the single-end tenements, is that domestic space was their (unpaid) workplace. Their responses to establishing and maintaining their married lives in such confined conditions touch on how their experience as women differed from that of men. One of the themes in the People's Palace housing exhibition is 'Living Together'. This theme addresses setting up home, marriage and its dissenters, having children, who does the housework; its content is largely created through oral history quotes. Oral history has made it possible to give a much more nuanced picture of working-class identity by collecting intangible experiences and examining different gender roles.

From tenements to towers

The present regeneration area in the Gorbals shows that tower blocks are not the end of the housing story. However, the postwar rehousing schemes literally loom large in many working-class districts of Glasgow and newer generations may have no experience of other forms of housing. It is possible for public housing schemes to be recognised officially as heritage. The Twentieth Century Society campaigns for 'the best buildings of the period' in the UK to be designated, using established aesthetic criteria for evaluating architecture (at the time of writing it is campaigning for the designation of Robin Hood Gardens, an estate in Tower Hamlets, London). A massive estate designed by prominent architects Alison and Robert Smithson was listed Grade II* by English Heritage in 1998, at Park Hill, Sheffield. The dominant arguments are still aesthetic and championed by diverse architectural experts, not necessarily by the local communities.

Living in the high rises: Pollok

One of the many uses of heritage for political ends is as a means to resolve social divisions, and Glasgow's heritage is no exception. Concerns about tensions between ethnic groups (historically in Scotland between Catholic and Protestant Christians) and socially disengaged youth are high on political agendas. The Heritage Lottery Fund (HLF) supported a recent project to investigate social change in the working-class district of Pollok, outer Glasgow.

The previous discussion of the Gorbals explored a district that had been integrated historically with central Glasgow. However, there was also a process of dispersal of working-class inhabitants from these inner districts to an outer ring of districts as part of the postwar rehousing schemes. Pollok is one such district. In 2005 the Village Story Telling Centre, a charitable trust based in Pollok, gained HLF funding to capture the experiences of former slum tenement dwellers who were rehoused to Pollok's new housing estates in the 1950s and 1960s. Their memories of the harsh conditions of the life they and their parents experienced before the move were researched by high-school students from asylum-seeking families. This work was mirrored by students from another school who collected interviews from asylum-seeking families housed in the high-rise tower blocks (the housing least popular with council tenants). The school students were trained in oral history techniques, and as well as conducting interviews they made field trips to relevant places elsewhere in Glasgow, including the People's Palace and the National Trust's Tenement House. The built environment used in this way became a meeting place to explore Pollok's history of immigration across generations (*From Plantation to Pollok, from Kabul to Kennished*, HLF, 2005; Stewart, 2006). It is another use of oral history to collect intangible heritage, particularly from groups under-represented in mainstream sources.

Remembering the high rises: demolition in the Gorbals

Some concrete tower blocks of the 1960s became as notorious as the nineteenth-century environments they replaced. Back in the Gorbals regeneration area, a tower-block scheme called Hutchesontown C (Queen Elizabeth flats) was demolished in 1993. This had been finished in 1965 as part of a scheme to replace 7600 houses in the Gorbals (see Figures 8.2 and 8.3). The long range of linked blocks became home to 400 households. They were one of three high-density schemes in the district, but were unusual for being designed by Sir Basil Spence, one of the UK's most prominent postwar architects, who made his name with high-profile sites such as Sussex University, Coventry Cathedral and Glasgow Airport.

Born and based in Edinburgh, Spence was familiar with the tenement system, and thought about how women would run their homes in the new tower

blocks. He suggested that the gallery gardens, installed in groups of four in the towers, would be the place for mothers to put out their washing and let their children play, an attempt to recreate the intimacy of the former streets (Figure 8.10). However, practical problems of long-term maintenance (damp being the biggest problem) combined with the strong emotionally antagonistic responses from tenants and neighbours to these monumental concrete blocks created a consensus for their demolition.

The second loss of homes in the Gorbals within living memory has been captured using now-familiar heritage practices: archive creation and community-based memory activities using oral history techniques. Interestingly, the Queen Elizabeth towers were not given heritage protection but were noticed for their canonical status as part of a prominent architect's work (as noted earlier in the case of the Linen Bank tenement on Main Street). They form part of an official architectural archive of Spence's papers donated by his family to RCAHMS. Tower blocks can, then, become part of an AHD provided that they fulfil the criteria of aesthetic value as assessed by architectural experts. This value was obviously highly contested by the community prior to demolition, and indeed is still debated. The heritage discourse for the Queen Elizabeth flats has been expanded, however, to incorporate some wider social values. As part of the curatorial work to catalogue and make the archive accessible, RCAHMS went to the Gorbals

Figure 8.10 Garden/drying area in Spence flats, Gorbals, Glasgow, 1987. Unknown photographer. Photo: © Royal Commission on the Ancient and Historical Monuments of Scotland.

to share archive materials about the flats with schoolchildren and former residents, a project that resulted in interviews by the children about life in the flats and a short film. The Sir Basil Spence website, hosted by RCAHMS, invites public contributions of memories and photographs relating to his buildings.

Less formally, the relationship of concrete tower blocks to the quality of urban life continues to be debated on the internet, and Basil Spence's buildings appear in growing numbers on social space websites. Gorbals residents with web access continue to explore the meanings of their lost social environments.

This case study has surveyed the nature of working-class housing in Glasgow, from tenements to tower blocks and, in the case of regenerated Gorbals, back to tenements again. It has shown that working-class identities have always been sub-divided by economic divisions, which have been formally recognised by public housing policies. The intervention of official heritage interests has become more visible in the last two decades, since Miss Toward's tenement and the People's Palace gallery offered the tenement as a heritage experience. The increasing use of oral history techniques in community-based projects has expanded the range of recognised heritage from tangible housing to intangible experiences. Class is also experienced through gender and ethnic identities, to name just two variables, and these nuances are also better expressed by intangible heritage.

Reflecting on the case study

The heritage of urban working-class housing presented with life stories is still unusual. The Lower East Side Tenement Museum, New York, claims that it is the first such (dwelling of urban working class and immigrants) to be preserved and interpreted in the USA. It is in the urban quarter densely settled by migrants from the port of New York. Unlike the settled character of Miss Toward's life in her tenement flat in Glasgow, the Lower East Side tenement block is estimated to have housed an incredible flow of 7000 people over its seventy-odd years (1863–1935). It is a six-storey block, each tenement flat being three rooms leading off from the communal stairs. The museum currently presents five flats as reconstructions of named families' periods of occupation, distinguishing them by ethnic origin and occupation. Most of the families had a connection with the local garment-making trade, sometimes using their living accommodation to carry out work. The museum's use of life stories and reconstructions, and its explicitly political mission to promote tolerance through understanding the history of immigrant experiences, is a highly charged blend of the techniques seen in the Glasgow case studies. Its location in a tenement block in a busy street adds visible relevance to its local community, and a certain continuity of issues. Its insistence on the social

benefits of its mission, linked to outreach work and spin-off community projects within the quarter's contemporary mix of recent and settled immigrants, is similar to the uses of intangible heritage collected in Glasgow.

Class, cultural capital and the consumption of heritage

Most of us are consumers of heritage, in that we incorporate heritage activities into our leisure time. The language of economics is also used in the concept of cultural capital, treating 'culture' as an asset (capital) that allows the possessor to sustain or gain some advantage. This theory of the work that culture in the sense of knowledge capital does in western capitalist societies was developed further by the French social anthropologist Pierre Bourdieu during the 1960s (Bourdieu, 1984, 1990).

Bourdieu used the term 'culture' in a particular way, starting with an investigation of how cultural forms are given status values, which turns them into cultural capital for consumers. 'High culture' embraced particular art forms (opera, ballet, sculpture) or genres (art cinema, canonical authors) or activities (fine dining) that were highly valued and associated with consumption by the middle and upper classes. You will recognise these as falling within classic AHD definitions of tangible heritage. The least amount of cultural capital was accumulated in 'popular' or 'low' culture (music hall, mass-market crime novels and street food) associated with consumption by working-class groups. Few of these get consideration as official heritage; only the music hall is an obvious candidate as a historic building rather than as a genre of performance.

Bourdieu considered how people use culture to project and normalise their values on to the world. The groups with the greatest amount of economic and political power were also in a position to represent their taste (as high culture) as the dominant cultural forms in society. This can clearly be related to the idea of the AHD, the selection of heritage relating to power groups and their histories. The English country house is a strong example of a dominant group's culture being used in this way.

Bourdieu went on to consider how the assets represented by this cultural activity were used by groups to maintain their class identity (and to distinguish their group from others, hence his use of the term 'distinction' to summarise the effects of cultural capital). Most importantly, he suggested that culture did more than mark out differences between social groups. He saw it as acting in the same ways as economic capital to structure social inequalities. The bridge that linked economic and cultural capitals for Bourdieu was education.

Cultural tastes, knowledge and forms of cultural participation in Britain have been extensively researched in a recent study that produced a cultural map of the UK for 2003, shown as a statistical plot of people's likes, dislikes and level

of participation in cultural activities superimposed with the standard sociodemographic variables of occupation, education, gender etc. (Gayo-Cal, Savage and Ward, 2006; Gayo-Cal, 2006). Bourdieu's three variables of cultural capital, education and social class remain the dominant features of contemporary British attitudes to culture. The groups who graze across a number of high and low forms are the educated middle class of all ages. But the traditional divides between high and low culture still operate, particularly when matched with age categories (Bennett and Silva, 2006).

We can take a closer look at the people who take up a very specific heritage activity, shown on the cultural map as visiting **stately homes** and historic sites. Visitors to a group of English country houses have been the subject of a detailed study that picks up on the themes of social class identity and what the visitors think about their heritage experience. This is a rare example of research that explores the range of visitor perceptions and experiences during their heritage encounter, designed to open up the hidden layers of meaning that might be present for the visitor.

Case study: investigating the country house visitor

Values and the English country house

This case study makes extensive use of a survey by Laurajane Smith, undertaken in 2004, to investigate the meanings of English country houses to visitors. There are three values that underpin most discussions of the significance of country houses as heritage sites: national identity, aesthetic value and social significance. The first two will be familiar concerns for heritage studies as key planks of the AHD, the latter is more recently visible in heritage arguments that remind us of the value of life stories and a sense of place. The social significance of country houses to most visitors is shown to revolve around class identities. Smith concludes that visitors bring with them expectations about a conservative interpretation of class distinctions, which are unchallenged by their experiences of the visit. However, this is not a simplistic response. Visitors make the connections between their personal identity and nationalism through reflecting on class and the uses of heritage.

Open to visitors

Historians and architectural historians usually define a country house as the centre of a landed estate: the owning family's residence surrounded by its subsidiary buildings, gardens, parkland, farms and woods. The house represents intangible power relations concerned with being a land-owner

(wealth, political influence, social networks). The largest country houses impress visitors with their size, historic interiors and rich contents, and with that intangible sense of history emphasised by rows of family portraits. These houses are a tiny proportion of any housing stock in their region and are at the top of the regional hierarchy of land-owners (Figure 8.11).

Country houses, although numerically small, are a dominant category of tangible heritage in the UK because they fit so closely the AHD that privileges aesthetic, monumental, tangible qualities defined by experts (Mandler, 1997; Smith, 2006, p. 120). They all enjoy formal heritage designations, often at the highest grade, and usually sit in protected landscapes. The economic and political power that the historic owners exercised also defined the cultural power that their material possessions symbolised. The most highly valued crafts skills, artistic achievement, materials and media were available to them. They embody a high degree of cultural capital.

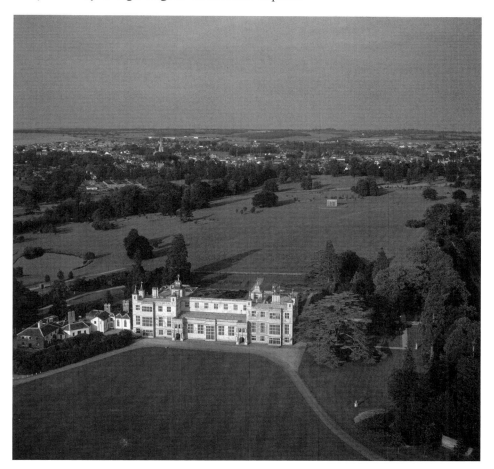

Figure 8.11 Audley End House and park, Essex. Unknown photographer. Photo: © Skyscan Photolibrary/Alamy.

Country houses that are open to visitors are in this position for many reasons. There is a long tradition of socially respectable people (with the cultural capital to appreciate what is presented to them) being shown around great houses. This tradition was extended and commercialised in the second half of the twentieth century when the economic benefits of mass tourism were welcomed by owners who were increasingly financially pressed. Chatsworth House, Derbyshire, country seat of the dukes of Devonshire, is probably the most commercially successful privately owned example.

The twentieth century was a very challenging time for country house owners, as staff costs grew, taxes on inheritance were massively increased and the costs of maintaining museum-quality buildings and contents were outstripping land income. The impact of two world wars on agricultural estates and, through military requisitioning, on the condition of many country houses, was also considerable. Many smaller country houses became divorced from their land and were sold off or demolished for the price of their materials before heritage designation in the form of listed buildings began in the 1940s.

This considerable change in the social and cultural fabric of rural England was picked up on by the National Trust who began to acquire many country houses from despairing owners in an attempt to keep landscapes, houses and their contents together. By the time the Trust celebrated its centenary in 1995, it had gone from owning two country houses in 1934 to a portfolio of 230 (Fergusson, 2004; Samuel, [1994] 2008, pp. 280, 284). The government through the Ministry of Works (now English Heritage) also began to acquire some examples. It now cares for approximately twenty-five medieval and later country houses, including ruins.

Houses still privately owned but open to the public are represented through membership of the Historic Houses Association (HHA). About 350 of these 'open regularly to the public on a commercial basis', accounting for 15 million visits annually (Historic Houses Association, 2008). With the National Trust and English Heritage, this gives a working total of about 600 English country houses as commercial heritage sites (Smith, 2006, p. 125). If the HHA figure for visits is simply doubled, that makes a significant amount of visitor interest.

Making the English country house meaningful

If it is acceptable to equate this level of country house tourism with popular support, a critical consideration of exactly what is being supported raises some questions. I have already claimed that the English country house is *the* symbol of the English ruling classes, a minority group. Critical accounts about the meanings that the country house bears are highly politicised. In particular,

English country houses (and houses with English owners in Ireland, Wales and to a lesser degree Scotland) have been positioned in a discourse of national identity. They may act as carriers of a patrician and patriarchal social position which attempts to unify a kingdom (modern UK) forged out of conquest and contested alliances (Hall, [1999] 2008, pp. 219–22). Less critical (or more conservative) understandings would agree that country houses have a job to do in representing a set of 'British' values (as a unified kingdom) centred on the relationship between artistic excellence, good stewardship and Protestant political democracy. I've compressed both positions considerably but the point is to show that country houses have been interpreted (since at least the eighteenth century) as carrying cultural meanings beyond their local context (Colley, 1994).

Country houses also carry 'hidden histories', as Samuel termed the unconsidered pasts of the disempowered (Samuel, 1994). It is now more common for heritage houses to show greater areas of the servants' working areas and living quarters, for instance. The building itself, perhaps also the lavish furnishings, may have been paid for by colonial gains, a difficult heritage to acknowledge. The commemoration in 2007 of the abolition of the British Atlantic slave trade emphasised the human misery underlying the economic gains of the trade, one that helped pay for some country houses. Harewood House, Yorkshire, has pioneered the representation of this 'hidden history' behind its creation (Smith, 2006, p. 127). The presence of black servants in country house households has also been highlighted as an under-researched topic. Other social history investigations include the role of women in the owning families and as servants (and see West and McKellar, 2010). Country houses carry many personal stories beyond those of the owning families. The point to be explored using Smith's research is how the class relations of the country house are experienced and understood by contemporary visitors.

The 'high-art' content of these heritage sites, celebrated as they are for their architecture and their contents, often finds them being described as 'treasure houses' (Jackson-Stops (ed.), 1985). I suggested earlier that this is the primary reason for their early adoption as heritage sites. The aesthetic argument can be seen in the outcry and successful resolution of the threatened dispersal in 2008 of the historic contents of a Scottish country house, Dumfries House. The campaign to 'save' the house for the nation was centred on the historic interest of the Chippendale furniture made for the 1750s house and the high quality of the rest of the original interior schemes. This was an argument setting the house into the canon of art and architectural design.

The Scottish Parliament decided to support this cause for the sake of promised regeneration benefits of the rescue proposals for the depressed area where the house is located and the incidental prestige for Scottish history. The total price

paid to the marquis of Bute by a consortium of heritage bodies and the government was £45 million. Thus a 'high art' heritage site will have to find ways of engaging with non-traditional heritage visitors, that is, those outside the roughly 30 million annual visits. The aesthetic, national and social values identified all come into play here.

Smith follows Hewison and other critics in seeing the country house as the symbol of a highly elitist way of life standing in for a set of national 'great' qualities (Smith, 2006, p. 117). The sale of Dumfries House to the nation does nothing to challenge that reading if only the arguments made publicly by specialist art bodies are heard. The more interesting test of meaningfulness for Dumfries House will come from the range of visitors, the presentation of the property to the visitors, and the visitor responses.

Visitor responses to the English country house

Visiting country houses has been a significant activity for at least 200 years, first by fellow members of the ruling classes and now by mass tourists. Smith speculates that country house visiting might be an established historical practice, one that is meaningful within English culture (Smith, 2006, p. 121). The visual appeal of country houses continues to be reinforced by their popularity as locations for film and television, particularly with major adaptations of English literature that use the country house setting to explore class distinctions. Some country houses make a point of this in their promotional material, offering visitors access to the 'real' stage sets of their favourite drama.

The class associations of country houses with the British ruling classes are unavoidable. Equally, most country house visitors are from the UK and as such are likely to be self-aware of their own class identity. A visit to a country house may therefore represent an encounter between the visitor's class identity and the range of class identities historically present in the house.

Smith is interested in identifying how the AHD operates and how unofficial, or popular, understandings or uses of heritage interact with the official discourse. Her survey of country house visitors is a case study for how visitors experience this particular historic environment and what their motivations might be. Her research is informed by investigative techniques used in social sciences and her conclusions draw on her wider theoretical stance (Smith, 2006, p. 115–61).

For Smith, people understand heritage through cultural activities that have intangible forms and results: memory, performance, identity and experience. These activities can be highly personal or shared as community activities, but by their nature they are unlikely to generate consensus. Smith is interested in tensions and dissonance, because her model of the AHD and the alternative

unofficial uses of heritage predicts that there should always be competing discourses generated between the official heritage workers and users/creators of heritage. One result of this competition is that the very processes intended to conserve the physical heritage (for the general public good) actually end up constraining if not policing the range of experiences available ('please do not touch', 'no visitors beyond this point'). Smith wanted to research if and how visitors feel such limitations on their experience of the visit.

'Performing identities at the country house': visitor survey research

The 2004 survey of visitors to six English country houses

Smith's survey created 454 visitor interviews conducted at six English country houses in 2004. Interviewers made verbatim notes of the answers, which were later sorted into groups. Her questionnaire contained thirteen open questions about what visitors got from their visit. For example, the question 'whose history are you visiting here?' allowed visitors to respond in their own terms. Their answers frequently used 'the family' as the phrase denoting the owners (when other possible terms could have been 'the aristocracy' or 'the ruling classes') (Smith, 2006, pp. 137–8, Table 4.3). Closed questions invited visitors to pick answers from a list. The question about reasons for visiting offered ten possibilities including education, taking the children and 'it's a pleasant pretty place'. The highest proportion of reasons were 'recreation' and 'for the experience of going to a country house'. Smith's data allowed her to link the latter response to the social profile of the respondents (below), showing that visitors with a university education tended to answer in this way (Smith, 2006, pp. 138–9, Table 4.4).

The visitor profile matched other characterisations of the typical country house visitor as white, middle aged and middle class. Sixty-two per cent of visitors in the survey were women. Just under half were members of an amenity society or a heritage organisation, and under half were making a repeat visit to the house in question. There were no significant variations in the results between the different houses, despite their varied ownership (private aristocratic; National Trust; English Heritage) so Smith's discussion groups the visits together.

Visitors responded to questions about what the word 'heritage' means to them, their reasons for making the visit, the experiences they said they valued at the house, the messages they took away with them and whether the house 'spoke' to any aspects of their personal identity. They were also asked to comment on the interpretation materials and information provided to visitors at the house.

Why visit a country house?

I began this case study with a discussion of the principal meanings attributed to country houses, which were discourses about national identity, aesthetic value and, increasingly, social significance. Smith concludes from her survey that national identity was commonly expressed in 'unproblematic' terms. English visitors felt a direct connection between their sense of Englishness and the cultural achievement that the country house represented as a specific contribution to the world. It was the English interest in preserving these houses and allowing access to them (that is, heritage practices) that distinguished England from other nations and supported visitors' claims to having a deep history (Smith, 2006, pp. 136–7). The 'expert' arguments for the role of English country houses in the formation of national identity do seem to be current for visitors, which leads Smith to conclude that this form of the AHD is active.

Aesthetic value comes low in percentage terms in visitor responses. Only 2.9 per cent said that architectural history was part of the experience. From a list of reasons for visiting, 10.1 per cent chose 'to see the collection in the house'. Perhaps the most telling response is to the open question 'how does it make you feel to visit this place?' where only 5.5 per cent of visitor answers could be grouped as 'aesthetically engaged' (Smith, 2006, p. 140, Table 4.5). Indeed, Smith does not offer an analysis specifically about aesthetic value. Most visitors do not identify themselves as experts in art, antiques or architecture and consequently do not prioritise aesthetic engagement. The contribution that aesthetic qualities make to their visit is immense, however, as a background theme to their strongly expressed sense of place and 'comfort'. This is drawn out most strikingly through 'what experiences do you value on visiting this place?' Answers that could be grouped as 'gaining cultural capital' were received from 35.5 per cent of respondents. This 'included experiencing the aesthetic qualities of the house and grounds, of enjoying the aesthetic and cultural symbolism around them' (Smith, 2006, pp. 144–5, Table 4.6). Visitors appreciated the opportunity to immerse themselves in something out of the ordinary, feeling a range of benefits from tapping in to this current of cultural achievement. Smith argues the AHD of the aesthetic significance of the houses is accepted to the extent that it is a major part of the benefits to be gained from making the visit.

The social significance of country houses arises from their role as venues for acting out identities, including class, gender, ethnicity and religion (historically, the complexities of Catholic owners expressing loyalties within a Protestant state). The surveyed visitors were thinking about their own identities in relation to the class relations presented through the house. The stability that the country house apparently represents is a positive thing for them to reflect on. The historic class relations behind the house are unproblematic to the majority of visitors. Credit is given to the aristocracy for

creating and maintaining country houses; the negative connotations of the class divisions and the 'background' of slave trade issues are seen as prices to be paid for the positive achievements. Class is an accepted part of 'the English way of life' and has a clear link with visitor responses about national discourses. The question 'what meaning does a place like this have in modern England?' produced the greatest number, 31.3 per cent, of responses which could be grouped under 'nationalism/reactionary nostalgia' (Smith, 2006, pp. 146–9, Table 4.8). It would seem that the country house evokes both aspirational feelings, about a sense of closeness to the values of the aristocratic family, and nostalgia for a former more sharply defined period of class relations when 'people knew their place' (but the visitor would not have had access on these terms to the houses at all). Smith concludes that 'the specific messages ... are most frequently ones about accepting and nostalgically rejoicing in class difference ... [At] a personal level, the country house is about class identity ... class difference and privilege [are rendered] conformable, safe and acceptable' (Smith, 2006, pp. 151).

The visit reinforces the visitor's own sense of social class identity, here predominantly middle class. Visiting a country house is perceived as a middle-class activity, a sociable experience shared with other middle-class people. Visitors may be members of heritage 'clubs', such as the National Trust, and are seen to be members of their class 'club' by being there. Seeing themselves as part of a group, visitors undertake 'a collective remembering about the social values, taste and deference and preservationist values that constitutes a certain vision of being middle class' (Smith, 2006, p. 154). Visits, membership and voluntary support, all these practices bring country house heritage into being, arguably, to a greater extent than merely placing these houses on a heritage list.

There are elements of dissonance from the AHD messages, as 11 per cent of visitors were critical of the message they derived from the house, citing it as an example of class inequities, a reflection of a minority elite, an example of massive social control (Smith, 2006, p. 147, Table 4.7). Twenty per cent wanted more information on the workers, 13 per cent wanted more about the owners, although 40 per cent said the interpretation was fine as it was (Smith, 2006, p. 156, Table 4.10). Smith commented that the visitors wanting more information about the servants 'were saying that they wanted their sense of place expanded to be more inclusive of a wider sense of class experience'. A few visitors made it clear that they interpreted the whole package as something manufactured, 'another National Trust production', with a predictable set of messages.

Overall, Smith feels that 'the conservative and elegantly packaged messages of class and nation' were accepted by visitors (Smith, 2006, p. 158). The 'heritage performance' that visitors make at these houses is based on identity,

forged through a 'sense of engagement with "like people"'. The middle classes like these houses, but are also kept in their place, finishing their tour with tea in the stables, not in the parlour. The 'heritage performance' operates to legitimise the ruling classes and reinforce the middle classes, with no room for critical class consciousness or poly-vocality. Ultimately, the 'meanings of the country house itself have not substantially changed since they began to be built over 400 years ago' (Smith, 2006, p. 161).

The AHD and the visitor

Smith's visitor research seems to bear out Bourdieu's account, that visitors with the appropriate cultural capital seek out country houses because they view them as appropriate cultural fields to inhabit; it also sits in accord with the 'cultural map' of British residents and the strong relationship between cultural capital and social class. Smith is drawing attention to *why* visitors who 100 years ago would never have been admitted to these houses except as servants or paid professionals now feel comfortable in these 'high culture' environments. Smith points out that visitors should actually feel uncomfortable: they may still have a 'back-to-front' tour of the house that makes them come in through the kitchen, they may be given tea in the stables, not the parlour, and they may be bored by the endless family portraits and predictable family histories. Smith's visitors get round these inconveniences by suppressing their actual class history and by identifying more with the class history of the former owners; few of them ask the awkward questions about how these families came out on top. In Smith's terms, rather like Hewison's arguments from the 1980s, visitors swallow the confidence trick of taking the AHD as their own.

There are elements within the case study that could modify the level of acceptance of the AHD that Smith finds. Visitors are aware that there might be more to say about what is shown to them: only 40 per cent were content with the interpretation on offer. Some of the gaps were identified around the provision of access to and information about the servants' areas of the house and their histories. As Smith argues, this does not mean that critical class consciousness is in action. However, it does show that a majority of visitors are able to reflect on the structured interpretation they have been offered. Many visitors have been round several country houses and may be comparing the different presentations and level of interpretation.

Smith's account of the visitor experience at country houses focuses on the limitations of what is on offer. These include little attempt to explain what is seen, limited access to working areas, misdirection of visitors through back entrances and a general lack of engagement with the visitor. This is in accord with Smith's wider critical position that the AHD operates to constrain the visitor experience, noted at the beginning of the case study.

My own experience of working inside a heritage organisation suggests that curators work hard to balance visitor access and understanding with conservation. One of the houses in Smith's survey is the English Heritage property of Audley End, Essex, shown in Figure 8.11. This substantial house has a top floor of unconserved bedrooms, nurseries and a gallery where coal and hot water were stored. It makes an interesting contrast with the state rooms on the main floor and their rich (and highly maintained) interiors. However, it has so far been impossible to resolve the constraints of not damaging historic interiors with the beneficial introduction of a passenger lift to enable access for all to the upper floors, and fire safety requirements have ruled out general access to the top floor. The current solution is to offer special occasional tours of the top floor, showing visitors the state of the domestic rooms after army use in the Second World War. The misdirection charge is a little overstated: it is usually a priority to let visitors enter through the original main entrance, even if they exit through a secondary door.

A greater issue is how organisations communicate their own plural understandings of their properties to the visitors. The National Trust has been leading the way with effective displays of their extensive conservation programmes, finding ways of showing visitors the work in progress and explaining why and how conservation is done. There is usually a clear link shown between visitor support and the survival or enhancement of the object of heritage. In this way, I suggest that the AHD is considerably modified: it is shown to be accountable and indeed reliant on the visitor.

The twentieth-century history of the rise of country house tourism is the story of the transition from private to public access (and often of ownership). It is part of the shifts in class identity and access to cultural capital in the last forty years. It would be interesting to ask Smith's respondents more questions about what they think about the change of ownership that the properties in state and National Trust care represent. As UK taxpayers, they have a stake in public funds and in the tax status of major charitable trusts. Nearly half of Smith's respondents were expressing their support for official heritage practices by subscribing to heritage organisations.

The saving of Dumfries House is just one example where the demands for recognition of its excellence seem to fit well with the AHD but its future is bound up with wider socio-economic regeneration of the locality. This is an example of a heavily modified AHD, which accepts the need for high culture to be seen to be the bearer of benefits to a wider social constituency. A more radical view would see this as a transfer to publicly accountable ownership (for a fair price) of a private aristocratic cultural resource that had after all been assembled from the profits from other people's labour. The celebration of excellence in achievement by artisans, designers and builders might be recovered as an important means of redistributing cultural capital.

Reflecting on the case study

One of the problems with assessing Smith's conclusions about the visitor experience is the need for a lot of detail about exactly what AHD messages were at the houses and how they were offered to the visitor. You might be able to reflect on your own experience of visiting a historic house site for these two strands: first, whether the interpretation was narrow, and second your emotional and intellectual responses to the visit. One of the strengths of historic houses is usually the potential for holistic interpretation of multiple life stories, something harder to deliver in a gallery setting. But in the absence of fully labelled displays and explanatory panels, a historic house has to have alternative ways of delivering its stories. Smith may be suggesting that both sides (the house curators and the visitors) suffer from a failure of imagination in their alleged inability to get away from the AHD. This gives no credit to innovation and visitor curiosity, however.

Values and class

Understanding how class relations manifest themselves through heritage has taken us from the international status of World Heritage sites to the single-end tenement via the English country house. Class relations are everywhere: the near-destitute family in the single end in nineteenth-century Glasgow is positioned there because of its place in power relations structured through class. Some heritage sites are explicitly presented for their class relations; others like the industrial World Heritage sites have the material culture of class relations preserved but not written in to their official significance. The English country house occupies a rather liminal area, being overtly controlled by the most powerful class, serviced by the working class, and yet barely presented in these terms, even though it is clear that visitors are highly aware of class positions.

Official practices of heritage around working-class houses, as we saw in Glasgow, still tend to emphasise aesthetic values over social history. However, social history prevails in the absence of aesthetic value and where the curatorial mission is focused on exploring popular histories. In recent decades conservation professionals have taken on additional responsibility for expanding the range of meanings around the heritage they curate: witness the uptake of HLF projects around community identity and parallel projects in heritage agencies (treated as outreach projects). Grassroots activity on social networking sites is an interesting mixture, documenting memories and experiences of some difficult working-class heritage (damp tower blocks) and commenting on official assessments of significance (the aesthetic).

Smith asked questions about the uses of heritage to represent class identity: do country houses keep us in our place, still? How strong is the AHD in representing class relations as static and inevitable? One response is that the

AHD ignores class in favour of a set of aesthetic priorities, selected and promoted by a minority class. Class is not directly represented but is present as a structuring principle that we hardly notice. Aesthetic values are not the only ones to be closely woven in with class distinctions. In the UK the continued survival of the places and performances associated with the upper class and the monarchy acts as a representation of a set of power relations to us as spectators. It is extremely difficult to separate these ceremonies, parades, rituals and their environments from national discourses.

Conclusion

The opening of this chapter suggested that class was a variable of personal identity, along with ethnicity, gender and religious affiliation. The first case study focused on economic, or occupational, class to see how working-class housing was treated by official heritage practices. We noted the politics of housing, where public policy and prevailing attitudes towards community consultation (or its absence) were dominant over possible heritage interventions, such as designation or archive creation. Some community responses towards recovering their heritage, supported by official heritage organisations, are more recent responses to changes inflicted on working-class districts. People's sense of identity is inextricably linked to a sense of place.

The second half of the chapter focused on social class as group identity. The case study on visitor responses to English country houses concluded that the English white middle classes mainly found what they wanted to find at these heritage sites: reinforcement of their identity and their view of the nation. This is not without paradoxes, including the open access made possible through democratic power shifts in the later twentieth century. We can see how class operates with cultural capital to create and maintain groups regionally and nationally. Now we close with the thought that the global influence of capitalism, and with it modernity, is also the spread of class relations.

Works cited

Bennett, T. and Silva, E. (2006) 'Culture, tastes and social divisions in contemporary Britain', *Cultural Trends*, vol. 15, nos 2 and 3.

Bourdieu, P. (1984) *Distinction: A Social Critique of the Judgement of Taste*, trans. R. Nice, London, Routledge & Kegan Paul.

Bourdieu, P. (1990) *Reproduction in Education, Society and Culture*, trans. R. Nice, London, Sage.

Clark, H. and Carnegie, E. (2003) *She was Aye Workin': Memories of Tenement Women in Edinburgh and Glasgow*, Oxford, White Cockade Publishing.

Colley, L. (1994) *Britons, Forging the Nation 1707–1837*, London, Pimlico.

Davison, G. ([2000] 2008) 'Heritage: from patrimony to pastiche' in Fairclough, G., Harrison, R., Jameson, J.H. Jr and Schofield, J. (eds) *The Heritage Reader*, Abingdon and New York, Routledge, pp. 31–41.

Fergusson, J. (2004) 'Milne, (George) James Henry Lees- (1908–1997)', *Oxford Dictionary of National Biography*, Oxford, Oxford University Press; also available online at www.oxforddnb.com/view/article/68798 (accessed 6 November 2008).

Gayo-Cal, M. (2006) 'Leisure and participation in Britain', *Cultural Trends*, vol. 15, nos 2/3, pp. 175–92.

Gayo-Cal, M., Savage, M. and Warde, A. (2006) 'A cultural map of the United Kingdom, 2003', *Cultural Trends*, vol. 15, nos 2/3, pp. 213–37.

Hall, S. ([1999] 2008) 'Whose heritage? Un-settling "the heritage", re-imagining the post-nation' in Fairclough, G., Harrison, R., Jameson, J.H. Jr and Schofield, J. (eds) *The Heritage Reader*, Abingdon and New York, Routledge, pp. 219–28.

Heritage Lottery Fund (2005) *From Plantation to Pollok, from Kabul to Kennished* [online], http://www.hlf.org.uk/NR/rdonlyres/ BA7B3DDB-F956-454E-B4A3-5B5FC47354E3/5023/ FromPlantationtoPollokFromKabultoKennishead1.pdf (accessed 1 December 2008).

Hewison, R. (1987) *The Heritage Industry: Britain in a Climate of Decline*, London, Methuen.

Historic Houses Association (2008) [online], www.hha.org.uk/metadot/ index.pl (accessed 6 November 2008).

Horsey, M. (1990) *Tenements and Towers: Glasgow Working-Class Housing 1890–1990*, Edinburgh, Royal Commission on the Ancient and Historical Monuments of Scotland.

Jackson-Stops, G. (ed.) (1985) *Treasure Houses of Britain: Five Hundred Years of Patronage and Collecting*, New Haven, CT and London, Yale University Press.

Lowenthal, D. (1985) *The Past is a Foreign Country*, Cambridge, Cambridge University Press.

Mandler, P. (1997) *The Fall and Rise of the Stately Home*, New Haven, CT and London, Yale University Press.

Samuel, R. (1994) *Theatres of Memory: Volume 1, Past and Present in Contemporary Culture*, London and New York, Verso.

Samuel, R. ([1994] 2008) 'Politics' in Fairclough, G., Harrison, R., Jameson, J.H. Jr and Schofield, J. (eds) *The Heritage Reader*, Abingdon and New York, Routledge, pp. 274–93.

Smith, L. (2006) *Uses of Heritage*, Abingdon and New York, Routledge.

Stewart, L. (ed.) (2006) *Doors Open: from Plantation to Pollok, from Kabul to Kennishead*, Glasgow, Village Storytelling Centre.

Tunbridge, J. ([1984] 2008) 'Whose heritage to conserve?: cross-cultural reflections on political dominance and urban heritage conservation' in Fairclough, G., Harrison, R., Jameson, J.H. Jr and Schofield, J. (eds) *The Heritage Reader*, Abingdon and New York, Routledge, pp. 235–44.

West, S. and McKellar, E. (2010) 'Interpretation of heritage' in West, S. (ed.) *Understanding Heritage in Practice*, Manchester, Manchester University Press/Milton Keynes, The Open University.

Wright, P. (1985) *On Living in an Old Country: The National Past in Contemporary Britain*, London and New York, Verso.

Further reading

Bennett, T. (1998) 'Museums and "the people"' in Lumley, R. (ed.) *The Museum Time Machine*, London and New York, Routledge, pp. 63–84.

Bennett, T., Savage, M., Silva, E.B., Warde, A., Gayo-Cal, M. and Wright, D. (2008) *Culture, Class, Distinction*, Abingdon and New York, Routledge.

Bourdieu, P. (1984) *Distinction: A Social Critique of the Judgement of Taste*, London, Routledge & Kegan Paul.

Carnegie, E. (2006) '"It wasn't all bad": representations of working class cultures within social history museums and their impacts on audiences', *Museum and Society*, vol. 4, no. 2, pp. 69–83.

Harwood, E. and Powers, A. (eds) (2008) *Housing the Twentieth Century Nation*, Twentieth Century Architecture 9, London, Twentieth Century Society.

Hill, K. (2005) *Culture and Class in English Public Museums, 1850–1914*, Aldershot, Ashgate.

Mandler, P. (1997) *The Fall and Rise of the Stately Home*, New Haven, CT and London, Yale University Press.

Appendix: cultural heritage policy documents

List of charters, conventions, and recommendations representing the chronological development of cultural policy over the course of the twentieth century. Reproduced from Getty Conservation Institute (2008).

1877–1904
The Principles of the Society for the Protection of Ancient Buildings as Set Forth upon its Foundation (The SPAB Manifesto) (1877)

Recommendations of the Madrid Conference (1904)

1930–39
General Conclusions of the Athens Conference (1931)

Carta Di Atene (1931)

Charter of Athens (1933)

Roerich Pact: Protection of Artistic and Scientific Institutions and Historic Monuments (1935)

1950–59
Hague Convention: Convention for the Protection of Cultural Property in the Event of Armed Conflict (1954)

European Cultural Convention (1954)

Recommendation on International Principles Applicable to Archaeological Excavation (1956)

Recommendation Concerning International Competitions in Architecture and Town Planning (1956)

1960–69
Recommendation Concerning the Most Effective Means of Rendering Museums Accessible to Everyone (1960)

Recommendation Concerning the Safeguarding of the Beauty and Character of Landscapes and Sites (1962)

The Venice Charter: International Charter for the Conservation and Restoration of Monuments and Sites (1964)

Recommendation on the Means of Prohibiting and Preventing the Illicit Import, Export and Transfer of Ownership of Cultural Property (1964)

Norms of Quito: Final Report of the Meeting on the Preservation and Utilization of Monuments and Sites of Artistic and Historical Value (1967)

Recommendation Concerning the Preservation of Cultural Property Endangered by Public or Private Works (1968)

European Convention on the Protection of the Archaeological Heritage (1969)

1970–78

Convention on the Means of Prohibiting and Preventing the Illicit Import, Export and Transfer of Ownership of Cultural Property (1970)

Convention Concerning the Protection of the World Cultural and Natural Heritage (1972)

Recommendation Concerning the Protection, at National Level, of the Cultural and Natural Heritage (1972)

Resolutions of the Symposium on the Introduction of Contemporary Architecture into Ancient Groups of Buildings (1972)

European Charter of the Architectural Heritage (1975)

Declaration of Amsterdam (1975)

Resolutions of the International Symposium on the Conservation of Smaller Historic Towns (1975)

Cultural Tourism (1976)

Convention on the Protection of the Archeological, Historical, and Artistic Heritage of the American Nations, Convention of San Salvador (1976)

Recommendation Concerning the Safeguarding and Contemporary Role of Historic Areas (1976)

Recommendation Concerning the International Exchange of Cultural Property (1976)

Recommendation for the Protection of Moveable Cultural Property (1978)

1980–89

Recommendation for the Safeguarding and Preservation of Moving Images (1980)

The Florence Charter: Historic Gardens (1982)

Deschambault Charter for the Preservation of Quebec's Heritage (1982)

Tlaxcala Declaration on the Revitalization of Small Settlements (1982)

Declaration of Dresden (1982)

Appleton Charter for the Protection and Enhancement of the Built Environment (1983)

Declaration of Rome (1983)

European Convention on Offences Relating to Cultural Property (1985)

Convention for the Protection of the Architectural Heritage of Europe (1985)

First Brazilian Seminar about the Preservation and Revitalization of Historic Centers (1987)

The Washington Charter: Charter on the Conservation of Historic Towns and Urban Areas (1987)

Recommendation on the Safeguarding of Traditional Culture and Folklore (1989)

The Vermillion Accord on Archaeological Ethics and the Treatment of the Dead (1989)

1990–99

Charter for the Protection and Management of the Archaeological Heritage (1990)

Quebec City Declaration (1991)

Charter for the Conservation of Places of Cultural Heritage Value (1992)

A Preservation Charter for the Historic Towns and Areas of the United States of America (1992)

Charter of Courmayeur (1992)

European Convention for the Protection of the Archaeological Heritage of Europe (Revised) (1992)

New Orleans Charter for the Joint Preservation of Historic Structures and Artifacts (1992)

Declaration of Rio (1992)

Declaration of Oaxaca (1993)

The Fez Charter (1993)

Guidelines for Education and Training in the Conservation of Monuments, Ensembles and Sites (1993)

UN General Assembly Resolution (A/RES/48/15) on the Return or Restitution of Cultural Property to the Countries of Origin (1993)

Buenos Aires Draft Convention on the Protection of the Underwater Cultural Heritage (1994)

The Nara Document on Authenticity (1994)

Resolution on Information as an Instrument for Protection against War Damages to the Cultural Heritage (1994)

Unidroit Convention on Stolen or Illegally Exported Cultural Objects (1995)

Bergen Protocol on Communications and Relations among Cities of the Organization of World Heritage Cities (1995)

Charter for Sustainable Tourism (1995)

Secretary of the Interior's Standards for the Treatment of Historic Properties (1995)

Charter for the Protection and Management of the Underwater Cultural Heritage (1996)

Final Communiqué of the NATO-Partnership for Peace Conference on Cultural Heritage Protection in Wartime and in State of Emergency (1996)

Declaration of Valencia (1996)

Declaration of San Antonio (1996)

Declaration of Quebec (1997)

Document of Pavia (1997)

Evora Appeal (1997)

The Stockholm Declaration: Declaration of ICOMOS marking the 50th anniversary of the Universal Declaration of Human Rights (1998)

Declaration of Melbourne (1998)

Recommendation on Measures to Promote the Integrated Conservation of Historic Complexes Composed of Immovable and Moveable Property (1998)

The Burra Charter: the Australia ICOMOS Charter for the Conservation of Places of Cultural Significance (1999)

Charter on the Built Vernacular Heritage (1999)

International Wood Committee Charter: Principles for the Preservation of Historic Timber Buildings (1999)

International Cultural Tourism Charter: Managing Tourism at Places of Heritage Significance (1999)

Second Protocol to the Hague Convention of 1954 for the Protection of Cultural Property in the Event of Armed Conflict (1999)

2000–

Convention on Biological Diversity (2000)

European Convention on Landscape (2000)

Convention on the Protection of Underwater Cultural Heritage (2001)

Convention for the Safeguarding of Intangible Cultural Heritage (2003)

Ename Charter (2nd Draft 2004)

Works cited

Getty Conservation Institute (2008) Cultural Heritage Policy Documents [online], www.getty.edu/conservation/research_resources/charters.html (accessed 8 September 2008)

Glossary

Aboriginal people see **indigenous people**

aesthetic concerned with sensory (primarily visual) judgements of beauty, taste and value.

archives collections of written materials in any form.

authentic see **authenticity**

authenticity a measure of the extent to which a thing might be considered to be the remains of the original. It has an ethical connotation – 'authentic' is the opposite of 'fake' or 'sham', both of which assume deception.

biodiversity variety of species in a biological system. Biodiversity can be threatened by industrial farming, uncontrolled hunting or other factors. Reduction of biodiversity is considered dangerous for a number of reasons, including overdependence on a few species and reduced resistance to disease. It is often also considered ethically and aesthetically desirable to maintain biodiversity.

canon set of things that embody a standard by which others may be assessed, for example the literary or artistic canon. In heritage terms, it refers to a set of heritage places which are actively selected to embody the values of a group using official heritage criteria, and which exemplify the values of distinction and taste in their selection. See also **representative**.

collective memory the way in which a society or social group recall, commemorate and represent their own history (as opposed to personal memory).

commodification the process of turning things into commodities that can be bought or sold. Often used metaphorically to draw attention to the material and economic forces that influence how a thing is used and perceived; for example, commodification of a heritage site does not literally mean that it can be bought or sold, but rather that several aspects of visiting such a site (entry fees, the shop, etc.) are commercial and that a measure of its value is considered to be its profitability. See also **museumification**.

community value see **social values**

conservation in the UK, the processes of maintenance and protection from destruction or change, usually with some legal sanctions. In the USA, the term 'preservation' is used.

criteria in heritage terms, a list of conditions that must be met prior to listing on a statutory heritage register, such as the **World Heritage List**.

cultural heritage object, place or practice of heritage that is of human origin. The term is often used by way of contrast with **natural heritage**.

cultural landscape humanly modified landscape believed to be of importance due to the interplay of natural and cultural influences. A distinct category of cultural landscape was recognised in the revisions to the **World Heritage Convention** in 1992.

designation the identification and description of a heritage object, place or practice in order to confer legal protection. Sometimes the term inscription is used. See also **nomination** and **listing**.

diaspora the geographical spread of people outside their country of origin, either through forced or voluntary migration.

discourse lit. speech or discussion; often used in a more theoretical context to describe a form of communication that requires specialised ('inside') knowledge.

English country house large house or mansion, originally built as the centre of a large estate (landholding) as the owner's residence, intended to house an extended household of family and domestic servants, with extensive outbuildings for food preparation and storage. Usually surrounded by formal gardens and an open area of parkland, in contrast to the farms on the estate. The wealthiest families owned several country houses on estates around the UK, as well as owning or renting substantial houses in London. Referred to colloquially as **stately homes**.

first nation(s) see **indigenous people**

heritage list see **heritage register** and **World Heritage List**

heritage register a statutory list of objects, places or practices of heritage significance. See also **World Heritage List**.

indigenous people ethnic group who occupied a geographic area prior to the arrival and subsequent occupation of migrant settlers. The term may be used in some circumstances to include groups who may not have been part of the 'original' occupation of an area, but who were part of an early historical period of occupation prior to the most recent colonisation, annexation or formation of a new nation-state. The terms **first nation** and **Aboriginal people** are also often used.

inherent the idea that the values of a heritage object, place or practice are inseparable from its physical qualities.

inscription see **designation**

intangible heritage something considered to be a part of heritage that is not a physical object or place, such as a memory, a tradition or a cultural practice, as opposed to **tangible heritage**.

interpretation the process of communicating information to the general public about a particular heritage object, place or practice.

intrinsic see **inherent**

land alienation the reclamation of land held under customary law by governments, especially in the context of colonialism. See also **land claims** and **land rights**.

land claims in heritage, this term is often used to describe indigenous claims for **land rights**.

land rights property rights pertaining to land. In heritage, the term is most often used to describe the legal rights of indigenous peoples in land and associated resources.

land tenure the system which describes by whom land is owned and under what conditions it might be accessed and used.

listing the process whereby heritage objects, place or practices are given the protection of the law by being placed on a statutory list. The term 'scheduling' is sometimes used in relation to archaeological sites in the UK. See also **nomination** and **designation**.

locality the location and particular qualities of a place.

museumification the transformation of a place into heritage, involving the fixing of values and appearance through an active intervention of conservation and management.

native title see **land rights**

natural heritage plants, animals, landscape features and biological and geological processes that are not humanly modified. The term is most often used in opposition to **cultural heritage**.

nomination the process by which places are put forward for **listing** on a **heritage register**.

official heritage state-sponsored or controlled processes of heritage **listing** and management. The term is often used in opposition to the term **unofficial heritage**.

oral history the transmission of history by verbal means. Often a feature of non-literate cultures.

oral tradition see **oral history**

preservation see **conservation**

repatriation returning something to its country of origin or, by extension, to an original owner.

representative model of heritage in which types of heritage object, place or practice are collected so that individual examples come to stand for the whole. This model inverts conventional understandings of heritage as the best, biggest, oldest or most rare, and assesses the significance of heritage in terms of the extent to which an object, place or practice is most typical of the range of types being considered. Often discussed in opposition to the **canon**ical model of heritage.

representativeness the extent to which one heritage site could stand as an exemplar of its type.

reserves areas of crown- or state-owned land that are designated for particular purposes. One use of this term refers to land set aside for conservation of plant and animal species as nature reserves. Another use refers to land formally designated for occupation and use by **indigenous people**.

restoration in heritage parlance, returning something to an earlier condition, sometimes involving the removal of later additions or alterations and the replacement of lost elements. See also **authentic**.

sacred sites places that have spiritual significance. The term is often used in settler societies to describe places that are believed to have spiritual significance to **indigenous people**.

significance in heritage terms, the relative importance of one heritage object, place or practice when compared with another.

social values the value of a heritage object, place or practice to society. The term is most often contrasted with other types of heritage values (e.g. **inherent** or intrinsic values) that are determined by experts, and is closely linked with the concepts of **community value** and **intangible heritage**.

stately home large house or mansion built as a status symbol in the country. See also **English country house**.

stupa dome-shaped buildings constructed over the site of relics that are reputed to be associated with the Buddha.

subaltern subordinate or overlooked. A person or group of low social status and their cultural expression which is excluded from common representations of the nation.

tangible heritage physical heritage, such as buildings and objects, as opposed to **intangible heritage**.

taxonomic an approach that is concerned with ways of classifying or grouping types of heritage.

unofficial heritage objects, places or practices which are not considered to be part of the state's official heritage, but which nonetheless are used by parts of society in their creation of a sense of identity, community and/or locality. The term is often used in opposition to the term **official heritage**.

values in heritage parlance, the reason that explains the definition of an object, place or practice as heritage. See also **significance**.

Venice Charter The International Charter for the Conservation and Restoration of Monuments and Sites, which was drafted at the Second International Congress of Architects and Technicians of Historic Monuments in Venice in 1964 and adopted by ICOMOS in 1965.

World Heritage Convention The Convention Concerning the Protection of World Cultural and Natural Heritage, adopted by the General Conference of UNESCO on 16 November 1972, which established the World Heritage List and the process for listing **World Heritage sites**.

World Heritage List list of places considered by the World Heritage Committee to have outstanding universal value. The list was established by the 1972 UNESCO **World Heritage Convention**.

World Heritage site a place listed on the **World Heritage List**.

Acknowledgements

Grateful acknowledgement is made to the following sources for permission to reproduce material in this book.

Pages 127–9: http://whc.unesco.org/en/globalstrategy. 'Global Strategy'. UNESCO World Heritage Centre website. Copyright © UNESCO World Heritage Centre. Reprinted with permission;

Pages 304–8: http://www.getty.edu/conservation/research_resources/ charters.html. 'Cultural Heritage Policy Document List'. The Getty website. Copyright © J. Paul Getty Trust.

Every effort has been made to contact copyright holders. If any have been inadvertently overlooked the publishers will be pleased to make the necessary arrangements at the first opportunity.

Index

Page numbers in **bold** refer to illustrations.